# ASTRONOMY ✦
# PHOTOGRAPHER
## OF THE YEAR

# ASTRONOMY
# PHOTOGRAPHER
## OF THE YEAR

ROYAL
OBSERVATORY
GREENWICH

FIREFLY BOOKS

# A FIREFLY BOOK

Published by Firefly Books Ltd. 2015
Copyright © 2015 Firefly Books Ltd.
Text copyright © 2015 National Maritime Museum, Greenwich, London
Photographs copyright © individual photographers, see pages 275–281
Guide to Astrophotography © *Sky at Night Magazine* 2015

In association with Royal Museums Greenwich, the group title for the National
Maritime Museum, Royal Observatory Greenwich, Queen's House and *Cutty Sark*
Greenwich
London SE10 9NF

**Publisher Cataloging-in-Publication Data (U.S.)**
Astronomy photographer of the year : prize-winning images by top
astrophotographers / The Royal Observatory, Greenwich ; foreword by Terence
Dickinson.
Summary: Images compiled by the Royal Observatory from the Astronomy
Photographer of the Year competition. The prints capture a variety of
astronomical phenomena within our solar system and far into deep space.
Guide to astrophotography included.
ISBN-13: 978-1-77085-473-4
1. Astronomical photography – Pictorial works. I. Royal Observatory,
Greenwich. II. Dickinson, Terence. III. Title.
522.63   dc23   QB121.A7866   2015

**Library and Archives Canada Cataloguing in Publication**
Astronomy photographer of the year : prize-winning images by
top astrophotographers / the Royal Observatory, Greenwich ; foreword
by Terence Dickinson.
Includes index.
ISBN 978-1-77085-473-4 (bound)
1. Astronomy — Pictorial works.  2. Astronomical photography.
3. Astronomical photography — Competitions.  I. Dickinson, Terence,
writer of supplementary textual content  II. Royal Observatory,
Greenwich, compiler
QB68.A87 2015   520.22'2   C2015-901171-X

Published in the United States by
Firefly Books (U.S.) Inc.
P.O. Box 1338, Ellicott Station
Buffalo, New York  14205

Published in Canada by
Firefly Books Ltd.
50 Staples Avenue, Unit 1
Richmond Hill, Ontario  L4B 0A7

Interior design: HarperCollins Publishers Ltd
Map image: Courtesy of NASA/Earth Observatory

Printed in China by RR Donnelley APS

"Here you will find literally the best of the best from astrophotographers on planet Earth: outstanding examples of starscapes, planets, galaxies, nebulas and, my favorites, Earth and the night sky in the same scene."

**TERENCE DICKINSON**

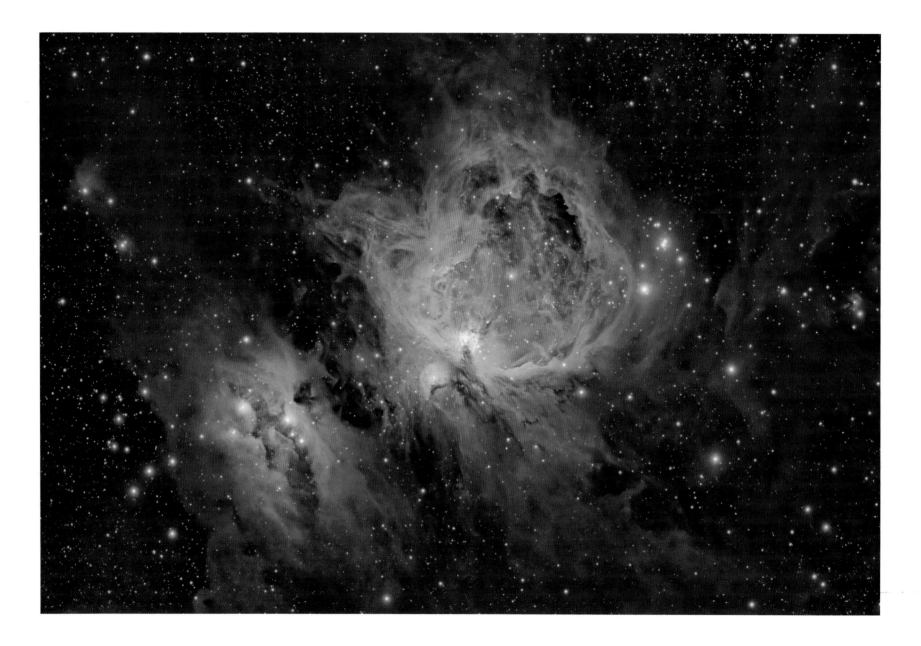

**MARCUS DAVIES** *(Australia)*          *HIGHLY COMMENDED*

### The Sword and the Rose (Orion's Sword and M42)
[10 January 2010]

**MARCUS DAVIES:** Apart from its sheer beauty and astronomical significance, I imaged this object because it's quite difficult to capture properly. My goal was to render the complex colours as vividly and as faithfully as possible.

**BACKGROUND:** This cloud of dark dust and glowing gas in the Sword of Orion is the M42 nebula, a stellar nursery where new stars are being born. M42 is visible to the naked eye but a telescope reveals the full beauty of this giant star factory. The fierce radiation from newly-formed stars peels back the layers of gas, like a giant flower unfurling its petals.

**Takahashi TOA-150 150mm refractor; Takahashi EM-400 equatorial mount; SBIG STL11000M CCD camera**

# CONTENTS

# FOREWORD

The second decade of the 21st century appears to be the golden age of astronomical imagery. Not only are large research observatory telescopes gathering an unprecedented bounty of celestial portraits of previously unseen celestial wonders, but a cadre of enthusiastic amateur astronomers using their own equipment and creative techniques are producing images that surpass anything being done just a generation ago. It's this latter group that is celebrated on these pages.

Here you will find literally the best of the best from astrophotographers on Planet Earth: outstanding examples of starscapes, planets, galaxies, nebulas and, my favourites, Earth and the night sky in the same scene. We observe the Universe from the surface of a small speck in the immensity of a cosmos of a trillion trillion stars and planets. Perspective is a challenge, but as H.G. Wells said more than a century ago, "The starry night sky soothes the soul."

Anyone whose memories of reading astronomy books reach back to the early 1950s, like myself, will recall that astronomy—what little of it was available then in popular book and magazine form—was entirely in black and white. It wasn't just that color printing was an expensive enterprise at the time but that no color photos of any planets, nebulas or galaxies existed. Color-film technology was not yet up to the task. To the curious citizen of planet Earth, it was literally a black and white universe, imparting a distinct ghostlike pallor to the subject.

The first color pictures of celestial objects that had sufficient quality to merit widespread publication were taken in the mid-1950s on Kodachrome and Anscochrome film emulsion by pioneering astrophotographers Robert Leighton of Caltech and W.S. Finsen of the Union Observatory, Johannesburg, South Africa (both imaged Mars), and William Miller of Palomar Observatory (some of the brightest nebulas and galaxies). Today, more detailed images of the same objects are routinely taken by backyard hobbyists using digital cameras and telescopes that can fit into the trunk of a car. By contrast, some of Miller's pictures required the use of the Palomar 200-inch telescope, the world's largest astronomical instrument at the time. His color gallery was the cover story in the June 1955 issue of *National Geographic*.

Since then, the biggest advance has been digital-imaging technology, which replaced film as a recording medium at research observatories during the 1970s and 1980s. Backyard astronomers interested in astrophotography followed a decade or two later. Digital imaging is faster and more sensitive to light wavelengths beyond the range of film emulsion and is easier to store, record and transmit—especially from interplanetary spacecraft! Every image on the following pages is a digital photograph. There is no doubt that we do, indeed, live in the golden age of astronomical imagery. And it can only get better.

**Terence Dickinson**
Editor
*SkyNews* magazine

## INTRODUCTION TO COMPETITION

### ASTRONOMY PHOTOGRAPHER OF THE YEAR

2014 was the sixth year of Astronomy Photographer of the Year, the competition to showcase the best celestial images taken from Planet Earth, organized by the Royal Observatory, Greenwich, and run in association with *BBC Sky at Night Magazine*, with the help of Flickr. Each year the competition continues to grow, and in 2014 over 1700 entries were submitted from photographers all around the world in the categories of 'Earth and Space', 'Our Solar System', 'Deep Space' and 'Young Astronomy Photographer of the Year'.

In each category the competition's judges select a winner, a runner-up and three highly commended entries. The four winning images then go forward to compete for the title of Astronomy Photographer of the Year.

Three special prizes reflect the constantly evolving nature of astrophotography. 'People and Space' and 'Robotic Scope' celebrate the creativity and technological advances that photographers continue to bring to the field of astrophotography; while the Sir Patrick Moore Prize for Best Newcomer honours the man who did more than any other to engage the public with the wonders of the night sky.

This collection brings together some of the best shortlisted and winning images from the past six years of the Astronomy Photographer of the Year competition. Images are arranged in three sections based on the competition categories: Earth and Space, Our Solar System and Deep Space. This curated selection of shortlisted entries is followed by the Overall Winners from 2009–2014. Entries from the 'Young Astronomy Photographer of the Year' category and the three special prizes are shown within the section appropriate to the subject.

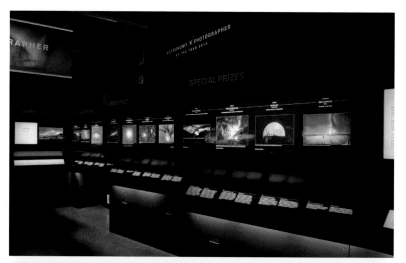

2013 Astronomy Photographer of the Year exhibition

## COMPETITION CATEGORIES

### EARTH AND SPACE
Photos that include landscapes, people and other 'Earthly' things alongside an astronomical subject.

Planet Earth is a special place; even powerful instruments like the Hubble Space Telescope have yet to find another planet with landscapes and environments as varied and beautiful as those of our own world. Photographs submitted in this category showcase the Earth's amazing scenery against the backdrop of the heavens, reflecting our planet's relationship with the wider Universe around us.

### OUR SOLAR SYSTEM
Photos of the Sun and its family of planets, moons, asteroids and comets.

We can see the Moon, the Sun and our local planets on a daily basis, even with the naked eye. But the photographs in this category present our cosmic neighbours in a new light, using equipment which reveals incredible levels of detail and by imaginative compositions which highlight their unique beauty.

### DEEP SPACE
Photos of anything beyond the Solar System, including stars, nebulae and galaxies.

Deep-space images give us a window into some of the most distant and exotic objects in the Universe; from the dark dust clouds where new stars are born to the glowing embers of supernova remnants, and far beyond to distant galaxies whose light set out towards us millions of years ago. These pictures take us to the depths of space and the furthest reaches of our imaginations.

### YOUNG ASTRONOMY PHOTOGRAPHER OF THE YEAR
Photos by people under 16 years of age.

The mission of the Royal Observatory, Greenwich, is to explain the wonder and excitement of astronomy and space science to the public. Inspiring young people and encouraging them to study science is an important part of this mission. The Young Astronomy Photographer category is a way to showcase the amazing skill and imagination of younger photographers, and to nurture their curiosity about the Universe.

## SPECIAL PRIZES

### PEOPLE AND SPACE
Photos that include people in a creative and original way.

At some time or another we have all experienced that moment when you look up at the vastness of the night sky and suddenly realize that you are a very small part of the Universe. This prize is awarded to pictures which juxtapose human and cosmic scales, with effects ranging from the profound to the humorous.

### THE SIR PATRICK MOORE PRIZE FOR BEST NEWCOMER
Photos by people who have taken up astrophotography in the last year and have not entered the competition before.

If the incredible skill and experience displayed by some of the winners of Astronomy Photographer of the Year can sometimes seem a bit intimidating, this special prize is a reminder that everyone was a beginner once upon a time. Indeed, imagination and an eye for the perfect shot can be just as important, and not every winning image was taken by an old hand.

### ROBOTIC SCOPE
Photos taken remotely using a robotic telescope and processed by the entrant.

Combining modern telescope technology with the power of the internet, robotic telescopes offer a new way for astronomy enthusiasts to experience the sky. Members of the public can sign up for time on state-of-the-art equipment in some of the best observing sites in the world, controlling the telescope remotely and downloading their images via the web. Robotic scopes give amateur astronomers access to equipment that previously only professional research observatories could afford.

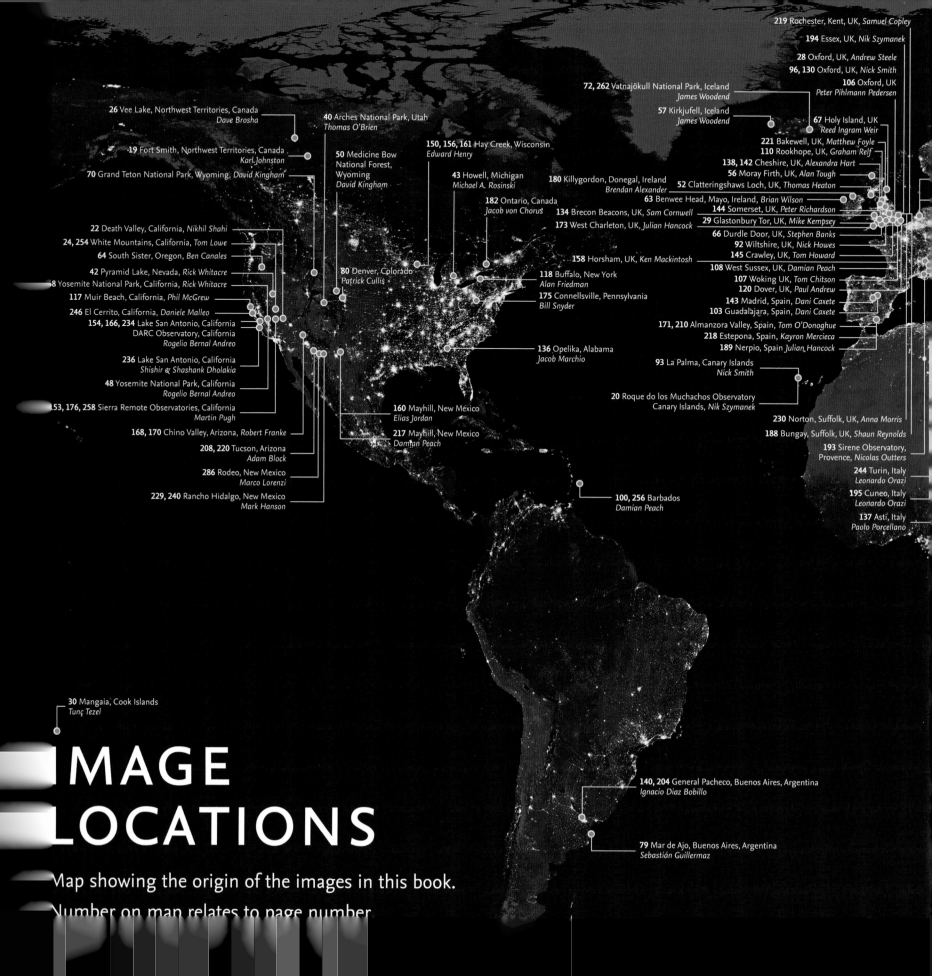

**219** Rochester, Kent, UK, *Samuel Copley*

**194** Essex, UK, *Nik Szymanek*

**28** Oxford, UK, *Andrew Steele*

**96, 130** Oxford, UK, *Nick Smith*

**106** Oxford, UK
*Peter Pihlmann Pedersen*

**72, 262** Vatnajökull National Park, Iceland
*James Woodend*

**57** Kirkjufell, Iceland
*James Woodend*

**67** Holy Island, UK
*Reed Ingram Weir*

**221** Bakewell, UK, *Matthew Foyle*

**110** Rookhope, UK, *Graham Relf*

**138, 142** Cheshire, UK, *Alexandra Hart*

**56** Moray Firth, UK, *Alan Tough*

**52** Clatteringshaws Loch, UK, *Thomas Heaton*

**180** Killygordon, Donegal, Ireland
*Brendan Alexander*

**63** Benwee Head, Mayo, Ireland, *Brian Wilson*

**144** Somerset, UK, *Peter Richardson*

**134** Brecon Beacons, UK, *Sam Cornwell*

**29** Glastonbury Tor, UK, *Mike Kempsey*

**173** West Charleton, UK, *Julian Hancock*

**66** Durdle Door, UK, *Stephen Banks*

**92** Wiltshire, UK, *Nick Howes*

**145** Crawley, UK, *Tom Howard*

**158** Horsham, UK, *Ken Mackintosh*

**108** West Sussex, UK, *Damian Peach*

**107** Woking UK, *Tom Chitson*

**120** Dover, UK, *Paul Andrew*

**143** Madrid, Spain, *Dani Caxete*

**103** Guadalajara, Spain, *Dani Caxete*

**171, 210** Almanzora Valley, Spain, *Tom O'Donoghue*

**218** Estepona, Spain, *Kayron Mercieca*

**189** Nerpio, Spain *Julian Hancock*

**26** Vee Lake, Northwest Territories, Canada
*Dave Brosha*

**40** Arches National Park, Utah
*Thomas O'Brien*

**19** Fort Smith, Northwest Territories, Canada
*Karl Johnston*

**50** Medicine Bow
National Forest,
Wyoming
*David Kingham*

**70** Grand Teton National Park, Wyoming, *David Kingham*

**150, 156, 161** Hay Creek, Wisconsin
*Edward Henry*

**43** Howell, Michigan
*Michael A. Rosinski*

**182** Ontario, Canada
*Jacob von Chorus*

**22** Death Valley, California, *Nikhil Shahi*

**24, 254** White Mountains, California, *Tom Lowe*

**64** South Sister, Oregon, *Ben Canales*

**42** Pyramid Lake, Nevada, *Rick Whitacre*

**8** Yosemite National Park, California, *Rick Whitacre*

**117** Muir Beach, California, *Phil McGrew*

**246** El Cerrito, California, *Daniele Malleo*

**154, 166, 234** Lake San Antonio, California
DARC Observatory, California
*Rogelio Bernal Andreo*

**236** Lake San Antonio, California
*Shishir & Shashank Dholakia*

**48** Yosemite National Park, California
*Rogelio Bernal Andreo*

**153, 176, 258** Sierra Remote Observatories, California
*Martin Pugh*

**168, 170** Chino Valley, Arizona, *Robert Franke*

**208, 220** Tucson, Arizona
*Adam Block*

**286** Rodeo, New Mexico
*Marco Lorenzi*

**229, 240** Rancho Hidalgo, New Mexico
*Mark Hanson*

**80** Denver, Colorado
*Patrick Cullis*

**136** Opelika, Alabama
*Jacob Marchio*

**118** Buffalo, New York
*Alan Friedman*

**175** Connellsville, Pennsylvania
*Bill Snyder*

**160** Mayhill, New Mexico
*Elias Jordan*

**217** Mayhill, New Mexico
*Damian Peach*

**93** La Palma, Canary Islands
*Nick Smith*

**20** Roque do los Muchachos Observatory
Canary Islands, *Nik Szymanek*

**230** Norton, Suffolk, UK, *Anna Morris*

**188** Bungay, Suffolk, UK, *Shaun Reynolds*

**193** Sirene Observatory,
Provence, *Nicolas Outters*

**244** Turin, Italy
*Leonardo Orazi*

**195** Cuneo, Italy
*Leonardo Orazi*

**137** Asti, Italy
*Paolo Porcellano*

**100, 256** Barbados
*Damian Peach*

**30** Mangaia, Cook Islands
*Tunç Tezel*

**140, 204** General Pacheco, Buenos Aires, Argentina
*Ignacio Diaz Bobillo*

**79** Mar de Ajo, Buenos Aires, Argentina
*Sebastián Guillermaz*

# IMAGE
# LOCATIONS

Map showing the origin of the images in this book.

Number on map relates to page number.

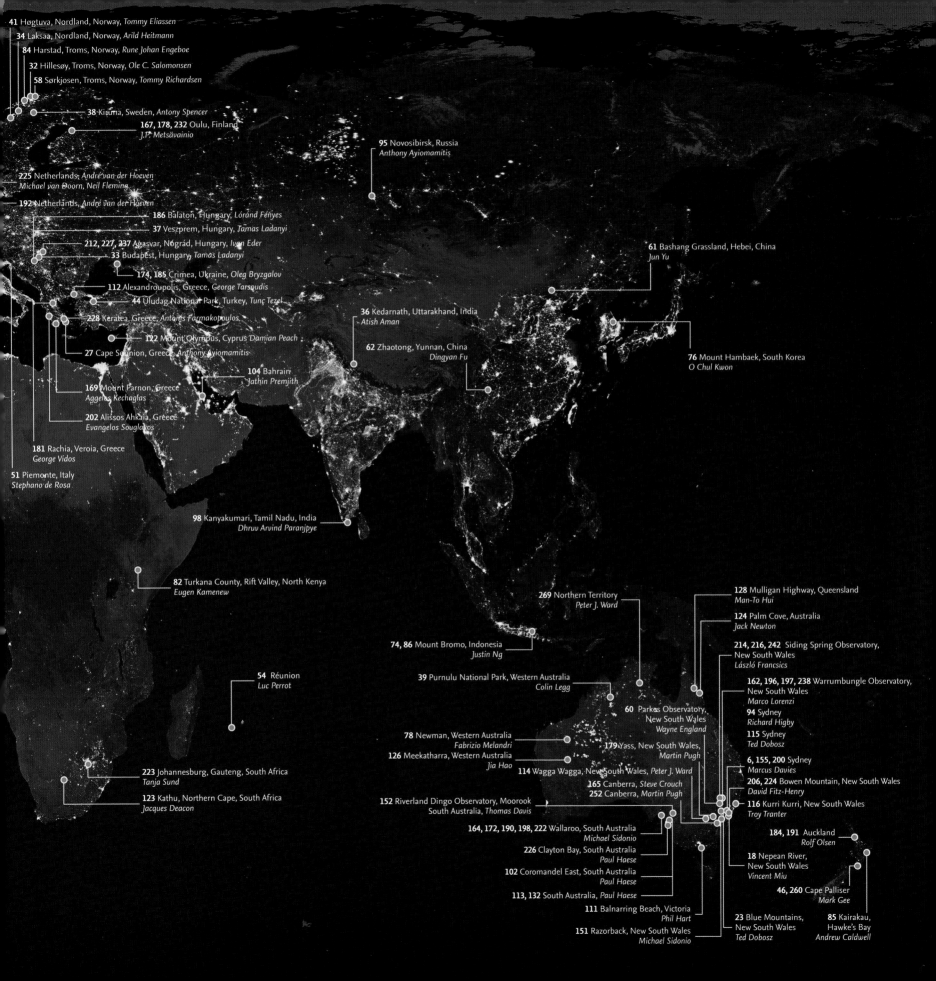

**41** Høgtuva, Nordland, Norway, *Tommy Eliassen*

**34** Laksaa, Nordland, Norway, *Arild Heitmann*

**84** Harstad, Troms, Norway, *Rune Johan Engeboe*

**32** Hillesøy, Troms, Norway, *Ole C. Salomonsen*

**58** Sørkjosen, Troms, Norway, *Tommy Richardsen*

**38** Kiruna, Sweden, *Antony Spencer*

**167, 178, 232** Oulu, Finland
*J.P. Metsävainio*

**95** Novosibirsk, Russia
*Anthony Ayiomamitis*

**225** Netherlands, *André van der Hoeven*
*Michael van Doorn, Neil Fleming*

**192** Netherlands, *André van der Hoeven*

**186** Balaton, Hungary, *Lóránd Fényes*

**37** Veszprem, Hungary, *Tamas Ladanyi*

**212, 227, 237** Agasvar, Nógrád, Hungary, *Ivan Eder*

**33** Budapest, Hungary, *Tamas Ladanyi*

**174, 185** Crimea, Ukraine, *Oleg Bryzgalov*

**112** Alexandroupolis, Greece, *George Tarsoudis*

**44** Uludag National Park, Turkey, *Tunç Tezel*

**228** Keratea, Greece, *Antonis Farmakopoulos*

**122** Mount Olympus, Cyprus *Damian Peach*

**27** Cape Sounion, Greece, *Anthony Ayiomamitis*

**104** Bahrain
*Jathin Premjith*

**169** Mount Parnon, Greece
*Aggelos Kechaglas*

**202** Alissos Ahkaia, Greece
*Evangelos Souglakos*

**181** Rachia, Veroia, Greece
*George Vidos*

**51** Piemonte, Italy
*Stephano de Rosa*

**61** Bashang Grassland, Hebei, China
*Jun Yu*

**36** Kedarnath, Uttarakhand, India
*Atish Aman*

**62** Zhaotong, Yunnan, China
*Dingyan Fu*

**76** Mount Hambaek, South Korea
*O Chul Kwon*

**98** Kanyakumari, Tamil Nadu, India
*Dhruv Arvind Paranjpye*

**82** Turkana County, Rift Valley, North Kenya
*Eugen Kamenew*

**54** Réunion
*Luc Perrot*

**269** Northern Territory
*Peter J. Ward*

**128** Mulligan Highway, Queensland
*Man-To Hui*

**124** Palm Cove, Australia
*Jack Newton*

**214, 216, 242** Siding Spring Observatory,
New South Wales
*László Francsics*

**162, 196, 197, 238** Warrumbungle Observatory,
New South Wales
*Marco Lorenzi*

**94** Sydney
*Richard Higby*

**115** Sydney
*Ted Dobosz*

**6, 155, 200** Sydney
*Marcus Davies*

**206, 224** Bowen Mountain, New South Wales
*David Fitz-Henry*

**116** Kurri Kurri, New South Wales
*Troy Tranter*

**74, 86** Mount Bromo, Indonesia
*Justin Ng*

**39** Purnulu National Park, Western Australia
*Colin Legg*

**60** Parkes Observatory,
New South Wales
*Wayne England*

**78** Newman, Western Australia
*Fabrizio Melandri*

**126** Meekatharra, Western Australia
*Jia Hao*

**179** Yass, New South Wales,
*Martin Pugh*

**114** Wagga Wagga, New South Wales, *Peter J. Ward*

**165** Canberra, *Steve Crouch*

**252** Canberra, *Martin Pugh*

**152** Riverland Dingo Observatory, Moorook
South Australia, *Thomas Davis*

**223** Johannesburg, Gauteng, South Africa
*Tanja Sund*

**123** Kathu, Northern Cape, South Africa
*Jacques Deacon*

**164, 172, 190, 198, 222** Wallaroo, South Australia
*Michael Sidonio*

**226** Clayton Bay, South Australia
*Paul Haese*

**102** Coromandel East, South Australia
*Paul Haese*

**113, 132** South Australia, *Paul Haese*

**184, 191** Auckland
*Rolf Olsen*

**18** Nepean River,
New South Wales
*Vincent Miu*

**46, 260** Cape Palliser
*Mark Gee*

**111** Balnarring Beach, Victoria
*Phil Hart*

**151** Razorback, New South Wales
*Michael Sidonio*

**23** Blue Mountains,
New South Wales
*Ted Dobosz*

**85** Kairakau,
Hawke's Bay
*Andrew Caldwell*

# ASTRONOMY ✦ PHOTOGRAPHER

## OF THE YEAR

# EARTH
# AND SPACE

Photos that include landscapes,
people and other 'Earthly' things
alongside an astronomical subject

# CONTENTS: EARTH AND SPACE

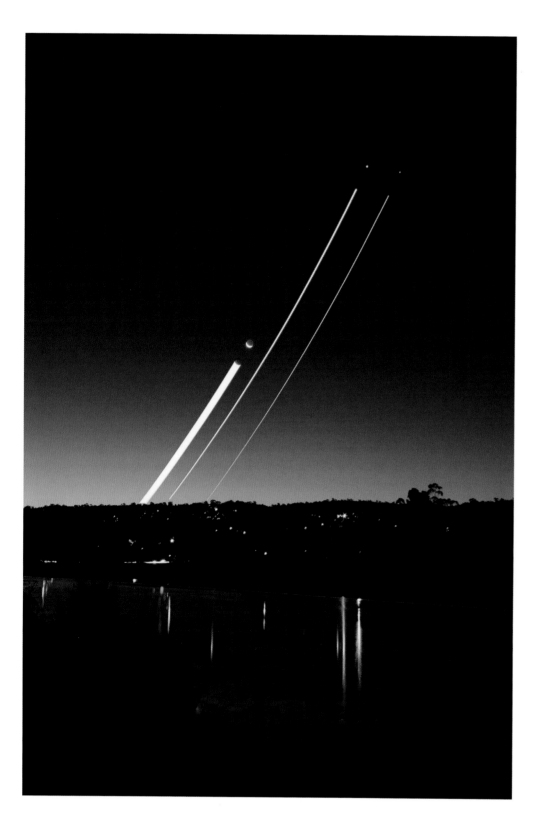

**VINCENT MIU** *(Australia)* <span style="float:right">*RUNNER-UP*</span>

## Venus, Jupiter and Moon Trails over the Nepean River
*[30 November 2008]*

**VINCENT MIU:** The concept of long exposures was inspired by a similar image I saw in a book many years ago. I was desperately scouting for a location with an unobstructed view towards the west. Finally, I settled for this spot along the river bank before it got too dark. I was setting up my tripod while others were packing up their fishing gear.

**BACKGROUND:** This orientation of the Moon (left), Venus (centre) and Jupiter (right) is rarely photographed. Taken with an exposure of two hours, the photograph shows the trail of the three bodies in the sky at sunset. Venus and Jupiter are five of the planets which are visible at various times with the naked eye from Earth, the others being Mercury, Mars and Saturn.

**Canon 400D DSLR camera; EF–S17 85mm IS USM lens; ISO 400; exposure range from 6 seconds to 2 hours**

<

**KARL JOHNSTON** (*Canada*)

## Bow of Orion
[*13 February 2009*]

**KARL JOHNSTON:** I always loved viewing the majestic *aurora borealis*, and I would always wonder why it would only be me out there watching them on the cold nights growing up in Fort Smith, NWT, Canada. Every night I would go for miles and miles to escape the light pollution, into the sub-arctic wilderness, trudging through three-and-a-half-foot snow and -40 °C weather or below to eventually stop, look up, and attempt to orchestrate the dance of the *aurora borealis* through my camera.

**BACKGROUND:** The aurorae or Northern and Southern Lights are caused by the interaction between the Earth's atmosphere and a stream of particles from the Sun known as the solar wind. The Earth's magnetic field funnels these particles down over the planet's poles, giving rise to 'glowing curtains' of coloured light which are best seen in the night sky.

**Canon 50D DSLR camera; Tokina 11–16mm lens; ISO 800; 20-second exposure**

## NIK SZYMANEK (UK)

### Milky Way
*[24 March 2009]*

**NIK SZYMANEK:** The night sky is full of mystery and romance and it's brought to life by long-exposure astrophotography. This picture was planned very carefully. The planning certainly paid off, as the picture came out exactly as intended and captures the evocative view of our home galaxy seen from the inside!

**BACKGROUND:** The Milky Way Galaxy is a collection of over 200 billion stars, together with clouds of dust and gas. It is a flat disc-like structure more than 100,000 light years across. Our own Sun is just one of the billions of stars situated within this disc; so when we look out into space we see the Milky Way as a band of bright stars and dark dust encircling the sky. This photograph was taken from La Palma in the Canary Islands; the Roque de los Muchachos Observatory can be seen on the right.

**Canon 20D DSLR camera; Canon 28mm lens; eight 3-minute sub-exposures combined into a mosaic**

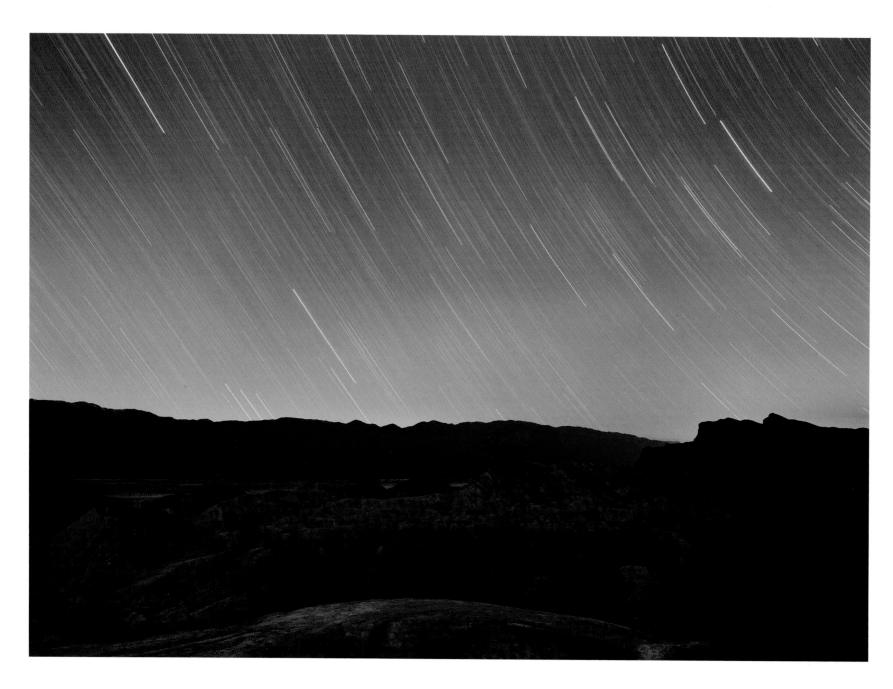

## NIKHIL SHAHI (USA)  *HIGHLY COMMENDED*

### Death Valley Star Trails
[*27 December 2008*]

**NIKHIL SHAHI:** While camping in Joshua Tree a few months ago, I saw how bright the stars appeared in a place far away from civilization. Since I first visited Death Valley, I wanted to capture the stark beauty of Zabriskie Point at night. This shot was taken around 3 a.m. on a cold winter morning facilitated by endless cups of hot coffee!

**BACKGROUND:** Although this photograph appears to show a dramatic shower of meteors in the night sky, it is actually a 40-minute exposure of the trails made by the stars as the Earth rotates. The three parallel lines near to the horizon on the left of the photograph are the trails of the stars that make up Orion's Belt.

**Nikon D700 DSLR camera; Nikon 24–70mm lens at 24mm; ISO 200; 40-minute exposure**

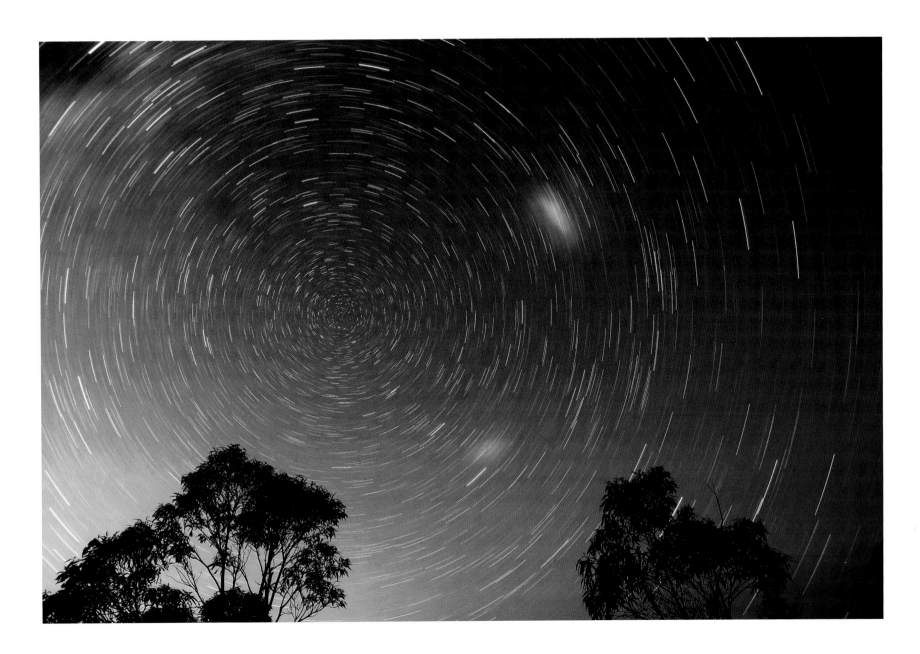

## TED DOBOSZ (Australia)

### Star Trails, Blue Mountains
[28 March 2009]

**TED DOBOSZ:** I recall clearly the night I grabbed an old film camera and placed it on a tripod and, using a cable release, I was able to keep the shutter open for a few minutes. Imagine my delight and surprise when a myriad of star streaks appeared in my pictures! Today that delight is still there whenever I again decide to try my hand at the most basic form of astrophotography, simple star trails from a long exposure. Anyone with a camera can do it: try it and enjoy the beauty of the night sky!

**BACKGROUND:** As the Earth spins during the 30-minute exposure of this photograph the stars make trails around the sky's South Pole. The orange glow at the bottom of the photograph is caused by light pollution from streetlights and other artificial illumination. A similar picture taken in the northern hemisphere would show Polaris (the Pole Star) apparently unmoving at the centre of the star trails. In the southern hemisphere there is no equivalent to the Pole Star but instead the Large and Small Magellanic Clouds, two companion galaxies to the Milky Way, are visible.

**Canon 40D DSLR camera; Tamron 17mm lens at f/3.5; 30-minute exposure**

*"It is the ghostly images of the Milky Way's two companion galaxies that make this image something very special. The trees give a sense of being rooted on Earth as the heavens turn above you."*
CHRIS LINTOTT

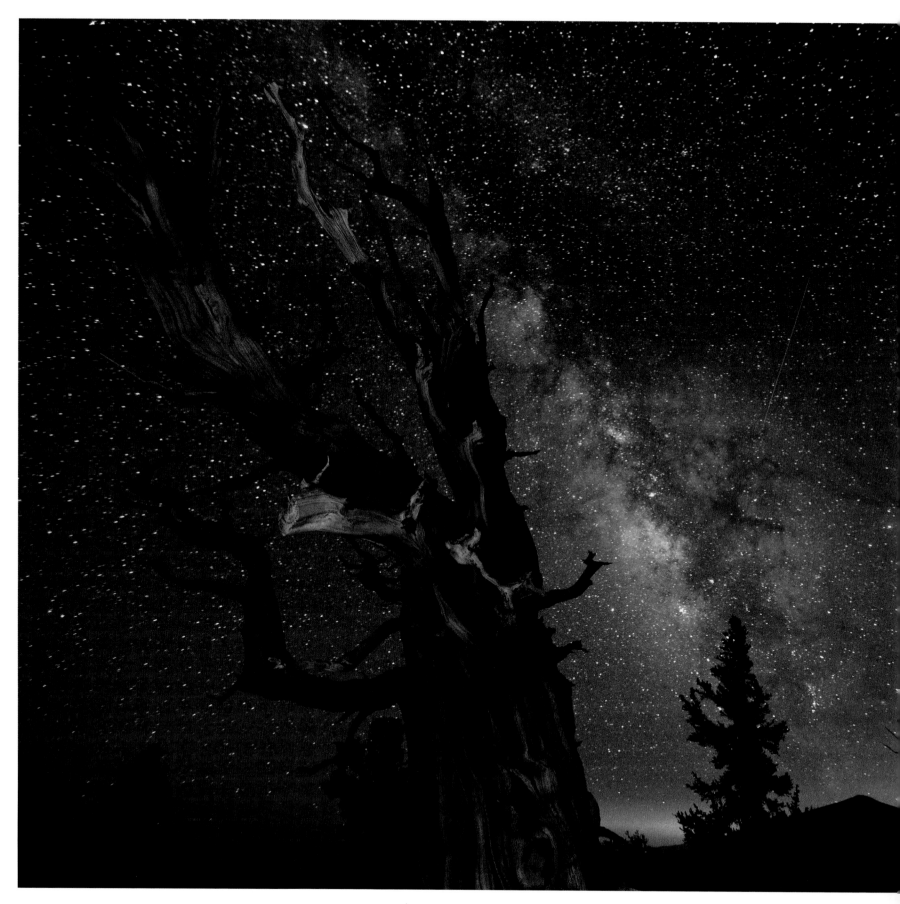

### Blazing Bristlecone
[*14 August 2009*]

**TOM LOWE:** If I could change anything about this photo, it would be the artificial lighting! The light on that tree occurred accidentally because I had my headlamp and possibly a camping lantern on while I was taking a series of test shots! The artificial light is too frontal for me and not evenly distributed, but in the end the light did in fact show the amazing patterns in the tree's wood.

The reason these trees inspire me so much, aside from their obvious and striking beauty, is their age. Many of them were standing while Genghis Khan marauded across the plains of Asia. Being a timelapse photographer, it's natural for me to attempt to picture our world from the point of view of these ancient trees. Seasons and weather would barely register as events over a lifetime of several thousand years. The lives of humans and other animals would appear simply as momentary flashes.

**BACKGROUND:** The gnarled branches of an ancient tree align with a view of our Milky Way galaxy. The Milky Way is a flat, disc-like structure of stars, gas and dust measuring more than 100,000 light years across. Our Sun lies within the disc, about two-thirds of the way out from the centre, so we see the Milky Way as a bright band encircling the sky.

This view is looking towards the centre of our galaxy, 26,000 light years away, where dark clouds of dust blot out the light of more distant stars. What appears to be an artificial satellite orbiting the Earth makes a faint streak of light across the centre of the image.

**Canon EOS 5D Mark II DSLR camera; Canon EF 16–35mm lens at 16mm**

OVERALL WINNER 2010

*"I like the way the tree follows the Milky Way and the definition is very good."*

SIR PATRICK MOORE

*"I think this beautiful picture perfectly captures the spirit of Astronomy Photographer of the Year, linking the awe-inspiring vista of the night sky with life here on Earth. The bristlecone pines in the foreground can live as long as five thousand years. But they are babies compared to the starlight shining behind them, some of which began its journey towards us almost 30,000 years ago."*

MAREK KUKULA

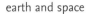

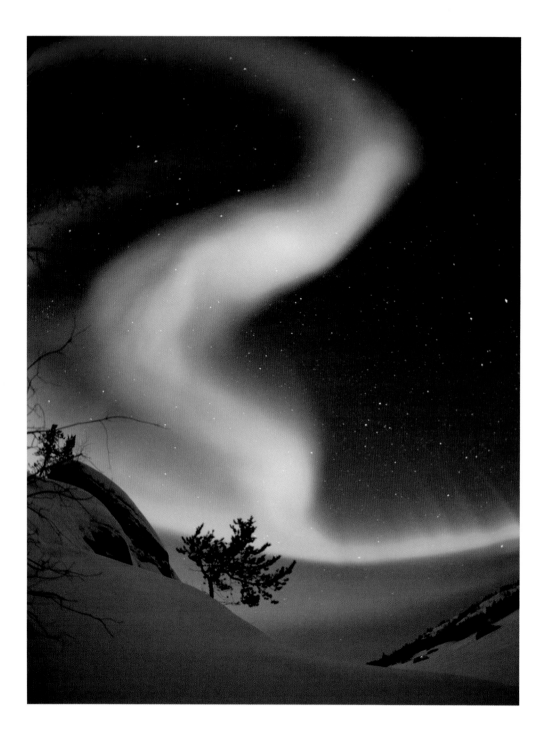

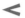

**DAVE BROSHA** *(Canada)*        *RUNNER-UP*

### Whisper of the Wind
[*3 April 2010*]

**DAVE BROSHA:** I photographed this on a bitterly cold night along the shores of Vee Lake, just outside Yellowknife, Northwest Territories … I wanted a composition that tied the land below into the grander display above, and when I saw the shape of this aurora on my viewfinder, which looked so gentle – like a soft wind was blowing it – I knew I had something special.

**BACKGROUND:** The aurorae, or Northern and Southern Lights, are caused by the interaction between the Earth's atmosphere and a stream of particles from the Sun known as the solar wind. The Earth's magnetic field funnels these particles down over the planet's poles giving rise to glowing curtains of coloured light. These are best seen in the night sky near to the North and South Poles.

**Canon EOS 5D Mark II DSLR camera; Sigma 15mm fisheye lens on a static tripod**

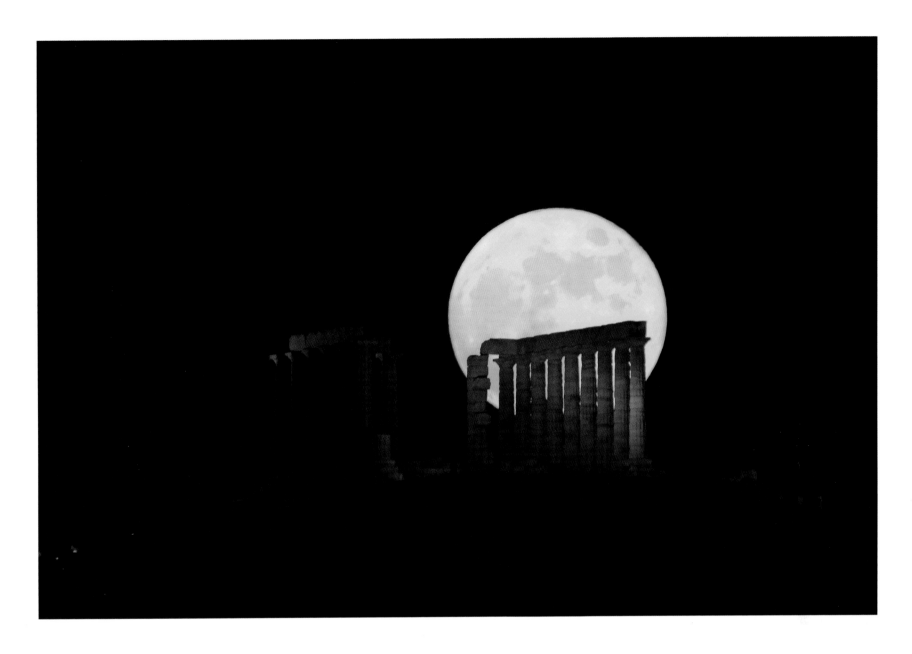

Λ

## ANTHONY AYIOMAMITIS (Greece)    *HIGHLY COMMENDED*

### Solstice Full Moon over Sounion
[*26 June 2010*]

**ANTHONY AYIOMAMITIS:** From a very young age I was always fascinated by the aura of Ancient Greece, and the rising full Moon at Sounion was a unique way to freeze a very special and breathtaking moment involving our 4.5-billion-year-old celestial neighbour and the 2500-year-old temple. A lot of work went into preparing for this single-exposure photo since there was absolutely no room for error.

**BACKGROUND:** At the Summer Solstice, the full moon rises behind the columns of the ruined temple of Poseidon on Cape Sounion, south of Athens. The Moon often appears orange or yellow when close to the horizon, as its light is filtered through the thick layers of the Earth's atmosphere. At these low angles, the Moon can look much larger than usual because our eyes compare it with familiar objects on the skyline.

**Takahashi FSQ-106 106mm refractor telescope; Astro-Physics 2x convertible Barlow lens; Canon EOS 5D Mark I DSLR camera**

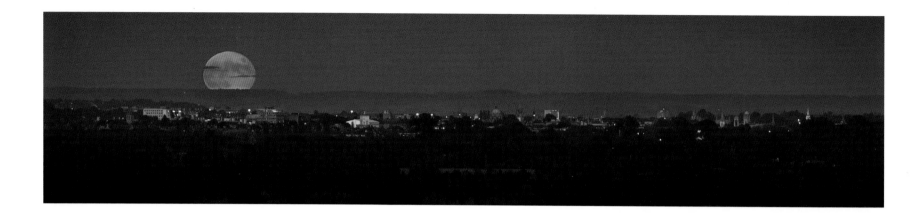

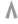

## ANDREW STEELE (UK)

HIGHLY COMMENDED

### Red Moon rising over Oxford
[16 June 2011]

**ANDREW STEELE:** After the lunar eclipse of 15 June was obscured by a thick blanket of cloud, I was determined to make the best of my careful planning, regardless. The following night, I went up the same hill from which I'd planned to photograph the eclipsed Moon behind Oxford, and captured this shot.

**BACKGROUND:** The Moon often appears coloured when close to the horizon, as its light is filtered through the thick layers of the Earth's atmosphere. In this image, made up of three overlapping photographs, an incredibly red full Moon rises over low clouds in the early evening. At these low angles, the Moon can look much larger than usual because our eyes compare it with familiar objects on the skyline.

**Nikon D90 camera; 70–200mm lens and TC-17E II teleconverter**

Λ

## MIKE KEMPSEY (UK)    *HIGHLY COMMENDED*

### Meteor at Midnight, Glastonbury Tor
[*12 August 2010*]

**MIKE KEMPSEY:** My interest in astrophotography stems from being both an incurable night owl and an incurable landscape photographer. I have a long-standing acquaintance with the Moon, and it has assisted me with my night photography on many occasions, but until last year, Perseus and its radiant display had escaped my camera's gaze.

**BACKGROUND:** During the Perseid meteor shower, which peaks each year in August, hundreds of meteors – often called shooting stars – can be seen in a single night. Meteor showers occur when the Earth passes through trails of debris left by comets. Small fragments of comet dust leave a bright and sometimes colourful streak as they heat up while passing through the Earth's atmosphere. This photograph captures one momentary flash beside the 15th-century St Michael's Tower.

**Canon 5D Mark II DSLR camera; Carl Zeiss 50mm Planar T\* lens**

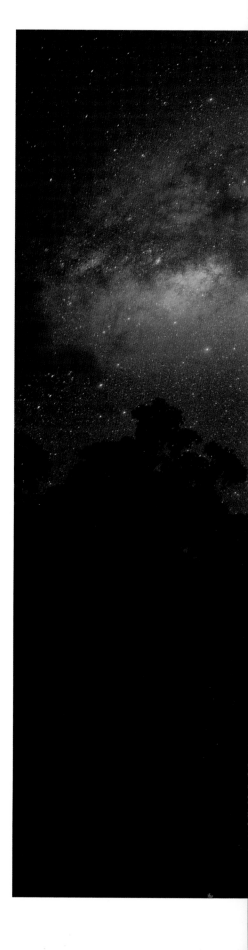

## TUNÇ TEZEL *(Turkey)*

### Galactic Paradise
*[11 July 2010]*

**TUNÇ TEZEL:** When I travelled to see the total solar eclipse of 11 July 2010, I stayed in Oneroa village on the west coast of Mangaia, Cook Islands. This is how the sky looked from a relatively open area just outside Oneroa village.

**BACKGROUND:** Forming a dramatic backdrop to a tropical skyline, the Milky Way galaxy contains hundreds of billions of stars in a disc-like structure. Our Sun lies within the disc, about two-thirds of the way out from the centre, so we see it as a bright band encircling the sky. This southern hemisphere view highlights dark clouds of dust that aboriginal Australian astronomers called the 'Emu in the Sky'

**Hutech modified Canon 5D DSLR camera; 24mm lens**

*"This beautiful image has a truly magical feel to it. I love how the rich star fields of the Milky Way appear to follow the line of the horizon. Look closely and you'll see many pink nebulae nestled within our galaxy's spiral arms."*

WILL GATER

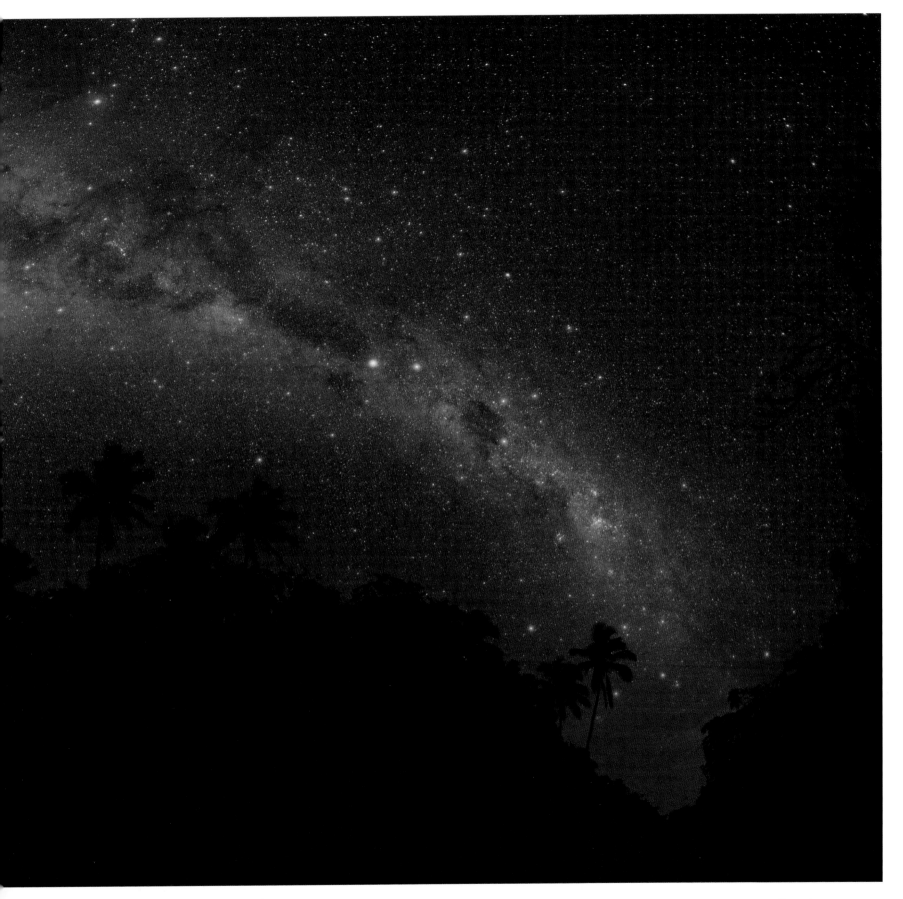

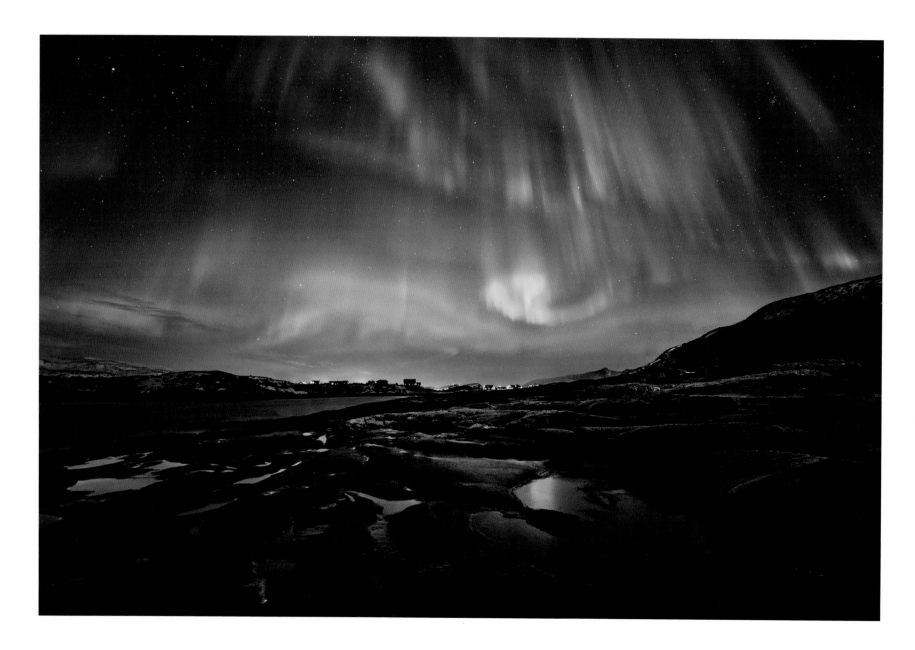

Λ

## OLE C. SALOMONSEN (Norway)          *RUNNER-UP*

### Divine Presence
[*11 March 2011*]

**OLE C. SALOMONSEN:** I love watching the aurorae dancing over my head, surrounded by stars, and sometimes the Moon and even shooting stars. It really puts things into perspective when you're standing there, and you realize how small you are in this endless universe we are living in.

**BACKGROUND:** The aurorae, or Northern and Southern Lights, are caused by the interaction between the Earth's atmosphere and a stream of particles from the Sun known as the solar wind. The Earth's magnetic field funnels these particles down over the planet's poles giving rise to the glowing curtains of coloured light. These are best seen in the night sky near to the North and South Poles.

**Canon 5D Mark II DSLR camera; Nikon 14–24mm lens at 20mm**

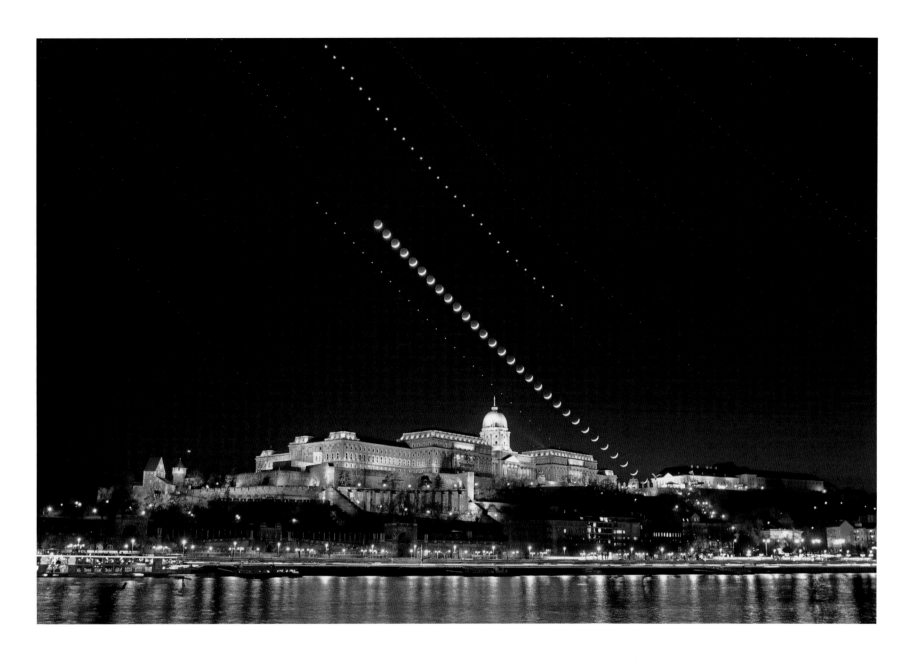

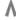

## TAMAS LADANYI (*Hungary*)

### Moon and Planets over Budapest
[*26 March 2012*]

**TAMAS LADANYI:** The conjunction of the Moon, Jupiter and Venus over Budapest, Hungary. A sequence of photos made this multi-exposure image and shows the Moon and planets gliding to the western horizon as the evening proceeded. Photographed here is the Buda Castle, a prominent icon of the Budapest World Heritage Site.

**BACKGROUND:** A series of regularly timed exposures captures the paths of Venus, the Moon and Jupiter as they set over the historic Buda Castle. Despite the light pollution of a major city, bright objects like these are still clearly visible even to the naked eye.

Canon 600D camera; Canon 16–35mm f/2.8 lens at 23mm; ISO 1600; 1/2-second exposure

## ARILD HEITMANN (Norway)      *RUNNER-UP*

### Green World
[*22 January 2012*]

**ARILD HEITMANN:** This is a special shot for me since it captures the intense feeling of standing deep in the mountains, far away from light pollution, watching the finest light show on the planet!

**BACKGROUND:** The shimmering curtains of the *aurora borealis* trace the shifting patterns of the Earth's magnetic field. The eerie green light in this image comes from oxygen atoms high in the atmosphere, which have been energized by subatomic particles from the solar wind.

**Canon 5D camera; 16–35mm f/2.8 lens at 16 mm; ISO 1600; 23-second exposure**

*"In this image, the curves and folds in the Earth's magnetic field lines are beautifully depicted by a sky full of green aurora. There's a great balance here between the frozen landscape and the spectacle above. I particularly like the perspective of the trees as they appear to diminish in size from right to left combined with the aurora becoming less detailed from top to bottom as the elements of the display increase in distance from the camera. For me, this is a great and pleasing composition."*

PETE LAWRENCE

*"This wonderful image really gives a sense of what it's like to stand under a display of the Northern Lights. I love the tranquillity of the shot and the way the glow of the aurora casts a soft green light over the snowy landscape."*

WILL GATER

*"This wonderfully eerie image brings a new twist to the aurora borealis. I like the softness of the snow and the wildness of the trees."*

MELANIE GRANT

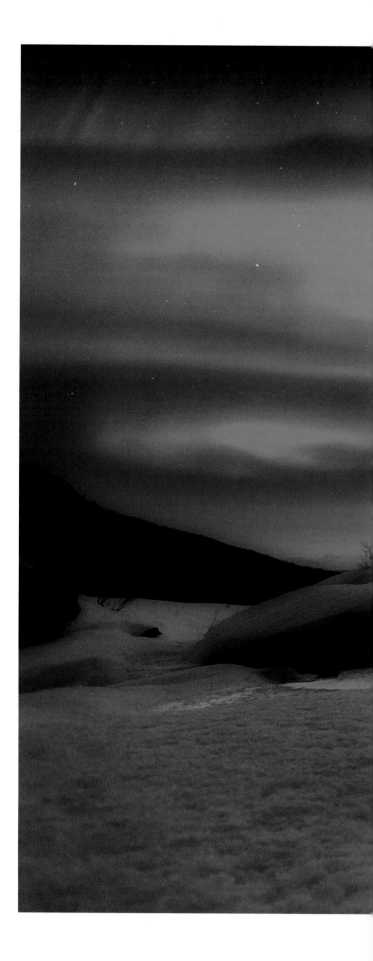

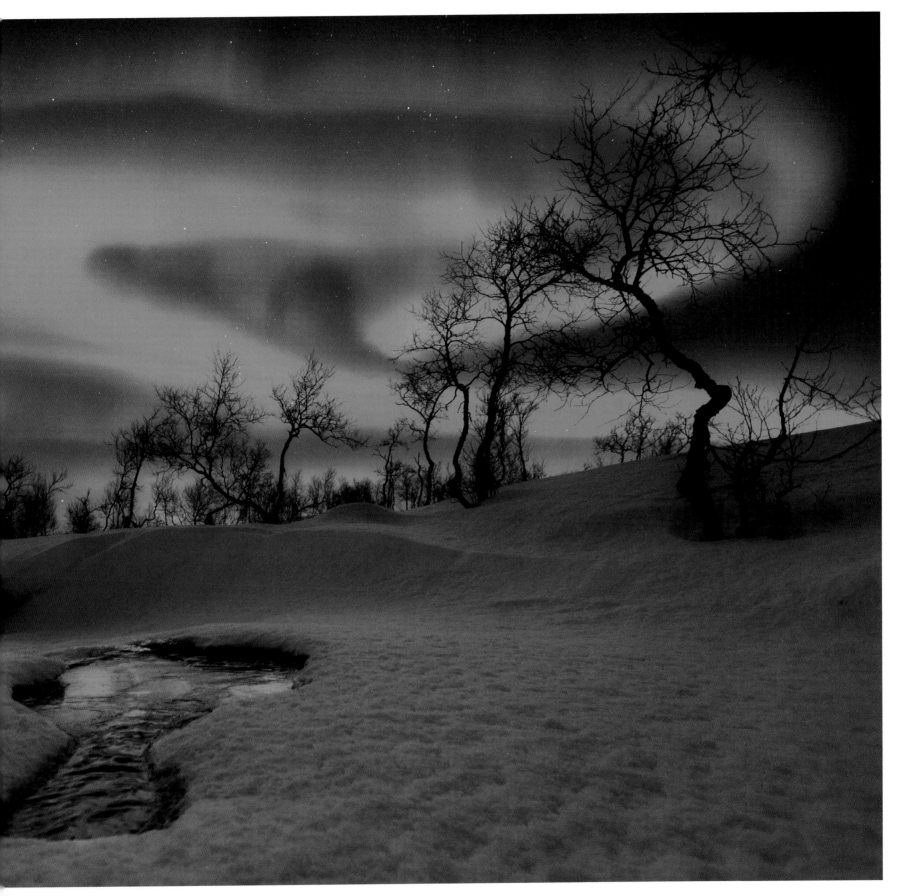

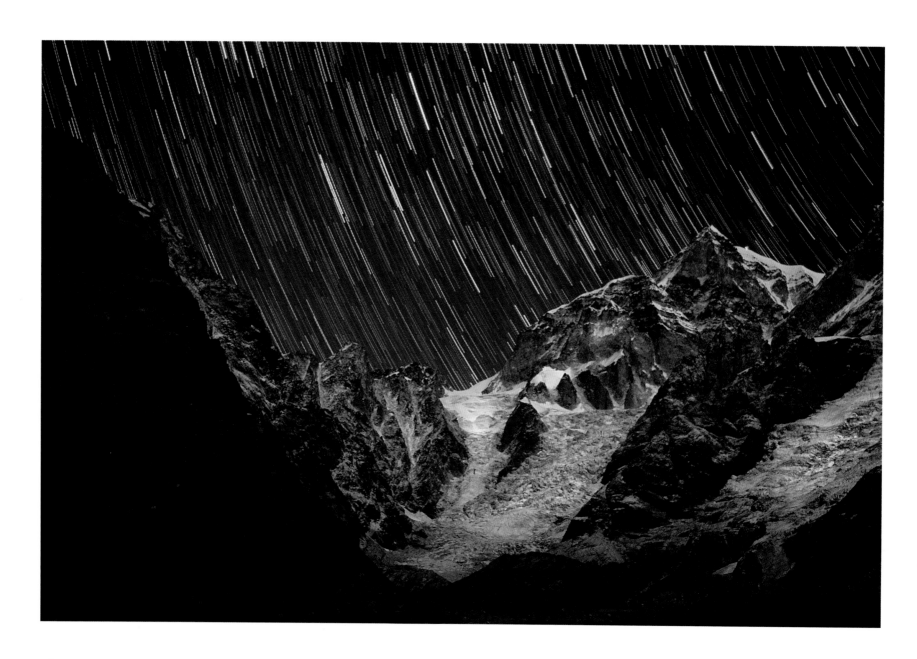

Λ

**ATISH AMAN** *(India)*

### Star Trails over Moonlit Himalayas
[*10 October 2011*]

**ATISH AMAN:** Kedarnath is located near the source of the River Mandakini at an altitude of 3580 metres above sea level. This photo was taken from a hilltop 3700 metres above sea level, about two kilometres away from the village.

**BACKGROUND:** The mighty Himalaya mountains were forced up from our planet's crust by immense tectonic processes millions of years ago. They form a suitably dramatic foreground for the slow turning of the Earth, shown by the star trails in this long exposure photograph.

**Nikon D80 camera; 50mm f/1.8 lens**

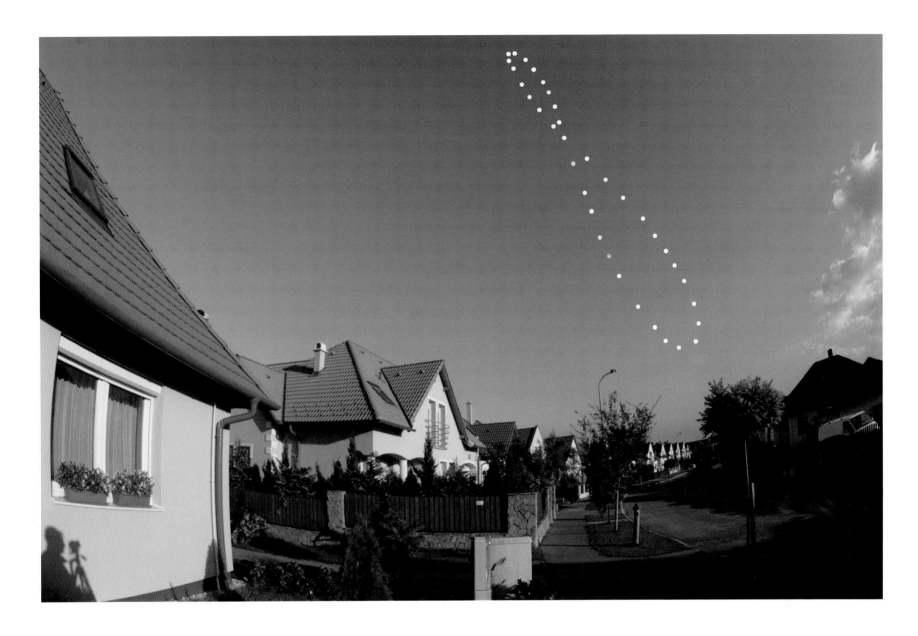

## Λ

**TAMAS LADANYI** *(Hungary)*

### Analemma over Hungary
[*9 October 2010*]

**TAMAS LADANYI:** This analemma shows the Sun's apparent motion observed from a fixed position on the Earth... Pictured in the foreground of this composite image is my house and neighbourhood in Veszprem, Hungary. The foreground image was made without a solar filter, in October, during the late afternoon when the Sun was on the other side of the sky, causing my shadow to appear on the wall.

**BACKGROUND:** An analemma is the apparent path traced out by an astronomical object in the sky as the Earth moves around its orbit. This clever and painstaking picture is composed of exposures of the Sun taken at the same time on thirty-five different days during one year. It clearly shows how the Earth's tilted axis and orbital motion cause the relative position of the Sun to alter, giving rise to seasonal changes in day length and temperature.

**Canon 500D camera; Sigma 10mm f/2.8 lens**

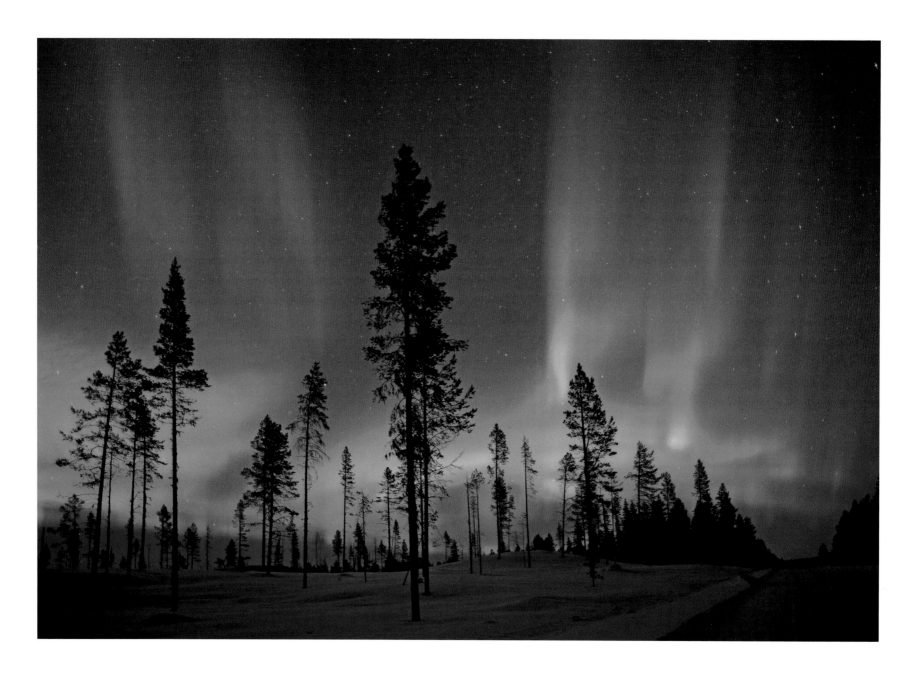

Λ

## ANTONY SPENCER (UK)

### Kiruna Aurora
[5 March 2011]

**ANTONY SPENCER:** I was forced inland from the coast at Tromsø due to the cloud and made a six-hour drive through the mountains and tundra to Kiruna where the forecast was better. I arrived with a small amount of daylight remaining and drove around scouting a decent location to photograph any aurorae. I couldn't believe my luck when I found these trees, just perfect. That night, even though no major aurorae were predicted, I witnessed a beautiful display for about an hour or so. I just loved the way the curtains of aurora danced between the pine trees here.

**BACKGROUND:** The *aurora borealis* shimmers over this northern landscape. Like all life on Earth, the trees on the ground are shielded from dangerous particles of the solar wind by our planet's magnetic field. The particles which manage to penetrate this magnetic barrier are absorbed by the atmosphere, creating these colourful light shows.

Canon 5D Mark II camera; 24mm f/1.4 lens; ISO 800; 8-second exposure

## COLIN LEGG (*Australia*)

### Galactic Domes
[*1 July 2011*]

**COLIN LEGG:** The image was taken at the Bungle Bungle Range, Purnululu National Park, Western Australia. A crescent Moon lights the landscape and the slope of the domes nicely matches the plane of our Milky Way galaxy.

**BACKGROUND:** The myriad stars visible in this view of the Milky Way demonstrate the excellent dark skies which can be enjoyed in remote regions. Here in Western Australia, far from the light pollution of towns and cities, the most spectacular night skies can be enjoyed.

**Canon 5D Mark II camera**

<

## THOMAS O'BRIEN (USA)

### Double Arch with a Perseid Meteor and the Milky Way
[22 *September 2011*]

**THOMAS O'BRIEN:** This shot was captured by complete chance really. I was at home in Aspen, Colorado, the night of the Perseid meteor shower ... I knew it was cloudy all around where I lived so I jumped in the car and headed to Moab Utah. Three hours later I arrived in Arches National Park and set up...my camera to do a vertical panoramic. I took one test shot, then took the bottom image of the arches, then the middle image of the arches, and as soon as I opened the shutter for the third shot, the biggest meteor I have ever seen in my life streaked across the sky directly above the arches.

**BACKGROUND:** A meteor burning up, high in the Earth's atmosphere, punctuates the vastness of the night sky. Catching a bright meteor in a carefully planned shoot like this one is a fine stroke of luck. Down below, the photographer has used an artificial light source to illuminate and emphasize the dramatic rock formations.

Canon 5D Mark II camera; Canon 24mm f/1.4 lens; ISO 3200; 20-second exposure

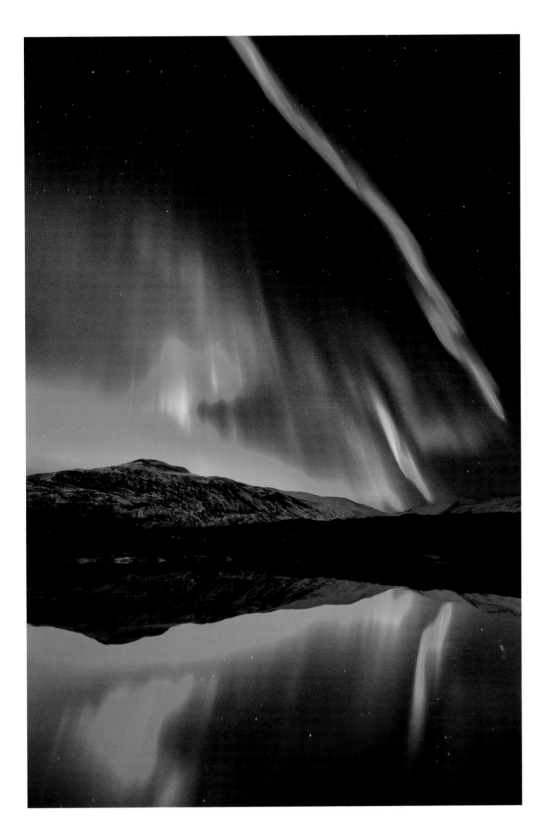

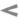

**TOMMY ELIASSEN** *(Norway)*

### Sky Show
*[25 October 2011]*

**TOMMY ELIASSEN:** This night everything worked out better than I could dream of. I set up the camera near a small lake, pointing south towards the mountain called Høgtuva. I was hoping for the aurora to play along with the composition and after a while it slowly came dancing into the frame. For the first time I could see the bright red colours in the aurora with my own eyes. The outburst lasted for over an hour and it's still the best aurora display I have witnessed.

**BACKGROUND:** The Earth's magnetic field funnels particles from the solar wind down over the planet's polar regions. More than 80 kilometres above the ground, these particles collide with atoms and molecules of gas in our atmosphere, causing them to glow in the characteristic colours of green and pale red for oxygen, and crimson for nitrogen.

**Nikon D700 camera; Nikkor 14–24mm f/2.8 lens at 14mm; ISO 2000; 10–24-second exposure**

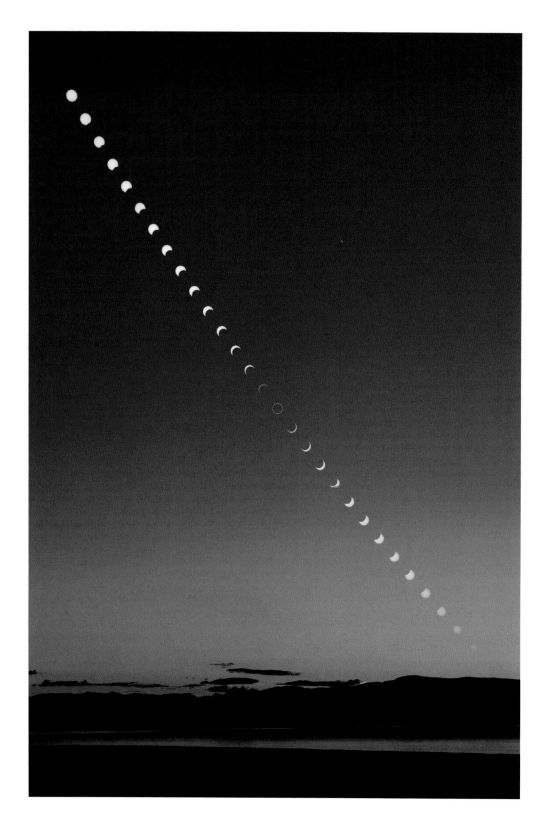

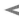

## RICK WHITACRE (USA)

### Strand of Pearls
[20 May 2012]

**RICK WHITACRE:** This image shows the 2012 annular eclipse from Pyramid Lake, Nevada. This location was on the 'centre-line' of the eclipse so the Moon was perfectly centred on the Sun.

**BACKGROUND:** A series of exposures captures the progress of an annular eclipse, as seen from Nevada on 20 May 2012. Annular eclipses occur when the Moon is at the furthest point in its orbit around the Earth, so that its apparent size is smaller than that of the Sun. At the height of the eclipse, a ring, or annulus, of the Sun is still visible around the Moon's disc.

Canon 5D Mark II camera; Canon 24–105mm f/4 lens at 47mm; ISO 400; 1/250-second exposure

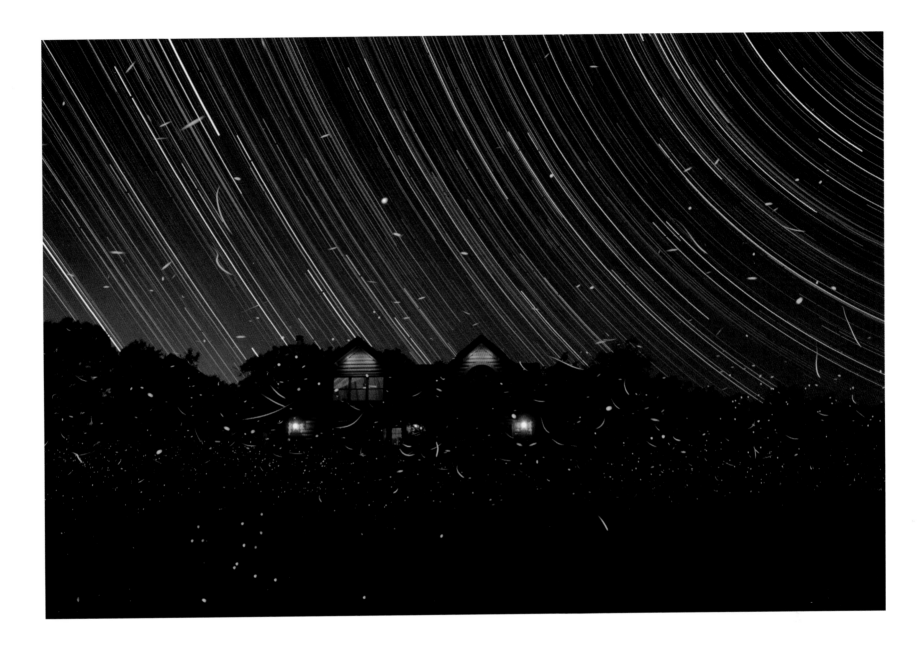

## MICHAEL A. ROSINSKI (USA)    HIGHLY COMMENDED

### Summer Nights in Michigan
[20 June 2012]

**MICHAEL A. ROSINSKI:** I've been taking combined fireflies and star trail images since 2010: it's a learned technique. I noticed that, due to the hot weather, the fireflies seemed to be peaking much earlier than in either 2010 or 2011 – four to five weeks sooner. With the heat wave, the fireflies were going bonkers on this particular evening, so I was motivated to capture them! I had to start imaging at 11 p.m., as it was too light before that.

**BACKGROUND:** Earthly and heavenly sources of light are contrasted in this long-exposure image. Up in the sky, the rotation of the Earth draws the stars out into neat concentric trails, while down on the ground the swarming of fireflies creates a more frenzied pattern.

Canon T1i camera; Canon 15–85mm zoom lens at 15mm; ISO 800;
25-second exposure

*"What I like about this image is the way it makes you think. When you realize what's being shown, you can't help but feel that this is a very clever picture. Here you have the ordered trails of the distant stars captured during a long exposure mixed with the random, somewhat chaotic motion of fireflies. The contrast between the regular star arcs and the defiantly irregular firefly trails is truly beautiful."*

PETE LAWRENCE

*"Physics and biology seem to collide in this image – the crazy antics of the fireflies are a brilliant contrast to the stately rotation of the Earth."*

MAREK KUKULA

**TUNÇ TEZEL** *(Turkey)*　　　　HIGHLY COMMENDED

### Sky away from the Lights
[*12 August 2010*]

**TUNÇ TEZEL:** In the evening of 12 August 2010, I went up to Uludag National Park near my hometown of Bursa, Turkey. My destination was the glacial lakes area and … my first aim was to catch the evening planets and the Moon before they set, and then watch the Perseids as the meteor shower peaked… The lights of towns and villages down below were greatly diffused by the dust, haze and humidity accompanying the heat wave of July–August 2010. Normally, it is either very clear or the lower lands are lost under the clouds all together.

**BACKGROUND:** The distant lights of towns and villages seem to be embedded into this landscape in Turkey, which has been the site of human civilization for thousands of years. The Milky Way above would have been a familiar sight to even the earliest settlers.

**Hutech modified Canon 5D camera; 35mm f/2 lens at f/2.8; ISO 3200; 30-second exposure**

*"Two beautiful lightscapes compete for your attention here. The beauty and majesty of the star fields close to the centre of our galaxy compete with misty, man-made pockets of encroaching artificial light below."*

PETE LAWRENCE

*"This wonderfully atmospheric vista over a dark landscape is really put in context by the galaxy arcing over it: though the misty lights appear to stretch miles to a distant horizon, they are dwarfed by the stars and the band of the Milky Way. Tunç Tezel's picture also highlights the impact that man-made lighting is having on a precious natural resource – darkness."*

CHRIS BRAMLEY

*"Light pollution can be a big problem for astronomers but I like the way this picture makes a virtue of necessity, using the artificial lights to create a rather beautiful contrast with the night sky."*

MAREK KUKULA

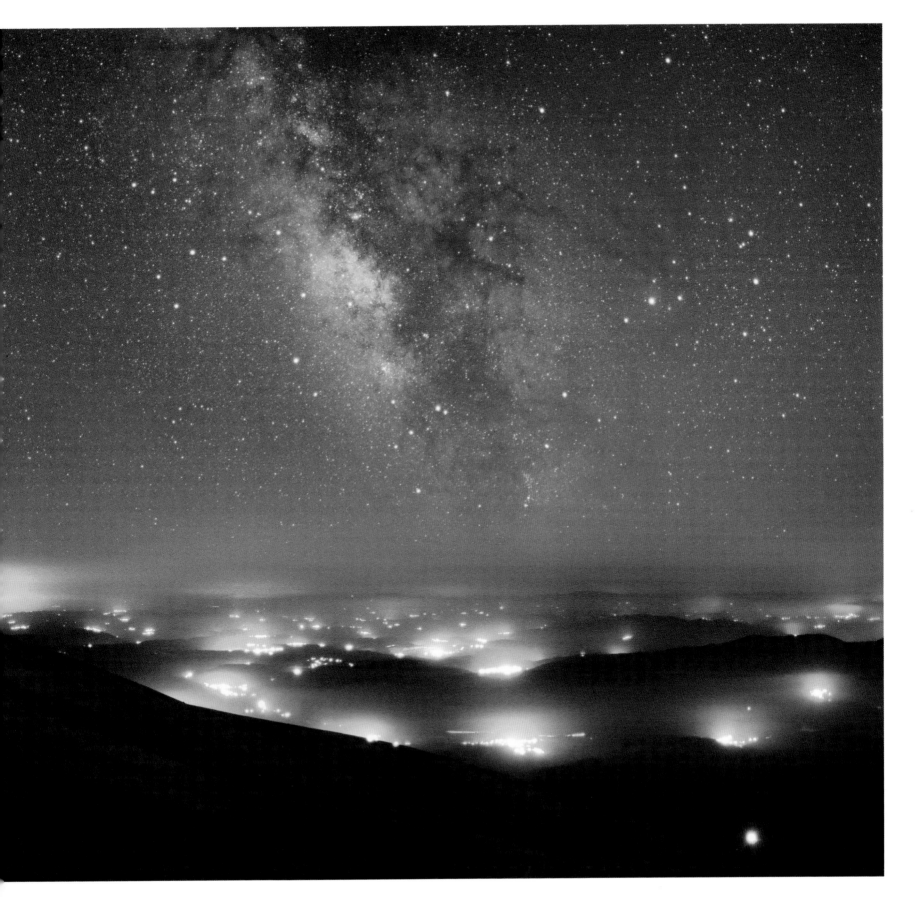

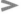

## MARK GEE (Australia)

### Guiding Light to the Stars
[*8 June 2013*]

**MARK GEE:** I recently spent a night out at Cape Palliser on the North Island of New Zealand photographing the night sky. I woke after a few hours sleep at 5am to see the Milky Way low in the sky above the Cape. The only problem was my camera gear was at the top of the lighthouse, seen to the right of this image, so I had to climb the 250-plus steps to retrieve it before I could take this photo. By the time I got back the sky was beginning to get lighter, with sunrise only two hours away. I took a wide panorama made up of 20 individual images to get this shot. Stitching the images together was a challenge, but the result was worth it!

**BACKGROUND:** The skies of the Southern Hemisphere offer a rich variety of astronomical highlights. Here, the central regions of the Milky Way Galaxy, 26,000 light years away, appear as a tangle of dust and stars in the central part of the image. Two even more distant objects are visible as smudges of light in the upper left of the picture. These are the Magellanic Clouds, two small satellite galaxies in orbit around the Milky Way.

**Canon 5D Mark III camera; 24mm f/2.8 lens; ISO 3200; 30-second exposure**

*OVERALL WINNER 2013*

*"One of the best landscapes I have seen in my five years as a judge. Much photographed as an area but overwhelming in scale and texture. Breathtaking!"*

MELANIE GRANT

*"This is a great composition. I love the way that the Milky Way appears to emanate from the lighthouse – really cementing the connection between the stars and the landscape. I also love the way the Milky Way drags your view out to sea, inviting you to go out and explore the unknown."*

PETE LAWRENCE

*"Some images have a real ability to evoke a real emotional response. This image gives me a feeling of pure peace. Cape Palliser in New Zealand is now on my list of places to visit."*

MAGGIE ADERIN-POCOCK

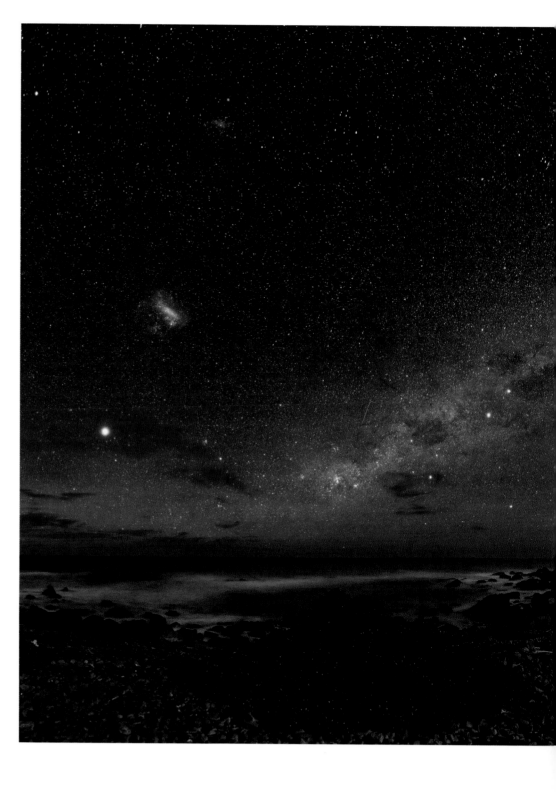

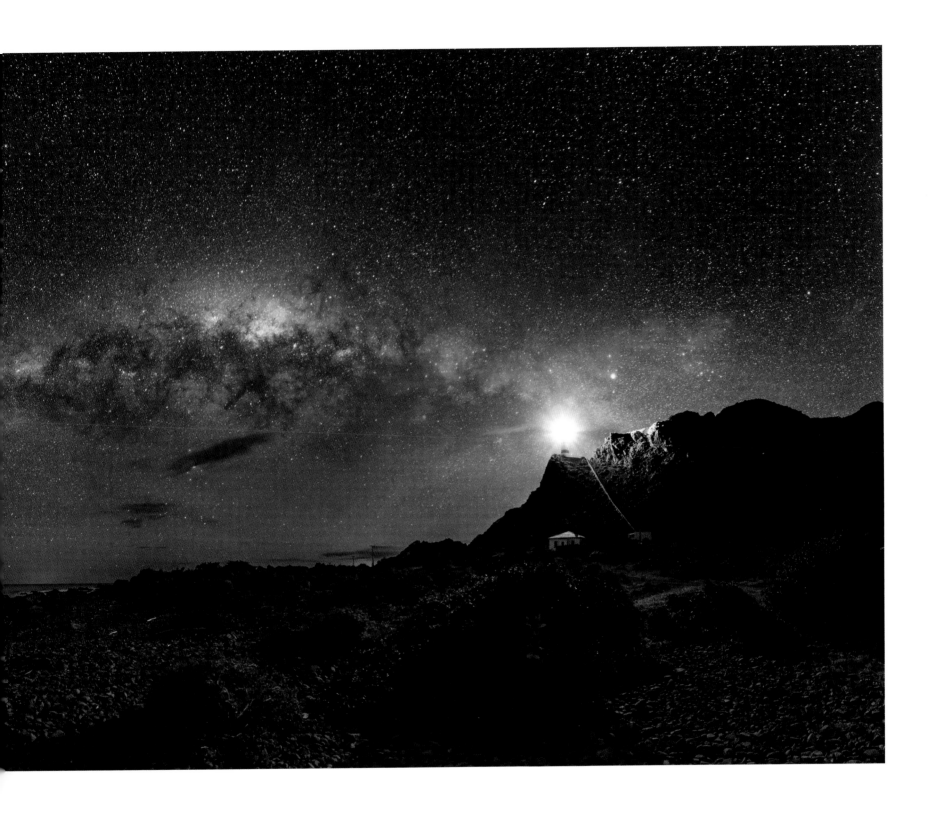

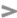

## ROGELIO BERNAL ANDREO *(USA)*

### A Flawless Point
*[18 May 2013]*

**ROGELIO BERNAL ANDREO:** Glacier Point is an extremely popular site that has been photographed thousands of times, but I wanted a unique view that would show the place under a different light. My first attempt failed due to unfavourable lighting conditions, so I carefully planned a second trip a few days later. I figured the best time would be when a waning crescent moon would be almost below the horizon but still up, so I would get some moonlight over the mountains. The unusual 'lenticular' cloud formation on the horizon was worrying me at first, as I thought it would cover the rising Milky Way, but in the end it was almost a blessing as it added a lot to the image.

**BACKGROUND:** This striking and unusual panoramic shot is the result of meticulous planning, an artist's eye for dramatic lighting and sheer chance. The photograph shows the Milky Way arching over Yosemite Valley in California's famous national park. A lens-shaped (lenticular) cloud hovers over the distinct granite dome of Liberty Cap, which rises to an elevation of over 2000m, near the centre of the photograph.

**Canon 5D Mark II camera; Sigma 20mm f/2.5 lens; ISO 2500; 30-second exposure per pane; 8 pane mosaic**

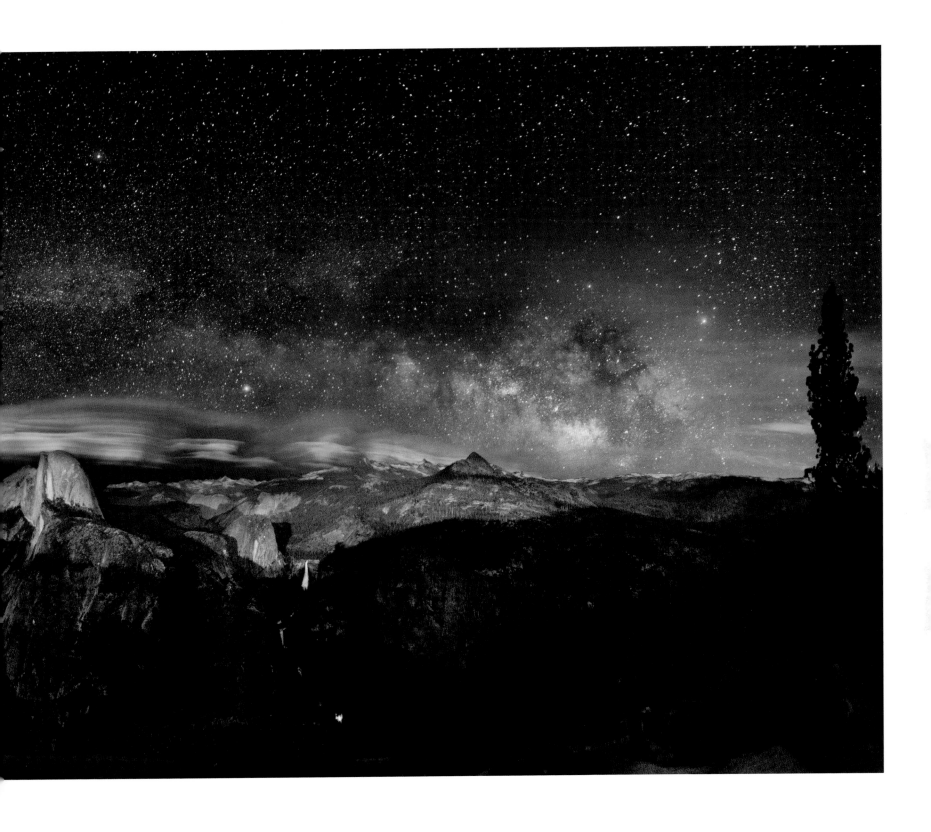

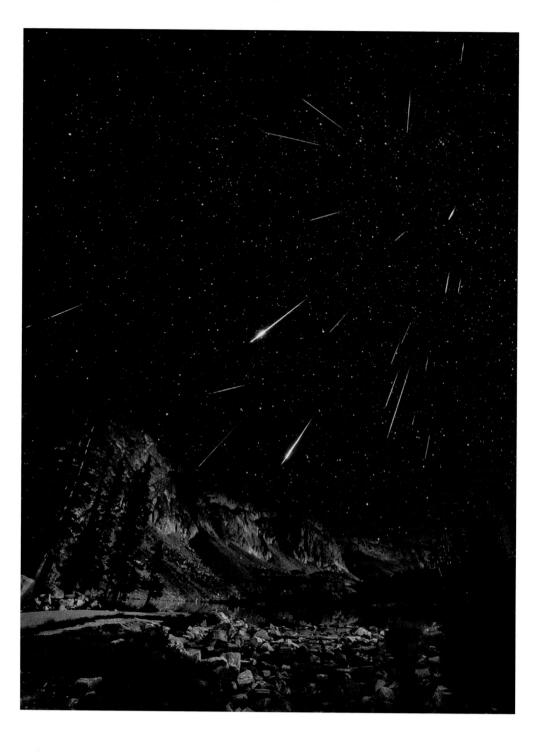

## DAVID KINGHAM (USA)  HIGHLY COMMENDED

### Snowy Range Perseid Meteor Shower
[*12 August 2012*]

**DAVID KINGHAM:** For the 2012 Perseid meteor shower I knew I wanted to create a unique nightscape. To achieve this, I needed dark skies free of light pollution and a moonlit landscape in the perfect orientation with the constellation Perseus. After many hours of scouting, I found my location in south-central Wyoming in the Medicine Bow National Forest. The skies in this area were some of the darkest I have seen in my lifetime. I set up my equipment just as twilight was fading away. I spent the next seven hours taking continuous photos until the Sun rose; capturing 22 meteorites and an iridium flare … An incredible night not to be forgotten.

**BACKGROUND:** A great deal of careful planning, a long night of photography and hours of painstaking image processing have gone into creating this startling composite image of the Perseid meteor shower. The Perseid meteors get their name from the constellation of Perseus from where they appear to come. However, even at the peak of the shower it is impossible to predict exactly when or where the next meteor will appear. Here, the photographer has combined 23 individual stills to convey the excitement and dynamism of this natural firework display.

**Nikon D700 camera; Rokinon 14mm f/2.8 lens; ISO 3200; 30-second exposure**

*"I love the way the photographer has created a sense of drama by compressing several hours' worth of meteors into a single picture. It almost makes you want to duck out of the way!"*

MAREK KUKULA

*"In this composite image, the drama of witnessing a meteor shower has really been captured. The colour of the light streaks is particularly rich against the dramatic nightscape."*

CHRIS BRAMLEY

*"The meteor shower has a Star Wars feel about it, like an intergalactic power struggle taking place in Wyoming."*

MELANIE GRANT

*"This composite photo has a lot of energy. A wonderful array of meteor trails on show, all emanating from the Perseid radiant located upper right."*

PETE LAWRENCE

**50**  ASTRONOMY PHOTOGRAPHER OF THE YEAR

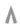

**STEFANO DE ROSA (Italy)**

### Hunter's Moon over the Alps
[*30 October 2012*]

**STEFANO DE ROSA:** I took this image in the morning. The yellow Hunter's Moon (the first full Moon after the autumnal equinox) setting over the Alps, kissed by the first light of the day, was a stunning spectacle. The mountain visible in the picture is Rochemelon (3538m high) in the Italian Graian Alps.

**BACKGROUND:** As the full Moon sinks in the west, the Sun rises in the east, lighting up the snow-capped Alpine horizon. Although both Moon and mountain are illuminated by sunlight in this image, their different colours reveal the scattering effects of the Earth's atmosphere on the white light of the Sun. The rays of the rising Sun pass through the full thickness of the air causing the blue, green and yellow light to be scattered in all directions and leaving only the red light to reach the distant mountains. The Moon is slightly higher in the sky, so its reflected sunlight is scattered less severely, retaining a warm yellow glow.

*Canon 5D Mark II camera*

## THOMAS HEATON *(UK)*

### UK Meteor, Clatteringshaws Loch
[21 *September 2012*]

**THOMAS HEATON:** My girlfriend and I were out stargazing for the first time. It was her birthday and I had just bought her her first telescope. We were not expecting to see much. However, undeterred we made our way to Clatteringshaws Loch, Dumfries and Galloway. As I was photographing the Milky Way, an incredibly bright light appeared in the sky. It wasn't long before I realized that this light was an extraordinary meteor. I dashed to my camera, hit the shutter and hoped for the best. It was an anxious 30 seconds. When I saw this image, I knew I had captured a very rare and special event.

**BACKGROUND:** In this image a fireball streaks across the sky above the Galloway Forest Park in south-west Scotland. Bright meteors like this occur when small chunks of rock, perhaps from an asteroid, burn up in the Earth's upper atmosphere. They are much brighter than a typical 'shooting star' and can last much longer. From the multiple trails, it appears that this object broke apart before burning up. In 2009, Galloway Forest Park was designated as a 'Dark Sky Park' by the International Dark-Sky Association for the exceptional quality of its night skies.

Canon 5D Mark III camera; Sigma 10–20mm f/3.5 lens; ISO 800;
30-second exposure

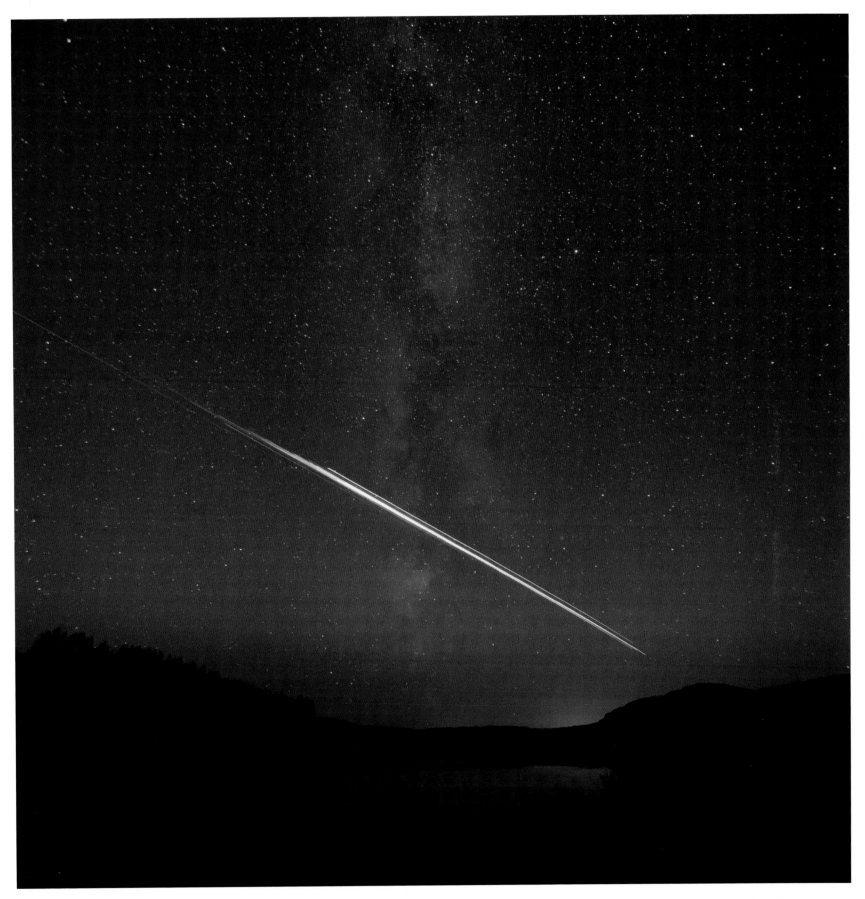

## LUC PERROT *(Réunion Island)*

### The Island Universe
[*2 May 2013*]

**LUC PERROT:** Ten minutes of clear sky – that was the time given to me to realize this shot, an idea that germinated in my head a few weeks before. Nothing had been simple. At first I spent time researching detailed maps on the internet to locate this little hidden place. Next came finding the exact location on the coast. This done, I went back at night and waited for three hours, sometimes in the rain, for clear sky ... it lasted ten minutes, half an hour before moonrise!

**BACKGROUND:** Patience, planning and a fortuitous gap in the weather lie behind this dramatic view of the Milky Way in a sky full of stormy clouds. The 15-second exposure allows the stars to shine through brightly while giving the restless sea an evocatively misty appearance. The image was taken from the tropical island of Réunion off the east coast of Madagascar.

**Nikon D800 camera; Nikkor 24mm f/1.4 lens; ISO 3200; 15-second exposure; 12 shot panoramic**

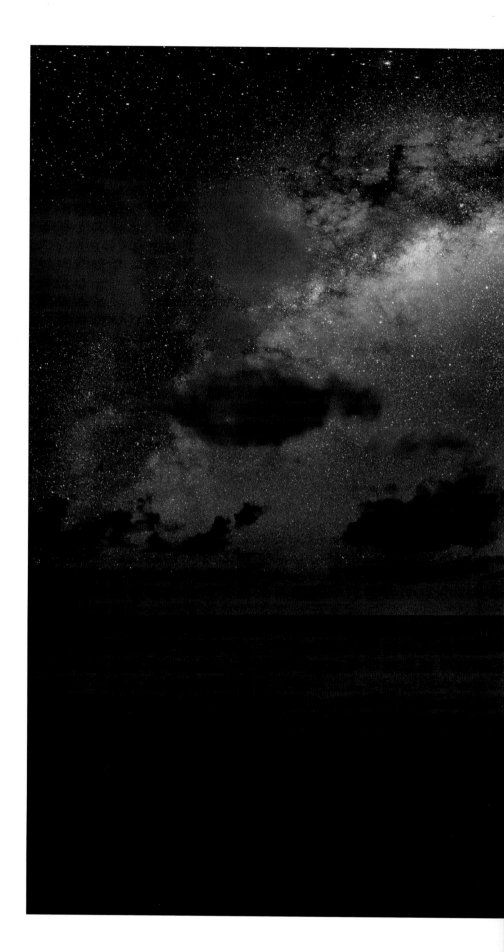

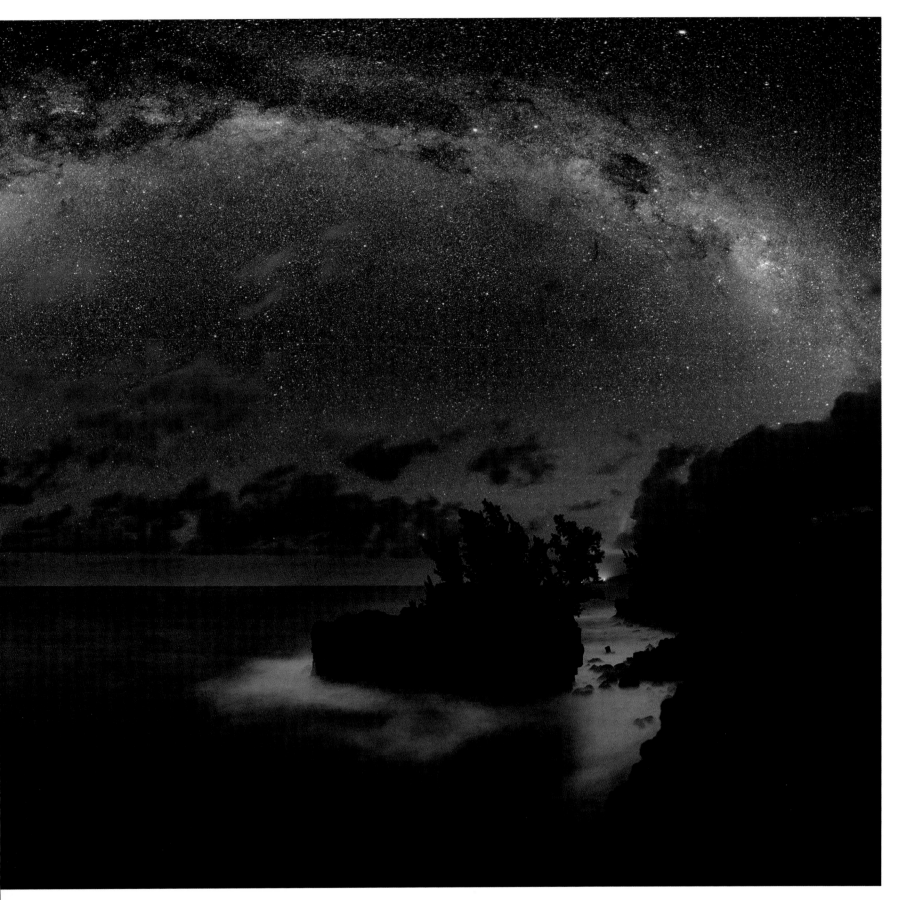

## ALAN TOUGH (UK)

### Night-Shining Clouds
[30 May 2013]

**ALAN TOUGH:** This was a spectacular early season noctilucent cloud display over the Moray Firth, north-east Scotland. Conditions for viewing and photographing this natural phenomenon were near-perfect.

**BACKGROUND:** The brief nights of the Scottish summer, when the Sun never strays far below the horizon, provide ideal conditions for illuminating these ghostly high-altitude clouds. Only visible during twilight, noctilucent clouds are high enough to catch the rays of the Sun, while the Earth and lower cloud formations are in shadow.

**Canon 6D camera; 20mm f/3.2 lens; ISO 320; 1-second exposure**

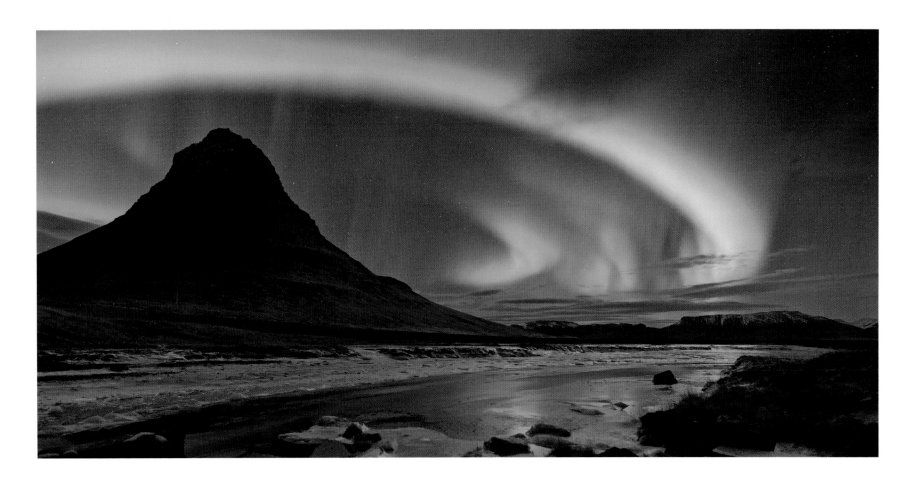

## Λ

### JAMES WOODEND (*UK*)

#### Aurora at Kirkjufell, West Iceland
[*14 December 2012*]

**JAMES WOODEND:** This is an amazing aurora, flowing fast across the sky and appearing (but not really) to wrap around the mountain. I could not come to grips with how green it was – you have to see the un-edited raw file to appreciate it. The Geminid meteor shower was going on at the same time; it was an epic experience to see both simultaneously.

**BACKGROUND:** Sinuous arcs of auroral light seem to ring this Icelandic mountain as they follow the curve of the water below. 2012 and 2013 have seen some spectacular displays of the Northern and Southern Lights as the Sun's activity has neared its eleven-year peak.

**Canon 1DX camera; Canon 24mm f/1.4 lens at f/3.5; ISO 1600; 15-second exposure**

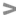

## TOMMY RICHARDSEN *(Norway)*

### Aurora Brutality
[*14 November 2012*]

**TOMMY RICHARDSEN:** This was a spur-of-the-moment shot. I had been out shooting pictures for 16 hours prior to coming here ... I was on my way to get some sleep when I looked out the window at this monster of an aurora. I ran like crazy to the closest, darkest spot to capture this image, and I was certainly not disappointed. What I could have done differently would have been to stay a few more hours and to not go home and empty the memory card, but I was getting mighty tired and thinking about getting some sleep after a long day.

**BACKGROUND:** Photographs of the aurora usually emphasize its ghostly and ethereal appearance. Here, however, the photographer has captured an auroral display which seems to convey the raw energy behind this powerful natural phenomenon. Subatomic particles are violently ejected from the Sun before slamming into the Earth's upper atmosphere, exciting atoms of gas and causing them to glow with vivid colours.

Nikon D800 camera; 14–24mm f/2.8 lens; ISO 1600; 6-second exposure

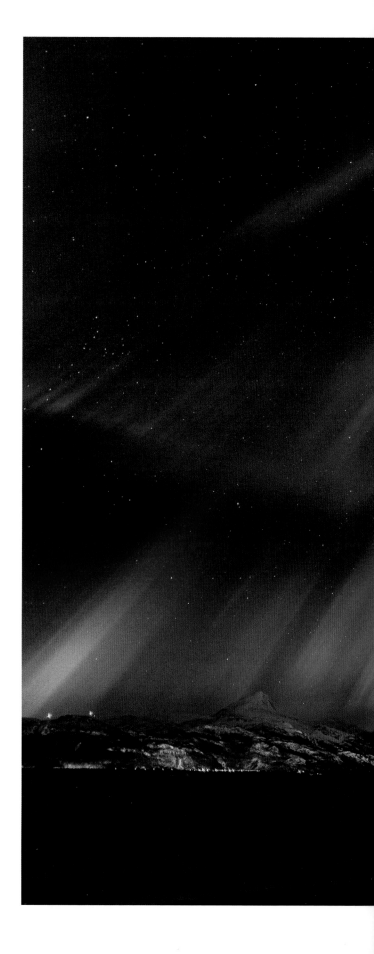

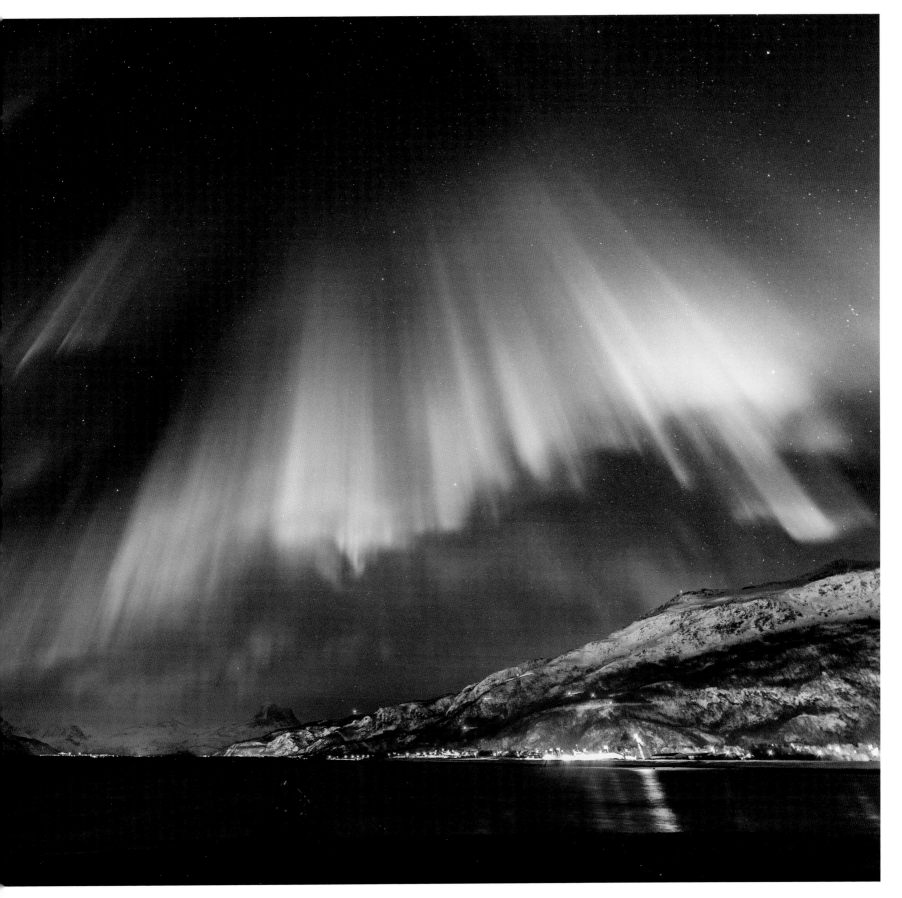

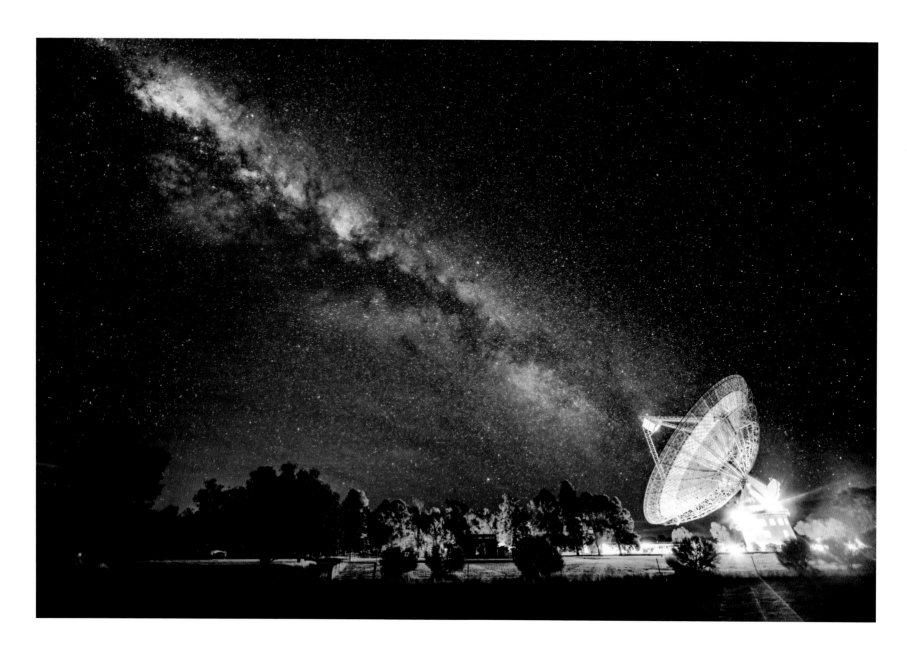

∧

## WAYNE ENGLAND (Australia)

### Receiving the Galactic Beam
[15 July 2012]

**WAYNE ENGLAND:** Instead of receiving radio waves, 'The Dish' (Parkes Radio Telescope) looks like it is receiving the whole Milky Way like a big tractor beam! I tried to line up the Milky Way to give this effect and I think it worked well.

**BACKGROUND:** Here, the photographer has managed to catch the moment when the Milky Way appears to line up with the giant 64m dish of the radio telescope at Parkes Observatory in Australia. As can be seen from the artificial lights around the telescope, light pollution is not a problem for radio astronomers. Radio and microwave interference is a big issue however, as it masks the faint natural emissions from distant objects in space. For this reason many radio observatories ban mobile phone use on their premises.

**Nikon D800E camera; Nikon 14–24mm f/2.8 lens; ISO 6400; 20-second exposure**

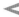

## JUN YU *(China)*

### Beyond the Milky Way
*[18 August 2012]*

**Original competition category: people and space**

**JUN YU:** Only by standing under the Milky Way can you really feel your own insignificance. This photograph was taken on the Fengning Bashang Grassland, Hebei Province in China.

**BACKGROUND:** In this image two tiny human figures are dwarfed by the immensity of our home galaxy, the Milky Way. Shaped like a flat disc, the Milky Way appears to us as a band of starlight encircling the entire sky. This is because our sun is inside the disc, along with over a hundred billion other stars, clouds of glowing gas and dark dust. The scale of the Milky Way is truly staggering: a ray of light would take more than a hundred thousand years to cross from one side to the other. Yet it is just one of billions of galaxies in the visible Universe.

**Canon 450D camera; 24mm f/2.8 lens; ISO 1600; 120-second exposures; 5-panel mosaic**

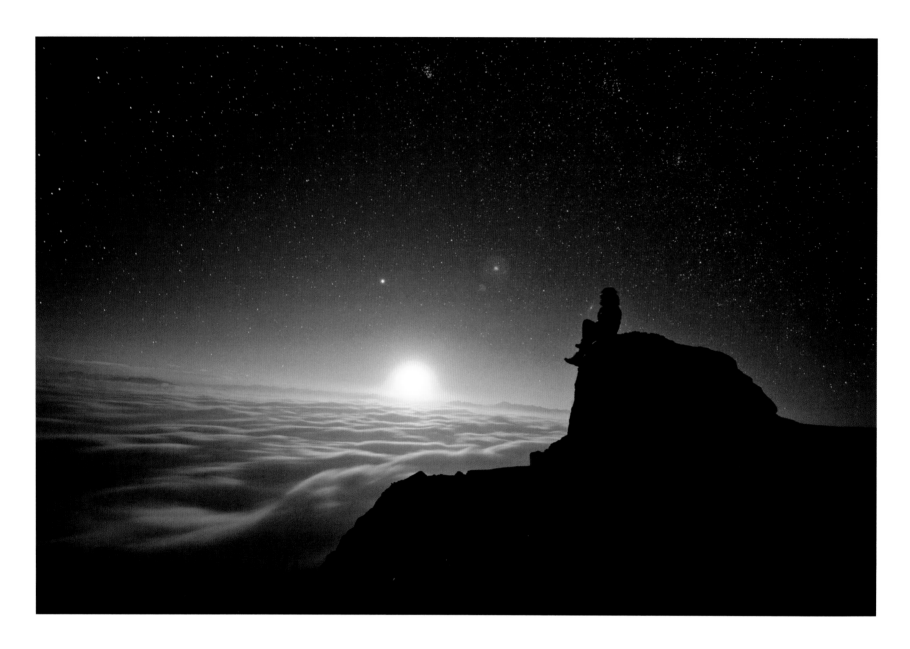

**∧**

**DINGYAN FU** *(China)*

### Pride Rock under Starry Sky

[*2 January 2012*]

**Original competition category: people and space**

**DINGYAN FU:** The title was inspired by the film *The Lion King*. This photo was taken at 1.17am, the precise moment when the Moon fell into a sea of clouds from the mountain of Zhaotong in Yunnan, China.

**BACKGROUND:** Here, a lone observer sits high above the clouds as the Moon sinks below the horizon. Many modern astronomical observatories are built in breathtaking locations like this, allowing them to take advantage of many more clear nights than they would get at sea level. Time is a precious commodity for astronomers: there are only 365 nights in a year, and every cloudy night is an opportunity lost.

**Nikon D3 camera; 14mm f/2.8 lens; ISO 1000; 30-second exposure**

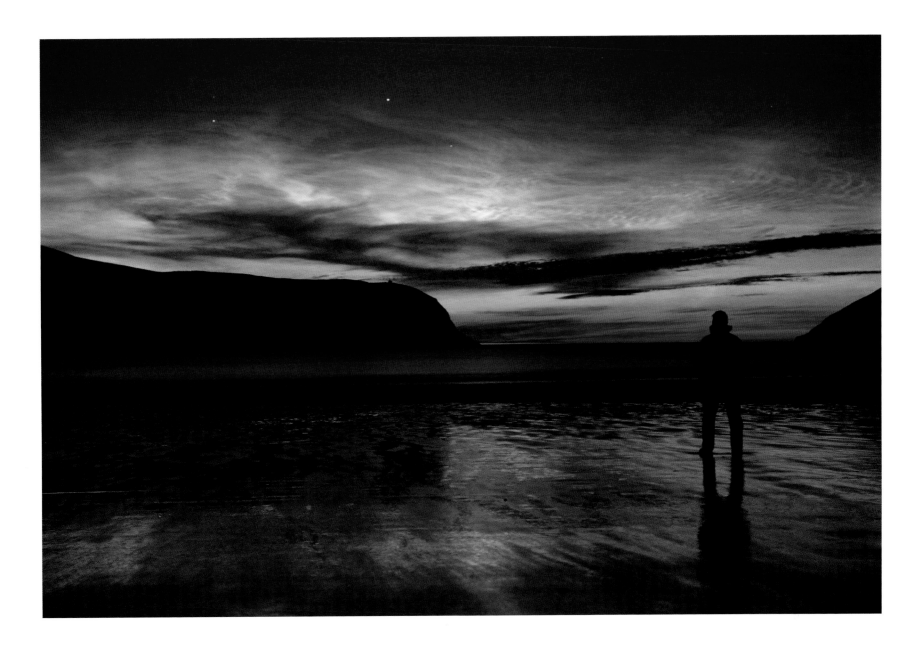

## BRIAN WILSON (Ireland)

### More Than Words
[9 June 2013]

**Original competition category: people and space**

**BRIAN WILSON:** I picked this location for obvious reasons – a view to the north with wet sands to reflect the light from the noctilucent clouds and the silhouette of the headland, the location of a World War II lookout post (LOP 63). The image was even better than how I had imagined it, with that orange glow on the horizon just adding something special. What I had not thought about was what it was going to be like standing

on that beach on this calm night. The sound of the waves gently breaking, the odd oystercatcher piping, the very slight ozone-scented breeze on my face, the marram grass whispering on the dunes behind me: all were punctuated by the sound of the shutter on the camera. Reluctantly I turned my back on the ghostly clouds at 3am and headed home knowing that I captured something very special.

**BACKGROUND:** Noctilucent clouds are the highest clouds in the Earth's atmosphere, formed of tiny ice crystals at altitudes of around 80km. They can only be seen under special conditions, in deep twilight with the Sun just below the horizon so that the lower atmosphere is in the Earth's shadow.

**Pentax K30 camera; 35mm f/2.4 lens; ISO 200; 20-second exposure**

## BEN CANALES (USA)

### Hi.Hello.

[*21 July 2012*]

**Original competition category: people and space**

**BEN CANALES:** I was mesmerized by the emptiness of this mountain-top scene. The snow-filled summit gave a clean slate allowing the Milky Way to seem unusually prominent. It is my favourite representation of what it feels like to stand beneath a vast starry sky.

**BACKGROUND:** Appearing like a column of smoke rising from the horizon, a dark lane of dust marks the plane of the Milky Way in this photograph. This dust plays a vital role in the life story of our galaxy. Formed from the ashes of dead and dying stars, the dust clouds are also the regions in which new stars will form.

**Canon 1DX camera; Canon 14mm f/2.8 lens; ISO 8000; 30-second exposure**

*"I love the muted colours and the sense of scale in this image. The human figure is dwarfed by the vastness of space."*

MAREK KUKULA

*"Without a doubt my favourite entry in this year's competition. It talks to the art historian in me. In terms of colour, feel and composition, it reminds me of Caspar David Friedrich's 1808 'Monk by the Sea.' It has that 19th-century romantic feel about solitude, the small human figure lost in the middle of the cool immensity of the earth and the sky. Simply, utterly, movingly beautiful."*

MELANIE VANDENBROUCK

*"This solitary moment of icy calm contrasts nicely to a busy Milky Way. The colours are stunning."*

PETE LAWRENCE

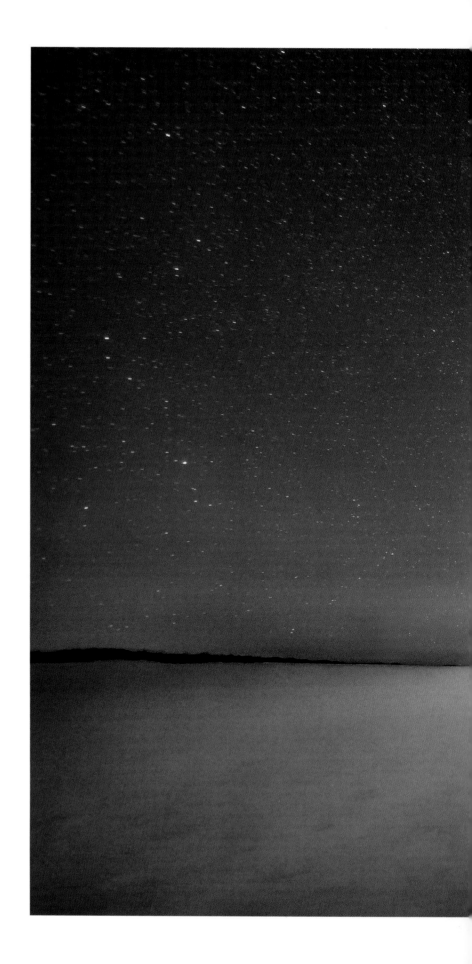

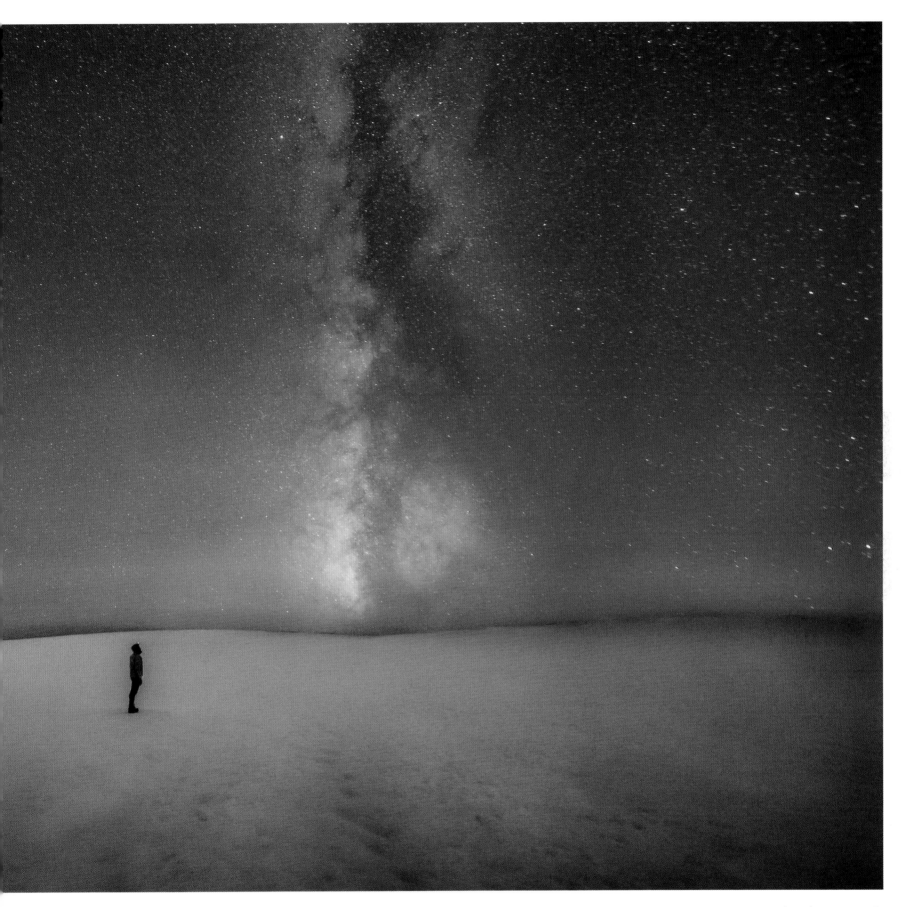

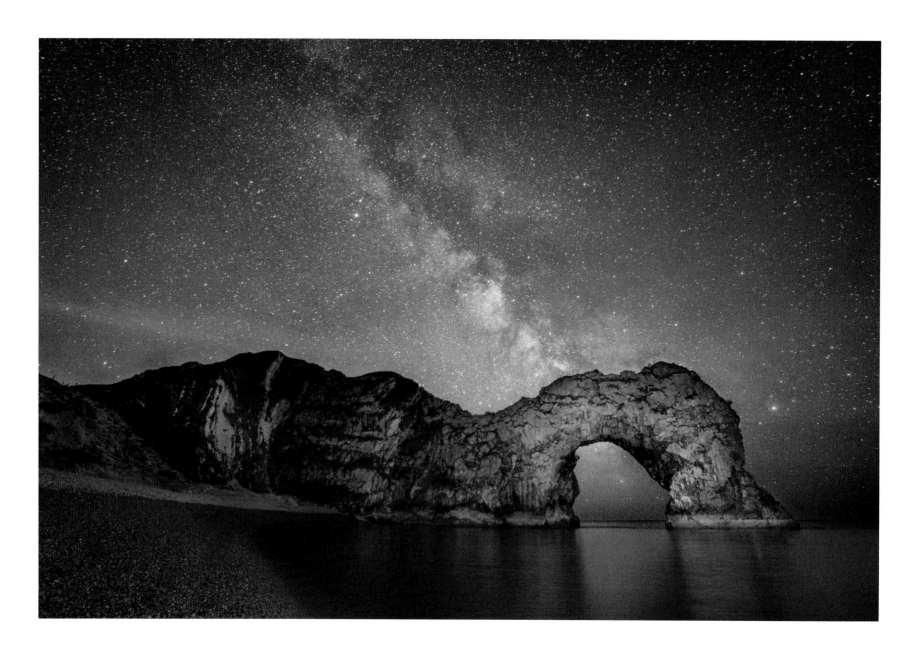

## STEPHEN BANKS (UK)

### Archway to Heaven
[5 June 2013]

**Original competition category: best newcomer**

**STEPHEN BANKS:** This was the first chance to really push my full-frame camera to its limits. An almost perfectly clear night in one of the darkest locations in Dorset – it did not disappoint. With the outer spirals of the Milky Way visible to even the naked eye, I knew that a long exposure at a high ISO would produce tremendous detail. Additional lighting was provided by my LED torch, as the arch was silhouetted against the light the stars were giving off. This is by far my best stargazing shot to date.

**BACKGROUND:** The natural rock archway of Durdle Door dramatically frames the distant band of our Milky Way in this carefully composed shot. The spectacular rock formations in this part of Dorset's Jurassic Coast are more than 100 million years old. However, many of the stars that make up the Milky Way are far older, at up to ten billion years old.

**Nikon D800 camera; Samyang 14mm f/2.8 lens; ISO 6400; 30-second exposure**

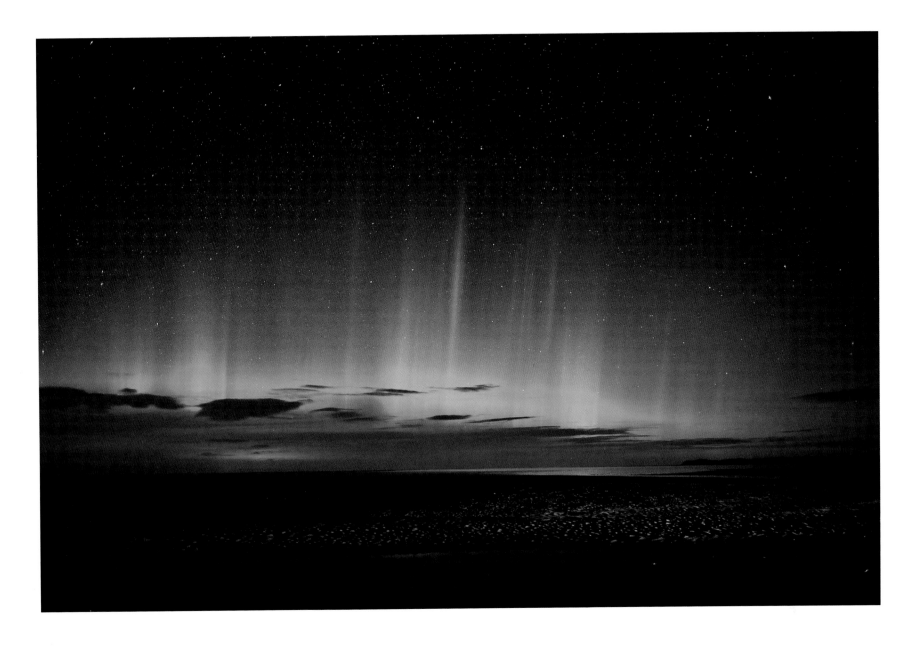

## REED INGRAM WEIR (UK)

### North-East Rays
[22 January 2012]

**REED INGRAM WEIR:** This is another display witnessed at Holy Island (Lindisfarne) after racing up from Newcastle upon Tyne. It was a fantastic display and I felt so lucky to have been there at the right time. The small amount of light on the sand is from a car's headlights in the distance.

**BACKGROUND:** Cut off twice a day by the tide, Lindisfarne's remote location ensures that the island remains largely free from light pollution. These dark conditions are perfect for capturing the striking colours of this intense auroral display.

**Canon 5D Mark II camera; 24mm f/2 lens; ISO 3200; 8-second exposure**

# RICK WHITACRE (USA)

## 'Warp Factor 9, Mr Sulu' – 2013 Perseid Meteor Shower
[12 August 2013]

**RICK WHITACRE:** The northern arm of the Milky Way plays host to the Perseid meteor shower over Half Dome in Yosemite National Park. This is a time-shifted composite. The individual meteors were shot with a 14mm wide-angle lens. This image has 27 of the best meteors captured between 10pm and 4am on the same night.

*Glacier Point, Yosemite National Park, California, USA*

**BACKGROUND:** On a clear night under dark skies you can catch an infrequent shooting star but for a true celestial lightshow the Perseid shower cannot be beaten. Each year in August the Earth passes through the debris trail of comet Swift-Tuttle and our atmosphere deals with the harmless dust grains in spectacular fashion. Each one momentarily glows brightly as it pushes through the air at speeds of up to 70km per second.

**Canon 1D X camera; 14mm f/2.8 lens; ISO 12800; 15-second exposure**

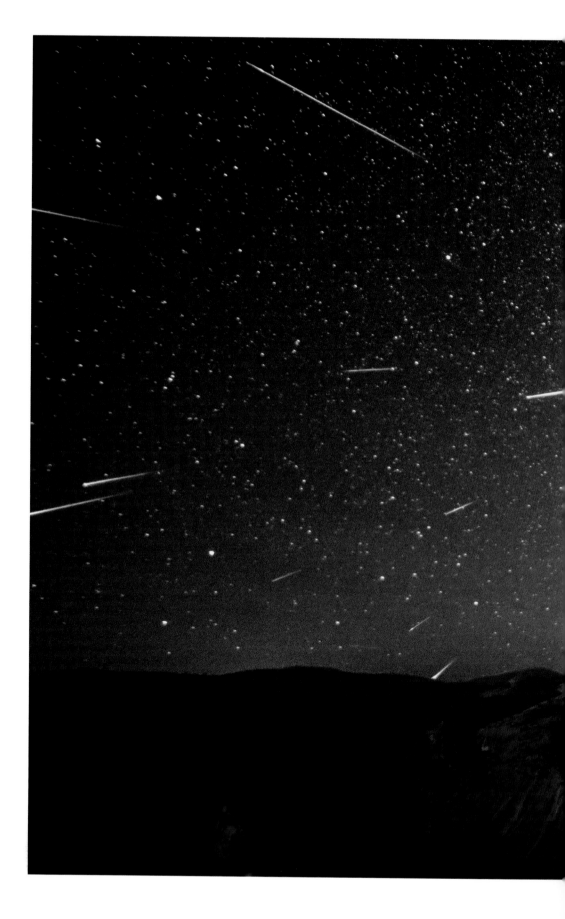

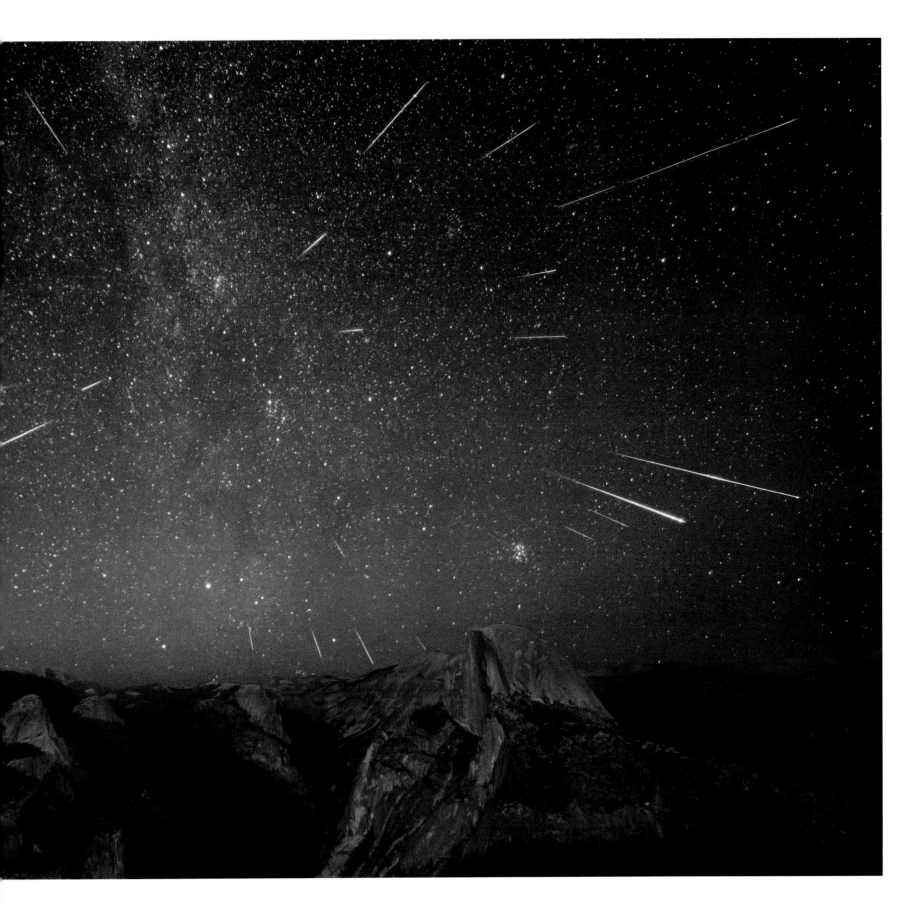

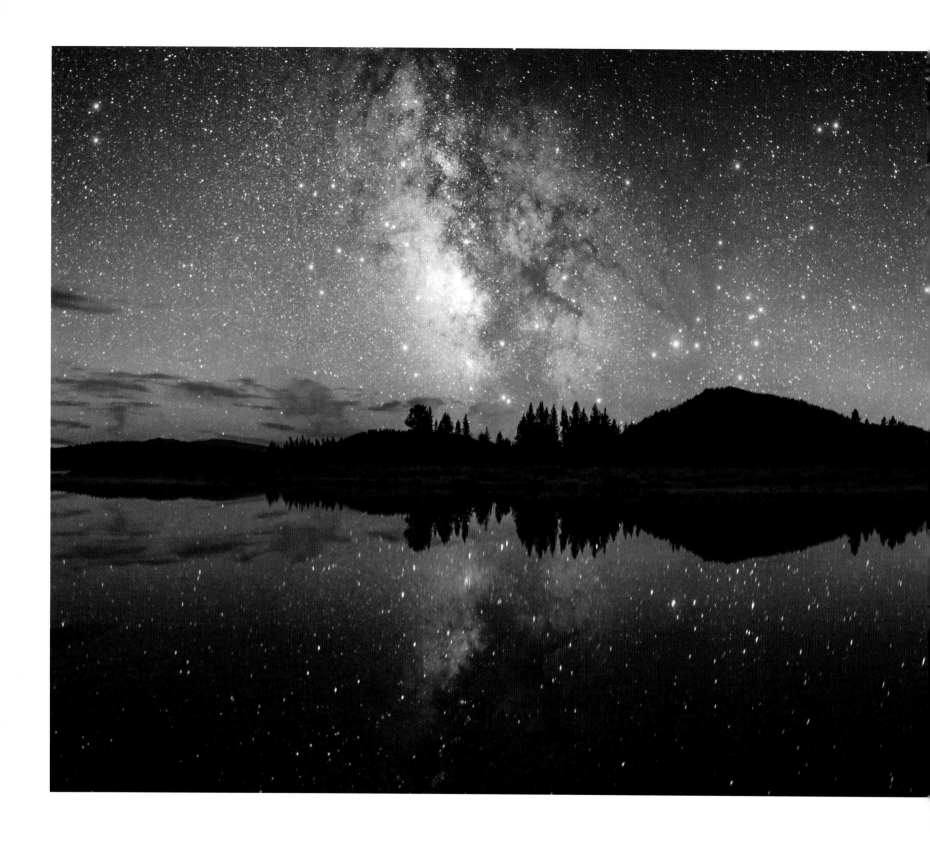

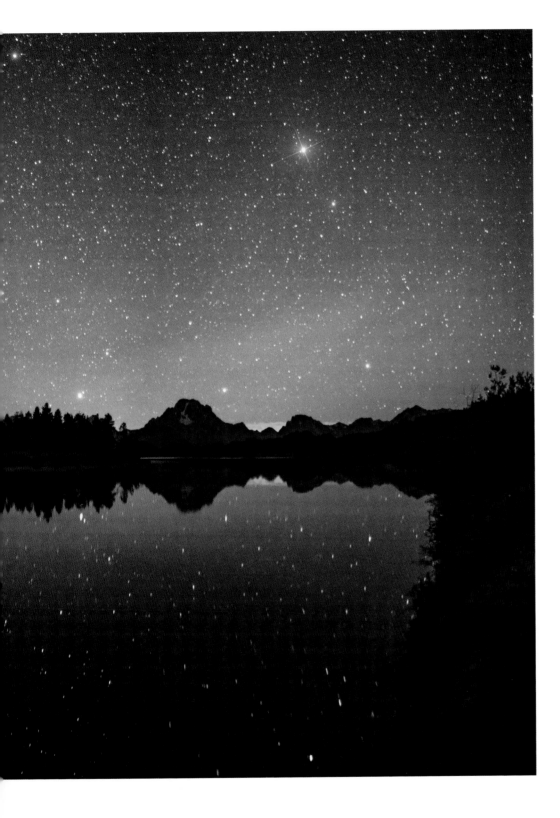

<

**DAVID KINGHAM** *(USA)*

## Oxbow Bend Reflections
*[14 July 2013]*

**DAVID KINGHAM:** The Milky Way reflected in the Snake River at the famous Oxbow Bend in Grand Teton National Park. This is a nine-image panorama.

*Grand Teton National Park, Wyoming, USA*

**BACKGROUND:** The sensitive detector chip of the digital camera reveals a sky crowded with stars, many of them too faint for the unaided eye to see. The heart of our galaxy, the Milky Way, is poised just above the horizon like a glowing cloud. In this dense region the stars are packed so closely together that there would be no true night at all: instead even our weak eyes would see a dazzling vista of thousands upon thousands of stars crowding the heavens and rivalling the Sun for brightness.

**Nikon D700 camera; 24mm f/1.4 lens; ISO 6400; 20-second exposure**

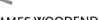

## Aurora over a Glacier Lagoon
[9 January 2014]

**JAMES WOODEND:** Jökulsárlón Glacier lagoon with an overhead aurora reflected in the water. Although it is not a strong aurora, sometimes these make the best reflection shots. The water was very still – you can see the icebergs floating in the lagoon and their reflections. In the background is the Vatnajökull Glacier.

*Jökulsárlón, Vatnajökull National Park, Iceland*

**BACKGROUND:** A total lack of wind and current combine in this sheltered lagoon to produce a striking mirror effect, giving the scene a feeling of utter stillness. Even here, however, there is motion on a surprising scale: the loops and arcs of the aurora are shaped by the slowly shifting forces of the Earth's enveloping magnetic field.

**Canon 5D Mk III camera; 33mm f/3.2 lens; ISO 1000; 10-second exposure**

OVERALL WINNER 2014

*"Beautiful curves and symmetry! A wonderful, icy picture – I love the combination of whites and blue in the glacier with the chilly green of the aurora."*
MAREK KUKULA

*"I absolutely love the colours and auroral symmetry in this image as well as the contrast between the serene floating ice and the dramatic light display above. The blue ice is exquisite and the overall composition is mesmerizing. If you described this image on paper it would sound very alien indeed but the photographer has recorded the scene in a way that looks totally natural. The true beauty of planet Earth captured by camera: a worthy winner of the competition!"*
PETE LAWRENCE

*"Breathtaking shot! With its surreal colours and majestic aura it could be the landscape of a fairy-tale. I love the sense of depth, the sharpness of the turquoise ice, the structured symmetry, but, above all, its ethereal feel."*
MELANIE VANDENBROUCK

*"The lime greens and ice blues of this arctic landscape literally bounce off the page. A scenic dream of epic proportions."*
MELANIE GRANT

*"This beautiful image captures what it's really like to see a good aurora – the landscape, with the reflections which seem almost sharper than the shapes in the sky, is a terrific bonus, too! This is the first time an aurora image has won the overall prize; I think what captivated the judges was that it really looked like the aurora was right in front of the viewer – there's no need for exaggerated or stretched colour."*
CHRIS LINTOTT

*"This image is wonderful; it's a really natural portrayal of the aurora as diffuse and veil-like over the sparkling white landscape below."*
CHRIS BRAMLEY

## JUSTIN NG *(Singapore)*

### Eta Aquarid Meteor Shower over Mount Bromo
[*5 May 2013*]

**JUSTIN NG:** A bright meteor streaked across the magnificent night sky over Mount Bromo just one day before the peak of the Eta Aquarid meteor shower, which is caused by Halley's Comet. Mount Bromo, visibly spewing smoke in this image, is one of the most well-known active volcanoes in East Java, Indonesia. The highest active volcano is called Mount Semeru (3676m), and the extinct volcano, Mount Batok, is located to the right of Mount Bromo.

*Mount Bromo, Bromo Tengger Semeru National Park, Indonesia*

**BACKGROUND:** Periodically the Earth passes through the trail of dust left behind by a comet, giving rise to a meteor shower that can last for several nights. But solitary meteors – like this bright example, caught over a misty volcanic landscape – can occur at any time of year, as particles of space dust or larger rocks burn up in the Earth's atmosphere.

**Canon 5D Mk II camera; 16mm f/2.8 lens; ISO 1600; 30-second exposure**

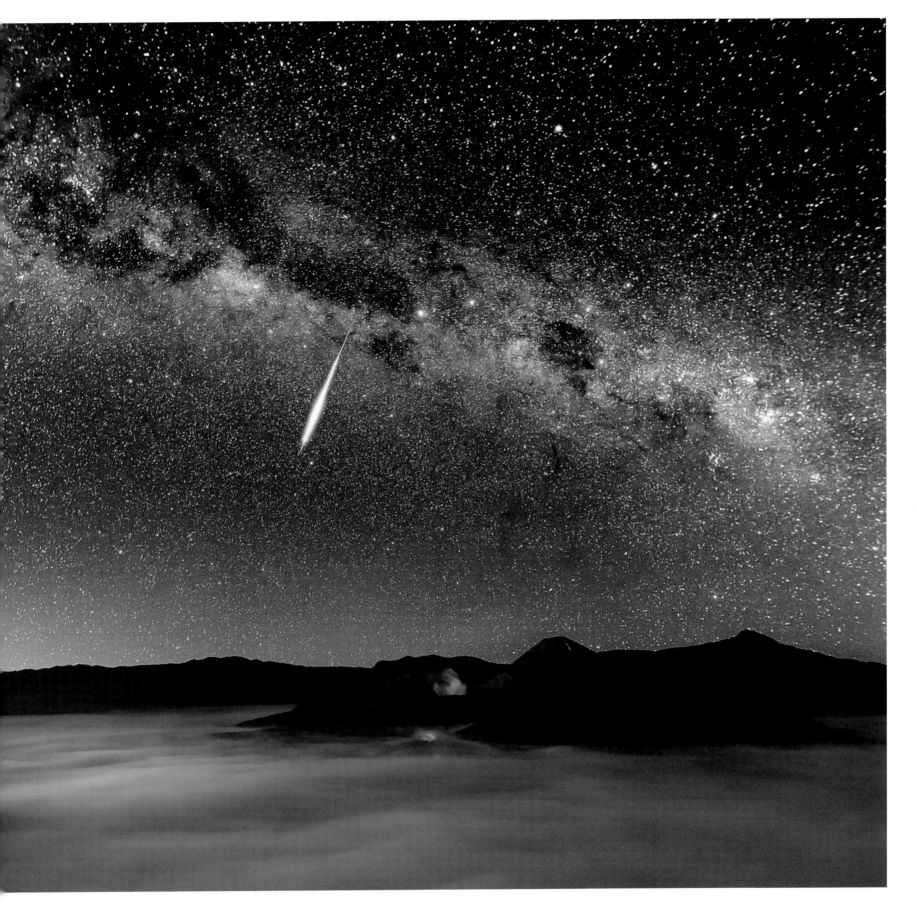

> 

## O CHUL KWON *(South Korea)*     HIGHLY COMMENDED

### Venus-Lunar Occultation
[*14 August 2012*]

**O CHUL KWON:** It was mid-August, before sunrise, when the rising
Moon covered Venus. Originally, I took a time-lapse with three cameras,
using my telescope and a wide angle lens. In this sequence, I picked
ten-minute interval photos. The Moon was so bright that I took it with
HDR. I have waited for this phenomenon since the 1989 Venus-Lunar
occultation. At that time, I was young and had no camera. I finally
succeeded in 2012. That night it was raining, but just before the
occultation, it stopped and the clouds cleared.

*Mount Hambaek, Gangwon-do, South Korea*

**BACKGROUND:** Using High Dynamic Range (HDR) the photographer
balances the brightness of the rising Moon and the much more distant
planet Venus, to show us what happens when they come to the same
apparent position in the sky. Venus is temporarily hidden from view by
our nearest neighbour, only to re-emerge in less than one hour. This
underscores the relatively quick apparent motion of the Moon through
our skies as it makes its 27.3-day orbit around the Earth. Such spectacular
occultations can be seen from somewhere on Earth several times a year,
but careful planning is required to photograph them.

**Canon 5D Mk III camera; 24mm f/2.8–f/4 lens; ISO 1600–ISO 400;
1–1.3 second exposures**

*"A really interesting composition which rewards closer inspection. The
atmospherically colour-adjusted red Moon is amazing!"*

PETE LAWRENCE

*"I love the atmospheric coloration of the lowest image of Venus."*

MAGGIE ADERIN-POCOCK

*"What attracted me with this picture is the way the celestial bodies in
the pure night sky compete for attention with the bright city lights in the
valley, reflected in the low-hanging clouds. This shot shows great technical
accomplishment, but also a very strong artistic quality."*

MELANIE VANDENBROUCK

*"There's a lot to see in this beautifully framed photograph, which makes a
stunning record of a celestial event."*

CHRIS LINTOTT

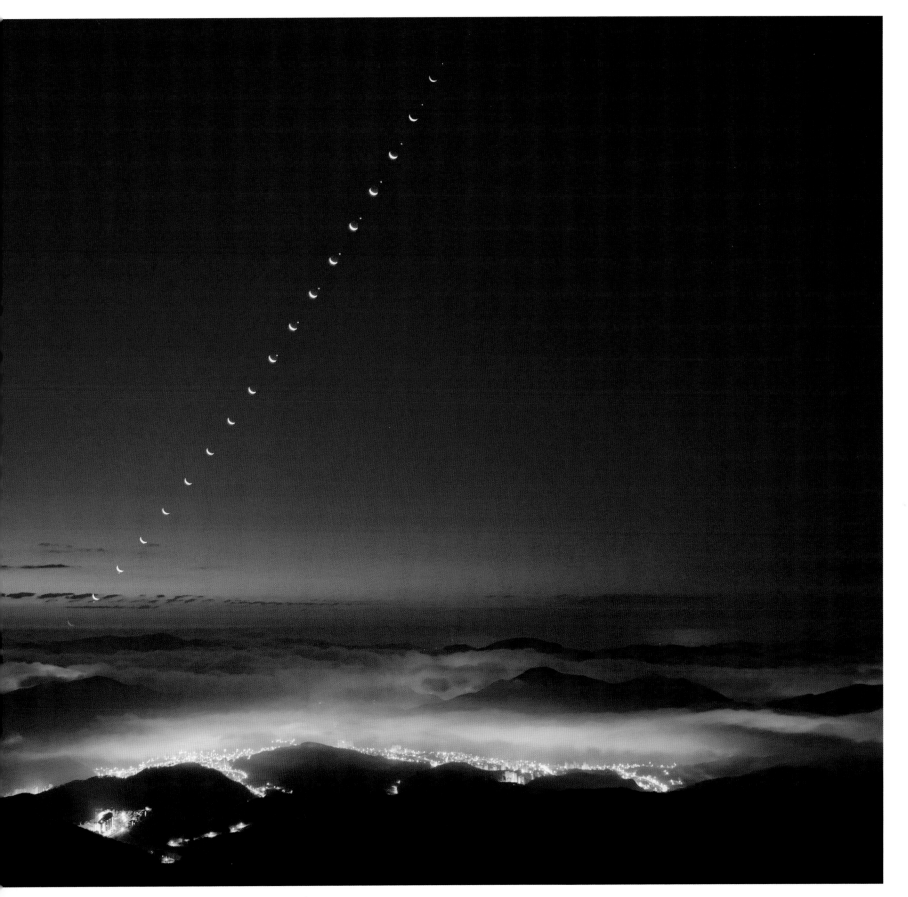

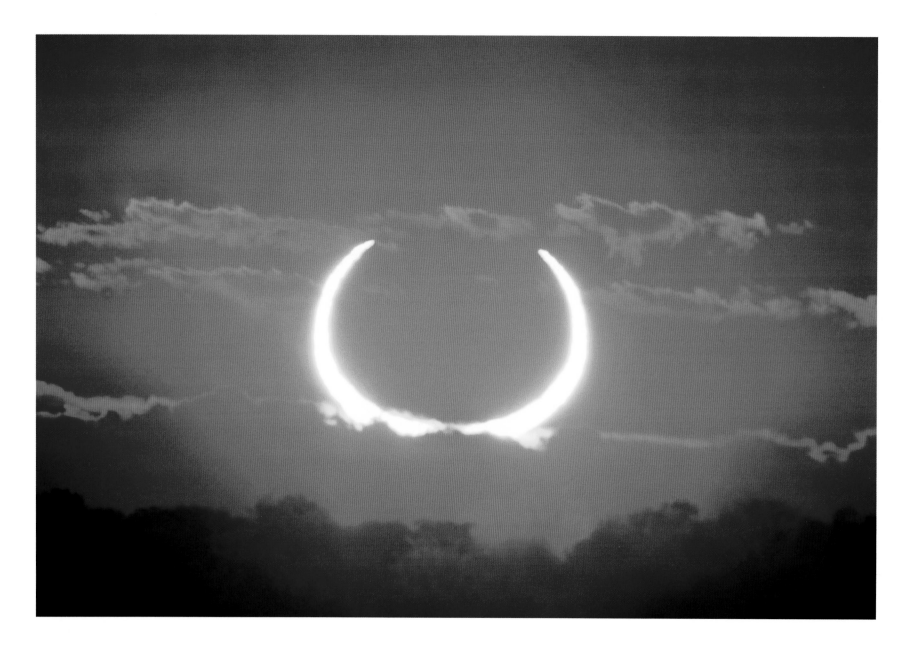

Λ

**FABRIZIO MELANDRI** *(Italy)*

### Horns of Fire Sunrise
[*10 May 2013*]

**FABRIZIO MELANDRI:** Sunrise about 100km south of Newman, Western Australia, on a morning in May, with the annular eclipse in progress.

*Newman, Pilbara, Western Australia*

**BACKGROUND:** Here the distortion of the Sun and Moon as the light passes through the thickest part of our atmosphere provides a different perspective on this celestial event. During annular eclipses the Moon is too far away from the Earth to appear big enough to cover our distant star in the background. On the date this image was taken the Moon was about 400,000km away from us, while the Sun was around 150 million km away.

**Nikon D7000 camera; 700mm f/7 lens; ISO 100; 1/750-second exposure**

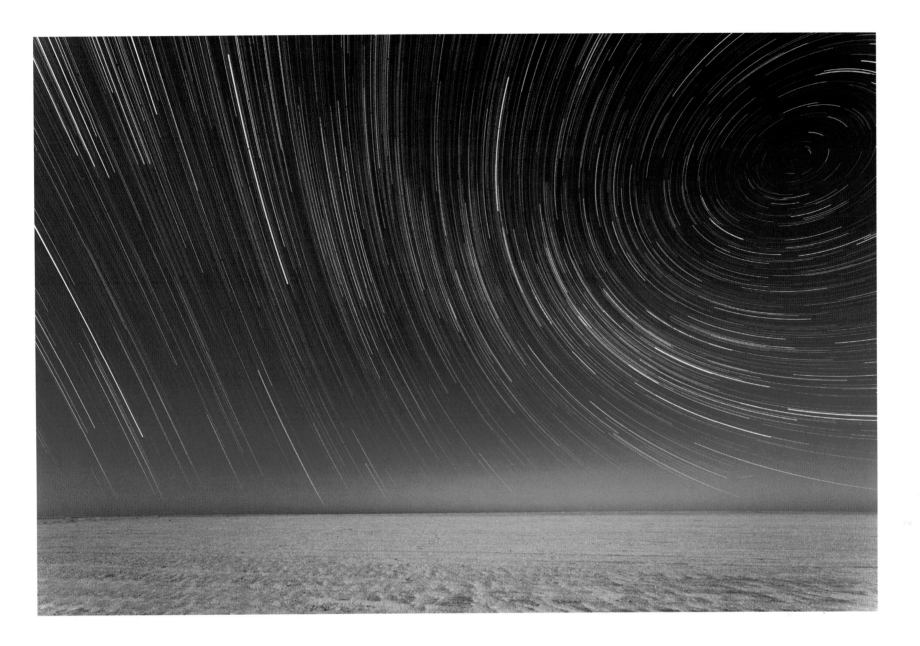

## Λ

**SEBASTIÁN GUILLERMAZ** *(Argentina)*

### Star Trails on the Beach
[*26 February 2014*]

**SEBASTIÁN GUILLERMAZ:** I stacked 268 photos to compose the star trail. The sky appears blue and bright by the light of the full Moon.

*Mar de Ajo, Buenos Aires Province, Argentina*

**BACKGROUND:** In this technically complex picture, multiple shots have been used to produce a time-lapse effect, as the Earth's rotation draws the light from the stars into long trails. Almost abstract in its block colours and strong linearity, this picture plays with contrasts, that of the sharp curves and obliques of the star trails against the warm plane of the beach.

**Canon 6D camera; Samyang 14mm f/4 lens; Manfrotto tripod**

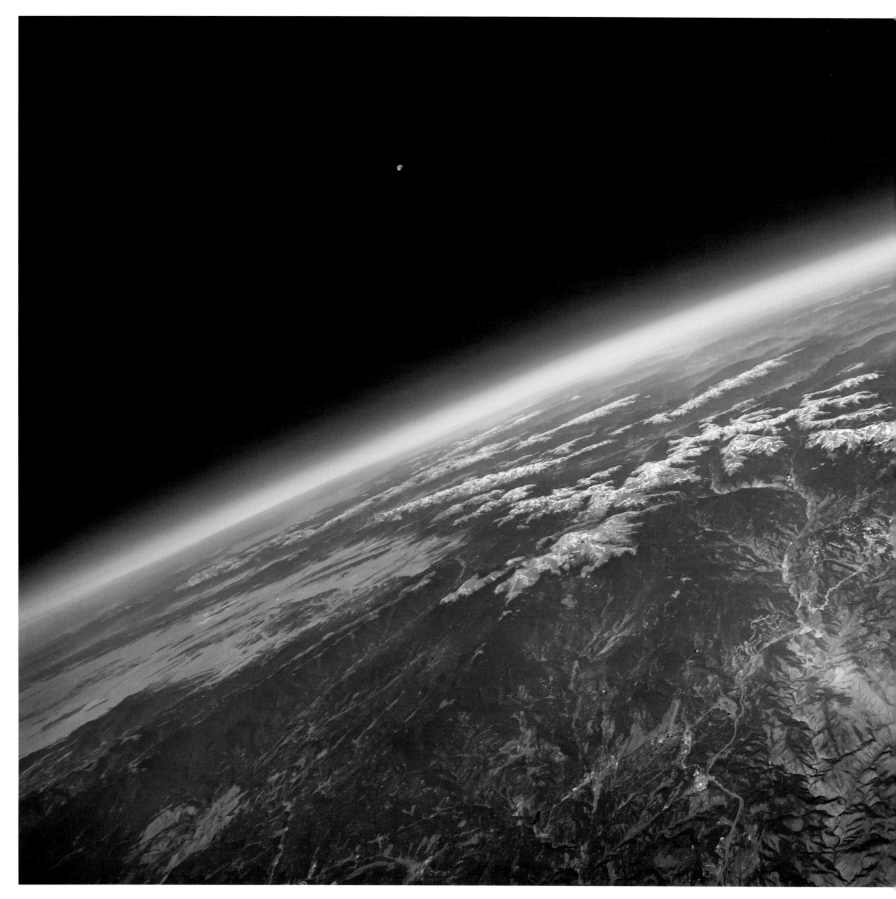

**PATRICK CULLIS** *(USA)*

### Moon Balloon

[*27 June 2013*]

**PATRICK CULLIS:** This image was taken from a high altitude balloon, launched from Boulder, Colorado. The Moon only became visible when the balloon had cleared the bright haze of our atmosphere and entered the thin air of the stratosphere. Photographed from 26,500m above and west of Denver, Colorado.

*Denver, Colorado, USA*

**BACKGROUND:** Poised on the edge of space, this astonishing shot clearly shows the curvature of the Earth with the towering Rocky Mountains reduced to tiny wrinkles on the surface far below. Once the sole province of meteorologists and spies, high altitude balloons are increasingly being used by keen amateurs and even school pupils to carry out experiments – and to take spectacular pictures like this one. The tiny dot of the Moon serves to emphasize the vast distance between our planet and its nearest cosmic neighbour.

**Canon 5D camera; 17mm f/11 lens; ISO 200; 1/500-second exposure**

*"To capture the distant Moon and a dramatic Earthly landscape together like this using a remote camera strapped to a balloon is quite an achievement. Our first Earth and Space picture to be taken from the edge of space itself! High altitude balloons are becoming more accessible to amateur photographers, but it's still very difficult to take a really great shot like this."*

MAREK KUKULA

*"This picture shows just how far astrophotography has come in recent years. No longer are amateurs limited to imaging the Cosmos from the ground. From high up in Earth's atmosphere the rocky oasis we call home stands in stark contrast to the black of space and the tiny distant Moon lost in the darkness."*

WILL GATER

*"This is an impressive result from a high altitude balloon – space is no longer the preserve of expensive missions!"*

PETE LAWRENCE

*"Earth and space: does what it says on the tin. An image first taken by astronauts, now more accessible to us all."*

MAGGIE ADERIN-POCOCK

*"The detail in this entry is astounding."*

MELANIE GRANT

*"Balloon-borne astronomy has a long history, but I think this is the most beautiful such shot I've seen. The Moon looks tantalizingly out of reach above the thin atmosphere of the Earth."*

CHRIS LINTOTT

*"This shot encompasses it all: houses and valleys far below and the blackness of space looming above. Between the two is the thin delicate blueness of our atmosphere, which shields life on Earth from the endless hard vacuum beyond."*

CHRIS BRAMLEY

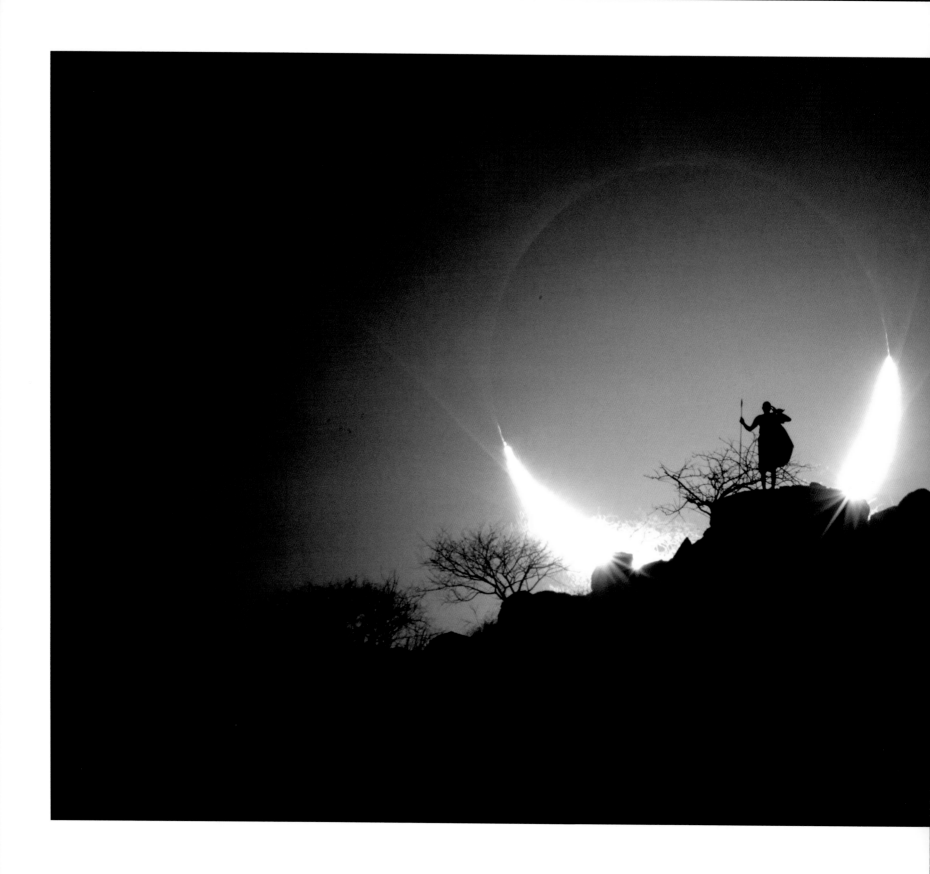

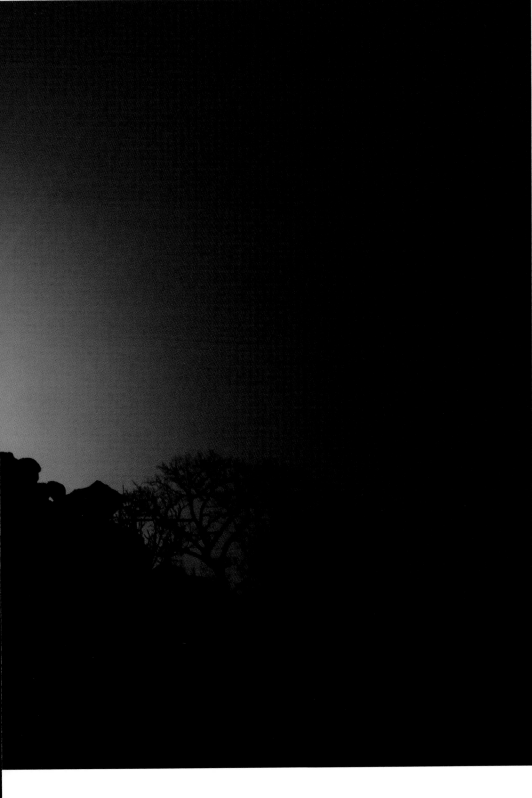

## EUGEN KAMENEW (Germany)

### Hybrid Solar Eclipse 2
[*3 November 2013*]

Original competition category: people and space

**EUGEN KAMENEW:** Geoffrey Lowa was a friend I never met in person. He was planning to be my host, driver, tour guide and, last but not least, my photographic model for a hybrid solar eclipse in North Kenya on 3 November 2013. On 8 October he sent me his last message via Facebook, excited at the prospect of our trip: 'Turkana should be blessed…it's the cradle of mankind. Oil and enormous underground lakes [were] recently discovered and now [we have a] hybrid solar eclipse…'. Sadly he was killed just one week before I arrived. These photographs are my tribute to Geoffrey.

*Turkana County, Rift Valley, North Kenya*

**BACKGROUND:** Sun and Moon sink together behind a Kenyan savannah skyline, locked in an eclipse in which the Moon is silhouetted against the Sun's bright disc. This particular event, in November 2013, was a rare example of a hybrid solar eclipse. It began at sunrise over the western Atlantic as an annular eclipse, in which the Moon does not entirely block the Sun, leaving a bright ring or annulus uncovered. As the Moon's shadow swept eastwards across the ocean the eclipse became total, with the whole of the Sun concealed from view. By the time the eclipse reached Kenya the Sun was once again emerging from behind the Moon, producing this spectacular crescent shape at sunset.

**Canon 5D Mk II camera; 700mm f/22 lens; ISO 400; 1/1600-second exposure**

*"For me, this photo really captures the emotional impact of a solar eclipse. Seeing one is always an unforgettable experience."*
MAREK KUKULA

*"This is an incredibly powerful image. Amazing timing and a crystal sharp image of the eclipse. The 'starburst' effect caused by the divided solar crescent is stunning. A magnificent image."*
PETE LAWRENCE

*"An eclipse is magical enough but with the silhouetted figure an extraordinary image is created."*
MAGGIE ADERIN-POCOCK

*"This image is rich on many levels: solar as well as terrestrial, human above all. The composition is very powerful too: soft edges, bright focus, delicate silhouetting; the refracting spikes of the sun shining through the rugged landscape."*
MELANIE VANDENBROUCK

*"To see an eclipse you have to be in precisely the right place – and the sense of location in this shot is very present."*
CHRIS LINTOTT

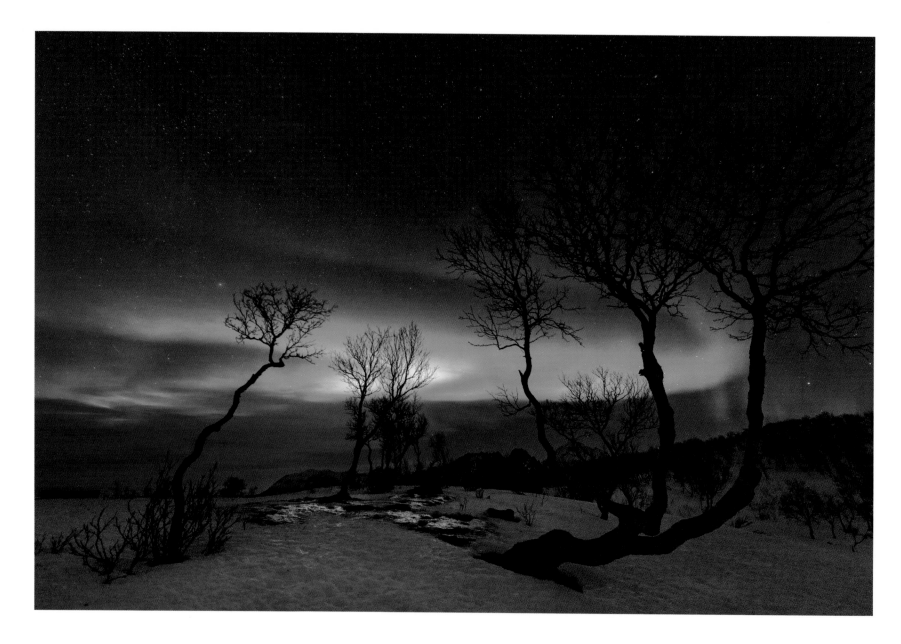

Λ

**RUNE JOHAN ENGEBOE** *(Norway)*

### Flow
[*2 February 2014*]

**RUNE JOHAN ENGEBOE:** Green rivers in the sky, frozen rivers on the ground. A perfect moment.

*Harstad, Troms, Norway*

**BACKGROUND:** Triggered by bursts of subatomic particles fired out by the Sun, aurorae are most common close to the Earth's magnetic poles and can occur at any time of the day or night. However, these delicate atmospheric lights only become visible to us when the sky is dark. This makes the long, cold nights of the northern winter a particularly good time to see them.

**Nikon D800 camera**

## ANDREW CALDWELL *(New Zealand)*

### Falling to Earth
[*2 March 2014*]

**ANDREW CALDWELL:** The International Space Station (ISS) traverses the galactic core, far above Hawke's Bay, New Zealand. This is a composite of eight consecutive frames; one used as the base image and seven others used only for the ISS trail. This image covers 100 seconds of the ISS trail.

*Kairakau, Hawke's Bay, New Zealand*

**BACKGROUND:** The careful image combinations for this final composition allow the scene to contain both the intense reflected sunlight from the space station and the faint glow of stars in the Milky Way galaxy. The ISS speeds around the Earth at approximately 28,000km per hour, but even at this fantastic speed it would take just over one billion years to reach the heart of our galaxy that is also captured in the backdrop.

Nikon D800 camera; 17mm f/2.8 lens; ISO 1600; 13-second exposure

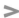

**JUSTIN NG** *(Singapore)*

### Good Morning Horses!
[*30 September 2013*]

**Original competition category: people and space**

**JUSTIN NG:** A tale of two horses, catching a glimpse of the breathtaking sunrise from two awe-inspiring locations. One from above the fog on the crater of Mount Bromo, an active volcano, and the other located in our very own galaxy, the Milky Way! Needless to say I have created this composite image in order to tell the story.

*Mount Bromo, Bromo Tengger Semeru National Park, Indonesia*

**BACKGROUND:** Horses are the stars of this panoramic scene; a composite of an Earthly sunrise with an expertly-snapped view of our galaxy above. The Earth-bound steed is easy to spot, but you might need to look a little harder to see its celestial companion. Squint at the dark clouds of dust that thread the Milky Way and you should find the silhouette of a horse rearing to greet the dawn.

**Canon 5D Mk II camera; 16mm f/2.8 lens; ISO 1600; 10-second exposure**

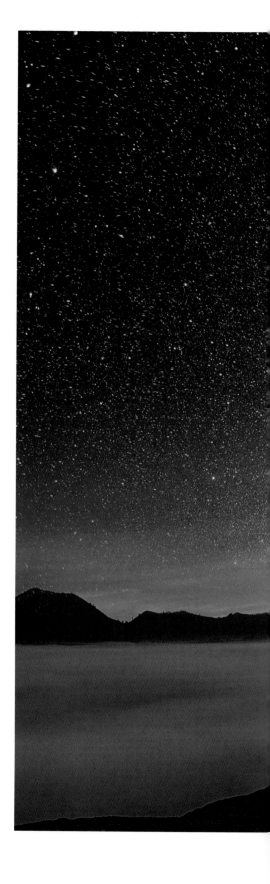

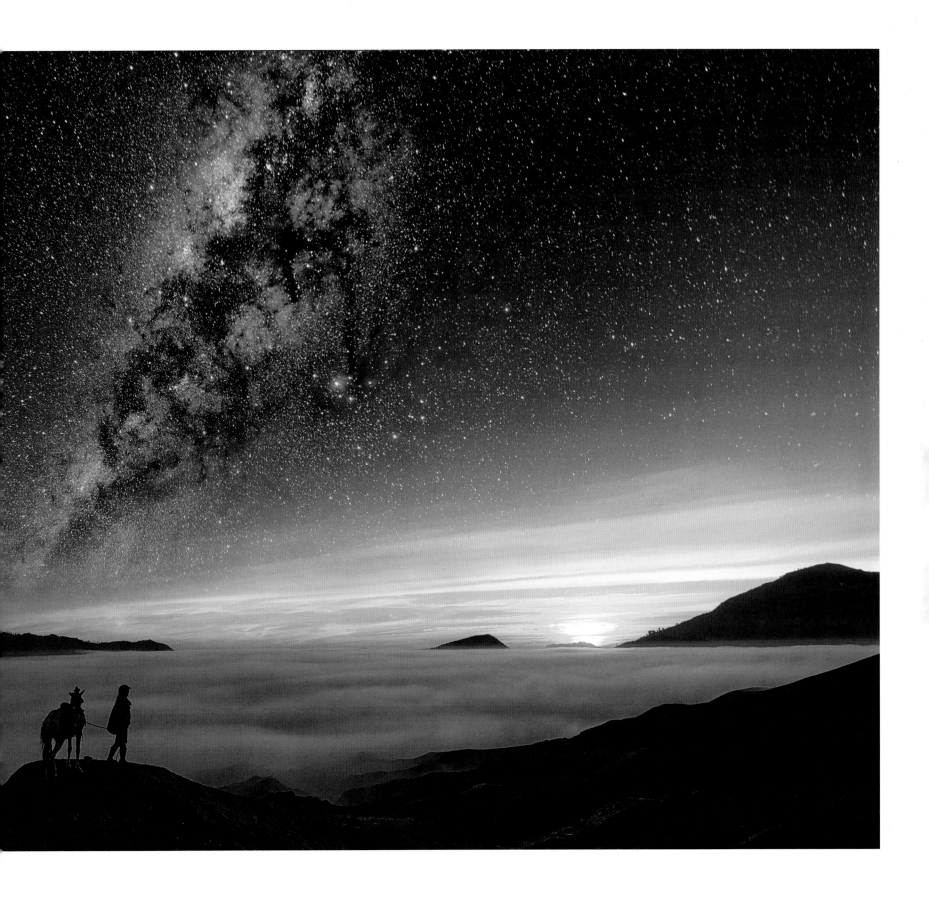

# ASTRONOMY ✦ PHOTOGRAPHER
## OF THE YEAR

# OUR SOLAR SYSTEM

Photos of the Sun and its
family of planets, moons,
asteroids and comets

# CONTENTS: OUR SOLAR SYSTEM

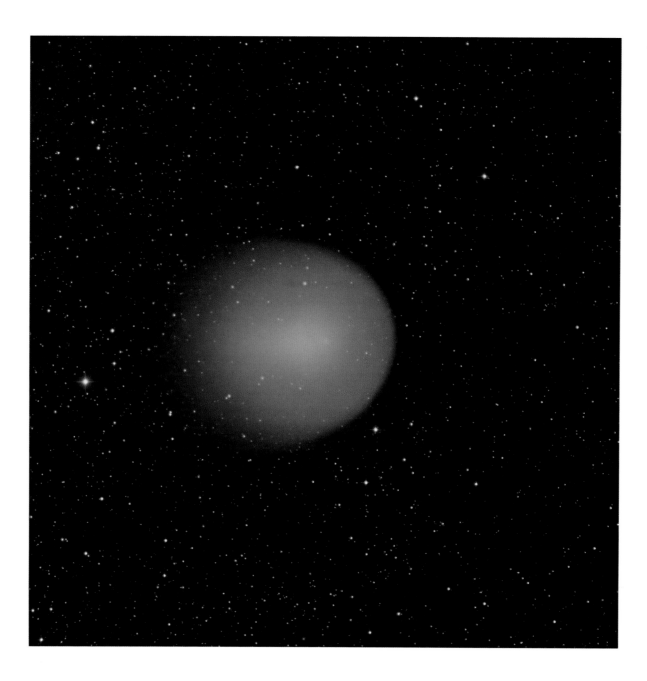

## NICK HOWES (UK)  HIGHLY COMMENDED

### Comet Holmes
[18 February 2009]

**NICK HOWES:** This image was taken with friends and neighbours in the garden watching with binoculars as the laptop was providing a close-up view via my scope and camera. A nine-year-old-boy, whose grandparents live next door, looking in awe at the sky just reminded me of how I must have looked and felt at that age; and yet, over thirty years on, I still feel the same way.

**BACKGROUND:** The nucleus of a comet is a 'dirty snowball' just a few kilometres across and made of ice, rock and frozen gases. As the comet's orbit approaches the Sun, solar radiation heats the nucleus, evaporating the surface ices to produce a vast halo of gas and dust which streams off to form the distinctive tail. Comet Holmes (17P/Holmes) has an orbit between Mars and Jupiter and can be seen about every seven years as a very faint object in the sky.

**Atik 314L monochrome CCD camera; Orion ED80 refractor with RGB filters**

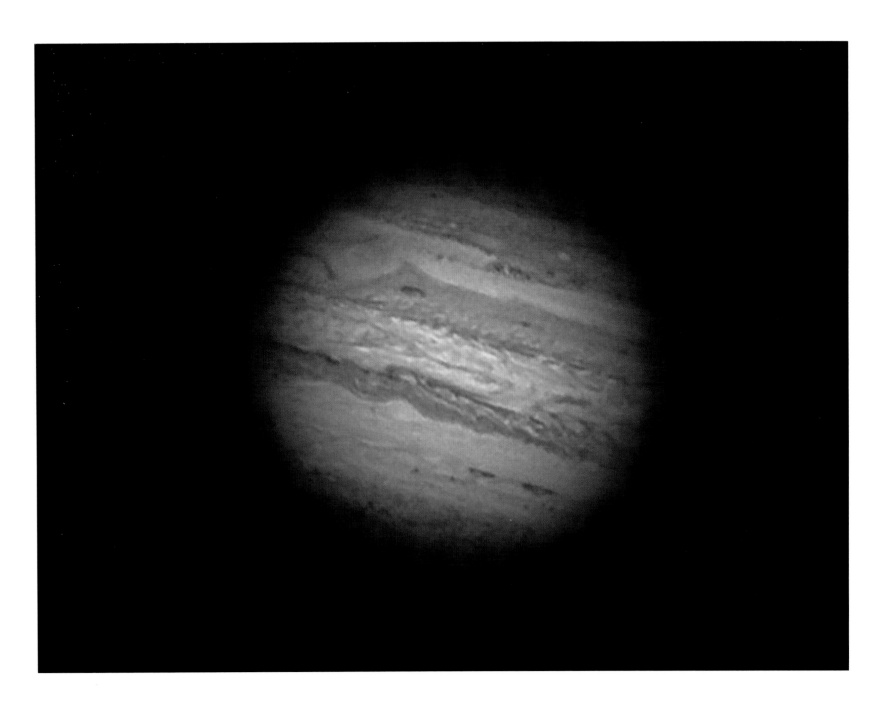

Λ

**NICK SMITH** *(UK)*

## Jupiter
*[15 August 2009]*

**NICK SMITH:** My first telescope was a 50mm Tasco refractor that I had aged ten! It was only about five years ago that I realised it was possible for amateurs to take really high resolution images of the Moon and planets using low-cost consumer webcams.

**BACKGROUND:** Jupiter is the largest planet in the Solar System. A giant ball of gas with no solid surface, its atmosphere is streaked with colourful bands of cloud. This image was taken just after a large asteroid plunged into Jupiter's atmosphere, exploding beneath the clouds. A dark patch near the top of the planet's disc marks the impact.

**Celestron C14 14-inch Schmidt-Cassegrain telescope; Tele Vue 1.8x Barlow lens; Lumenera SKYnyx 2-0M CCD camera**

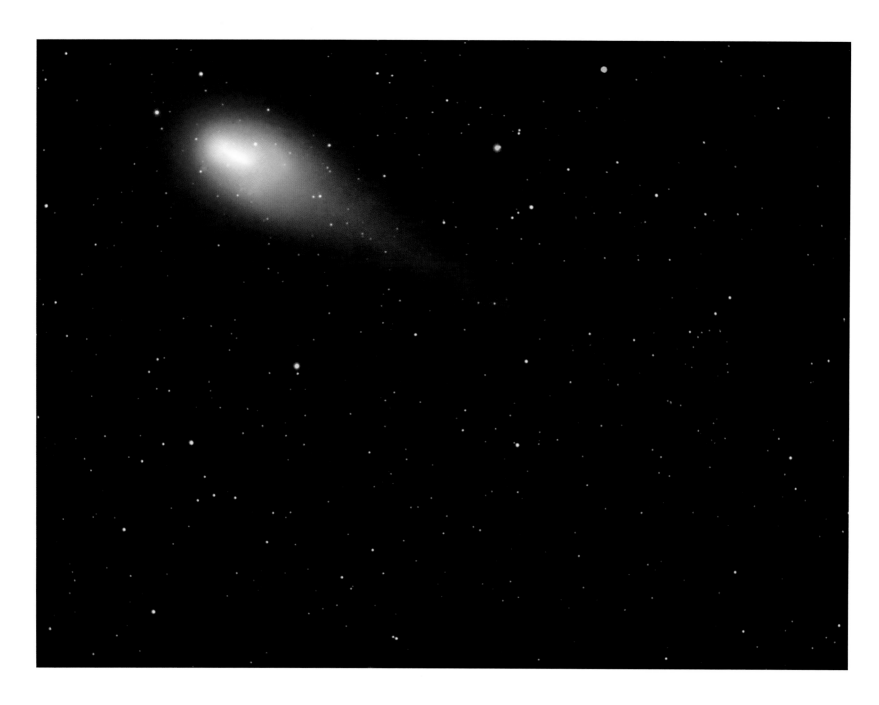

Λ

**RICHARD HIGBY** *(Australia)*          *HIGHLY COMMENDED*

### The Green Visitor – Comet Lulin
*[3 March 2009]*

**RICHARD HIGBY:** I had read that Comet Lulin was approaching our solar system. This speeding dirty snowball would not revisit us during our lifetime! This was all that was needed to rush home on a number of occasions praying for a break in the clouds and weather to capture the green visitor from our backyard in North Sydney, Australia.

**BACKGROUND:** Comets are visitors from the frozen edges of the Solar System. A comet's nucleus is a chunk of ice and rock just a few kilometres across. As it passes close to the Sun, ice on the surface evaporates. This streams off into space to produce the comet's spectacular tail of dust and gas, millions of kilometres long.

**Wiliam Optics Megrez 90mm doublet apochromatic refractor; Takahashi EM200 equatorial mount; SBIG ST-2000MXC CCD camera**

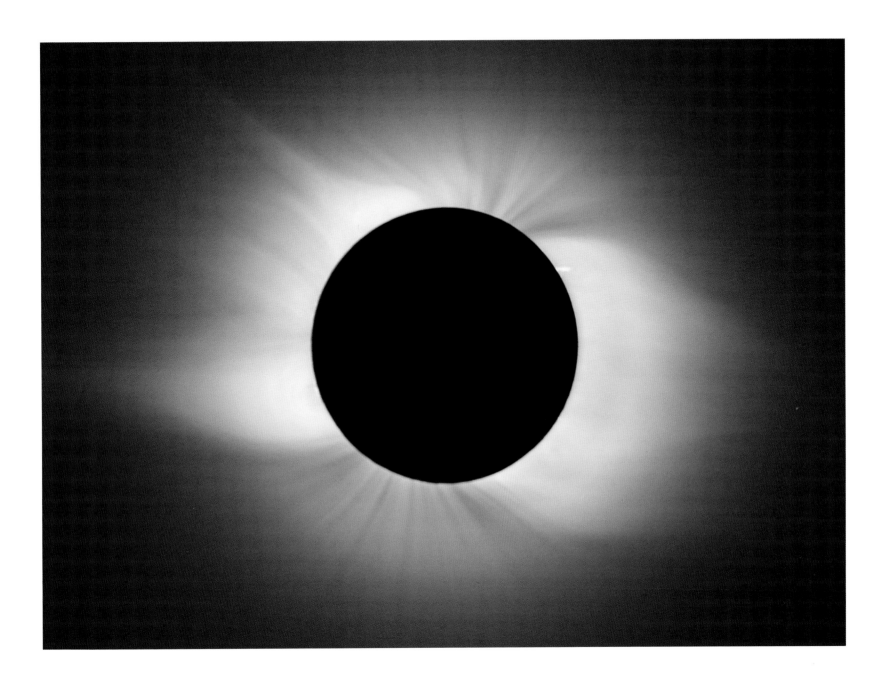

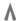

**ANTHONY AYIOMAMITIS** (*Greece*)                    *WINNER*

### Siberian Totality
[*1 August 2008*]

**ANTHONY AYIOMAMITIS:** On eclipse day, the clouds were present everywhere and only one hour before first contact (partial phase) did the skies clear … and they cleared beautifully and with pristine transparency. There was a slight wind, especially at the top of the roof of the Institute of Nuclear Physics, but it was a very small price to pay.

**BACKGROUND:** During a total solar eclipse, the Moon passes directly in front of the Sun. For a few minutes, with the dazzling light of the solar disc blocked from view, we gain a rare glimpse of the corona, the Sun's outer atmosphere. Powerful magnetic fields warp and shape the super-heated gas of the corona into glowing loops and streamers.

**Takahashi FSQ-106 106mm refractor telescope; Celestron CG3 German equatorial mount; Canon EOS 350D XT DSLR camera**

*"The processing used maintains an exquisite level of detail right across the corona and delivers a view similar to what would be seen with the human eye. This is something that's not easy to do with a camera and the end result completely justifies all the hard work that's gone into producing this beautiful image."*

PETE LAWRENCE

## NICK SMITH (UK)

### Sinus Iridum
[*26 January 2010*]

**NICK SMITH:** The *Sinus Iridum* shot was taken from my back garden in Oxford in the UK. It is an area of the Moon that I often return to in the hope of capturing a few more of the illusive 'craterlets' that litter the floor of the bay.

**BACKGROUND:** *Sinus Iridum*, or the 'Bay of Rainbows' lies on the edge of the Moon's 'Sea of Rains' (*Mare Imbrium*). The smooth floor of the bay is filled with dark lava, which solidified billions of years ago and is surrounded by rugged mountains. These highlands are older than the lava plains and are therefore more heavily scarred by craters – the relics of ancient meteorite impacts.

**Celestron C14 14-inch Schmidt-Cassegrain telescope; Tele Vue 1.8x Barlow lens; Lumenera Infinity 2-1M CCD camera**

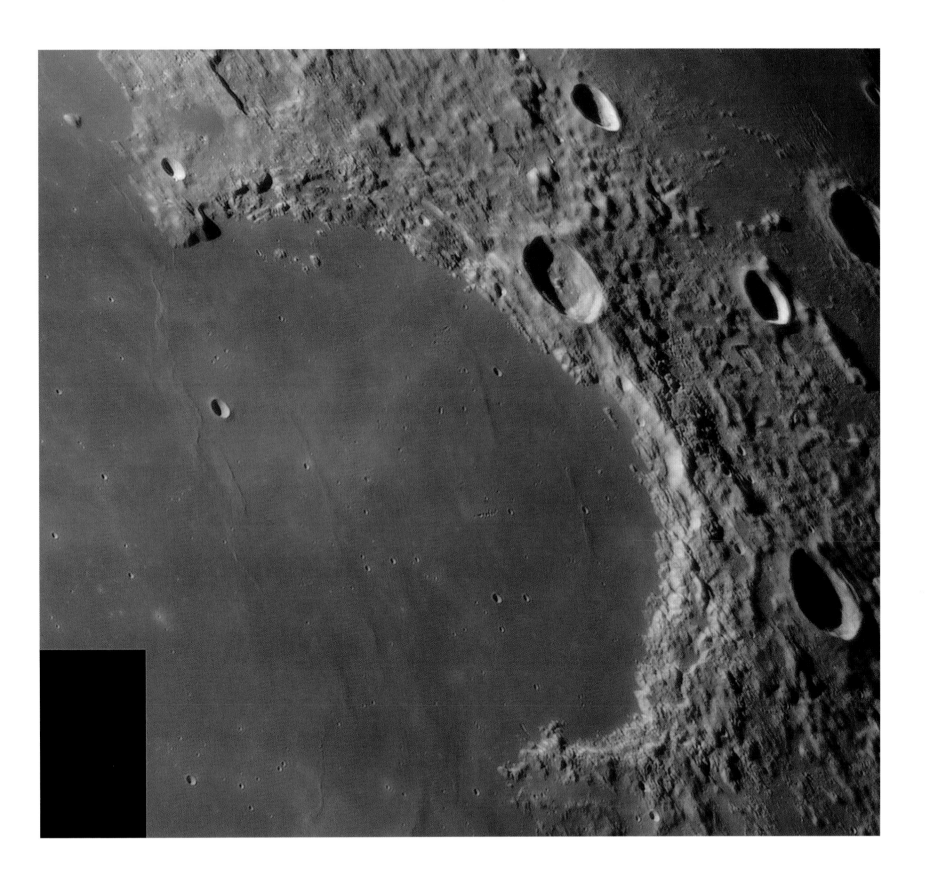

## DHRUV ARVIND PARANJPYE *(India)*, AGED 14    *WINNER*

### A Perfect Circle
[*15 January 2010*]

**Original competition category: young photographer**

**DHRUV ARVIND PARANJPYE:** My father got me a telescope and a digital camera, and the annular eclipse was a perfect opportunity to test my skills. The photograph was clicked from the southernmost tip of the Indian Peninsula, Kanyakumari.

**BACKGROUND:** An annular eclipse occurs when the Moon is too far from the Earth to cover the Sun's disc completely, as it would during a total solar eclipse. Seen here through a layer of cloud, a bright ring appears as the uncovered part of the Sun shines around the edges of the Moon.

**Nikon E3700 digital camera**

*"I loved how the perfect geometry of the eclipsed Sun contrasts with the chaotic shapes of the clouds. By using the clouds as a filter, Paranjpye has been able to reproduce wonderful, contrasting colours."*

REBEKAH HIGGITT

**DAMIAN PEACH** *(UK)*

## Jupiter with Io and Ganymede, September 2010
[*12 September 2010*]

**DAMIAN PEACH:** This photograph was taken as part of a long series of images taken over a three-week period from the island of Barbados in the Caribbean – a location where the atmospheric clarity is frequently excellent, allowing very clear and detailed photographs of the planets to be obtained.

I've been interested in astronomy since the age of ten and have specialized in photographing the planets for the last fourteen years. I'm very happy with the photo and wouldn't really change any aspect of it.

**BACKGROUND:** Jupiter is the largest planet in the Solar System. It is a giant ball of gas with no solid surface, streaked with colourful bands of clouds and dotted with huge oval storms.

In addition to the swirling clouds and storms in Jupiter's upper atmosphere, surface features of two of the planet's largest moons can be seen in this remarkably detailed montage. Io, to the lower left, is the closest to Jupiter. The most geologically active object in the Solar System, its red-orange hue comes from sulphurous lava flows. Ganymede, the largest moon in the Solar System, is composed of rock and water ice. The planet and its moons have been photographed separately, then brought together to form this composite image.

**Celestron 356mm Schmidt-Cassegrain telescope (C14); Point Grey Research Flea3 CCD camera**

*OVERALL WINNER 2011*

*"This is a truly incredible image of the planet Jupiter. Damian has even managed to capture detail on two of Jupiter's moons! It's truly astonishing to think that this was taken from the ground by an amateur astronomer using his own equipment."*

PETE LAWRENCE

*"There were so many beautiful images this year but this one really stood out for me. It looks like a Hubble picture. The detail in Jupiter's clouds and storms is incredible, and the photographer has also managed to capture two of the planet's moons. An amazing image."*

MAREK KUKULA

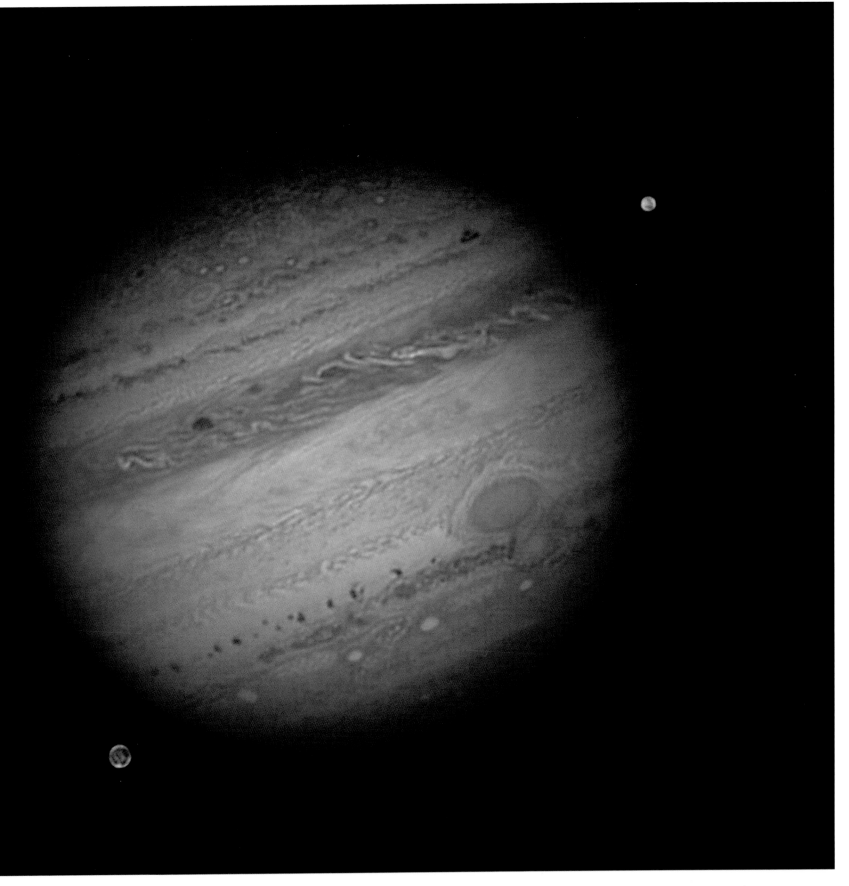

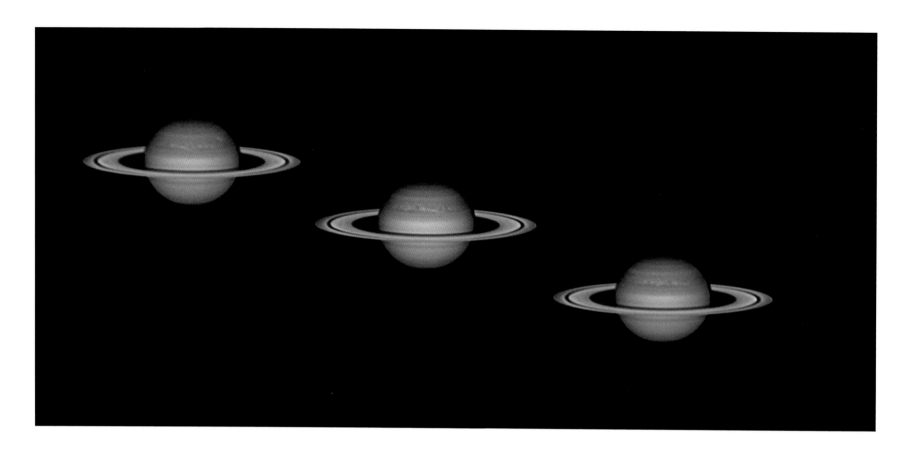

Λ

**PAUL HAESE** *(Australia)*                  *RUNNER-UP*

### Dragon Storm
[*29 March 2011*]

**PAUL HAESE:** This is the best image set I have obtained of Saturn. In the southern hemisphere we have been waiting a while for Saturn to climb high enough so we can get great detailed images.

**BACKGROUND:** Saturn, the second largest planet in the Solar System, is best known for its brilliant rings. These rings are made up of countless ice and dust particles orbiting the planet in intricate patterns, some of which can be seen in this series of photographs. Taken about forty minutes apart, these images show the progress of a huge storm, called the Dragon Storm, moving in Saturn's upper atmosphere as the planet rotates.

**Peltier cooled Celestron 356mm Schmidt-Cassegrain telescope (C14); PGR Flea3 CCD camera**

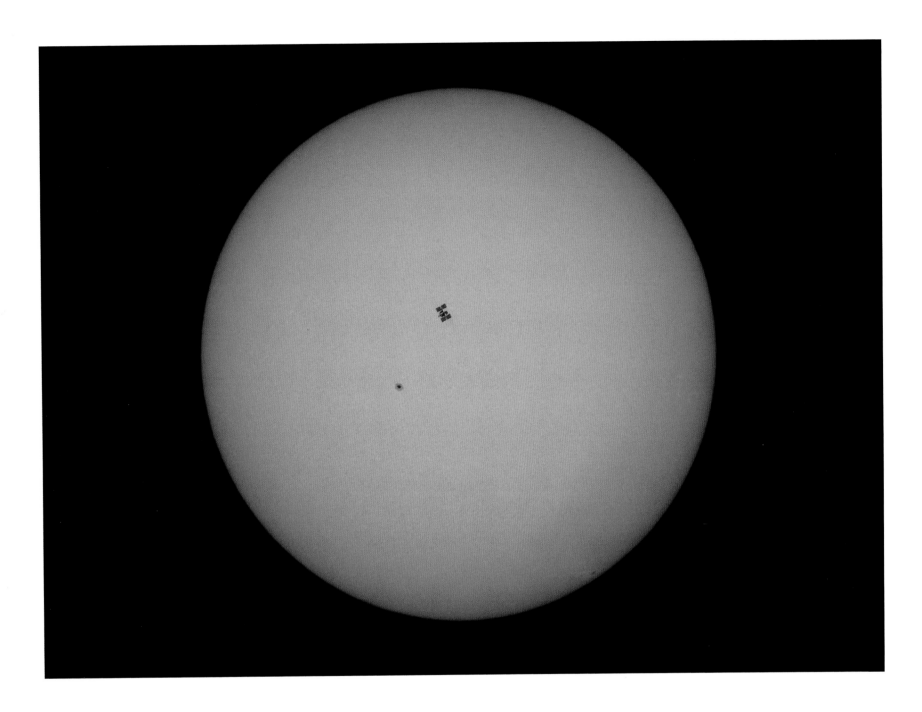

**DANI CAXETE** *(Spain)*        *HIGHLY COMMENDED*

### ISS and Endeavour Crossing the Sun
[*21 May 2011*]

**DANI CAXETE:** My dream was to immortalize the ISS (International Space Station) with the space shuttle *Endeavour* despite my novice-level knowledge and my humble equipment. I am very proud of the results achieved.

**BACKGROUND:** A perfectly timed photograph captures a silhouette of the International Space Station and docked space shuttle *Endeavour* as they passed in front of the Sun in less than half a second. Features of the Sun's photosphere – or visible layer – can also be seen, including a grainy texture resulting from the bubbling motion of gas at 6000 degrees Celsius. A dark spot to the left of the ISS is a sun spot, containing cooler gas, which is caused by intense magnetic activity.

**Celestron 127mm Schmidt-Cassegrain telescope (C5); Nikon D7000 camera**

## JATHIN PREMJITH *(India)*, AGED 15     *WINNER*

### Lunar Eclipse and Occultation
*[15 June 2011]*

**Original competition category: young photographer**

**JATHIN PREMJITH:** I was always fascinated by the coppery-red colour of the Moon during the total lunar eclipse. Also, it was interesting to note that not all lunar eclipses are the same, as the colour can change from light red to dark red depending on the position of the Moon and the amount of dust or pollution in the atmosphere at that time.

**BACKGROUND:** A lunar eclipse is a brief alignment of the Sun, Earth and Moon which places the Moon in the Earth's shadow. Here, the Moon is a red colour because it is lit by sunlight which has been filtered through the Earth's atmosphere. The photograph skilfully captures a second fleeting astronomical event, the moment a star appears from behind the orbiting Moon.

**Celestron CPC800 203.3mm (8-inch) Schmidt-Cassegrain telescope; Canon 5D Mark II DSLR camera**

*"The judges are always hugely impressed by the quality of the Young Astronomer entries. For me, this is one of the most striking images in the competition. The colour of the eclipsed moon, reflecting the red of sunsets all over Earth, is both delicately beautiful and truly majestic. The photographer has also captured just the right moment, with a bright but tiny star close to occultation."*

REBEKAH HIGGITT

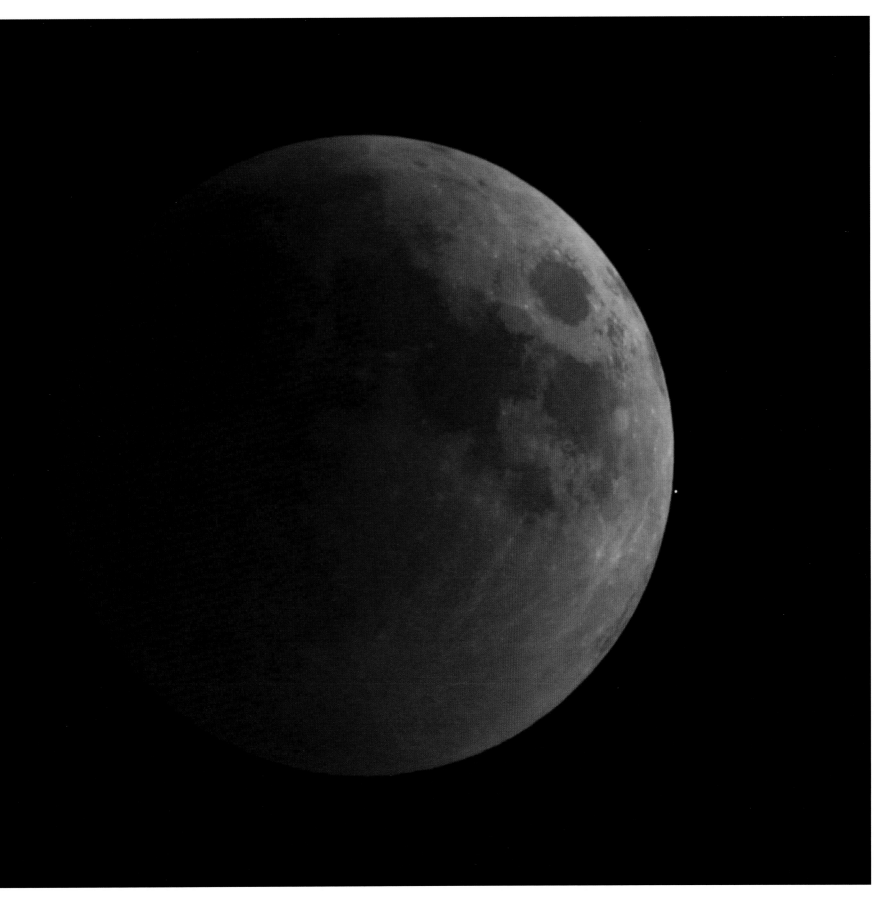

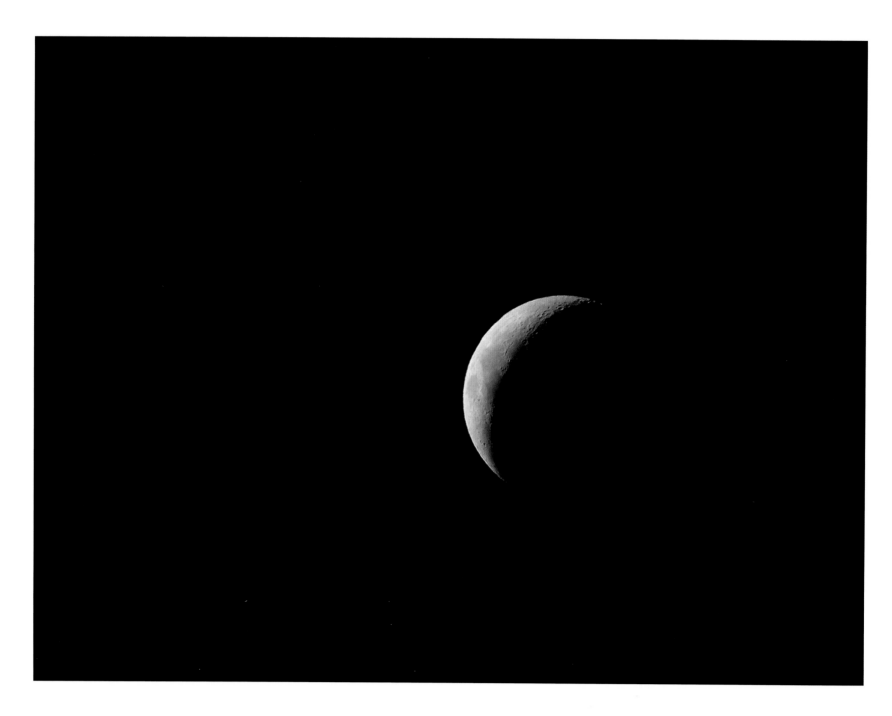

Λ

**PETER PIHLMANN PEDERSEN** *(UK)*, **AGED 15** *HIGHLY COMMENDED*

## Lonely Moon
*[9 March 2011]*

**Original competition category: young photographer**

**PETER PIHLMANN PEDERSEN:** I took this photo because I have had an interest in astronomy since a course in astronomy was offered in my school for GCSE. Since then, astronomy has been one my best hobbies.

**BACKGROUND:** Like the Earth, one half of the Moon is always lit by the Sun. It is the relative positions of the Earth, Moon and Sun that determine how much of this illuminated side we see from the Earth. Here a crescent moon displays a sliver of the Moon's sunny side.

**Skywatcher 114mm (4.5-inch) Newtonian reflector telescope; FinePix J250 compact digital camera**

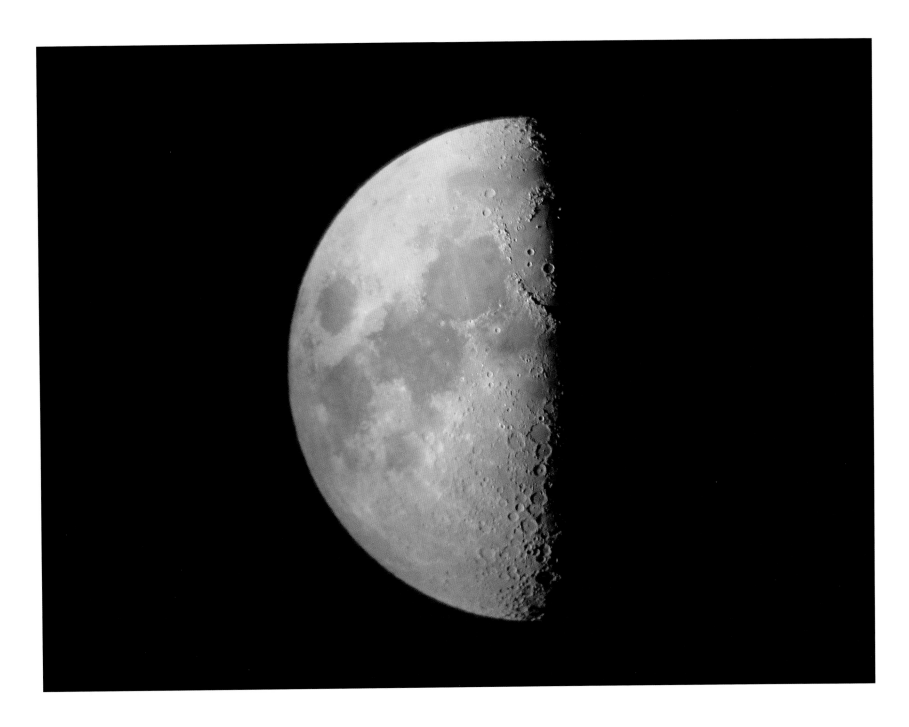

## TOM CHITSON (UK), AGED 15      *HIGHLY COMMENDED*

### First-Quarter Moon
*[8 July 2011]*

**Original competition category: young photographer**

**TOM CHITSON:** Last year at school, I had the opportunity to do a GCSE in astronomy. Our teacher for astronomy was very enthusiastic and got everyone in the class interested in the subject. From the first day of getting my telescope, I have been taking photos of the Moon, Saturn and Jupiter, all by just pointing a camera through the eyepiece of the telescope.

**BACKGROUND:** The features on the Moon that are easiest to see are close to the terminator, the boundary between the sunlit and dark sides. In this photograph, the craters and rugged mountain ranges stand out in sharp relief close to the terminator. The smooth, dark areas are lunar *maria* or 'seas', filled with dark lava which solidified billions of years ago.

**Celestron Nexstar 4SE 102mm (4-inch) Maksutov-Cassegrain telescope; Sony Cybershot W210 compact digital camera**

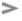

## DAMIAN PEACH (UK)

### Mars in 2012
[March 2012]

**DAMIAN PEACH:** The entire face of Mars during its aphelic opposition of 2012, where the apparent diameter reached only 13.9 arcseconds. Many interesting details can be seen, such as clouds surrounding the giant Tharsis volcanoes, and rifts and outlaying patches of ice around the north polar cap.

**BACKGROUND:** This sequence of photographs uses the rotation of Mars to build up a complete view of the planet's surface. It shows the gleaming north polar cap of water, ice and frozen carbon dioxide, the red equatorial deserts and the darker southern highlands. The photographer has captured an amazing level of detail, including wispy clouds in the thin Martian atmosphere.

**356mm reflector; PGR Flea3 camera**

*"Damian's work never ceases to amaze. Here is a sequence of images that show a full rotation of Mars ... the technical expertise and sheer investment of time needed to produce images of this clarity and range, especially from the UK, is immense."*

PETE LAWRENCE

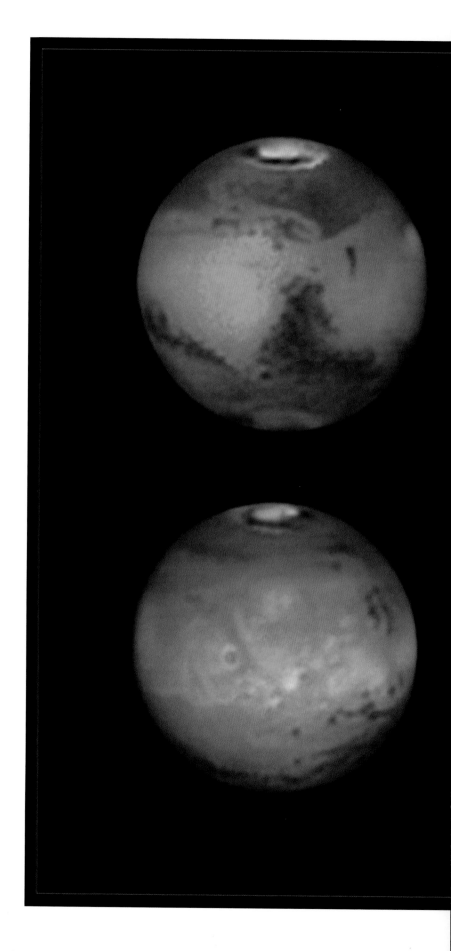

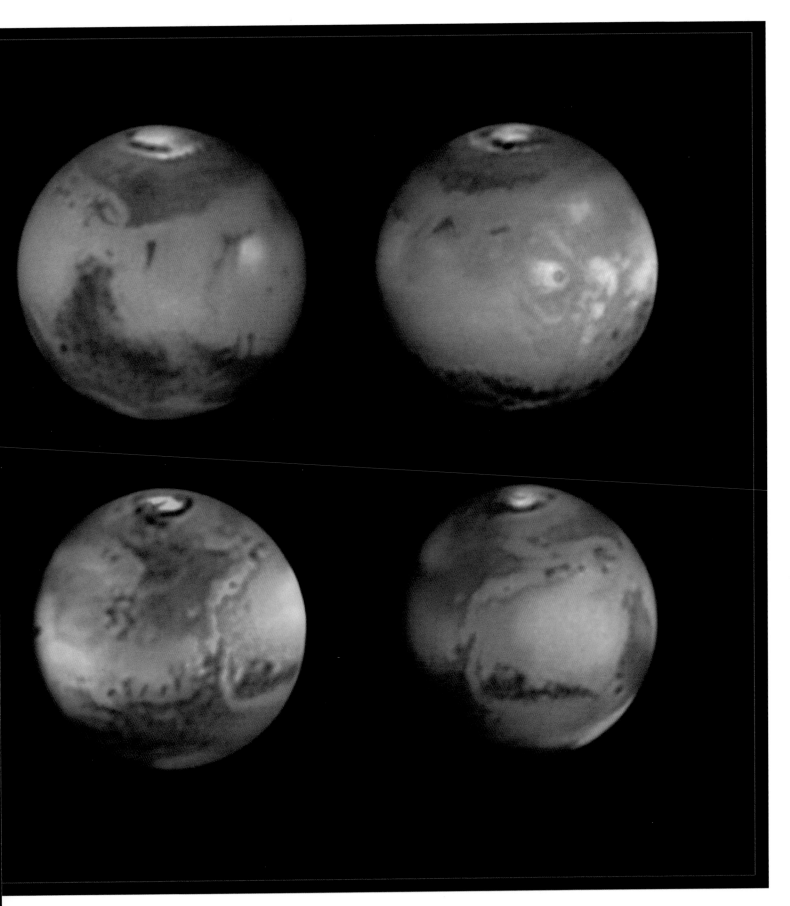

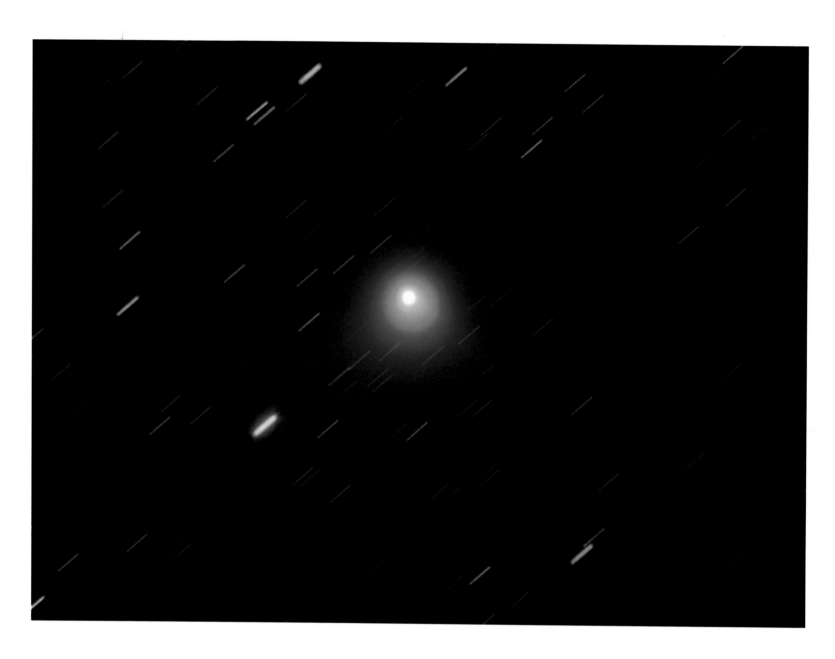

## GRAHAM RELF *(UK)*          *HIGHLY COMMENDED*

### Comet C/2009 P1 (Garradd)
*[19 March 2012]*

**GRAHAM RELF:** Comet C/2009 P1 (Garradd) has been visible from the UK for many months. It never reached naked-eye visibility but could be seen through binoculars. Its orbit is hyperbolic, so it has come from outside the Solar System and will never be seen from Earth again. My photograph shows how the comet moved relative to the stars in 38 minutes. The brightest star here is magnitude 6.4.

**BACKGROUND:** The photographer has used a long exposure to bring out the greenish glow of the comet's halo. The star trails show how he has tracked the comet's orbital motion in order to keep it in the centre of the frame. Comet Garradd was discovered in 2009 as it approached the inner Solar System. It became visible through binoculars in 2011.

**SkyWatcher 254mm Newtonian telescope; HEQ5 equatorial mount; f/4.8 lens; Canon 5D Mark II camera; ISO 6400; 32-second exposure**

*"I enjoy the muted colours in this photograph, the green of the comet nucleus, the blue of the faint tail, and the range of reds, blues, yellows and whites seen in the star trails. The sense of motion in the image conveys a fleeting glimpse of this icy visitor as it rushes through the inner Solar System."*
OLIVIA JOHNSON

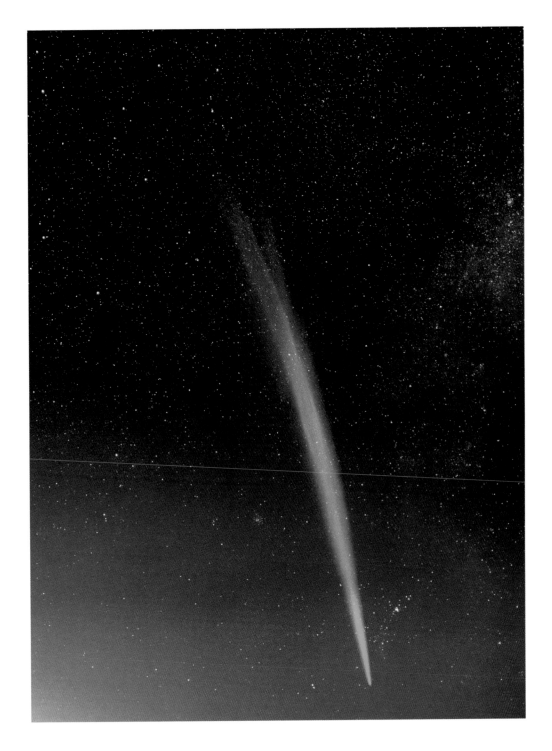

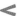

## PHIL HART *(Australia)*

### Lovejoy's Tail
[*24 December 2011*]

**PHIL HART:** I love a good comet, although very early on Christmas Eve was hardly convenient! I just dodged some early morning cloud to get this shot of Lovejoy's nice dusty tail.

**BACKGROUND:** Not every comet is as obvious as Comet Lovejoy, which put on a show for observers in the southern hemisphere in late 2011. This image shows the comet's long tail, composed of dust and vapour ejected from the tiny nucleus. Like all comets, the tail of Lovejoy points away from the Sun.

Canon 5D Mark II camera; 50mm f/2.2 lens, ISO 800; 60-second exposure

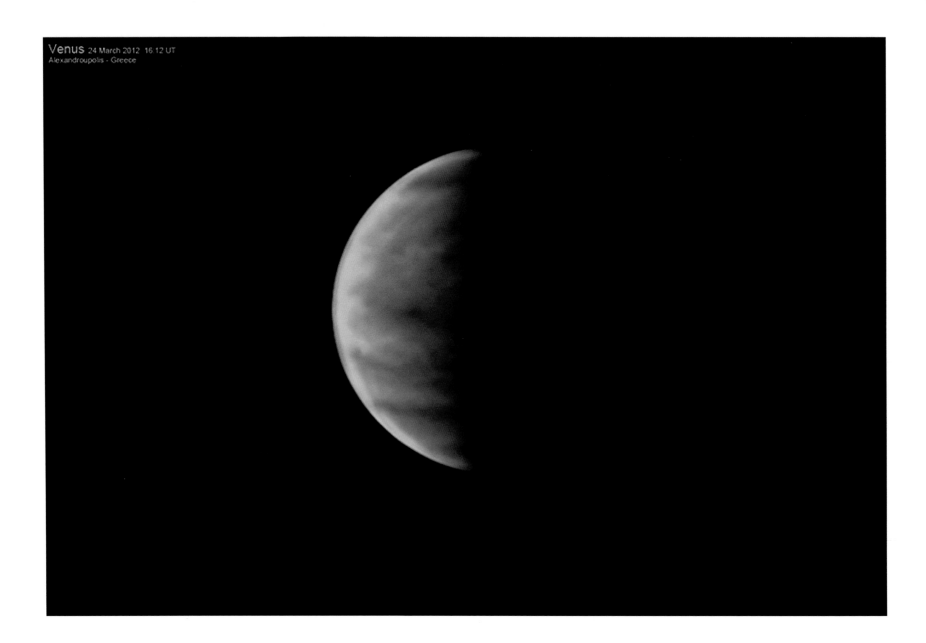

Venus 24 March 2012 16:12 UT
Alexandroupolis - Greece

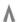

## GEORGE TARSOUDIS (*Greece*)

**Planet Venus 2012**
[*24 March 2012*]

**GEORGE TARSOUDIS:** The planet is named after Venus, the Greek goddess of love and beauty. Venus is the second planet from the Sun and it is not very easy to shoot in detail. In this image I used a UV filter for the L and B channel.

**BACKGROUND:** The transit of Venus across the Sun was one of the most memorable astronomical events of 2012. Venus, our neighbouring planet, appeared as a dark silhouette against the solar disc. By contrast, in the weeks leading up to the transit, Venus shone dazzlingly bright in the evening sky. This highly accomplished image shows us why: the planet is shrouded in a thick layer of sulphuric-acid cloud which reflects incoming sunlight.

10-inch Newtonian telescope at f/6.3; Barlow 3x lens; Unibrain Fire-i 785 camera

## ∧

**PAUL HAESE** (*Australia*)

### Active Sol
[*12 February 2012*]

**PAUL HAESE:** I remember this particular morning quite well. I went out to observe the Sun and saw this massive prominence. I just had to image it. To see the Sun with such a prominence is a joy.

**BACKGROUND:** 2012 saw the Sun moving towards the peak of its eleven-year cycle of activity following an unusually long and quiet lull. Sunspots, explosive flares and prominences are much more common now than in previous years, as demonstrated by this spectacular image of our closest star.

Coronado Solarmax 60 0.5A telescope; Imaging Source DMK41 camera; 6 panel mosaic with 723 frames in each panel

## PETER J. WARD *(Australia)*

### Tri-colour Transit
[*7 June 2012*]

**PETER J. WARD:** I am pleased with the image as it uniquely captures this rather rare event at high resolution. There are three distinct colour spectrums: the upper (hydrogen-alpha) and lower (calcium) chromosphere, as well as the photosphere (white light).

**BACKGROUND:** Taking photographs in different wavelengths of light helps to highlight the various physical processes occurring in the Sun. But in each of these three views the perfect black dot of Venus passing in front of the solar disc steals the show.

**Astro-Physics AP130 f/6 refractor, fitted with Calcium K, Hydrogen-Alpha and white light filters; Lumenera SKYnyx 2-2 camera; mosaic of up to 12 fields for each filter**

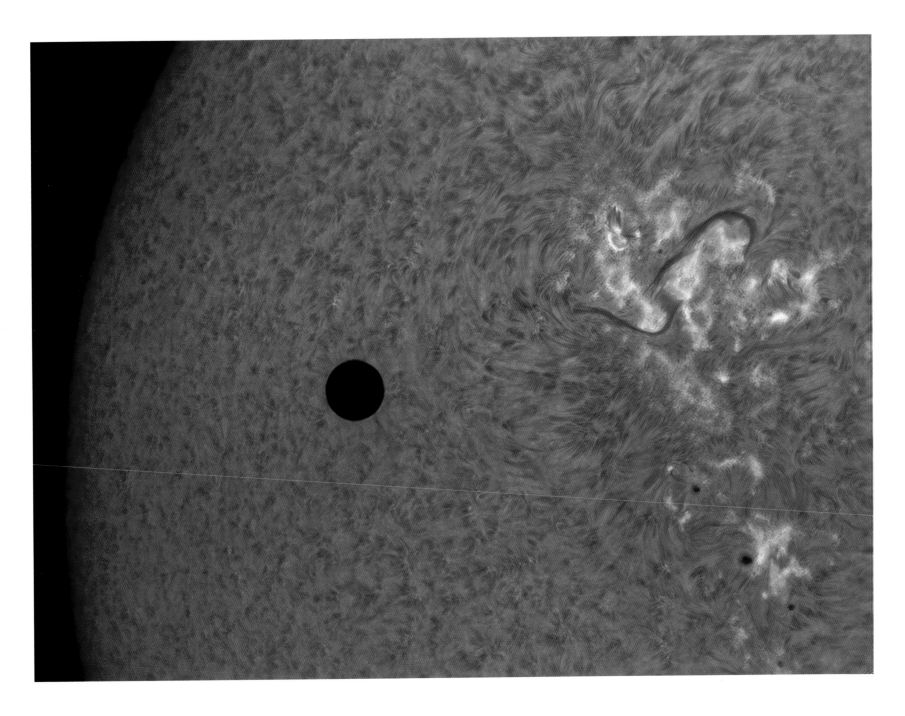

## TED DOBOSZ (*Australia*)

### Venus Transit of Sun in H-Alpha Band
[*9 June 2012*]

**TED DOBOSZ:** This image dramatically demonstrates the scale of the Sun compared to an Earth-sized Venus, and captures this black pearl against finely detailed surface structures and highly active regions of the Sun. This image was taken from Griffith which is a small rural town about 700 kilometres southwest of Sydney, Australia.

**BACKGROUND:** In the 21st century transits of Venus have acquired a new significance for scientists. By studying how sunlight is altered as it passes through the slender halo of atmosphere surrounding Venus, they can gain insights which will help them to understand the atmospheres of planets around other stars. In the future, this could help astronomers to investigate whether these exo-planets might harbour water, or even life.

**Dedicated H-Alpha Lunt LS80Tha telescope; Losmandy G11 mount; 80mm objective; Imaging Source DMK41 video camera**

**TROY TRANTER** *(Australia)*

### Saturn Super Storm
*[26 February 2011]*

**TROY TRANTER:** This image is unique because I was able to capture Saturn's large dragon storm (a rare event), as well as Tethys, Tethys's shadow, Dione and Enceladus at high resolution.

**BACKGROUND:** The deep, turbulent atmospheres of gas giant planets are the scenes of some spectacular weather. This image shows a vast pale storm streaking the cloud deck of Saturn, the second largest planet in our solar system.

**C9.25-inch Schmidt-Cassegrain telescope; CG-5 GT mount; SKYnyx 2-0 camera**

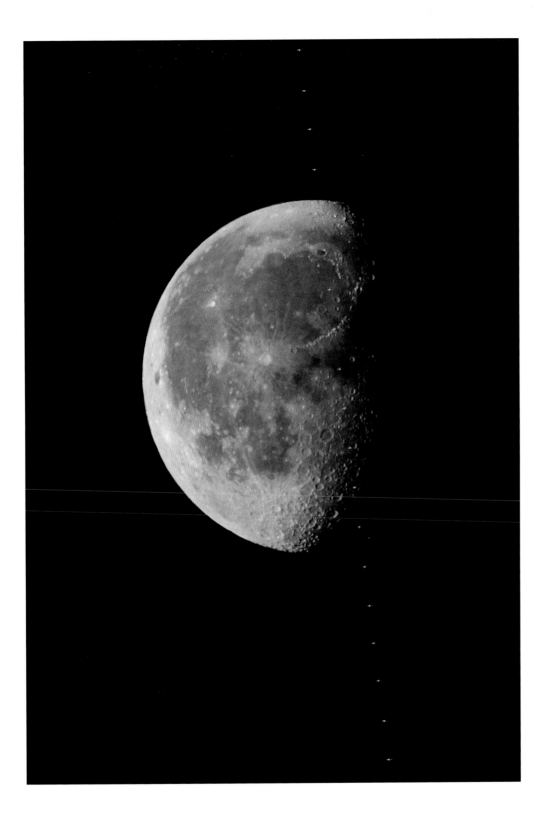

**PHIL MCGREW** *(USA)*

## Space Station Flies across the Moon!
*[14 January 2012]*

**Original competition category: best newcomer**

**PHIL MCGREW:** Finding a setting Moon, a sunlit space station, and a place where the two will meet was the most challenging photograph I've ever taken.

**BACKGROUND:** In a man-made echo of 2012's transit of Venus across the Sun, this image captures the swift transit of the International Space Station in front of the Moon in a series of split-second exposures. To take an image like this requires foresight, skill and planning.

**Canon 7D camera; 500mm f/4 lens; ISO2500; 1/1600-second exposure**

## ALAN FRIEDMAN (USA)   RUNNER-UP

### Magnetic Maelstrom
[11 July 2012]

**ALAN FRIEDMAN:** This is a close-up of the central area of Active Region 1520 – true magnetic poetry on the Sun.

**BACKGROUND:** The darkest patches or 'umbrae' in this image are each about the size of Earth, with the entire region of magnetic turmoil spanning the diameter of ten Earths. This image captures rich details directly around the sunspots, and further out in the so-called 'quiet' Sun where simmering hot plasma rises, cools and falls back. This produces a patchwork surface like a pot of boiling water, but on an epic scale – each bubbling granule is about the size of France.

**Astro-Physics Maksutov-Cassegrain telescope; Astro-Physics 900 mount; 255mm lens; Point Grey Research Grasshopper2 camera**

*"An almost abstract image with a great sense of depth and texture."*
MELANIE VANDENBROUCK

*"The level of detail shown here is quite astonishing. The sunspots themselves are showing incredible magnetic structure. The dark umbrae are surrounded by a lighter penumbra region which leads to the solar photosphere, or sphere of light; basically the visible surface of the Sun. A mark of a great high-resolution image of the photosphere is the granulated pattern that crosses it, visible as 'cells' all tightly packed in together. These are the tops of vast convection cells that start deep within the Sun. This is a beautiful way to show the high-resolution majesty of our nearest star."*
PETE LAWRENCE

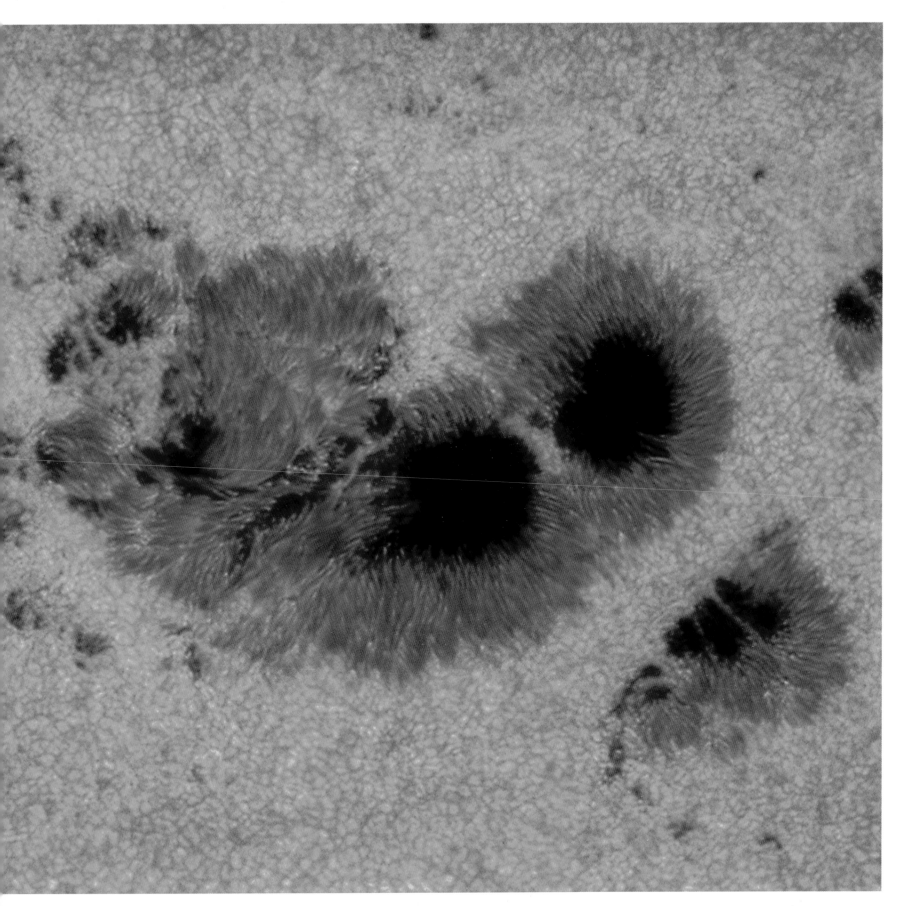

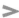

## PAUL ANDREW (UK)

### Incandescent Prominence
*[9 May 2013]*

**PAUL ANDREW:** This massive prominence was evolving for several days. Even though the weather was typical for our climes, I managed to record it over three days through breaks in the clouds. For me, this image exemplifies the power and beauty of the Sun.

**BACKGROUND:** This solar image has a surprisingly Earth-like feel with a wispiness like broken cloud on the horizon at dawn. The true nature of the image is awe-inspiring. It shows a gigantic arch of hot gas poised above the solar surface. This 'prominence' is so large that the Earth could easily roll beneath it. Solar prominences such as this have been known to arch over half the diameter of the Sun.

Lunt LS152THa telescope; EQ6 mount; 152mm lens; DMK 41AU02.AS camera; TeleVue 2.5x Barlow lens

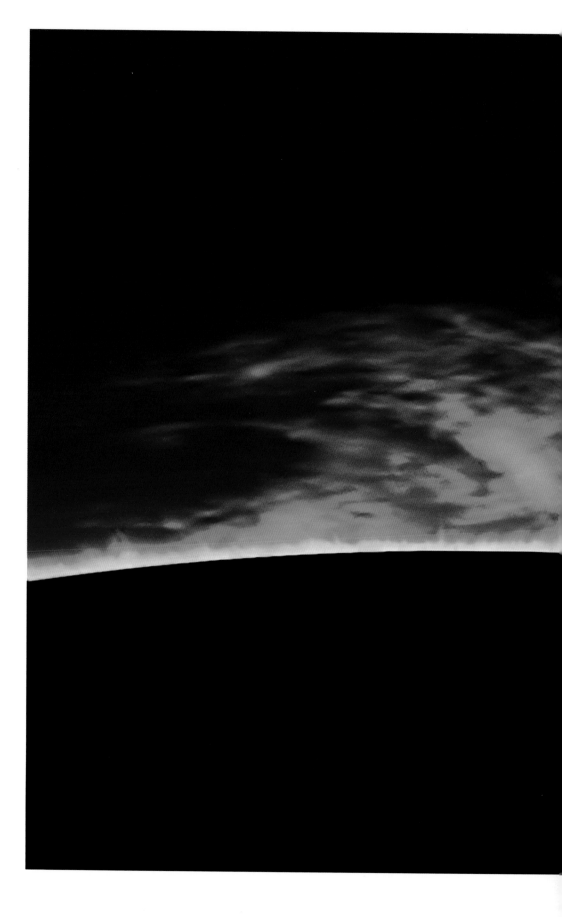

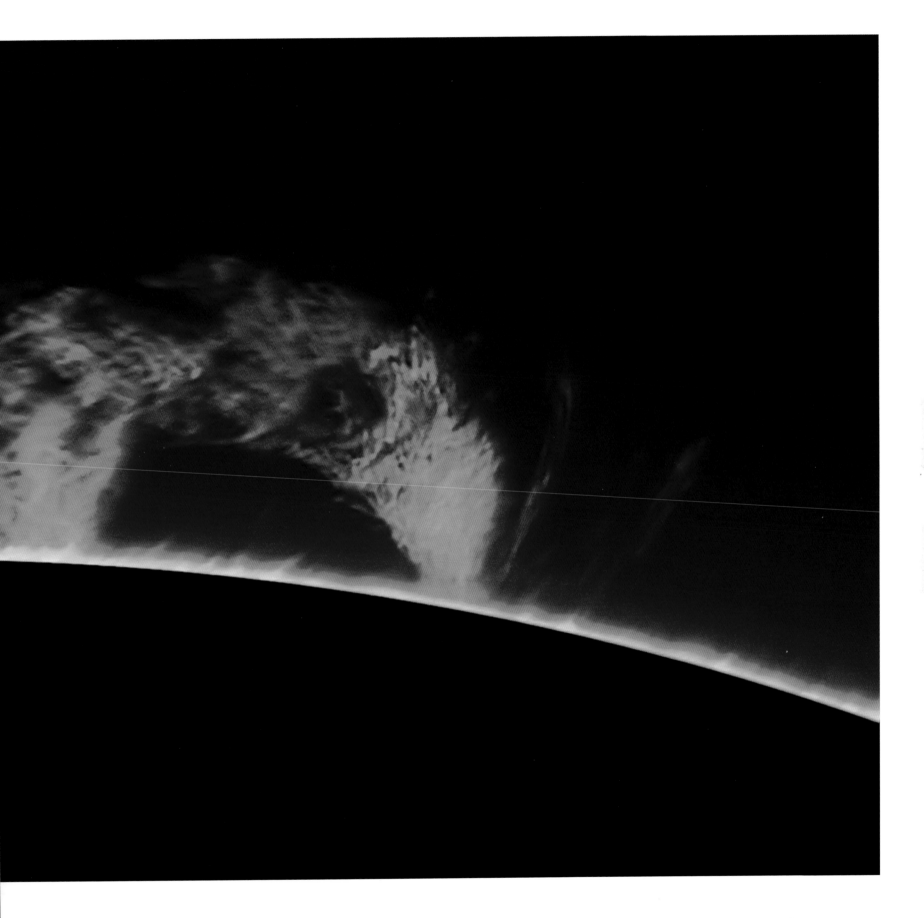

## DAMIAN PEACH (UK)

### Saturn at Opposition
[20 April 2013]

**DAMIAN PEACH:** This is Saturn close to opposition on 20 April 2013. It was taken from Mount Olympus in Cyprus at 1900m above sea level under near perfect conditions. Despite Saturn being only 38 degrees altitude, a very clear view of the planet was obtained, showing many fine details within the rings and atmosphere.

**BACKGROUND:** This incredibly sharp portrait brilliantly captures the jewel of our solar system, revealing the subtle banding around the orb that results from the planet's weather. It also shows the exquisite gradation of brightness and colour in the planet's rings with the ultra-faint inner 'D-ring' and outermost Encke gap clearly visible. The hexagonal storm at the North Pole – a scientific curiosity – shows off three of its angular kinks. Images with this much clarity challenge our ideas of what can be achieved with amateur telescopes.

**Celestron SCT telescope; Losmandy G-11 mount; ASI120MM camera; 356mm f/2.1 lens; stack of several thousand frames**

*"A beautifully executed and highly technical image of Saturn. The way the thin Encke Division is rendered around the extreme edge of the outer 'A-ring' is exquisite, a very hard feat to pull off. What I particularly love about this image is the subtle detail visible on the planet's globe. Saturn here almost looks like you could reach out and touch it!"*

PETE LAWRENCE

Λ

## JACQUES DEACON *(South Africa)*

### Lunar Occultation of Jupiter
*[2 November 2012]*

**JACQUES DEACON:** This is a special astronomical event where one of the sky's brightest objects (Jupiter) is engulfed by the Moon, only to appear again a few minutes later.

**BACKGROUND:** The word 'occultation' comes from the Latin for 'hidden'. In astronomy it is used to describe events in which one astronomical object passes behind another, as seen from Earth. This montage records the progress of Jupiter over a three-hour period as it passed behind the Moon. A close-up shot shows the moment that Jupiter disappeared behind the Moon's edge, or 'limb'. The giant planet appears tiny compared to the Moon, but only because it is over 2000 times further away from us.

**Celestron 235mm SCT telescope; Celestron CGEM mount; Sony A100 DSLR camera**

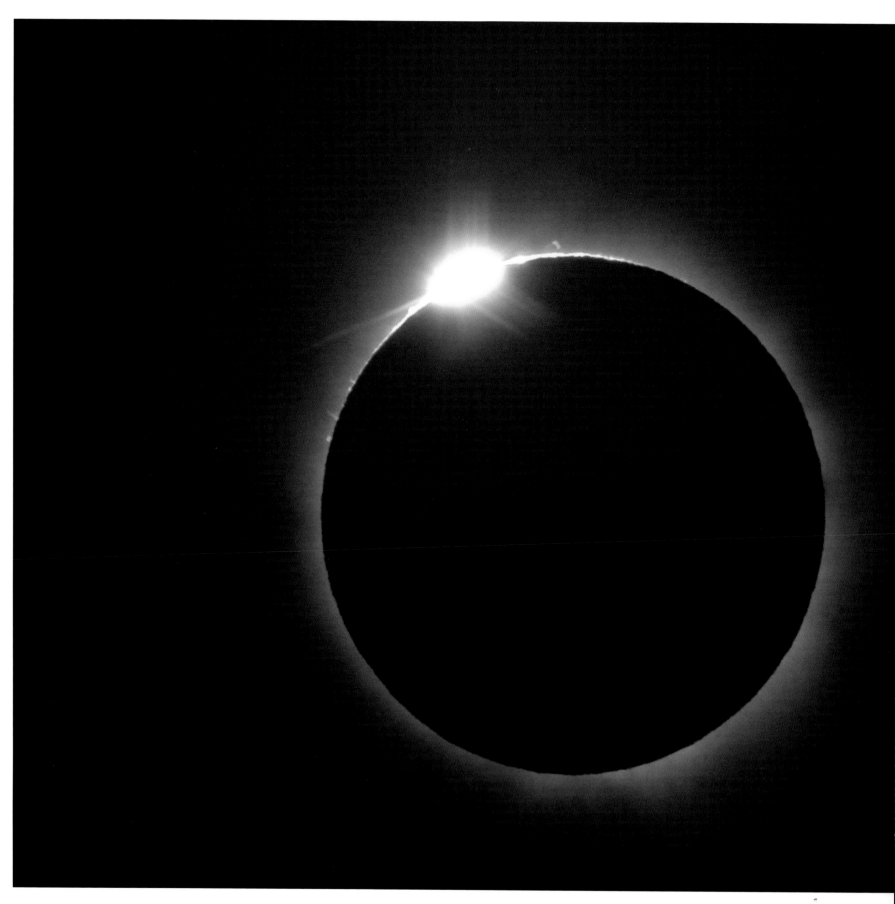

## JACK NEWTON (UK)

### The Diamond Ring
[*14 November 2012*]

**JACK NEWTON:** A most beautiful end to the solar eclipse of 2012. The tension of partly cloudy skies and thunderstorms in the days before the eclipse all added to the wonderful experience. On eclipse day, the clouds parted as if by divine intervention, to reward the efforts of all that travelled to witness the magic of a solar eclipse. The memories that this photograph rekindles will remain with me always.

**BACKGROUND:** No imagination is needed to understand how this phenomenon gets its name. A single bead of brilliant sunlight spills through a crevice on the Moon's rugged edge which creates the centrepiece of this beautiful celestial jewellery. Beside it, 'red flames', as the Astronomer Royal George Airy named them in 1842, leap from the Sun. These are solar prominences – eruptions in the atmosphere of our star. For many decades, total solar eclipses were invaluable in the scientific study of the Moon and Sun. Today, they inspire amateur astronomers to produce amazing photographs.

**Celestron Achromatic refractor; EQ3 mount; 70mm f/1.3 lens; Canon 350D camera; ISO 400; 1/1000-second exposure**

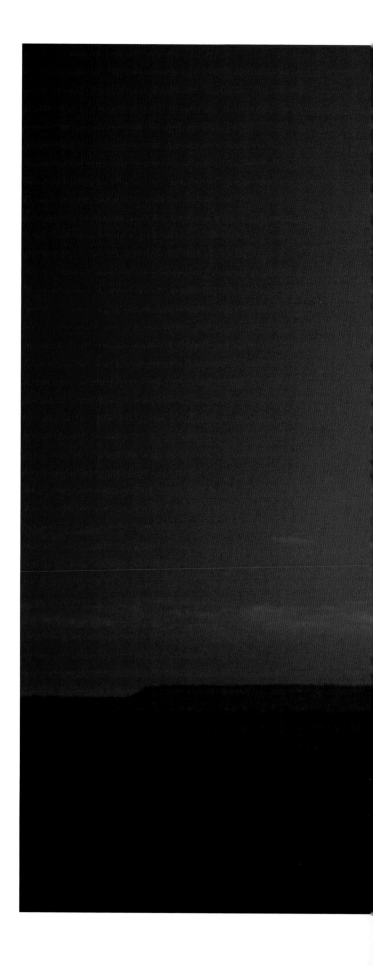

## JIA HAO (Singapore)    HIGHLY COMMENDED

### Ring of Fire Sequence
[9 May 2013]

**JIA HAO:** An annular eclipse can be boring if it happens when the Sun is high up in the sky. However, if the Sun is just on the horizon when eclipsed, the view can be as stunning as a total eclipse. I was blessed with crystal-clear skies on my expedition to Western Australia for the annular eclipse on 9 May. I managed to document the moment when the Sun rose as a golden horn, became a ring of fire, and returned to an upside down horn.

**BACKGROUND:** The Moon's orbit around the Earth is not perfectly circular, so that at different times the Moon can be slightly closer or further away than usual. If the Moon passes in front of the Sun when it is at its furthest point, it will appear to be too small to entirely cover the solar disc. This is an 'annular eclipse' in which a ring, or annulus, of the Sun remains visible. This composite shot shows the progress of an annular eclipse in May 2013. Close to the horizon the distorting effects of Earth's atmosphere can also be seen.

**Canon 5D Mark II camera; Canon 70–200mm f/4 lens plus 1.4x extender at f/5.6; ISO 200; 1/125–1/8000-second exposures**

*"I like the glowing progressive rings of fire in such a hot-looking sky."*
MELANIE GRANT

*"It is really hard to pull off a good shot of an annular eclipse of the Sun but the photographer has done a spectacular job here. This is a really great image because it uses the natural conditions and dimming of the Sun to help reveal this event. "*
PETE LAWRENCE

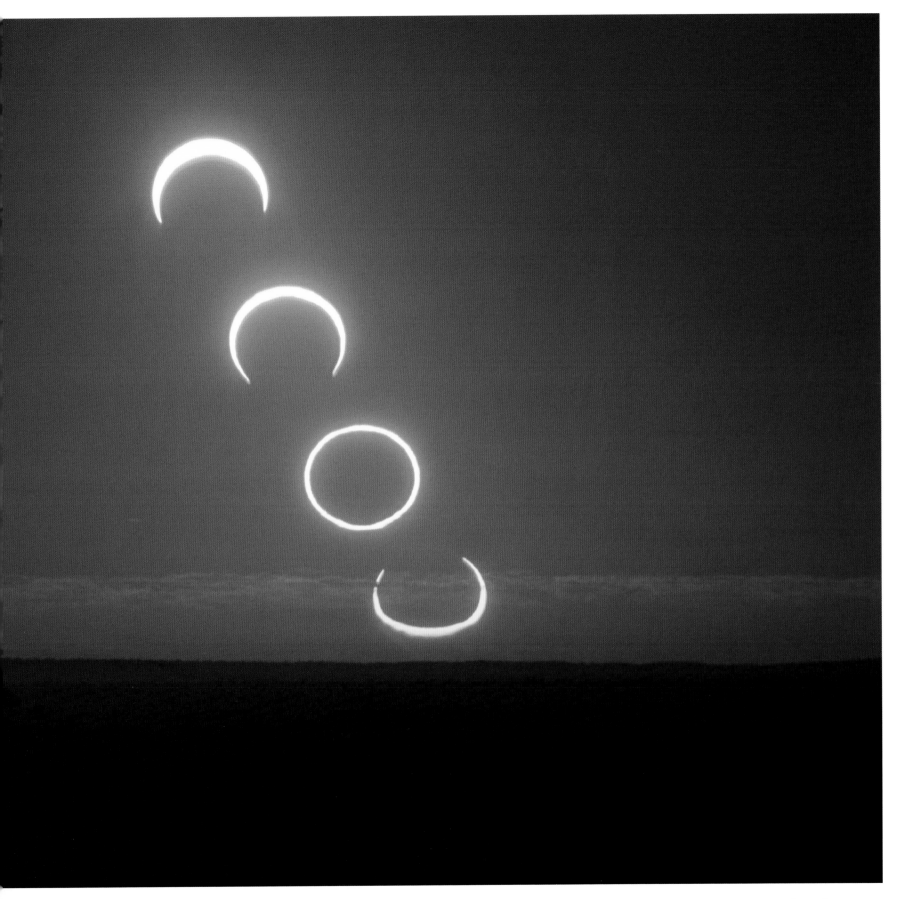

## MAN-TO HUI (China)                    *WINNER*

### Corona Composite of 2012: Australian Totality
[*14 November 2012*]

**MAN-TO HUI:** It took me two months to process all the images to achieve this relatively satisfactory corona composite result. This is the longest image processing work I have ever experienced. I did not push very hard to extract the very subtle details in the corona, but did slightly to reconstruct the view observed by the naked eye as vividly as I could. I spent a lot of time admiring the corona; it is beyond my description.

**BACKGROUND:** This image is a demonstration of both precision timing and rigorous post-processing. It gives the viewer a window onto the elusive outer atmosphere of the Sun – the corona. A natural dimming of the Sun's blinding brightness, courtesy of the Moon, reveals the ghostly glow of gas that has a temperature of one million degrees Celsius. For centuries total solar eclipses were the only way to study this hidden treasure of the Sun. By photographing this event, which lasted merely two minutes, the breathtaking experience of viewing a total solar eclipse is captured indefinitely.

Canon 50D camera; Canon 70–200mm f/4 lens at 200mm; ISO 100;
81 x 1/500–4-second exposures

*"The delicate wisps of sunlight peering behind the silhouette of the Moon
have a frailty that speaks of the unique beauty of our solar system."*

MELANIE VANDENBROUCK

*"A beautiful composition of light spikes."*

MELANIE GRANT

*"There are such delicate coronal structures in this amazing image. A total
eclipse of the Sun is a dramatic event to witness. Capturing the view with
a camera is very difficult but here the photographer has done a superb job.
What is incredible with this image is that looking at it from a distance does
convey how the corona looks visually, while examining it close up shows
some amazing magnetic structures."*

PETE LAWRENCE

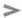

## NICK SMITH *(UK)*

### Ptolemaeus-Alphonsus-Arzachel
*[8 September 2012]*

**NICK SMITH:** This striking trio of craters is the first formation I can recall observing on the Moon as a young child.

**BACKGROUND:** Free from erosion by wind or rain, the Moon's surface preserves a record of meteorite impacts and volcanic activity dating back almost to its formation 4.5 billion years ago. Here, ancient craters are overlaid by more recent impacts and their floors are filled with solidified lava.

**Celestron C14 telescope; CGE mount; Lumenera Infinity 2-1M camera**

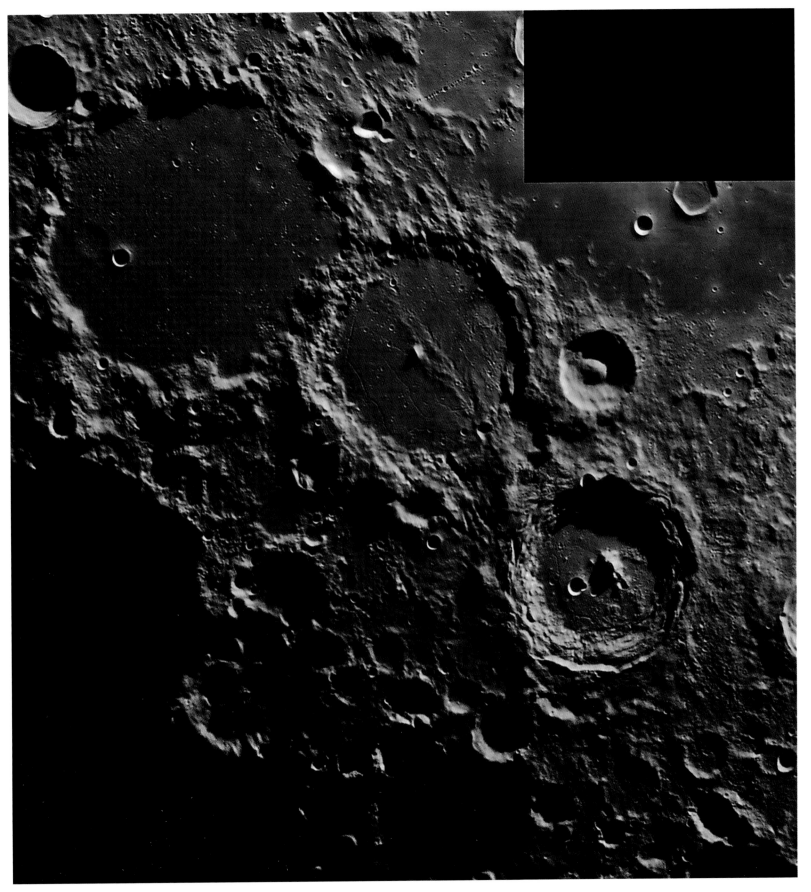

## PAUL HAESE *(Australia)*

### Solar Max
[*12 March 2013*]

**PAUL HAESE:** During our summers in South Australia the heat can be difficult for equipment and people alike. This day the temperature rose to 39 degrees Celsius. It was worth the effort though to obtain nice data like this. It is certainly one of the sharpest images I have taken of the Sun which is why I selected this shot for the competition.

**BACKGROUND:** This full disc image of the Sun is a visual feast. Looping filaments can be seen on the face and edge of the Sun. These features are known as prominences and are perfectly contrasted against the background sky. The spectacle is topped off with the seething surface of the Sun, pockmarked all over with sunspots. These features cannot be seen with the naked eye, but by tempering the Sun's intense light with an appropriate filter, the glare disappears and beautiful turmoil is unveiled.

**Lunt 80 LSHa telescope; Celestron CGE mount; Point Grey Research 2.8mp Grasshopper Express camera; 9 panel mosaic**

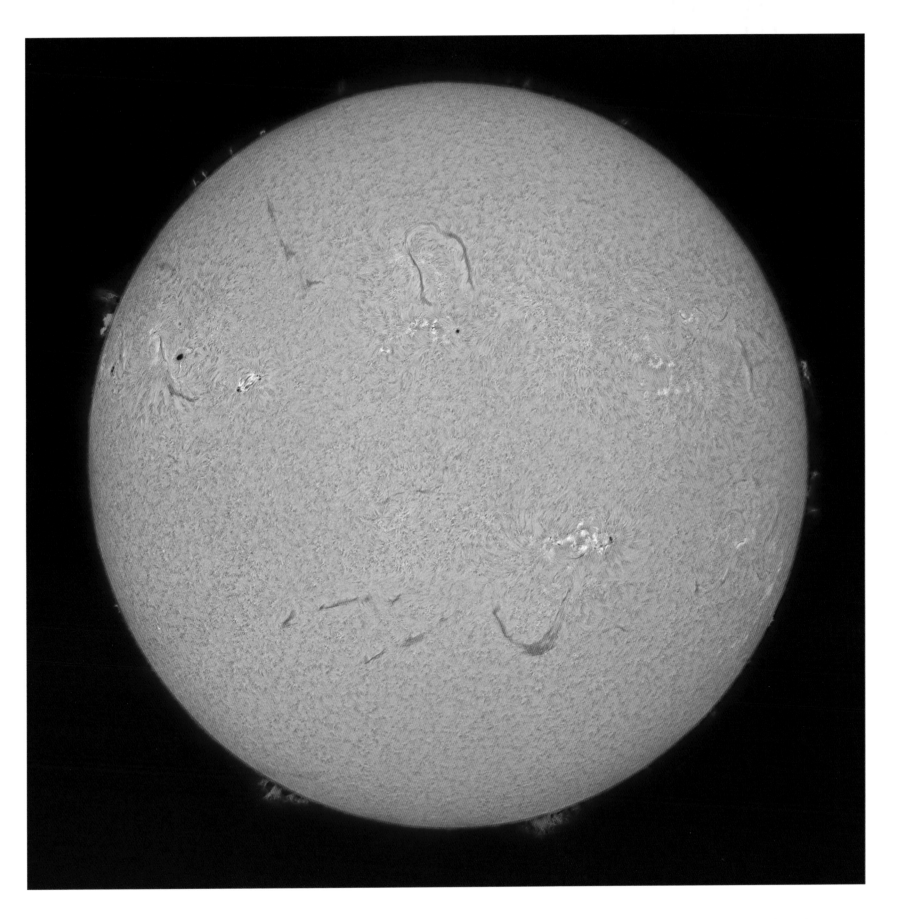

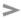

## SAM CORNWELL (UK)

### Venus Transit, Foxhunter's Grave, Welsh Highlands
[6 June 2012]

**Original competition category: best newcomer**

**SAM CORNWELL:** I am a complete amateur with regards to astrophotography. I saw the Venus transit of 2012 as a great opportunity to attempt to photograph one of the rarer spectacles of the Solar System. I took a group of friends and my camera equipment to the highest ground I knew locally, Foxhunter's Grave in the Brecon Beacons. We arrived at about 2am to set up. It was cold, raining, windy and cloudy. Within a couple of hours the area had filled up with 'real astronomers' who knew what they were doing. I felt like such a novice, but got stuck right in with my lens trained on the horizon where the Sun would be appearing. I thought I had missed the whole thing but on closer examination I could see Venus towards the edge of the Sun – a brilliant moment! It was truly one of the most amazing sights I have ever seen.

**BACKGROUND:** For those lucky enough to see it, the transit of Venus was one of the astronomical highlights of 2012. As the Planet took just six hours to cross the face of the Sun, cloudy weather was a potential disaster for observers – the next transit will not take place until 2117. Here, the final moments of the transit are revealed by a chance gap in the clouds, allowing the photographer to capture the picture of a lifetime. Extreme care should always be taken when photographing the Sun as its heat and light can easily cause blindness and damage digital cameras. Specialist solar filters are available to allow photography and observations to be carried out safely.

Canon 5D Mark II camera; 100–400mm f/4 plus 1.4x extender lens; ISO 50; 1/8000-second exposure

*"This is such a dramatic shot. I love the way Venus seems to make a notch in the edge of the Sun – we won't see this again until 2117."*
MAREK KUKULA

*"Anticipation is palpable in this picture. I like the sense of mystery. It is very atmospheric in the way the Sun appears behind the clouds and Venus gracefully appears on the edge of the solar disc."*
MELANIE VANDENBROUCK

*"Who said clouds are bad? It is the clouds that make the shot and convey the story. Their texture and lighting is fantastic – it looks like the Sun is nestling in cotton wool! The story comes from the difficulty the UK had in seeing this rare event – most were completely 'clouded out'. What a fantastic record this is of the last transit of Venus we will see in our lifetime."*
PETE LAWRENCE

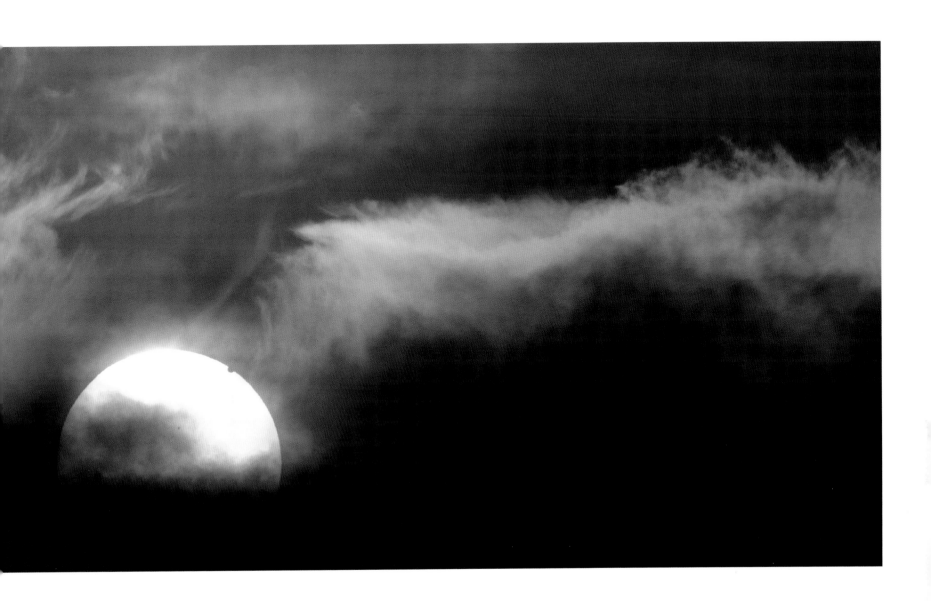

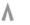

**JACOB MARCHIO** *(USA)*, **AGED 14**

### The Waxing Gibbous Moon
[*22 December 2012*]

**Original competition category: young astronomer**

**JACOB MARCHIO:** This photo is a stack of multiple single photographs taken in sequence.

**BACKGROUND:** Here, the Moon seems to be emerging from the interplanetary darkness. The photographer has beautifully captured the contrast between the dark lava-filled lunar 'seas' and the mountainous southern highlands.

Nikon D3100 camera; 500mm f/1.4 lens; ISO 400; 1/500-second exposure

## PAOLO PORCELLANA *(Italy)*

### ISS Transit
[*16 March 2013*]

**PAOLO PORCELLANA:** A lucky shot of the transit of the International Space Station (ISS) over the Sun, captured in H-alpha from my backyard at a focal length of 1400mm. I prepared the telescope a few hours before to be sure I was ready – the sky was clear but visibility was bad due to the wind. When I was thinking I had lost it, there it was; in the blink of an eye I could capture only four frames of the ISS. I am very happy as all my past attempts just produced blurred spots.

**BACKGROUND:** Here, four rapid exposures capture the fleeting passage of the International Space Station across the face of the Sun. Travelling at around 8km per second and at 420km above the Earth, the ISS is dwarfed by the scale and power of our local star.

Vixen ED100SF telescope; HEQ6 Pro mount; 100mm lens; PTG Chameleon Mono camera

## ALEXANDRA HART (UK)                                    WINNER

### Ripples in a Pond
[16 February 2014]

**ALEXANDRA HART:** Every moment I see the Sun through the telescope
a new scene takes my breath away. This day the view was exceptional
with a beautiful filament extending over the limb like a thin veil, together
with the massive active region AR11974. The active region resembled the
imprint created when stones hit the surface of a pond, with the magnetic
filaments as the ripples.

*Holmes Chapel, Cheshire, UK*

**BACKGROUND:** The Sun's boiling surface curves away beneath us in this
evocative shot, which powerfully conveys the scale and violence of our
parent star. The tortured region of solar activity on the left could swallow
up the Earth several times with room to spare. The photographer's
comparison with stones dropped into a pond is an apt one: the Sun's
outer layers do indeed behave as a fluid, but one that is constantly
twisted and warped by intense magnetic forces.

**TEC140 refractor; EQ6 Pro mount; Solarscope DSF 100mm f/18 lens;
PGR Grasshopper 3 camera**

*"You get a real sense of the Sun's seething, boiling surface in this photo.
A great reminder of the violent nature of our local star."*

MAREK KUKULA

*"The textures in this image are incredible. You really get a sense that there
are vast looping arcs of plasma leaping up and around the active region on
the left. I also love the way the patterns in the chromosphere draw your eye
towards the activity."*

WILL GATER

*"Amazingly detailed high resolution shot of the Sun's turbulent
chromosphere. The real achievement here is to show an active region
that looks three-dimensional. Brilliant image."*

PETE LAWRENCE

*"This image is unusual as it really gives a 3D impression of the Sun
in a 2D image. I feel we could jump in."*

MAGGIE ADERIN-POCOCK

*"There is a great texturing in this close-up view of the Sun, literally
sculpting the picture-plane of the photographic composition."*

MELANIE VANDENBROUCK

*"I love this swirling mass of fire and energy. A breathtaking example
of the Sun's power."*

MELANIE GRANT

*"This must be one of the most dramatic images we've ever had —
the turbulent magnetic forces that drive the Sun's activity are
almost visible here."*

CHRIS LINTOTT

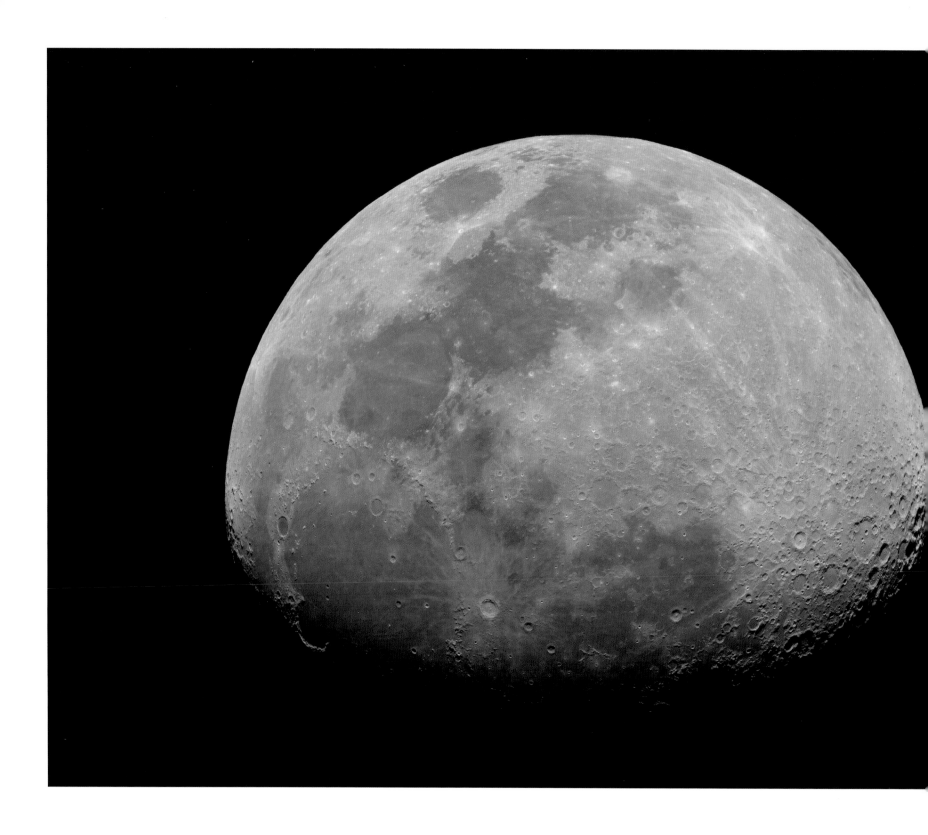

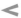

## IGNACIO DIAZ BOBILLO *(Argentina)*

### Zenithal Colour Moon
*[16 August 2013]*

**IGNACIO DIAZ BOBILLO:** This image of the Moon is unusual, not only because of its emphasized natural colours, but also by the way the acquired data was processed. Following the workflow of a typical deep space image, the 100 RAW snapshots were calibrated, registered, stacked, and post-processed, using powerful deep-space processing software. By exploiting the high contrast features of the lunar surface, the stack was precisely aligned from the 'skyline' of the limb, to the terminator.

*General Pacheco, Buenos Aires, Argentina*

**BACKGROUND:** Stacking multiple exposures allows a clear view of the Moon's surface, with highly defined craters. Our naked eye sees the Moon in shades of grey; the enhanced saturation (commonly used by astrophysicists) brings out vividly its muted natural colours to give clues about its geology. The light orange shows areas rich in iron, while the blue indicates the presence of titanium. Fresh impacts from meteors and asteroids are shining white. In this beautifully balanced picture, the crispness of the Moon's upper edge (or limb) is juxtaposed with the softly waning terminator, the boundary between day and night, where the Sun rises or sets.

AP130GT with 1.8x Barlow telescope; Losmandy G11 mount; Canon 1000D camera; 1500 mm f/11.5 lens; ISO 400; 100 x 1/160-second exposures

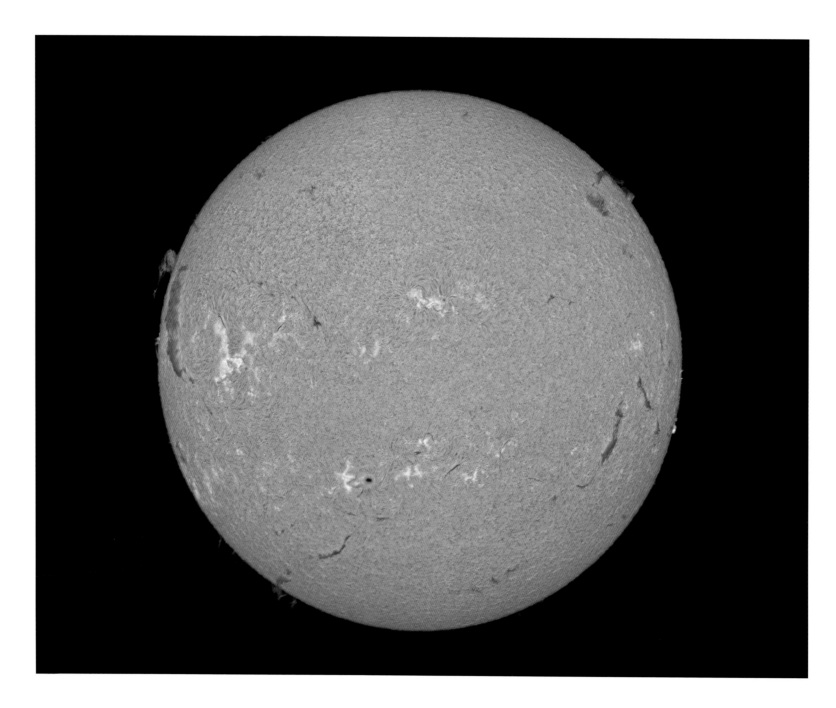

Λ

## ALEXANDRA HART (UK)

### Majesty
[22 September 2013]

**ALEXANDRA HART:** Certainly one is reminded of the majesty of our star, the life-giver of all, when encountering a sight such as this. The view through the eyepiece that day was the most beautiful I have ever seen, with many filaments extending over the limb. Who wouldn't want to share this with everybody?

*Holmes Chapel, Cheshire, UK*

**BACKGROUND:** The sight of the full disc of the Sun is put into perspective when realising that around 109 planets the size of Earth can be lined up across the Sun's equator. To be able to capture the detail seen here a H-alpha filter is needed to act like a very narrow light gate, allowing only a small fraction of the Sun's energy through the telescope to the camera.

TEC140 refractor; EQ6 Pro mount; Solarscope DSF 100mm f/9 lens; PGR Grasshopper 3 camera

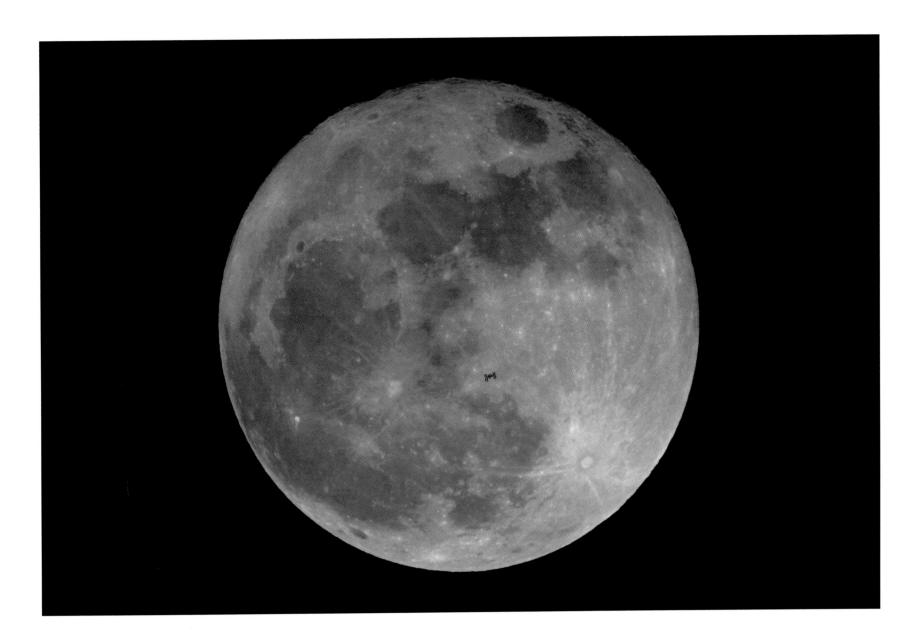

Λ

## DANI CAXETE *(Spain)*

### ISS Lunar Transit
[*17 December 2013*]

**DANI CAXETE:** This image captures the smallest full Moon of 2013, and in front of it is the International Space Station, orbiting at 28km per hour at a distance of 500km from the photographer.

*Madrid, Spain*

**BACKGROUND:** The Earth's two largest satellites, one artificial and the other natural, line up in this split-second shot as the International Space Station speeds across the face of the Moon. The idea of an artificial satellite orbiting the Earth with a human crew on board dates back to American author Edward Everett Hale's 1869 science fiction story 'The Brick Moon'. Today the ISS has a permanent crew of six, drawn from spacefaring nations around the world.

**Long Perng ED80 telescope; 550mm Barlow 2x lens; Nikon D7000 camera; ISO 1000; 1/1000-second exposure**

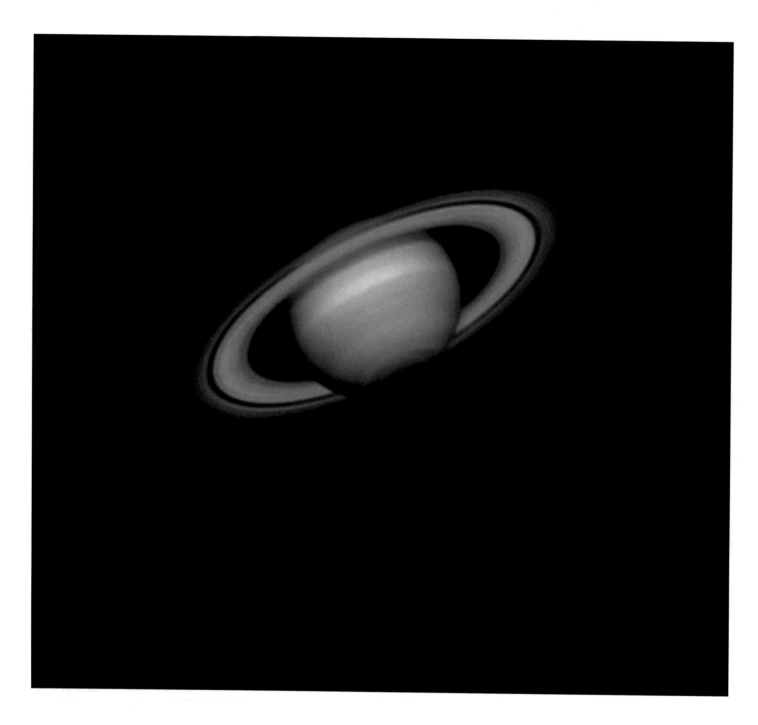

## PETER RICHARDSON (UK)

### Saturn from Somerset, April 2014
[10 April 2014]

**PETER RICHARDSON:** I love the planet Saturn. It was, like many others, my first view through a telescope and one of the main reasons I became hooked on imaging the heavens. This photo was especially pleasing to me due to the low altitude of 21° at time of capture.

*Bleadon, Somerset, UK*

**BACKGROUND:** This is a spectacular image of Saturn, particularly since it is incredibly challenging to photograph when it is so close to the horizon. The other gas giant planets in our solar system have rings similar to those of Saturn, made of ice and rock. However, as we can see from this beautiful image, there is definitely something extra-special about the complex rings of Saturn that make it an enchanting subject to photograph.

**LX200ACF 12-inch telescope; ASI120MM camera**

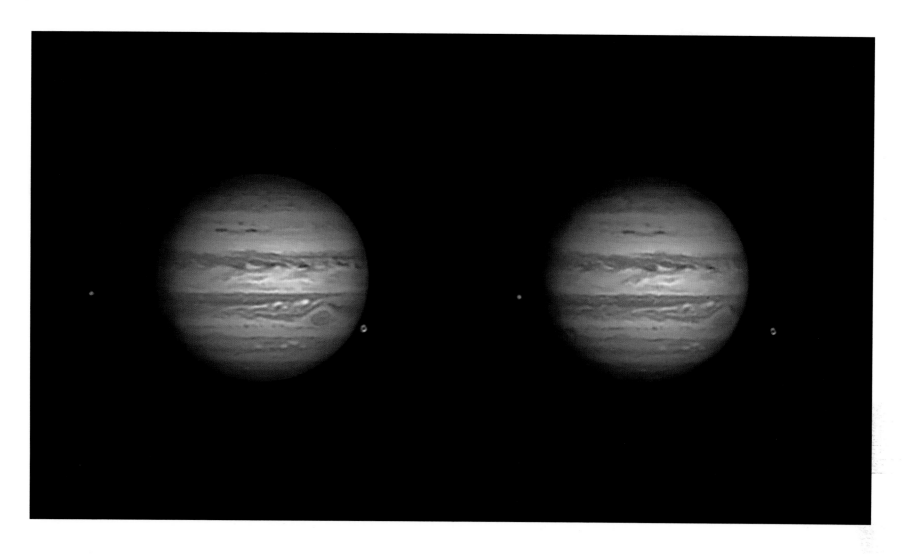

## ⋀

**TOM HOWARD** (*UK*)

### Thirty Minutes
*[16 March 2014]*

**TOM HOWARD:** I took the two images in this presentation exactly 30 minutes apart. In that time, Jupiter's Great Red Spot began to rotate out of view while Oval BA, its smaller cousin, made an appearance on the left side of the planet. The movements of the two moons, Io and Ganymede, also serve to demonstrate the dynamism of our largest neighbour and its system. It is this constant change – minute on minute, year on year – that makes Solar System imaging so rewarding for me.

*Crawley, Sussex, UK*

**BACKGROUND:** Despite having a diameter eleven times larger than the Earth, Jupiter spins on its axis every ten hours, more than twice as fast as our own world's daily revolution. Meanwhile, locked in the grip of the giant planet's gravity, Jupiter's moons hurtle around their parent at a dizzying rate. Placed side by side these two views of Jupiter, taken only 30 minutes apart, make this hectic motion apparent as cloud features slide around the planet and two of its moons visibly change their positions.

**Celestron Skyris 618C CCD camera**

# ASTRONOMY ✦ PHOTOGRAPHER
## OF THE YEAR

# DEEP SPACE

Photos of anything beyond the
Solar System, including stars,
nebulae and galaxies

# CONTENTS: DEEP SPACE

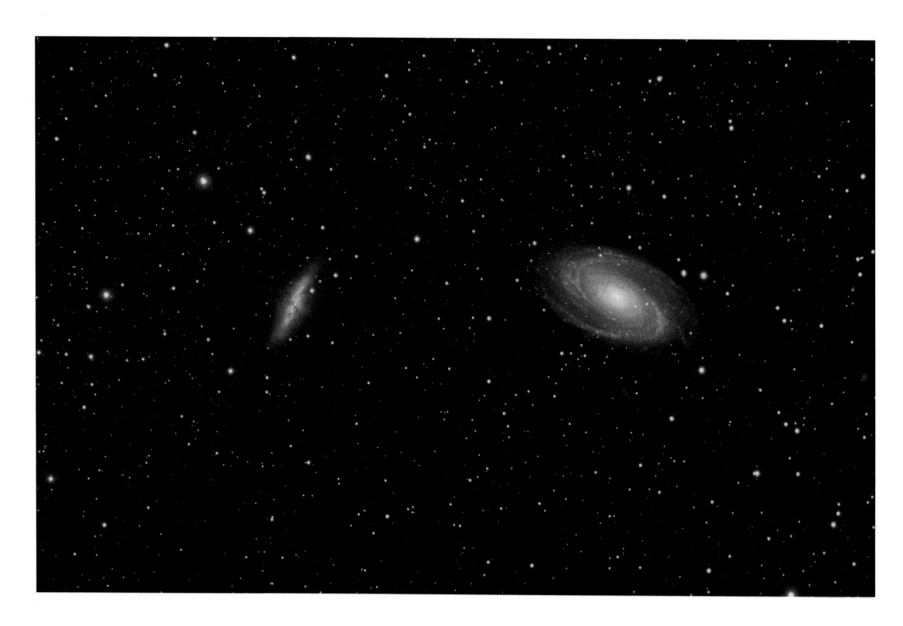

Λ

**EDWARD HENRY** *(USA)*                              *RUNNER-UP*

## Galaxies M81 and M82
[*11 February 2009*]

**EDWARD HENRY:** I got interested in astronomy at an early age and was about ten when I put two lenses together and saw what they did. I quickly learned that what I would like to do is take pictures, but knew that I wouldn't enjoy the way it had to be done then with film and manual guiding. As an older adult, when I saw the technology being created with computers and CCD cameras, I got back into it heavily and built my own observatory.

**BACKGROUND:** This composition shows two galaxies millions of light years away, each consisting of billions of stars. The galaxy on the right is a two-armed spiral galaxy, much like our own. The pink colour, enhanced by the photographer's filter, is hydrogen. The galaxy on the left is also a spiral, but is seen edge on. A spray of hydrogen is coming from its centre, forced out by a huge burst of star formation.

SBIG ST4000 colour CCD camera and SBIG ST10 XME CCD camera; TMB 130mm refractor, 10-inch Meade telescope and a Meade RCX400 12-inch telescope; two-part mosaic, 20 hours worth of exposure each

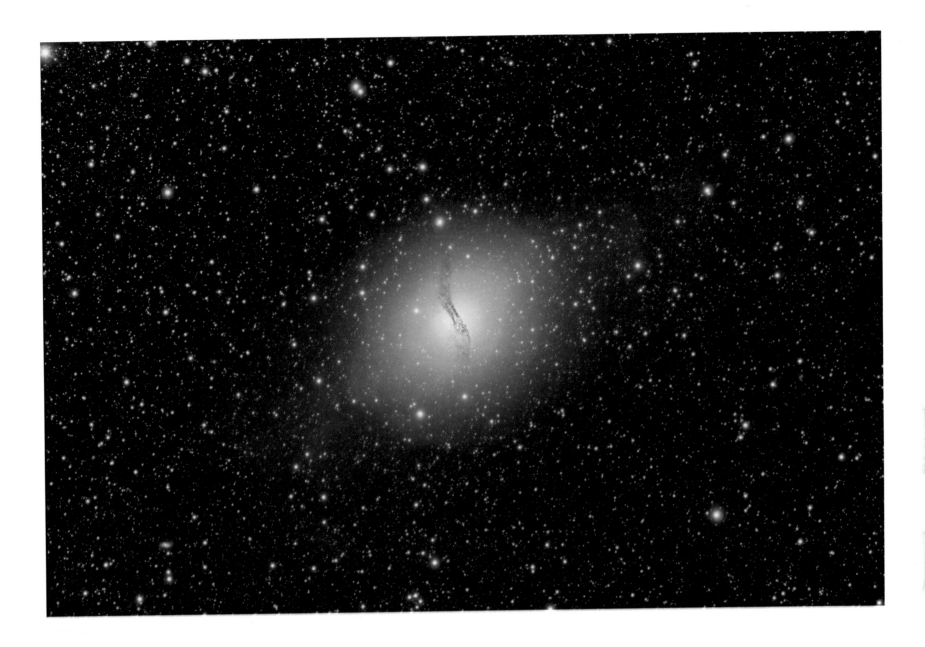

Λ

**MICHAEL SIDONIO** *(Australia)*

## Centaurus A: Ultra-Deep Field
[*8 May 2009*]

**MICHAEL SIDONIO:** Inspired by a challenge from Dr David Malin, I pointed my telescope and camera at this wonderful galaxy for three consecutive clear nights to see what was really there! This deep image reveals an enormous galaxy covering an area of sky several times larger than the full moon and the whole field is covered in ultra faint Milky Way dust.

**BACKGROUND:** All the stars seen in the foreground of this image are from our own Milky Way, with the Centaurus A galaxy in the centre, millions of light years beyond. At some time in the past Centaurus A has merged with another smaller galaxy and the debris from this collision forms the rusty brown band of dust across its middle.

**Finger Lakes Instrumentation ProLine 11002 CCD camera; Astro-Physics StarFire 152mm EDF refractor; 19.5 hours worth of exposures**

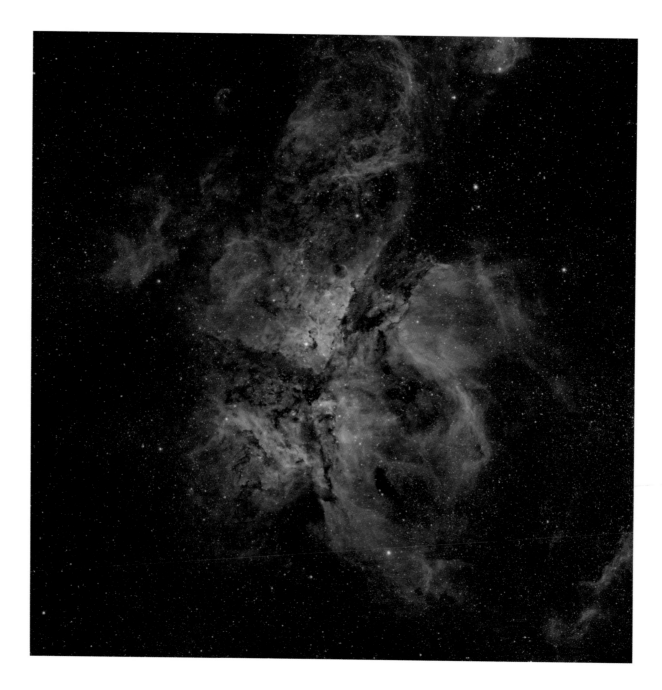

**THOMAS DAVIS** *(USA)*　　　　　*HIGHLY COMMENDED*

### Eta Carina Nebula
[*1 March 2009*]

**THOMAS DAVIS:** I had a telescope when I was young but whenever I looked through it I was somewhat disappointed by what I saw. None of the objects looked like the images in books. Therefore I started imaging, first on film and then CCD. Imaging allows me to see the wonders of the heavens in detail and colour. This image shows the massive star-forming region through narrowband filters, the so-called 'Hubble Palette'.

**BACKGROUND:** This photograph shows part of a vast nebula, or cloud of dust and gas, from which a new generation of stars is condensing. In the centre, a group of bright young stars has already ignited, burning off the surrounding gas and dust to form an enormous void in the heart of the nebula. The Eta Carina Nebula lies at an estimated distance of between 6500 and 10,000 light years away.

FLI Proline CCD camera; Astro-Physics 155mm EDF refractor; sulphur II, hydrogen alpha, and oxygen II filters; 13.5 hours worth of exposures

∧

**MARTIN PUGH** (*UK/Australia*)  RUNNER-UP

### The Veil Nebula in Cygnus
[*July–August 2009*]

**MARTIN PUGH:** I was struck by the way the blues and reds intermingle throughout this image, without manipulation. Rotated 90 degrees clockwise, the Veil Nebula transforms into an intergalactic jellyfish.

**BACKGROUND:** The Veil Nebula is the aftermath of a supernova explosion, the violent death of a star many times more massive than the Sun. Thousands of years later, the debris from the blast is still spreading out through space, in the form of this glowing cloud of gas. Explosions like this are the source of many of the chemical elements from which planets, and even life, have formed.

**Takahashi FSQ 106N 106mm apochromatic refractor; Software Bisque Paramount ME mount; SBIG STL11000M CCD camera**

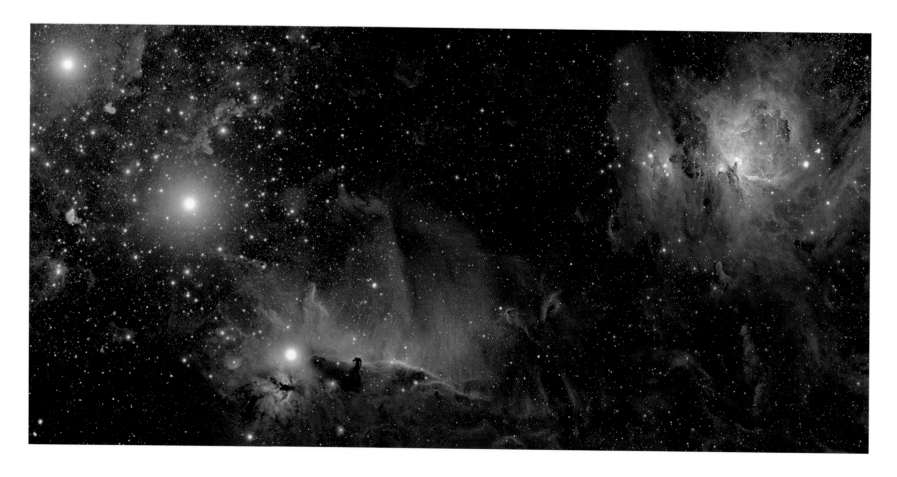

Λ

## ROGELIO BERNAL ANDREO (USA) — *WINNER*

### Orion Deep Wide Field
*[January–September 2009]*

**ROGELIO BERNAL ANDREO:** I love this image for several reasons. One, because it includes a feature easily recognizable even from light-polluted skies (Orion's belt), so anyone can 'place' this image in the sky. Another reason is because the composition resembles a complex and beautiful stellar landscape, rather than just an object placed in the middle of the frame.

**BACKGROUND:** The three bright stars of Orion's Belt, on the left of this image, are a familiar sight in the winter sky. Here, however, a long exposure reveals an epic vista of dust and gas clouds which are too faint to be seen by the naked eye. This is an immense region of space hundreds of light years across. It contains several well-known astronomical sights, including the Horsehead Nebula (bottom centre) and the Orion Nebula (top right).

**Takahashi FSQ 106 EDX 106mm refractor with 0.7x focal reducer; Takahashi EM-400 equatorial mount; SBIG STL11000 CCD camera**

*"This is a truly superb image which reveals an amazing amount of dark dust permeating the space in the direction of Orion's belt and down to his sword. The way the faint detail between the Orion Nebula and Horsehead Nebula has been brought out is nothing short of astonishing. This alien skyscape really captivates my imagination and I could look at it for hours on end!"*

PETE LAWRENCE

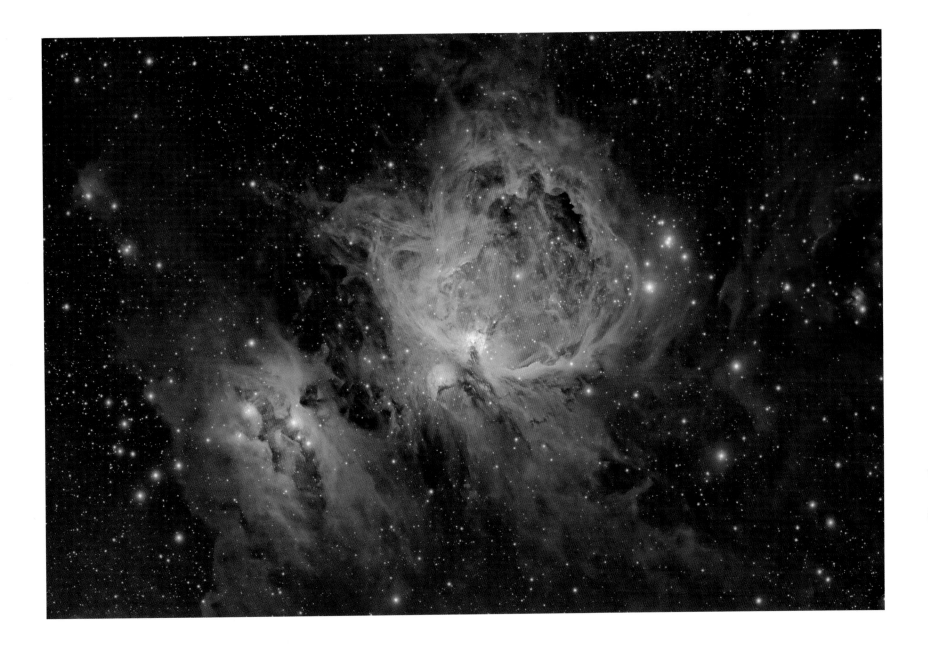

Λ

## MARCUS DAVIES *(Australia)*    *HIGHLY COMMENDED*

### The Sword and the Rose (Orion's Sword and M42)
[10 January 2010]

**MARCUS DAVIES:** Apart from its sheer beauty and astronomical significance, I imaged this object because it's quite difficult to capture properly. My goal was to render the complex colours as vividly and as faithfully as possible.

**BACKGROUND:** This cloud of dark dust and glowing gas in the Sword of Orion is the M42 nebula, a stellar nursery where new stars are being born. M42 is visible to the naked eye but a telescope reveals the full beauty of this giant star factory. The fierce radiation from newly-formed stars peels back the layers of gas, like a giant flower unfurling its petals.

**Takahashi TOA-150 150mm refractor; Takahashi EM-400 equatorial mount; SBIG STL11000M CCD camera**

## EDWARD HENRY (USA)

### The Andromeda Galaxy (M31)
[1 March 2009]

**EDWARD HENRY:** I like the way this came out. If I were going to do anything differently, I might bring out those red areas a little more … and, of course, more exposure time is always good.

**BACKGROUND:** Andromeda is one of the closest galaxies to our own Milky Way. Even so, the light from Andromeda takes 2.5 million years to reach us, so we see this galaxy as it appeared in the distant past. Like the Milky Way, Andromeda contains hundreds of billions of stars, as well as dust and gas swirling in its spiral arms. Seen from Andromeda, our own galaxy would probably look very similar to this.

**TMB 152mm refractor; SBIG STL11000M CCD camera**

## KEN MACKINTOSH (UK)

### The Whirlpool Galaxy (M51)
*[16–17 April 2010]*

**Original competition category: best newcomer**

**KEN MACKINTOSH:** I have been interested in astronomy since I was very young and took it as an option at university. My interest was very much rekindled recently when I realised (just casually browsing through flickr, in fact) how much more accessible the photography side of the hobby had become, and what good results could be achieved at not such a great cost or effort.

**BACKGROUND:** Galaxies are vast collections of hundreds of billions of stars, gas and dust bound together by gravity. M51, or the Whirlpool, is a classic example of a spiral galaxy with swirling patterns of newly formed stars lacing gracefully through its disc. A smaller, rounder galaxy is seen towards the top of this image. It is slowly colliding with its larger neighbour.

**Maxvision 127mm apochromatic refractor; EQ6 mount; modified Canon EOS 450D DSLR camera**

*"This is a lovely image of the Whirlpool Galaxy and its companion galaxy (NGC 5195). I particularly like the detail that has been captured in the faint dust lanes that can be seen silhouetted against the Whirlpool's bright spiral arms."*

WILL GATOR

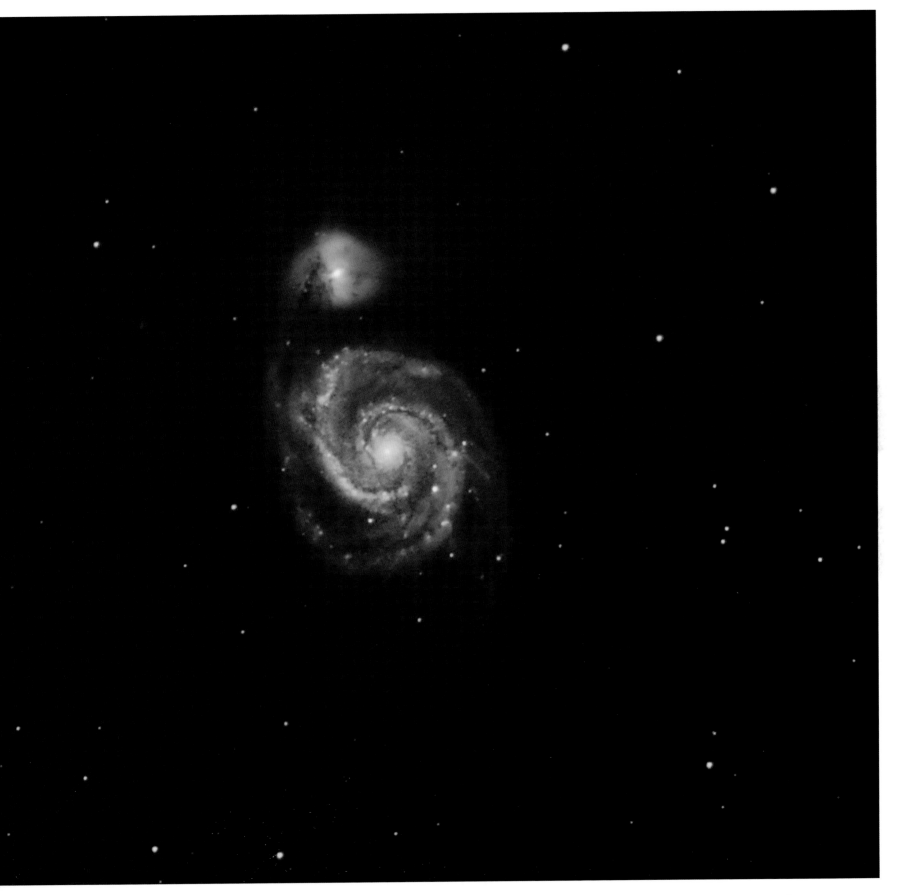

Λ

## ELIAS JORDAN (USA), AGED 15      *HIGHLY COMMENDED*

### The Pelican Nebula Up-Close
[22 June 2010]

**Original competition category: young astronomer**

**ELIAS JORDAN:** I took the photo during my 'Astrocation' (Astronomy Vacation) in New Mexico. Astronomy is just a science that excites the minds of everyone! After seeing the majestic rings on Saturn, I was hooked! Luckily, I was encouraged by my parents to continue to advance my knowledge in the subject, and thanks to their support, I was able to combine two of my favourite hobbies, photography and astronomy.

**BACKGROUND:** The Pelican Nebula is part of a huge cloud of gas and dust in which new stars are forming. Hydrogen gas heated by young stars glows pink, while dense clouds of dark dust stand out against the lighter background. A very bright star can be seen towards the bottom of the image.

**Takahashi FRC-300 300mm Ritchey-Chretien Cassegrain telescope; Software Bisque Paramount ME mount; SBIG STL11000M CCD camera**

## EDWARD HENRY (USA)

EDWARD HENRY (USA)

*RUNNER-UP*

### Leo Triplet
[*4 April 2011*]

**EDWARD HENRY:** I decided to create this image because I wanted a high-resolution shot of what is normally a low-resolution, wide-field image. This required a composite image, layering data from two different scopes, which gave me the desired effect.

**BACKGROUND:** The Leo Triplet is a group of three spiral galaxies located thirty-five million light years away. Like our own Milky Way, they are disc-like galaxies. They contain billions of stars with bright knots of gas and dark dusty lanes, which trace spiral patterns where new stars are formed. The galaxy on the left is seen edge-on, as we view our own galaxy.

356mm (14-inch) F10 Schmidt-Cassegrain telescope and TMB 130mm telescopes; STL 4020 camera

## MARCO LORENZI (Italy)

### Vela Supernova Remnant
*[5 February 2011]*

**MARCO LORENZI:** I've always been inspired by supernova remnants, in particular by their reach and their different compositions. After all, several of the building bricks of life are created during these apocalyptic events.

**BACKGROUND:** This intricate structure is the aftermath of a supernova explosion, the violent death of a star many times more massive than the Sun. It took place over 10,000 years ago. Seen against stars and gas in the disc of our Milky Way, this expanding shell of debris and heated gas now covers an area of the sky which is twenty times wider than the disc of the full Moon.

**Pentax 67 DEIF 300mm (12-inch) telescope; FLI Proline 16803 CCD camera**

*"This is a lovely picture of the Vela Supernova Remnant, so far as I know not quite the same as anything else in the sky. This splendid picture shows the details clearly. Such a pity we weren't there to see the supernova go off!"*

SIR PATRICK MOORE

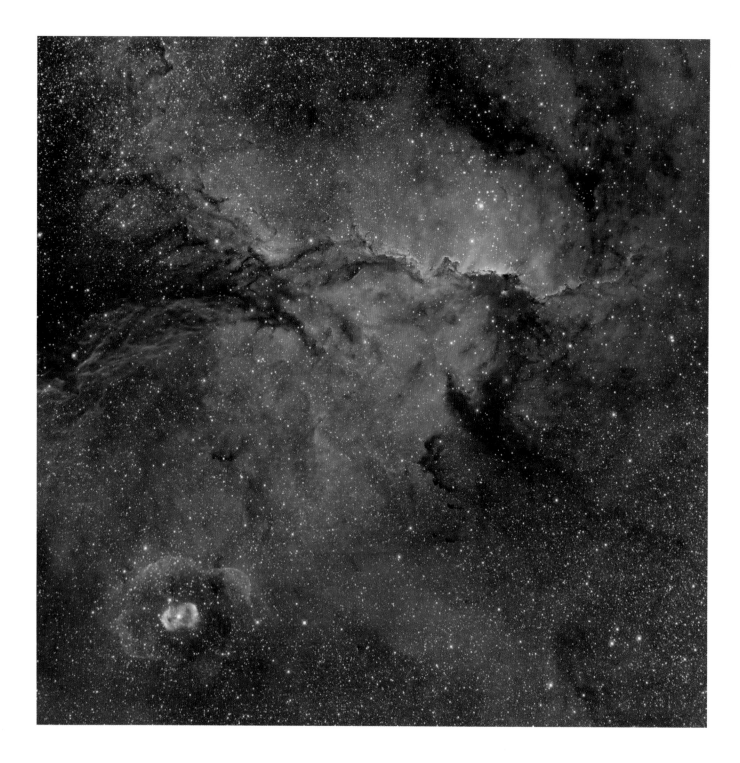

Λ

**MICHAEL SIDONIO** (*Australia*)     *HIGHLY COMMENDED*

### Fighting Dragons of Ara (NGC 6188 and 6164)
[*22 May 2011*]

**MICHAEL SIDONIO:** I wanted to showcase this beautiful piece of Ara in a fresh, new way that would highlight the amazing structures and also reveal the rarely imaged faint expanding shell around NGC 6164.

**BACKGROUND:** Powerful emissions of light and matter from hot, young stars are able to heat up and shape the clouds of gas and dust from which they form. The 'dragons' in this photograph have been shaped by the recent birth of stars much bigger and brighter than our Sun. One such star can be seen to the lower left of the image within two shells of glowing gas.

**Orion Optics 300mm (12-inch) F3.8 corrected Newtonian astrograph telescope; FLI ProLine 16803 camera**

## STEVE CROUCH *(Australia)*

### Planetary Nebula Shapley 1
[*28 May 2011*]

**STEVE CROUCH:** I've always been interested in imaging obscure objects. Shapley 1 is best known from the David Malin image of it and I wanted to try and do one at least as good. I was surprised at how well it came out which shows how much imaging technology has advanced since David took his shot in the 1980s.

**BACKGROUND:** When viewed through a small telescope, planetary nebulae like Shapley 1 resemble nearby planets in our solar system. They are, in fact, distant regions of hot, glowing gas ejected by stars as they run out of fuel at the end of their lives. The colours visible in the ring are caused by the temperature and chemical composition of the material this star has returned to its environment.

**12.5-inch RCOS Ritchey Chretien telescope; SBIG STL 6303E CCD camera**

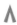

## ROGELIO BERNAL ANDREO (USA)

### Simeis 147 Supernova Remnant
[11 April 2012]

**ROGELIO BERNAL ANDREO:** Most images I've seen of this faint and large object (Simeis 147) deprive us from viewing the many other things happening around it. My goal was to produce an image that visually documents not only the main object, but also more of what's surrounding it.

**BACKGROUND:** Straddling the constellations of Auriga and Taurus, Simeis 147 is a supernova remnant, the expanding debris of a massive star which exploded around 40,000 years ago. As the wreckage continues to spread out into space it collides violently with the dust and gas between the stars, sculpting it into the glowing shells and filaments which have earned Simeis 147 the nickname 'Spaghetti Nebula'.

**Takahashi FSQ-106 EDX telescope; Takahashi EM-400 mount; 385mm f/3.6 lens; SBIG STL 11000 camera**

*"Supernova remnant Simeis 147 looks for all the world like a delicate flower in Rogelio Bernal's capture of it. The detail in the twisted filaments of gas and dust, coupled with the wide star field that surrounds it, makes it seem like you're floating next to this object in space, rather than being 3000 light years away."*
CHRIS BRAMLEY

*"This object is a supernova remnant; the remains of a large dying star which literally exploded into space. Simeis 147 is an incredibly faint and extensive object in the sky. Rogelio has done an amazing job of capturing its faint tendrils and filaments in this extraordinarily wide-field view. This is a stunning result."*
PETE LAWRENCE

*"It's an eerie feeling to look at this tangle of space wreckage and know that thousands of years ago it was once a star like the thousands of others in the image. We like to think of space as being peaceful and unchanging, but it really isn't!"*
MAREK KUKULA

## J.P. METSÄVAINIO *(Finland)*

### Cygnus
[*11 December 2011*]

**J.P METSÄVAINIO:** This is my main imaging project from the autumn of 2011. The image covers 22 x 14 degrees of sky and it has eighteen individual image panels stitched together as a mosaic. Each image was imaged three times, through narrowband filters, to show three main emission lines – hydrogen, oxygen and sulphur – as a colour image.

**BACKGROUND:** This mosaic image reveals a huge swath of the sky in the constellation of Cygnus. Huge clouds of colourful glowing gas, and lanes of dark dust stretch across the field of view. Their light is too faint to register with the human eye, but long exposure times and special filters allow us to appreciate their grandeur and scale.

**QHY9 camera; Canon EF 200mm f/1.8 lens**

ROBERT FRANKE (USA)  *HIGHLY COMMENDED*

## The Perseus Cluster – Abell 426
[*13 November 2010*]

**ROBERT FRANKE:** I chose this composition because I like the left to right flow and wide variety of galaxies. Although this is no Hubble Deep Field, over a thousand galaxies are visible.

**BACKGROUND:** The harder you look, the more you see in this astonishing view of deep space. The points of light are relatively nearby stars in our own Milky Way galaxy. Far beyond them, at a staggering distance of almost 250 million light years, lie the myriad galaxies of the Perseus Cluster, also known as Abell 426. The cluster contains thousands of individual galaxies. Some are spirals like the Milky Way, while others are giant, smooth elliptical systems. Together they form one of the largest structures in the Universe.

**RCOS 12.5-inch Ritchey-Chrétien telescope; Paramount ME mount; SBIG STL-11000 camera; 15-minute exposure**

*"This extraordinary image is packed full of galaxies of varying shapes and sizes. It's incredible to think that each one of these smudges of light contains millions, if not billions, of stars."*
**WILL GATER**

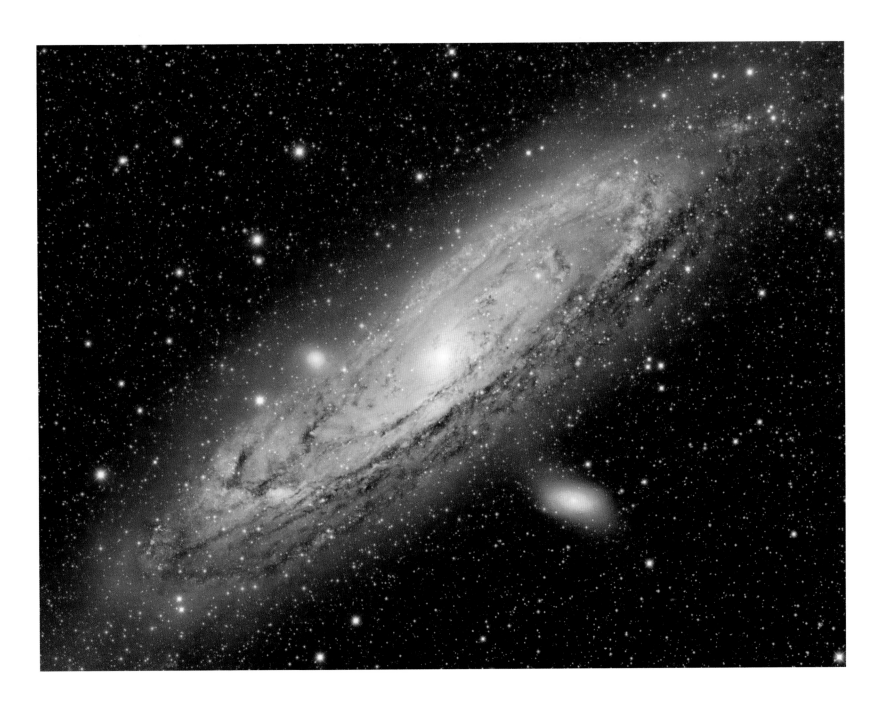

**AGGELOS KECHAGIAS** (*Greece*)

### The Andromeda Galaxy
[*17 December 2010*]

**AGGELOS KECHAGIAS:** I have taken this image from a very special mountain at 1420 metres above sea level. It is called Mount Parnon and it is near Sparta, Peloponnese, in Greece. I go there with my friends every month to bring back some wonderful photos and I think I have succeeded with this image of M31.

**BACKGROUND:** The Andromeda Galaxy is one of our closest galactic neighbours. Like a giant frisbee, it fills the frame with its swirling spiral arms, composed of billions of stars mixed with dark lanes of dust and gas. New stars are being born in the clouds of glowing pink hydrogen gas.

**Takahashi FSQ 106 f/3.6 telescope; QHY 9 mount**

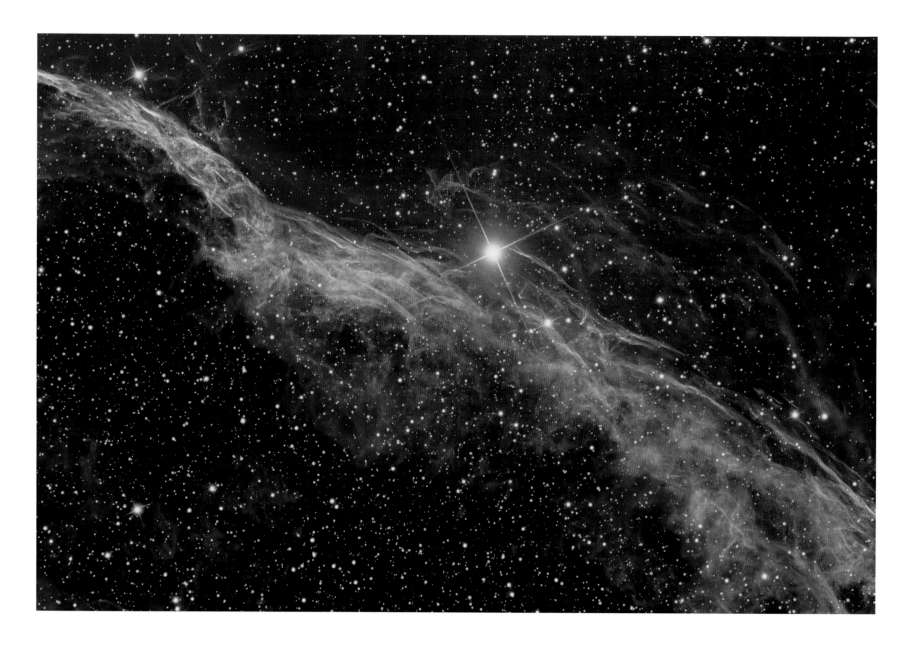

## ROBERT FRANKE (USA)          *HIGHLY COMMENDED*

### NGC 6960 – The Witch's Broom
[*9 September 2010*]

**ROBERT FRANKE:** This synthetic colour image was created with Ha and OIII filters. These narrowband filters greatly increase the detail while giving a reasonable representation of the nebula's colour. The Veil Nebula is located in the constellation Cygnus, at a distance of about 1400 light years.

**BACKGROUND:** Part of the Veil Nebula, the 'Witch's Broom' is the glowing debris from a supernova explosion – the violent death of a massive star. Although the supernova occurred several thousand years ago, the gaseous debris is still expanding outwards, producing this vast cloud-like structure.

RCOS 12.5-inch Ritchey-Chrétien telescope; Paramount ME mount; SBIG STL-11000 camera; 15-minute exposure

*"This is a wonderfully delicate image of intricate tendrils of enriched stellar material returning to interstellar space, following the explosion of a star thousands of years ago. Capturing the light from this faint, diaphanous source in such rich detail is really impressive."*

OLIVIA JOHNSON

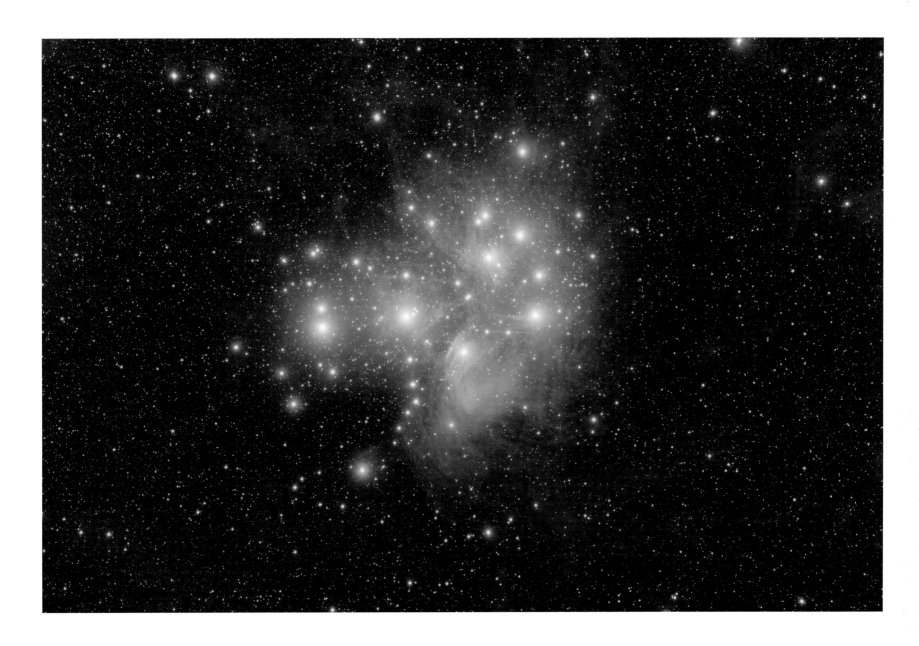

∧

## TOM O'DONOGHUE *(Ireland)*

### The Pleiades Star Cluster in Taurus
[*29 October 2011*]

**TOM O'DONOGHUE:** I love the way the star cluster is set against the background Taurus molecular cloud, with the gorgeous swaths of blue reflection nebulosity passing in front of the stars.

**BACKGROUND:** The stars of the Pleiades are easily visible to the naked eye but this long-exposure image shows them in a startling new light. We see that the familiar star cluster is embedded in a huge cloud of interstellar dust, which catches and reflects their blue-white light. Further from the stars the dust appears dark and cold.

**Takahashi FSQ 106N telescope; EM200 Takahashi mount; Atik 11000 CCD camera**

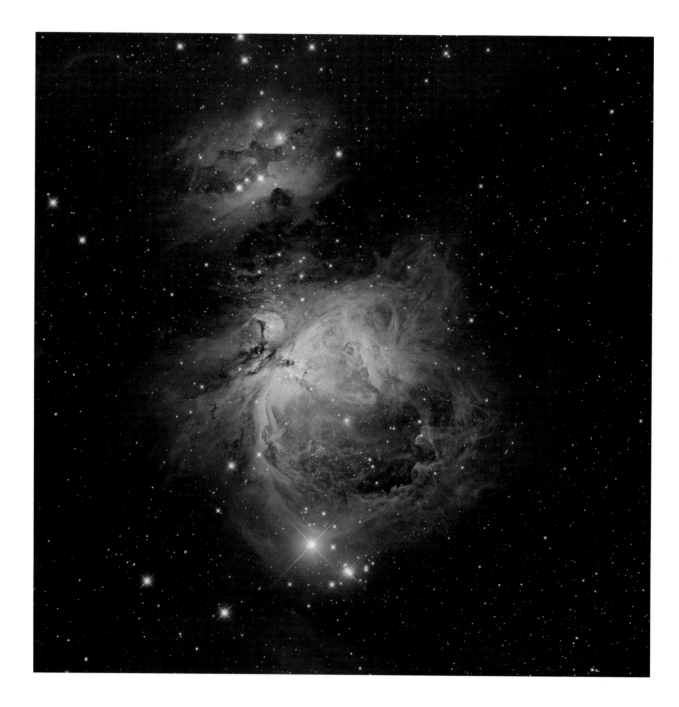

## MICHAEL SIDONIO (Australia)

### The Smoking Sword
[24 December 2011]

**MICHAEL SIDONIO:** The Orion Nebula region is often imaged but I wanted to produce a result that was natural and subtle in appearance, looked real by being bright where it should be and actually looked like dust and gas floating in space.

**BACKGROUND:** To the naked eye the Orion Nebula appears as a small patch of hazy light among the stars. The true scale and complexity of the Orion's Sword nebula only becomes apparent when viewed through a telescope. In the centre of the nebula newly-formed stars blast their surroundings with radiation, carving out a cavity in the dust and causing the hydrogen gas to glow pink.

**Orion Optics 12-inch f/3.8 telescope; Takahashi NJP German Equatorial mount; FLI ProLine 16803 camera; 10–60-minute exposure**

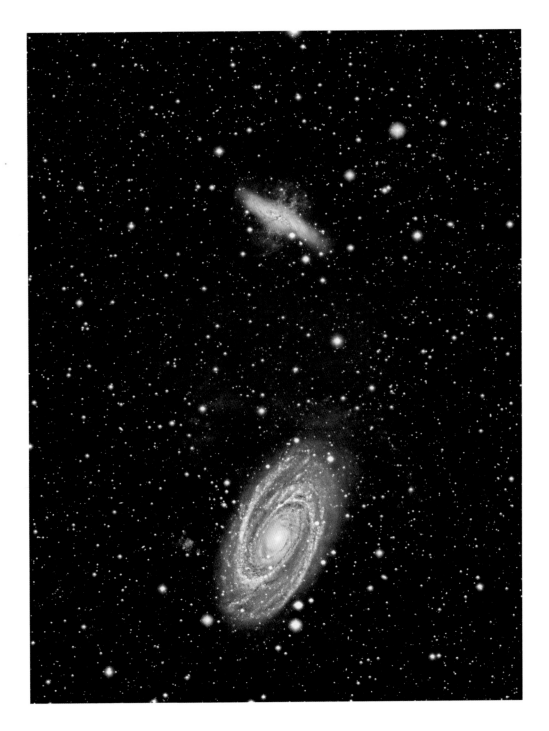

**JULIAN HANCOCK** (*UK*)

### M81–82 HaLRGB
[*26 February 2012*]

**JULIAN HANCOCK:** I have never imaged M81/M82 and was astounded by the detail I managed to capture. Not only the two galaxies but also the dwarf, irregular Holmberg Galaxy. The icing on the cake was the flux nebulosity from our own galaxy.

**BACKGROUND:** The galaxies M81 and M82 in Ursa Major (the 'Great Bear') are a popular target for astrophotographers. Like our own Milky Way, M81 is a regular, orderly spiral. Its companion M82 is a 'starburst galaxy' in which new stars are forming at a furious rate. The red tendrils of hydrogen gas extending from the galaxy are being blasted from its centre by the violent processes occurring there.

**William Optics FLT 110mm refractor; EQ6 mount; QSI 583WSG CCD camera**

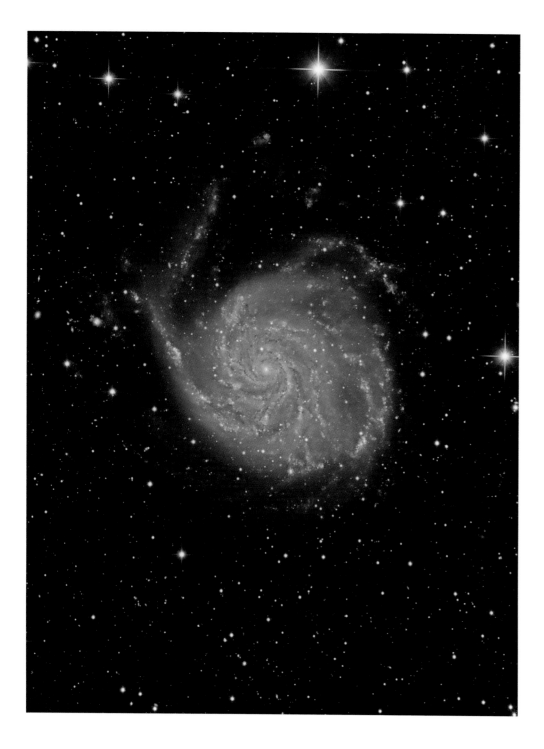

&lt;

**OLEG BRYZGALOV** *(Ukraine)*

### M101 – The Pinwheel Galaxy and Supernova SN 2011fe
*[26 May 2012]*

**OLEG BRYZGALOV:** Pictures like this show the beauty and perfection of the structure of our universe. Between the ideal logarithmic spiral arms of the galaxy shines a distant supernova in navy blue. We see death and birth.

**BACKGROUND:** Most of the individual stars in this image are part of our own Milky Way. Far beyond, the billions of stars that make up the Pinwheel Galaxy appear blended together as swirling haze of light. In 2011 one of the Pinwheel's stars suddenly came to prominence when it exploded as a supernova. For a few weeks the dying star (just to the left of the large spiral arm) was visible across a distance of more than 20 million light years.

Newtonian 10-inch reflector; WS-180 mount; 1200mm f/4.7 lens; QSI-583wsg camera; 7–15-minute exposure

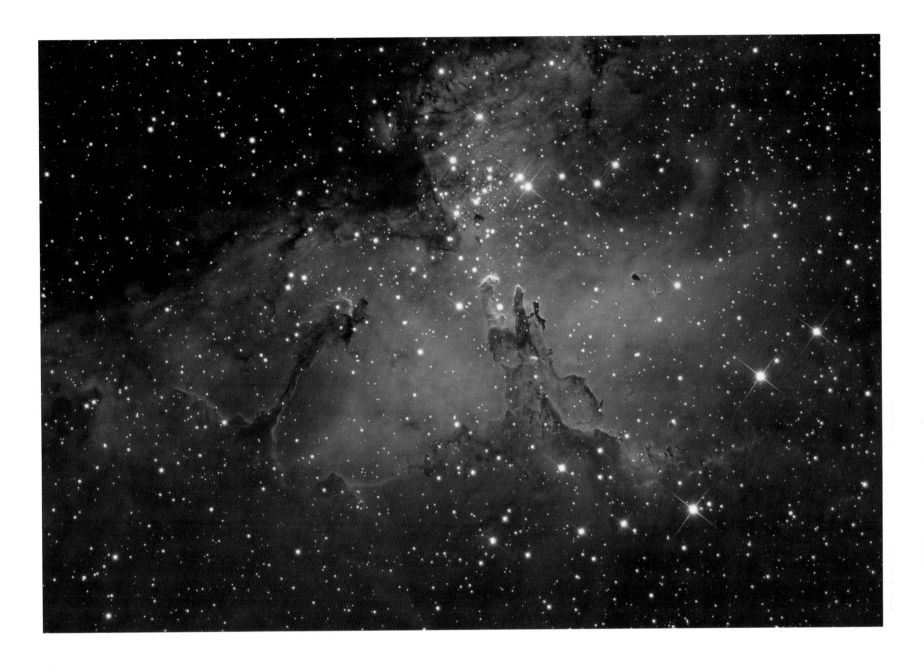

## BILL SNYDER (USA)

### M16 – Eagle Nebula Hybrid Image
[27 June 2012]

**BILL SNYDER:** I took this because I wanted a wide-field image of one of the more famous images produced with the Hubble Telescope, the 'Pillars of Creation'.

**BACKGROUND:** The Eagle Nebula was made famous by the Hubble Space Telescope's 'Pillars of Creation' image in 1995. It is a site of active star formation, in which dense clumps of gas and dust are collapsing under gravity to form new generations of stars. Towards the top of the image harsh radiation from a cluster of young stars is blasting out a cavity in the nebula. Dense knots of dust shield the material behind them, forming slender columns which stretch away from the central stars.

**TMB 130mm telescope; Atlas EQG mount; TMB 130mm lens;
Apogee U8300 camera**

**MARTIN PUGH** *(UK/Australia)*

## M51 – The Whirlpool Galaxy
[19 *June* 2012]

**MARTIN PUGH:** I was always going to be excited about this image given the exceptional seeing conditions M51 was photographed under, and the addition of several hours of Ha data has really boosted the HII regions.

**BACKGROUND:** A typical spiral galaxy, the Whirlpool or M51, has been drawn and photographed many times, from the sketches of astronomer Lord Rosse in the 19th century to modern studies by the Hubble Space Telescope. This photograph is a worthy addition to that catalogue. It combines fine detail in the spiral arms with the faint tails of light that show how M51's small companion galaxy is being torn apart by the gravity of its giant neighbour.

**Planewave 17-inch CDK telescope; Software Bisque Paramount ME mount; Apogee U16M camera**

OVERALL WINNER 2012

*"This is arguably one of the finest images of M51 ever taken by an amateur astronomer. It's not just the detail in the spiral arms of the galaxy that's remarkable – look closely and you'll see many very distant galaxies in the background too."*

WILL GATER

*"The depth and clarity of this photograph makes me want to go into deep space myself! A breathtaking look at the Whirlpool Galaxy."*

MELANIE GRANT

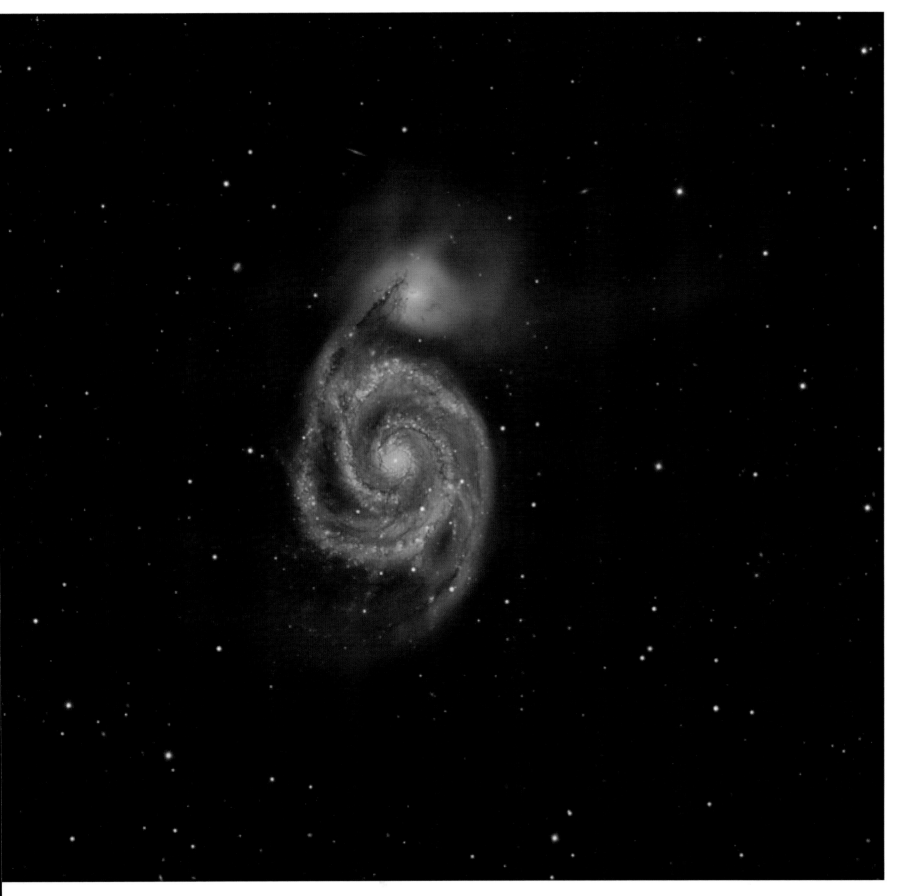

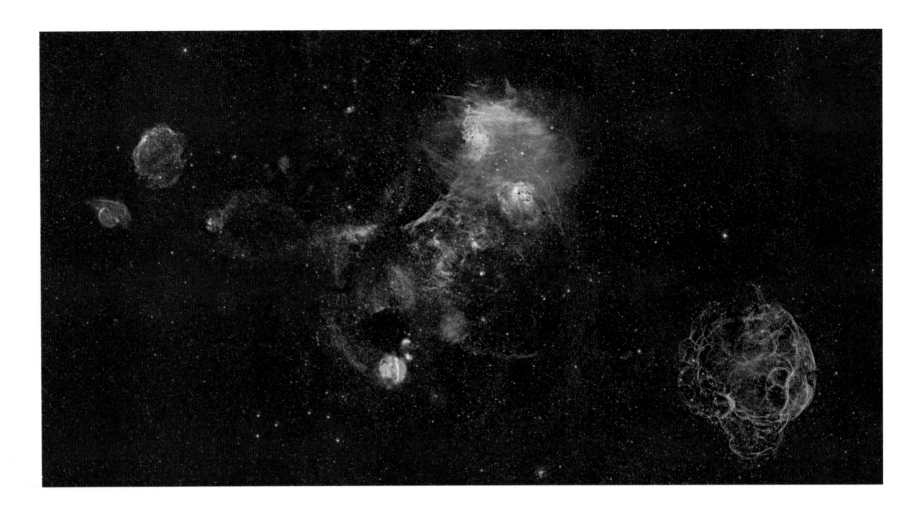

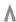 Λ

## J.P. METSÄVAINIO *(Finland)*

### Auriga Panorama
*[8 March 2012]*

**J.P. METSÄVAINIO:** This is my main imaging project from Spring 2012, just before we lost the astronomical darkness for about six months. The image covers 21 degrees of sky and has twelve individual image panels, each imaged three times through narrowband filters for a colour image. Generally mosaics need lots of work but nothing beats the final resolution. Another reason to produce wide-field mosaics is to show the true scale and orientation of the otherwise well-known objects. Even experienced astro imagers don't always have an idea how large many emission targets really are.

**BACKGROUND:** Several astronomical phenomena can be seen in this panoramic image. In the centre, the glowing gas of the Flaming Star Nebula is lit by the star AE Aurigae. Meanwhile, in the lower right, the thread-like wreckage of an exploded star forms the Simeis 147 supernova remnant.

**QHY9 camera; Canon EF 200mm f/1.8 lens**

**MARTIN PUGH** (*UK/Australia*)

## NGC 6188
[16 May 2012]

**MARTIN PUGH:** This is a fabulous piece of sky to image with narrowband filters and the combination of the telescope and camera allows the inclusion of the wonderful emission nebula NGC 6164 and its halo.

**BACKGROUND:** Just as ancient people saw heroes and animals in the patterns of the stars, modern observers like to give fanciful names to nebulae and galaxies. The rather dull sounding NGC 6188 is also known as the 'Fighting Dragons', based on its contorted and evocative structure.

**Takahashi FSQ 106N telescope; Software Bisque Paramount ME mount; SBIG STL11000M camera; 13-hour exposure**

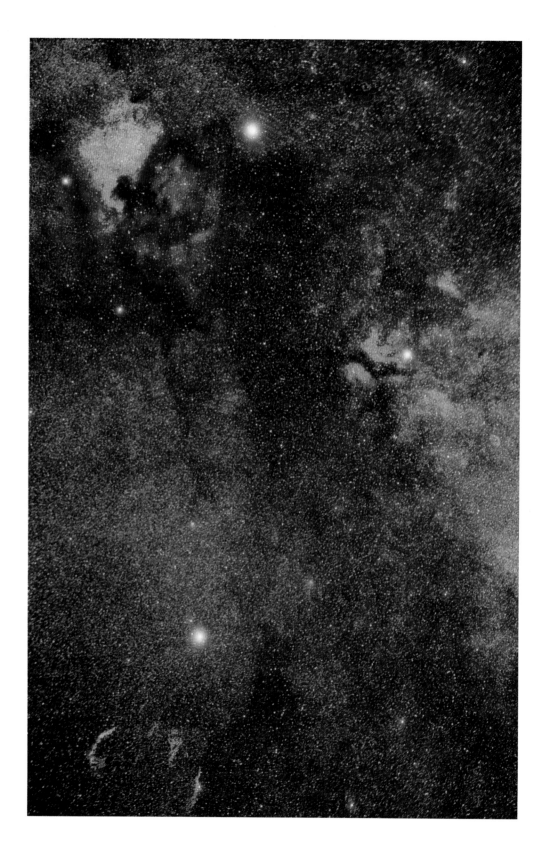

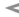

## BRENDAN ALEXANDER *(Ireland)*

### The Wing of the Swan
[*1 September 2011*]

**BRENDAN ALEXANDER:** Over the weekend I stacked and processed my data, going through the usual train of thought … Does that look right? … Maybe if I just tweak this … I finally settled on the image opposite. The bright star in the top centre of the image is Deneb and forms the tail of the swan while the star in the right centre of the frame is called Sadr and represents the mythical swan's body. Gienah, the star in the bottom left of the image, forms part of the wing of the swan. Finally, the dark dust lane of the Milky Way is visible in the image as the dark river running between the three stars Deneb, Sadr and Gienah.

**BACKGROUND:** This vast mixture of dark dust and glowing hydrogen gas is characteristic of the stellar nurseries that are scattered throughout the spiral arms of our galaxy. Perhaps the most striking aspect of this image, however, is the sheer number of stars that it reveals, but this is still only a tiny fraction of the hundreds of billions of stars that make up the Milky Way.

**Self-modified 1000D camera; Sigma 70–300mm APO lens at 70mm; ISO 1600; 10-minute exposure**

**GEORGE VIDOS** (*Greece*)

### IC 5067 – The Pelican Nebula
*[29 October 2011]*

**GEORGE VIDOS:** The Pelican Nebula is an HII region associated with the North America Nebula in the constellation Cygnus. The nebula resembles a pelican in shape, hence the name.

**BACKGROUND:** The birth of new stars is revealed in this colourful view of a star-forming nebula. In the centre of the image, a cloud of dust is collapsing under its own gravity, with the densest clumps destined to condense into new stars. On the left, this process is already complete, and the newly formed stars are blazing with light and heat. Their intense radiation is eroding the dust cloud in which they were born, carving it into peaks and tendrils and causing the surrounding hydrogen gas to glow.

RCOS 12.5 telescope; Paramount Me mount; SBIG STL-11000M camera; 10–30-minute exposure

> **JACOB VON CHORUS** (*Canada*), **AGED 15**    *WINNER*

## Pleiades Cluster
[*27 August 2011*]

**Original competition category: young astronomer**

**JACOB VON CHORUS:** This image was a test to see what would happen with such a long exposure. It was taken near dusk, with only two frames and an hour of exposure. This image has since become one of my best.

**BACKGROUND:** Among the nearest star clusters to Earth, the Pleiades is easily seen with the naked eye in the northern hemisphere's winter skies. While they are often called the Seven Sisters, this beautiful photograph reveals many more of the hot, young stars which comprise the cluster. The young photographer has also captured the swirling wisps of a diaphanous gas cloud through which the cluster is currently passing, lighting it with reflected starlight.

**Sky Watcher Equinox 80ED telescope; Celestron CG-5 mount; f/6.25 lens; Stock Canon 100D camera; ISO 800; 30-minute exposure**

*"The young astrophotographer category has once again produced some stunning results and this shot of the Pleiades (Messier 45) is simply breathtaking. The light from the stars reflects and scatters off the dust to produce the delicate blue-hued nebula you can see here. Jacob has rendered the colours of the nebula and stars beautifully to produce a result that many experienced astrophotographers would be extremely pleased to have achieved."*

PETE LAWRENCE

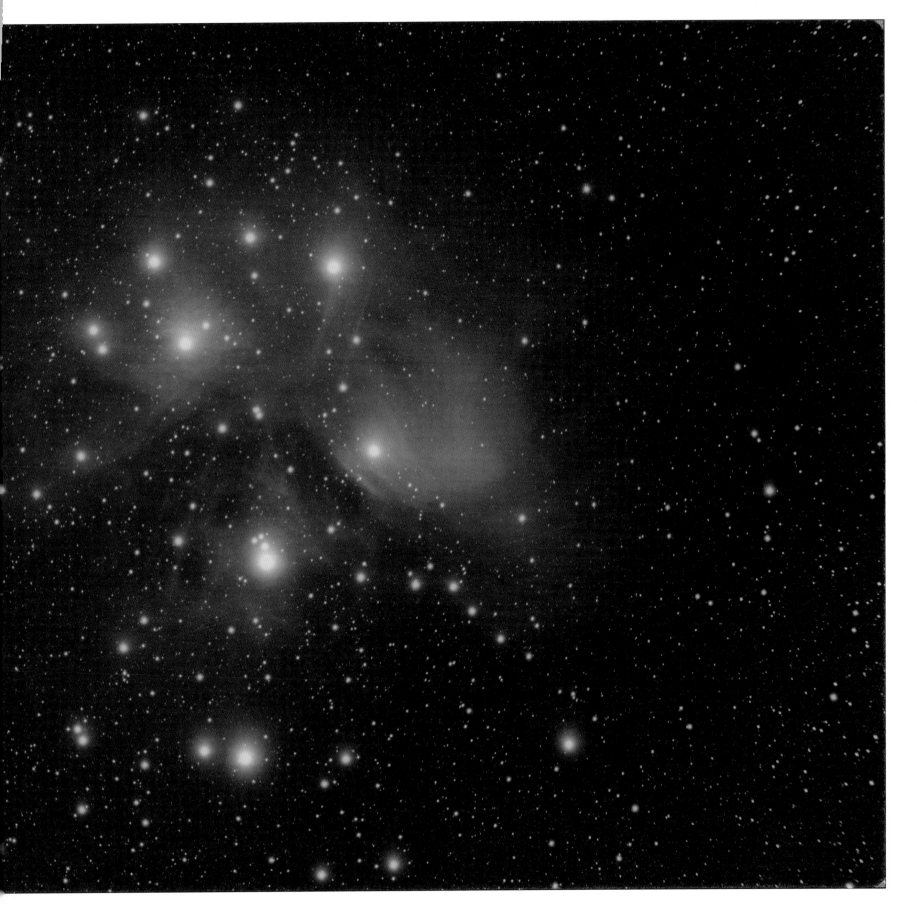

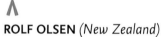

**ROLF OLSEN** *(New Zealand)*

### The Nearest Globular – Messier 4 in Scorpius
[22 June 2012]

**ROLF OLSEN:** This rather overlooked globular would be one of the most splendid in the sky if not obscured by the Rho Ophiuchi clouds which can just be seen on the left.

**BACKGROUND:** Messier 4 has been studied by astronomers for more than 250 years, and it was the first globular cluster in which individual stars could be distinguished as telescope technology improved. Those early astronomers would doubtless have been thrilled by this detailed image, in which thousands of ancient red stars can be seen crowding towards the cluster's dense core.

**Homebuilt 10-inch Serrurier Truss Newtonian telescope; QSI 683wsg camera**

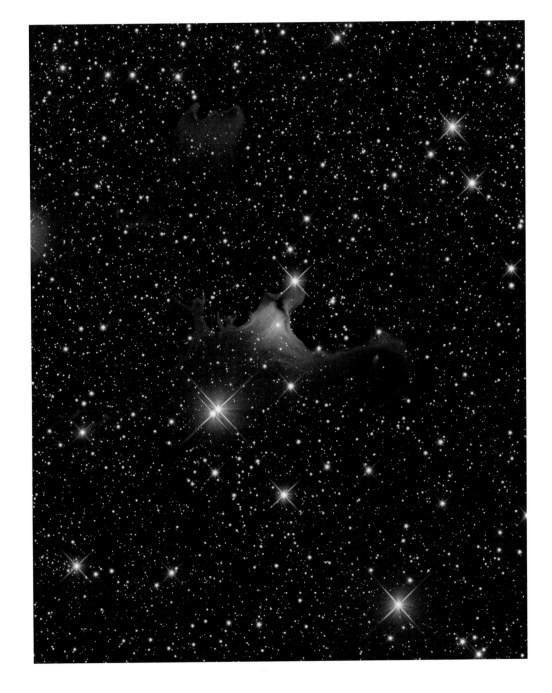

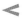

**OLEG BRYZGALOV** *(Ukraine)*      HIGHLY COMMENDED

### Sharpless-136: 'Ghost' in Cepheus
*[16 July 2011]*

**OLEG BRYZGALOV:** The constellation Cepheus is very rich in a variety of astronomical objects. Spooky shapes seem to haunt this starry expanse, drifting through the night. Of course, the shapes are cosmic dust clouds faintly visible in dimly reflected starlight. To shoot this image I had to drive 1000 kilometres to reach the mountains of the Crimea where the sky was dark enough.

**BACKGROUND:** Dust clouds like these are an important component of the Milky Way galaxy, filling huge volumes of space between the stars. The dust consists of tiny grains of minerals and ices and is an important building block for the formation of future stars and planets.

**Newtonian 10-inch reflector; WS-180 mount; 1200mm f/4.7 lens; QSI-583wsg camera; 10-minute exposure**

*"The more muted colours and ghostly forms of this cosmic dust cloud instantly captured my imagination as something that evokes the mystery of the deep sky – although looking more closely you spot the almost humorous 'figures' waving a salute."*
REBEKAH HIGGITT

*"I love the subtle colours and undulating shapes of the dust clouds in this image. Dust like this is the material that planets are made from, so it's really important stuff."*
MAREK KUKULA

## LÓRÁND FÉNYES *(Hungary)*

### Elephant's Trunk with Ananas
*[2 February 2012]*

**Original competition category: best newcomer**

**LÓRÁND FÉNYES:** I bought my first tube at the end of 2010. I didn't have any information about astronomy, so I started to learn the basic things about the sky and tried serious astrophotography at the beginning of 2011. It is my first attempt at entering your competition. The Elephant's trunk is my 34th photo.

**BACKGROUND:** The Elephant's trunk seems to uncoil from the dusty nebula on the right of the image, its tip curled around a cavity carved out by the radiation produced by young stars. Capturing a deep-sky object like this takes great skill and painstaking attention to detail.

**GSO-Orion 200/800 telescope; SkyWatcher HEQ5 mount; Canon 1000D camera; ISO1600; 8-hour exposure**

*"Imaging a deep sky object like this takes skill and dedication. This photographer makes it look easy! This mysterious scene could have come from the cover of a 70s Sci-Fi novel. A wonderful picture and a great achievement."*

MAREK KUKULA

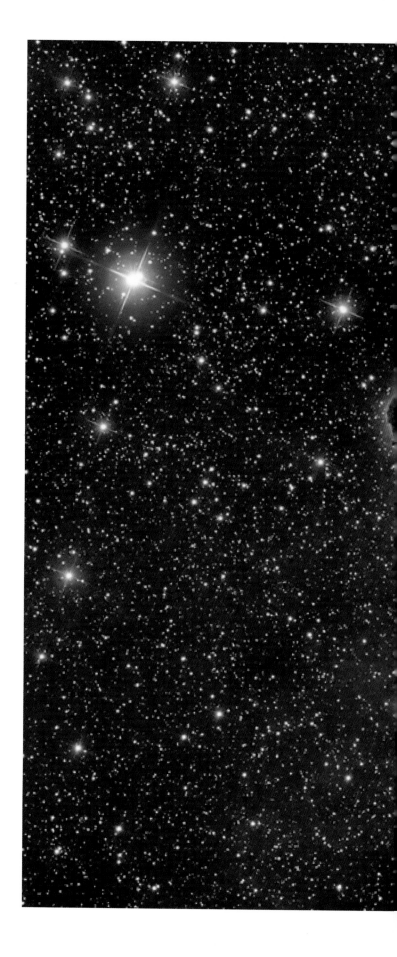

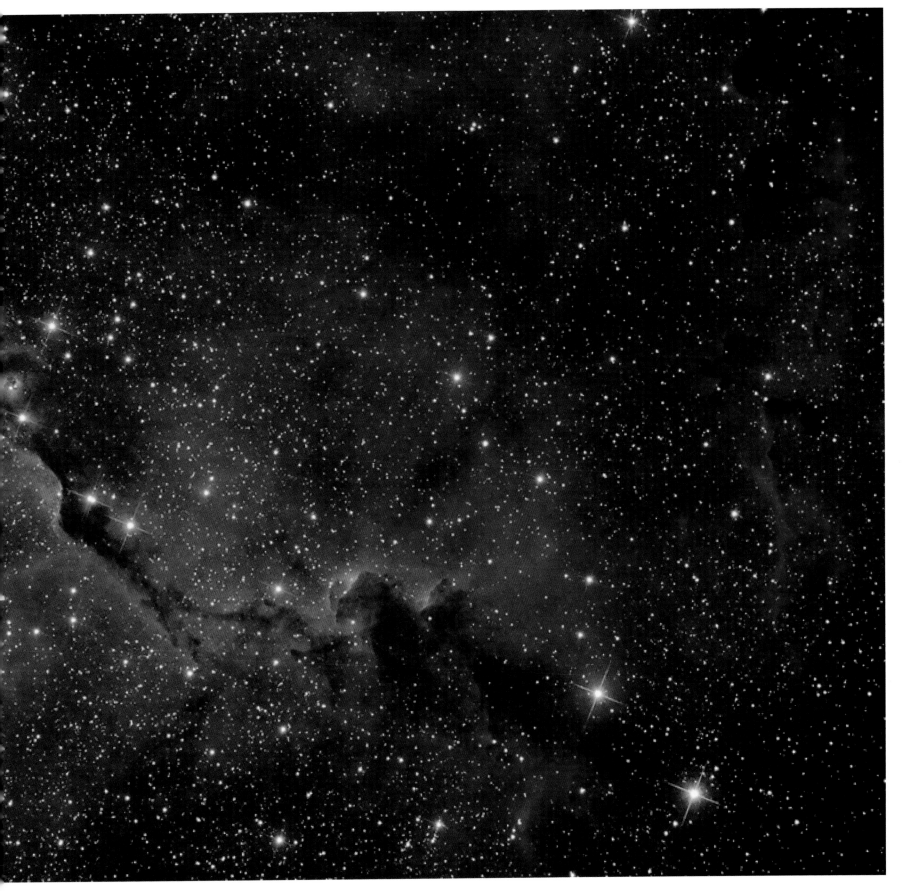

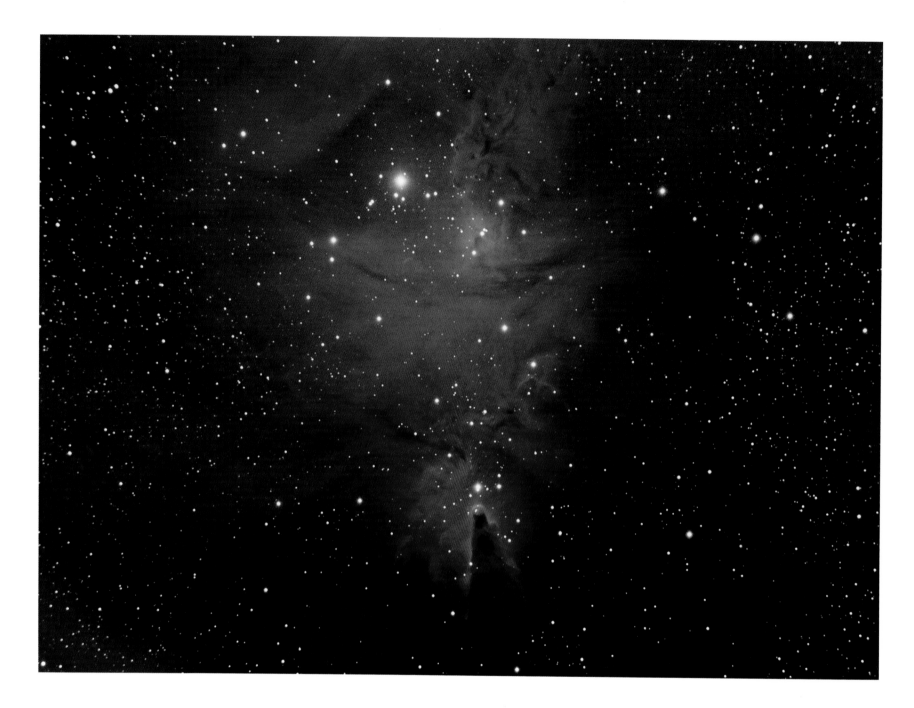

## SHAUN REYNOLDS (UK)

### Cone Nebula
[*29 March 2013*]

**SHAUN REYNOLDS:** This is the first colour image I took with my new CCD camera – a good size for my field of view. I love the pictures I had seen of this and wanted to take a narrowband version.

**BACKGROUND:** Extending from the lower part of this image, the Cone Nebula is a tower of dark interstellar dust around seven light years high. It is 2700 light years from Earth. The Cone is part of a much larger

region of dust and gas in which new stars are being formed. Some of these young stars can be seen at the top of this image, where their light is illuminating the surrounding gas and dust.

Williams Optics FLT 98 telescope; NEQ6 Pro mount; 98mm lens; SXV 694 mono CCD camera; 500mm f/5 lens; 6-hours total exposure

## JULIAN HANCOCK (UK)

### M63 LRGB
[1 June 2013]

**JULIAN HANCOCK:** This image was taken with twelve hours of luminance and six hours each of RGB (red, green, blue) filters taken with my remote telescope in Spain, while I was in the UK, where I live.

**BACKGROUND:** Messier 63 is a spiral galaxy. It has many short arms radiating from its centre like the petals of a flower, giving rise to its common nickname of the 'Sunflower Galaxy'. This object is part of a group of galaxies around 23 million light years away, which also includes the more famous Whirlpool Galaxy.

**Planewave 12.5 telescope; Paramount ME mount; QSI 583wsg CCD camera; 30-hours total exposure**

Λ

**MICHAEL SIDONIO** *(Australia)*

### Tunnel of Fire
[2 *January 2012*]

**MICHAEL SIDONIO:** This beautiful nebula in Monoceros is more commonly known as the Rosette Nebula. I love this nebula, it is so dynamic with so many interesting dark globules and having a beautiful cluster at its centre makes for a great picture – it really reminds me of a tunnel of fire. The gases in the nebula are being shaped and made to glow by the strong stellar winds from the massive stars of the open cluster NGC 2244 at the centre of the nebula.

**BACKGROUND:** The Rosette Nebula is what astronomers call an 'HII region' – a cloud of hydrogen gas which has been energized by radiation from nearby stars. This causes its atoms to glow with a characteristic red light. The cluster of bright blue stars at the centre of the nebula is the source of this energizing radiation.

Orion Optics AG12 305mm f/3.8 Newtonian telescope; Takahashi NJP mount; FLI 16803 CCD camera; 395-minutes total exposure

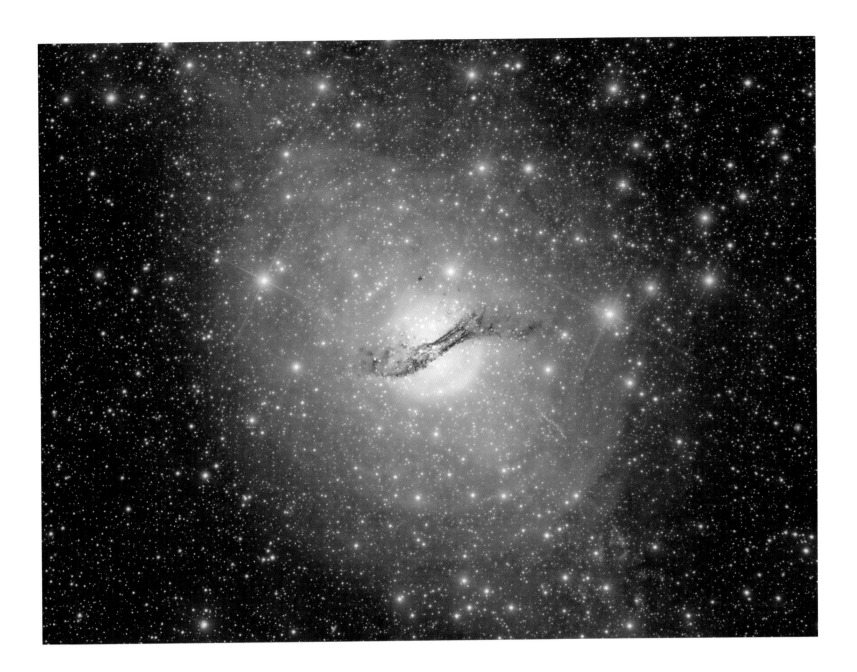

## ROLF OLSEN *(New Zealand)*

### Centaurus A Extreme Deep Field
[*5 February 2013*]

**ROLF OLSEN:** Over the past few months I have been on a mission to achieve a long-time dream of mine: to take a deep sky image with more than 100 hours of exposure! After having gathered 120 hours of data over 43 different nights in February–May 2013, this appears to be the deepest view ever obtained of Centaurus A (NGC 5128). It is also likely to be the deepest image ever taken with amateur equipment. I spent around 40 hours processing and analysing the data, with the goal of presenting this majestic southern galaxy as it has never been seen before – with all the main features showing in one single image.

**BACKGROUND:** Centaurus A is one of the most intensively studied galaxies in the sky. The band of dark dust across the middle of the galaxy is thought to be the remains of a smaller galaxy which it has 'cannibalized'. This galactic merger has also triggered a burst of new star formation, which is revealed by the red clouds of glowing hydrogen gas embedded within the dust. Deep in the heart of the galaxy, hidden by the thick dust lane, astronomers have discovered a supermassive black hole. It is 55 million times the mass of the Sun, and sends out X-ray and radio emissions as it devours nearby gas. Since its discovery in 1826, Centaurus A has been observed with some of the greatest telescopes in the world. This spectacular image by an amateur astronomer is a fitting addition to that catalogue.

**Serrurier Truss Newtonian 254mm f/5 telescope; Losmandy G11 mount; QSI 683wsg-8 camera; 120-hours total exposure**

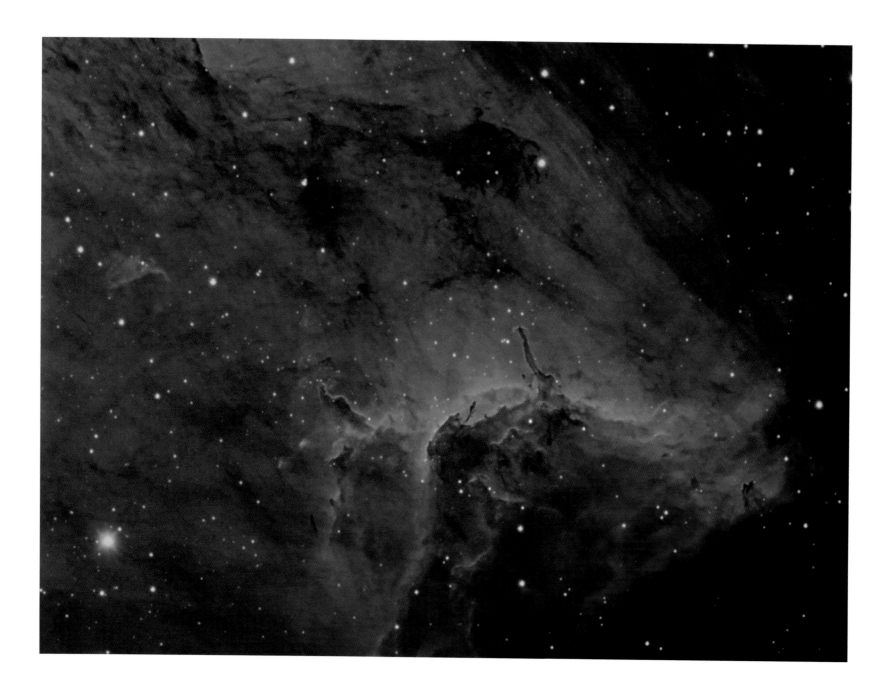

## ANDRÉ VAN DER HOEVEN (*Netherlands*)

### Herbig-Haro Objects in the Pelican Nebula
[*July 2012*]

**ANDRÉ VAN DER HOEVEN:** This image was taken over several nights in close co-operation with a fellow astrophotographer, Daniel Verloop. We focused on the Pelican Nebula hoping to get some nice details in this beautiful emission area. Literature shows that this area is rich in so-called 'Herbig-Haro objects', jets emitted by protostars in the clouds where they are born. Realizing that these jets are recently discovered made them very special to me. That is why I submitted this picture as it really shows the power of modern amateur astrophotography.

**BACKGROUND:** The birth of new stars is a complex process which astronomers are still trying to understand in detail. One fascinating aspect of stellar formation is the production of jets of material which blast out from the poles of some new-born stars. Here, these jets, or Herbig-Haro objects, can be seen emerging from the thick dust and gas clouds of the Pelican Nebula, a stellar nursery in the constellation of Cygnus.

Takahashi FSQ-85 and a Skywatcher ED80 telescope; Losmandy GM11 and a Skywatcher NEQ-6 mount; QSI-583 and a Starlight Express SXV-H9 camera; 54 x 1800-second exposures; the data was obtained by myself from Hendrik-Ido-Ambacht, Netherlands and by Daniel Verloop from Zoetermeer, Netherlands

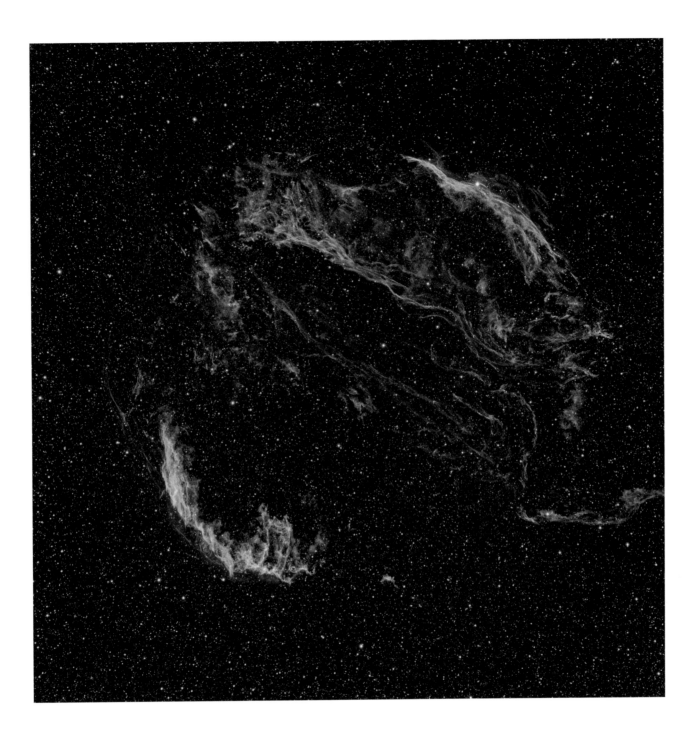

Λ

**NICOLAS OUTTERS** *(France)*

### Dentelles du Cygne (Veil Nebula)
*[28 August 2011]*

**NICOLAS OUTTERS:** This is a fascinating view of the Veil Nebula. This picture is the result of many hours of sub-exposures with special filters. My objective was to show all the remnants of the supernova. The sky at the observatory of Sirene in Provence is very deep and the 'seeing' is perfect.

**BACKGROUND:** Situated in the constellation of Cygnus the Swan, the Veil Nebula is the wreckage of a star which died in a supernova explosion more than 5000 years ago. Despite their violence, supernovae such as this generate many of the chemical elements which are essential for life. Here, the photographer has used false colour to highlight the fragile wisps of gas which are still expanding outwards from the explosion site.

**FSQ106 f/5 telescope; Paramount ME mount; Apogee 16U camera; 30.5-hours total exposure**

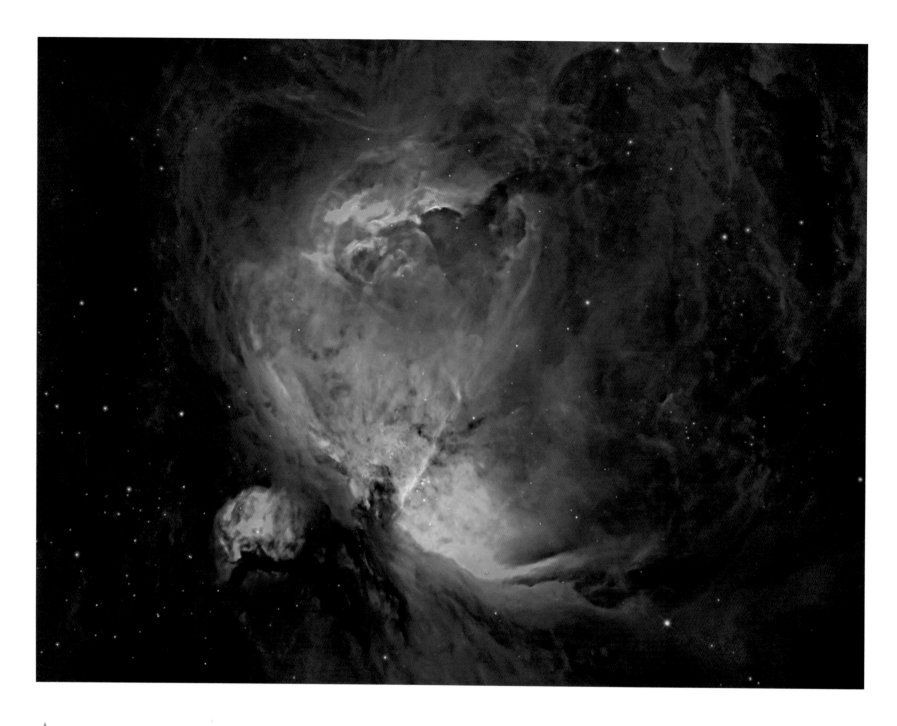

## NIK SZYMANEK *(UK)*

### Orion Nebula
[*1 February 2012*]

**NIK SZYMANEK:** This is a relatively easy image to take as the Orion Nebula is big, bright and responds well to narrowband filters and short exposures.

**BACKGROUND:** Modern cameras can detect light which is too faint for our eyes to see and are able to distinguish levels of detail which are well beyond our own capabilities. In rendering this information into an image, we can understand astrophotographers must make practical and aesthetic choices about contrast, brightness and colour. Here, the photographer has chosen an unusually subdued palette of colours to represent the Orion Nebula, replacing the familiar riot of reds and magentas with subtle greys and salmon pinks. These emphasize the delicate structure of the nebula's dust clouds.

**Ikharos 255mm RC telescope; Paramount ME mount; 255mm mirror with 0.67 Astro Physics focal reducer at f/5.5; QSI 583wsg camera**

## LEONARDO ORAZI (Italy)

### NGC 6822 – Barnard's Galaxy
[16 July 2012]

**LEONARDO ORAZI:** This was a difficult target for my latitude, but what a galaxy!

**BACKGROUND:** Only 7000 light years across, NGC 6822 is a small, faint galaxy in our 'Local Group', the region of space which includes our own Milky Way. However, small does not necessarily mean dull, as this photographer shows: the galaxy is dotted with bubble-like shells of glowing hydrogen gas, indicating sites of active star formation.

GSO Astrograph Ritchey-Chrétien telescope; 254mm f/8 lens; AP MACH1 GTO mount; QSI 640wsg camera

∧

**MARCO LORENZI** *(Italy)*

### Sharpless 308 – Cosmic Bubble in Canis Major
[*1 November 2012*]

**MARCO LORENZI:** Blown by fast winds from a hot, massive star, this cosmic bubble, Sharpless 308, lies some 5200 light years away in the constellation Canis Major. The star is near the centre of the nebula. I love the amazing colours of this object. It is a mystery that very few images exist of it. The intense blue hue is due to the long exposure through an OIII filter which allows the full extent of this giant bubble to be seen.

**BACKGROUND:** The bright blue object at the centre of this image is a Wolf-Rayet star which is over 20 times the size of our sun. It is blasting out a wind of particles in all directions at speeds of up to 2000km per second. Over the last 70,000 years this wind has blown a bubble of gas which is now 60 light years across. The star itself is now in the final stages of its life and will eventually die in a spectacular supernova explosion.

**TEC140 APO telescope; Paramount ME mount; 140mm f/7.1 lens; FLI Proline 16803 camera; 15-hours total exposure**

## MARCO LORENZI (Italy)

### Fornax Galaxy Cluster
[1 March 2013]

**MARCO LORENZI:** At a distance of approximately 62 million light years, the Fornax Cluster is the second richest cluster of galaxies, after the Virgo Cluster, within 100 million light years of us. It lies primarily in the constellation Fornax, and may be associated with the nearby Eridanus Group. Although it is small as clusters of galaxies go, the Fornax Cluster is a valuable source of information about the evolution of such clusters. At the centre of the cluster lies NGC 1399. NGC 1365 (at the bottom right in the image) is the most famous galaxy in the Fornax Cluster –

a beautifully-shaped barred spiral galaxy. To me this is one of the best galaxy clusters in the whole sky with the presence of several incredible galaxies in the same field.

**BACKGROUND:** The Fornax Cluster is one of the richest groups of galaxies in our corner of the Universe. It contains a wide variety of galaxy types. Most obvious are the large, featureless elliptical galaxies, whose yellow-orange colour gives away the great age of their stars. Scattered among them are spiral galaxies resembling our own Milky Way, in which young, blue stars can also be seen.

TEC140 APO telescope; Paramount ME mount; 140mm f/7.2 lens;
FLI Proline 16803 camera; 26-hours total exposure

## MICHAEL SIDONIO (*Australia*)    *HIGHLY COMMENDED*

### Floating Metropolis – NGC 253
[*13 October 2012*]

**MICHAEL SIDONIO:** NGC 253 is often referred to as the Silver Dollar Galaxy. This deep image shows many bright regions and unusual streamers of stars, which rise vertically across the enormous stellar disc. The extensive, but very faint and rarely seen, outer galactic halo of stars is also evident. This was my first venture under dark rural skies with my telescope. Next time I would like to go even deeper to see if the halo extends further.

**BACKGROUND:** First discovered by astronomer Caroline Herschel in 1783, NGC 253 is a rare example of a 'starburst galaxy'. Here new stars are being formed at many times the rate in our own galaxy, the Milky Way. Its mottled appearance comes from extensive lanes of dust which thread through the galactic disc. These are studded with many red clouds of ionized hydrogen gas, marking the sites where new stars are being born.

**Orion Optics AG12 305mm f/3.8 Newtonian telescope; Takahashi NJP mount; FLI 16803 CCD camera; 340-minutes total exposure**

*"The oblique angle at which we see this galaxy really conveys how thin and flat spiral galaxies are. I like the contrast between the old, yellow stars in the centre and the younger, blue stars in the spiral arms."*

MAREK KUKULA

*"The detail caught in the disc of this immense spiral galaxy is stunning. Dark clumps of dust are visible, as are the many reddish-pink regions where stars are forming, their radiation causing surrounding material to glow brightly even from a distance of 11.5 light years."*

CHRIS BRAMLEY

*"Quite superb! There are beautiful details within the galaxy. Being tilted over, the dust lanes appear close together but the photographer has managed to maintain a high level of detail throughout. The Silver Dollar has never looked so good."*

PETE LAWRENCE

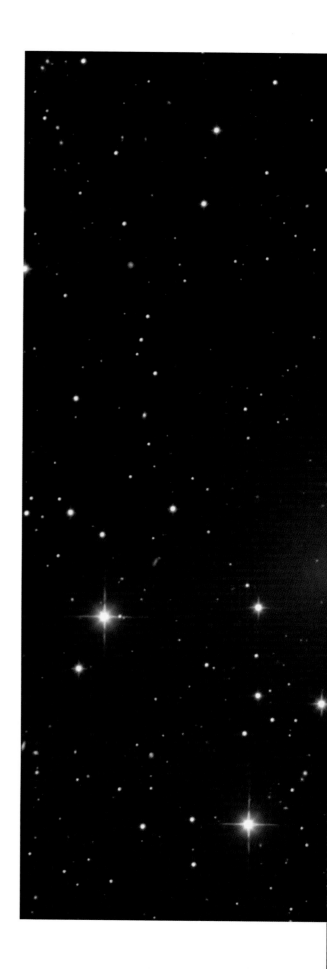

## MARCUS DAVIES *(Australia)*

### The Wake of Argo
*[24 March 2013]*

**MARCUS DAVIES:** The Great Nebula in Carina (NGC 3372) is arguably the most photographed object in the southern sky. Other images, however, rarely display the full extent of the nebula. It is this larger picture that I tried to render here. Best viewed at full resolution, this giant star-forming region is full of interesting and colourful detail. From the diffuse, blue-tinted reflection nebulae to the dark obscuring dust clouds and luminous gas in red and pink hues, it is a feast for the eyes.

**BACKGROUND:** An immense region of gas and dust containing several clusters of newly-formed stars, the Carina Nebula is one of the Milky Way's star factories. Some of the stars being formed here are true giants, weighing in at over a hundred times the mass of the Sun. Their sizzling radiation energizes the surrounding gas, making it glow with the characteristic red light of hydrogen, the most common chemical element.

**Takahashi TOA-150 telescope; Paramount ME mount; 150mm f/5.5 lens; SBIG STL-11000 camera; 7.3-hours total exposure**

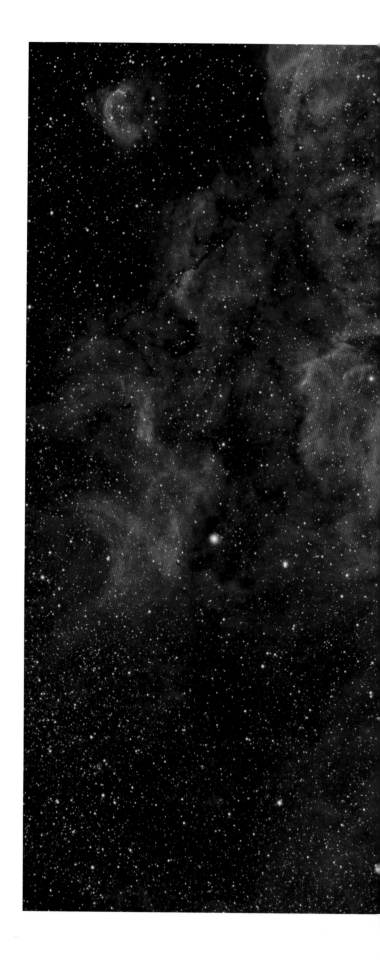

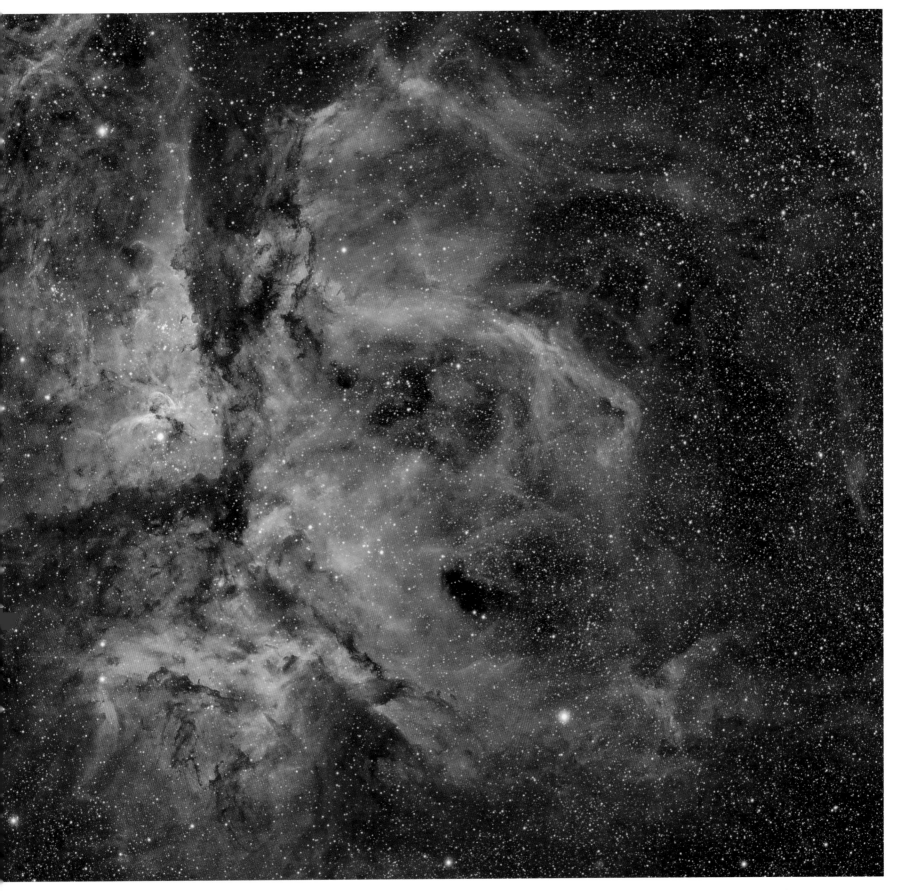

## EVANGELOS SOUGLAKOS (*Greece*)

### Pleiades Cluster – M45
[*5 January 2013*]

**EVANGELOS SOUGLAKOS:** The Pleiades or 'Seven Sisters' (M45) is an open star cluster containing middle-aged hot B-type stars located in the constellation of Taurus. It is among the nearest star clusters to Earth and is the one most obvious to the naked eye in the night sky.

**BACKGROUND:** In this image, the photographer has used a long exposure to reveal the veils of dust which surround the blue-white stars of the Pleiades Cluster and reflect their light. This dust was once thought to be the remains of the nebula in which the stars originally formed, but recent studies indicate that their association is much more recent. The cluster has simply drifted into the dust as it moved through the galaxy.

**Officina Stellare RH200 telescope; AP Mach1 GTO mount; ATIK 383L+ camera; 5-hours total exposure**

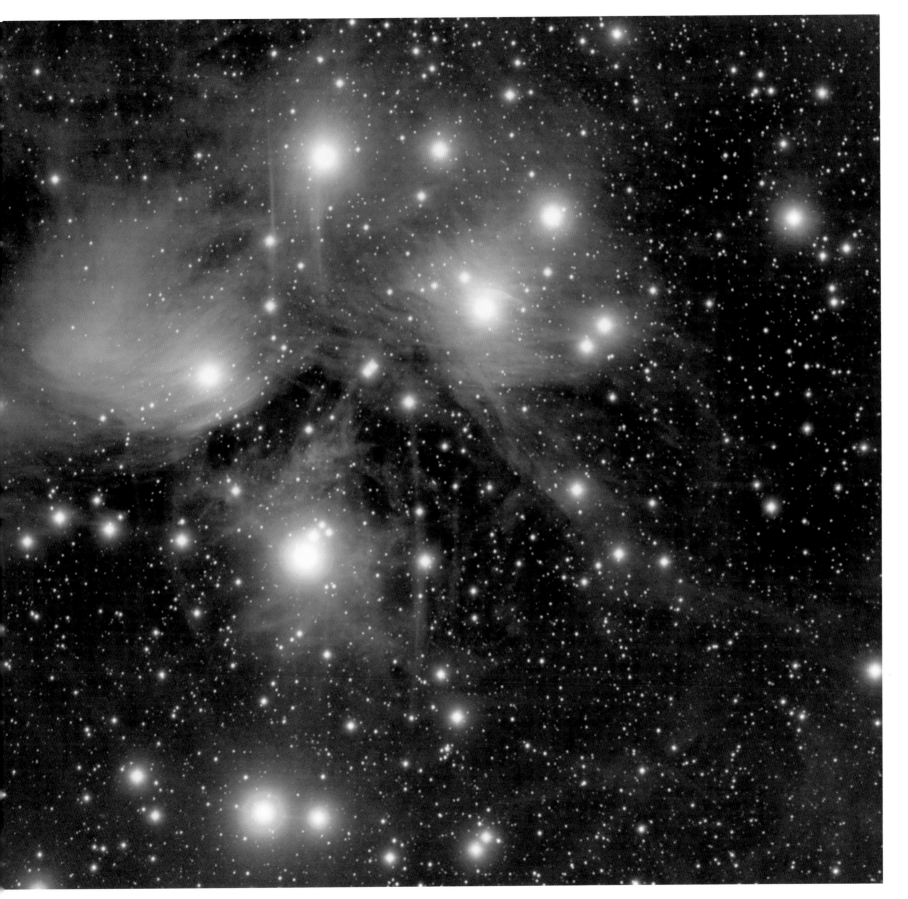

> 

**IGNACIO DIAZ BOBILLO** *(Argentina)* HIGHLY COMMENDED

## Omega Centauri
[*30 March 2012*]

**IGNACIO DIAZ BOBILLO:** This image was taken from my suburban backyard, on a night of particularly good viewing. The image was processed to enhance resolution and star colours.

**BACKGROUND:** Omega Centauri is a globular cluster, a spherical cloud containing several million stars. As this image shows, the stars are more densely clustered towards the centre. The pronounced red colour of several of the stars gives away the cluster's great age: it is thought to have been formed many billions of years ago. The cluster was first noted by the astronomer Ptolemy almost 2000 years ago and catalogued by Astronomer Royal Edmond Halley in 1677.

**AP130GT telescope; Losmandy G11 mount; Canon 1000D camera; ISO 800; 42 x 180-second exposures**

*"Packed with stars, Omega Centauri is the largest of the globular clusters that orbit our galaxy, the Milky Way. I particularly like the way that Ignacio has controlled the brightness to reveal individual stars from the outer edge to the very centre."*

CHRIS BRAMLEY

*"Although it is a big bright globular cluster, capturing Omega Centauri without over-exposing the core and keeping the component stars so tight and separate, is no mean feat. Quite an astonishing result. Just imagine what it would be like to be on a planet going around one of those stars!"*

PETE LAWRENCE

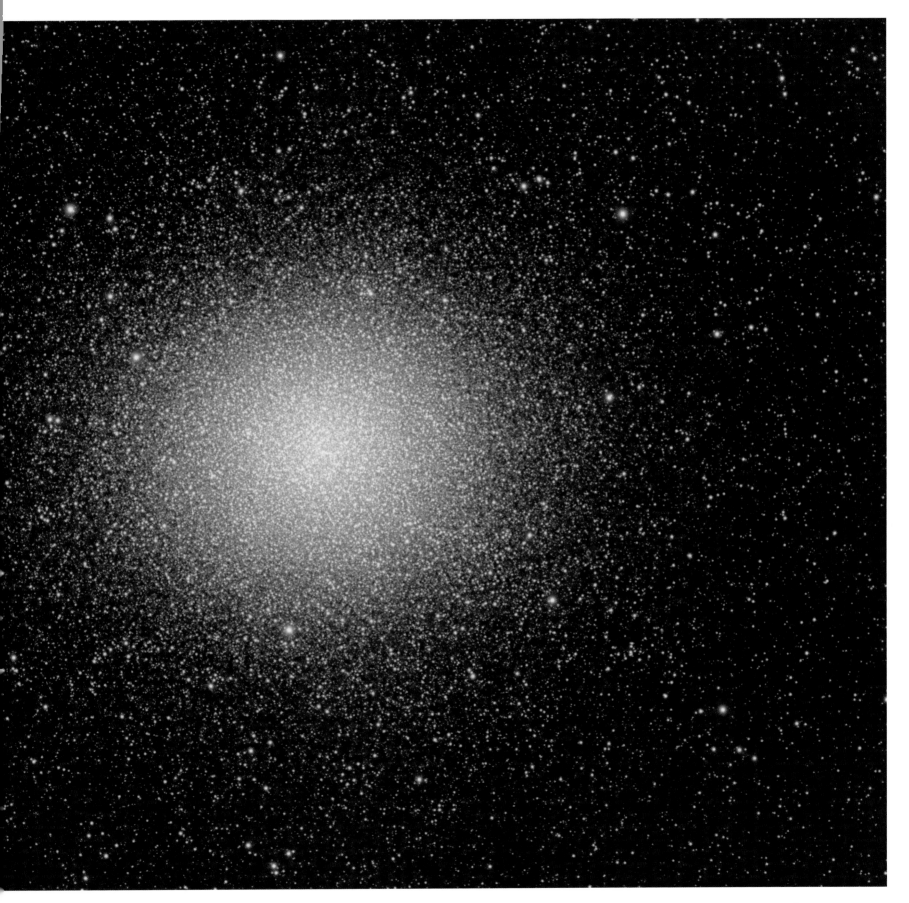

## DAVID FITZ-HENRY (*Australia*)

### Horsehead Nebula (IC 434 / Barnard 33), Reflection Nebula (NGC 2023) and Flame Nebula (NGC 2024)
[*13 December 2012*]

**DAVID FITZ-HENRY:** The Horsehead Nebula (also known as Barnard 33 in emission nebula IC 434) is a dark nebula in the constellation Orion. The nebula is located just to the south of the star Alnitak, which is farthest east on Orion's Belt, and is part of the much larger Orion Molecular Cloud Complex. I have always found this to be a beautiful region of the sky with the famous Horsehead and contrasting nebula colours. Imaging it was a good challenge to improve my processing skills (as well as contending with the very bright star Alnitak). It is a combination of two processing attempts with many steps in each; I would like to reprocess this and see if I could do it more efficiently (with fewer steps).

**BACKGROUND:** Despite possessing one of the most famous silhouettes in astronomy, the Horsehead Nebula is too faint to be seen with the naked eye. In fact, it owes its discovery to astrophotography, as it was first noticed in 1888 by Scottish astronomer Williamina Fleming on a photographic plate taken at the Harvard College Observatory. More than a century later astronomers are still unravelling the mysteries of the Horsehead.

**Home-built 12.5 f/5 Newtonian telescope; SBIG STL-11000M camera; 11-hours total exposure**

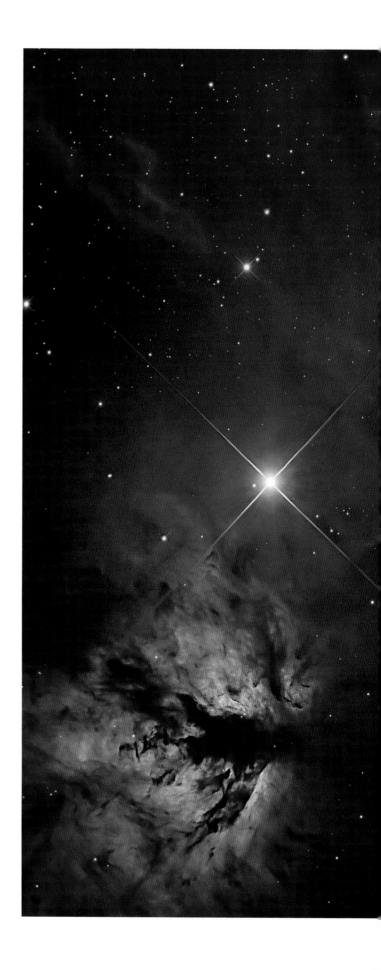

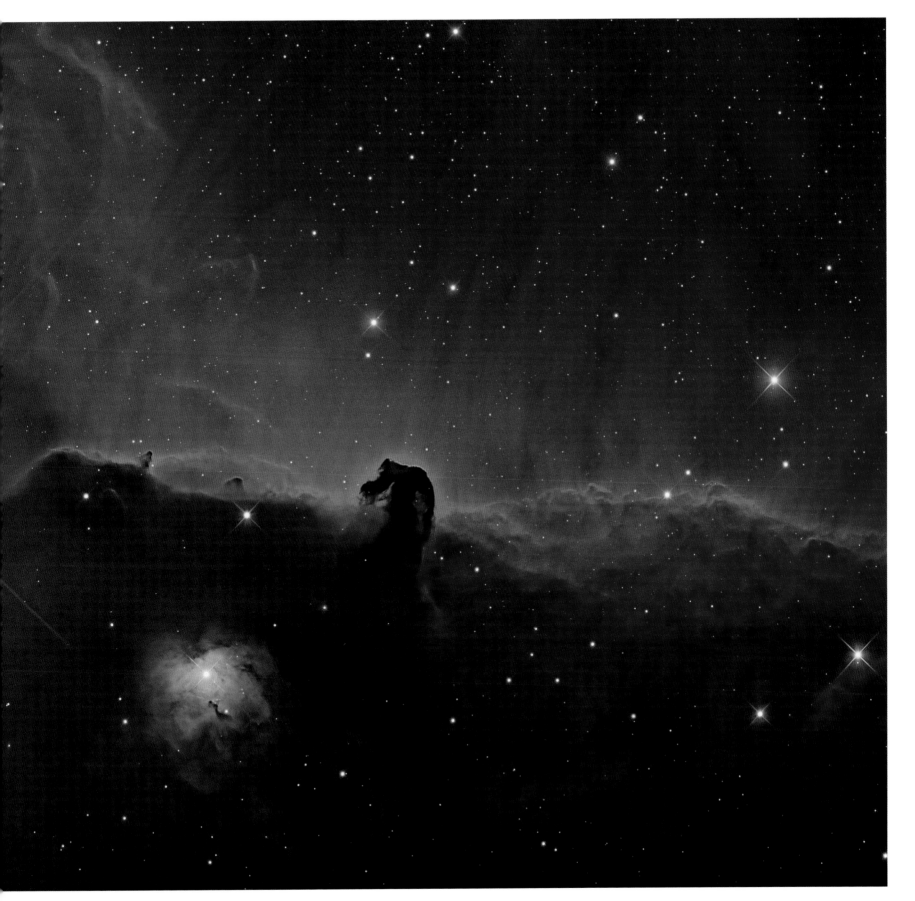

**ADAM BLOCK** *(USA)*

## Celestial Impasto: Sh2 – 239
[*10 November 2011*]

**ADAM BLOCK:** This is 'impasto' on a celestial scale! Imagine the brush that could express the delicate wisps of dust and the opaque cold, dark heart of this molecular cloud. Like a painter whose strokes leave behind a sense of motion and depth during the creation of an artwork, the star formation here seems to proceed quickly as revealed by the rapid evaporation in the foreground. Soon even the deepest part of this cloud will yield to unstoppable forces, and as the dust is blown away a young cluster of stars will shine.

**BACKGROUND:** Structures like this often seem unchanging and timeless on the scale of a human lifetime. However, they are fleeting and transient on astronomical timescales. Over just a few thousand years the fierce radiation from the stars in this nebula will erode the surrounding clouds of dust and gas, radically altering its appearance.

**Schulman 0.8m telescope; EQ mount; STX (SBIG) 16803 camera; 15-hours total exposure**

*"Gorgeous, dramatic colours. Could a picture of space get any more painterly?"*

MELANIE VANDENBROUCK

*"There's an ethereal quality to this image. The main bright nebula reminds me of a bullet-shaped spacecraft disintegrating, heading away from the viewer. Galactic dust has never looked so lovely. The pink filaments of the emission nebula are quite superb."*

PETE LAWRENCE

*"This is a really dramatic image, and is instantly memorable as dark clouds of dust swirl around gas illuminated by newly formed stars."*

CHRIS LINTOTT

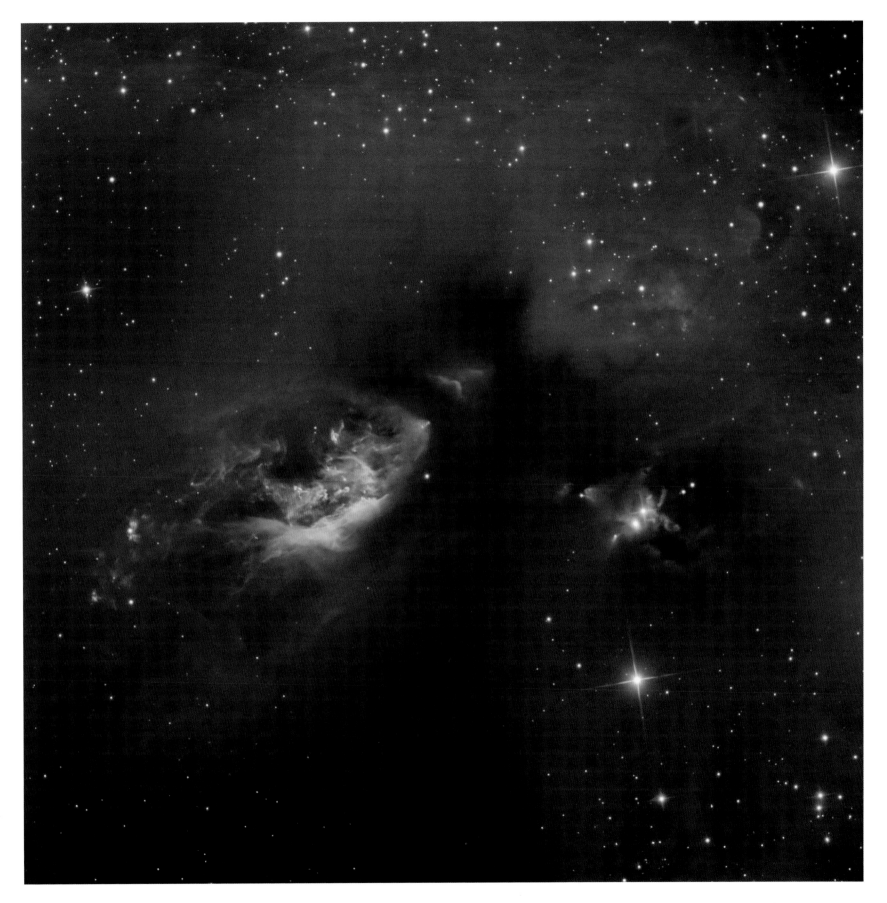

## TOM O'DONOGHUE (Ireland)  ·  *RUNNER-UP*

### Rho Ophiuchi and Antares Nebulae
### [2 July 2012]

**TOM O'DONOGHUE:** This is one of the objects I saw as a teenager in an astronomy magazine which made me think that one day I would like to try and take photographs of the night sky. This object is too low in the sky to see from Ireland, but was top of my imaging list from my location in Spain. This, along with the amount of time and effort needed to produce the image, is why I chose it for the competition. I was able to capture approximately three hours of data each clear night. After taking 30 hours in 2011, the image was still too 'noisy' due to its low altitude in the sky, and some low-lying cloud. In 2012 I added another 30 hours to finish up with a five frame mosaic, totalling 60 hours of exposures.

**BACKGROUND:** The smoky appearance of the dust clouds in this image is fitting, since the grains of dust which make up the nebula are similar in size to particles of smoke here on Earth. The dust can reflect the light of nearby stars, as seen in the blue and yellow regions. It can also block and absorb the light of more distant stars, appearing brown and black in this image. To the right, a bright star is ionizing a cloud of hydrogen gas causing it to glow red, while below it, far in the distance, is a globular cluster containing thousands of stars.

**Takahasi FSQ106N telescope; EM200 mount; Atik 11000 camera; 60-hours total exposure**

*"I love the variety in the dust clouds in this image. In some areas they block the light but in others we see them lit up by the nearby stars, taking on the colours of the starlight."*

MAREK KUKULA

*"This image is literally bursting with stars."*

MELANIE GRANT

*"It's the colour that really makes this image for me. The orange hue of Antares, the brightest star close to the bottom of the frame, seems to spill over into the dust. Just savour the contrast between the pink emission nebula with the blue reflection nebula – quite lovely."*

PETE LAWRENCE

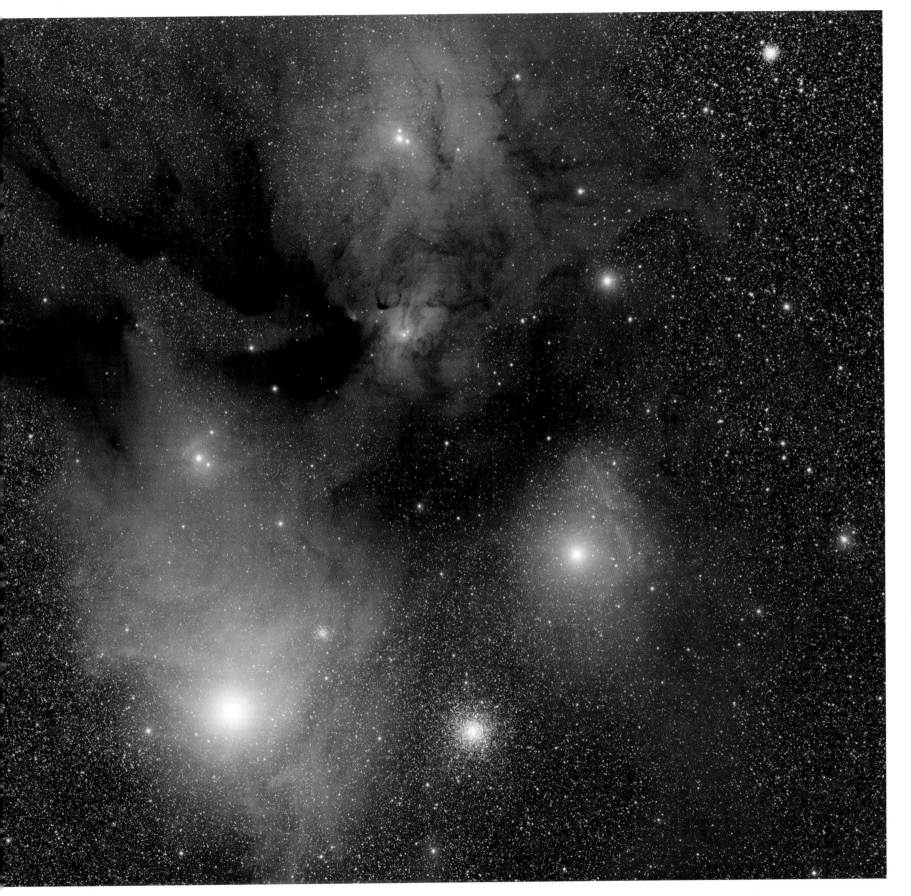

**IVAN EDER** *(Hungary)*                    HIGHLY COMMENDED

## M81–82 and Integrated Flux Nebula
[*February 2013*]

**IVAN EDER:** It took nearly 30 hours of total exposure time to record this faint Integrated Flux (IF) Nebula. The data was collected over three seasons, in 2009, 2011 and 2012. The majority of the exposures were taken in March 2012 over three nights. Note the star-forming regions in Holmberg IX, and the large blue giant stars (or clusters) forming faint and interesting outer arms of M81.

**BACKGROUND:** Lying at a distance of twelve million light years from Earth, M81 and M82 are galaxies with a difference. Close encounters between the two objects have forced gas down into their central regions. In M81 this influx of gas is being devoured by a supermassive black hole. In neighbouring M82 the gas is fuelling a burst of new star formation, which in turn is blasting clouds of hydrogen (shown in red) back out into space.

**300/1130 Newtonian (self-made) telescope; Fornax 51 mount; Canon 5D Mark II (self-modified) camera; ISO 1600; 309 x 5-minute exposures**

*"I am in awe of this image, not just because of the exquisite detail revealed in the two galaxies and the Integrated Flux Nebula, but also because it was captured with a DSLR camera. The smoothness of the background and the rich colours are superb. A truly spectacular deep space image!"*

WILL GATER

## LÁSZLÓ FRANCSICS (Hungary)

### The Trapezium Cluster and Surrounding Nebulae
[4 February 2013]

**Original competition category: robotic scope**

**LÁSZLÓ FRANCSICS:** I have always dreamed of capturing a 'protoplan-
etary disc', but an amateur astronomer hardly has the opportunity to
do so. However, in the Orion Nebula it is possible to capture darker
discs located in front of the shining background using ground-based
telescopes. After several attempts, I managed to catch a protoplanetary
disc surrounded by numerous stars in the Trapezium Cluster of the
Orion Nebula. This image was taken using two different telescopes, one
in Siding Spring, New South Wales, Australia, and my own telescope in
Hungary.

**BACKGROUND:** The great Orion Nebula is often described as a 'stellar
nursery' because of the huge number of stars which are being created
within its clouds of dust and glowing gas. As dense clumps of gas
collapse under their own gravity any remaining debris settles into a dark
disc surrounding each newly-formed star. One of these 'protoplanetary
discs' can be seen silhouetted against the bright background of glowing
gas in the central star cluster of this image. Within the disc, material will
condense still further, as planets, moons, asteroids and comets begin to
form around the star.

**0.50m f/6.8 astrograph with f/4.5 focal reducer; Planewave Ascension 200HR
mount; FLI-PL6303E CCD/ Canon 350D modified camera. Robotic telescope at
Siding Spring Observatory, NSW, Australia accessed via iTelescope.net online**

*"What an incredible image. I really like the way the photographer has
combined results from a remote telescope with his own colour images. The
final image is really stunning and a testament to not just the quality of the
remote instrument but also the skill of the imager. This really is a delight
to look at."*

PETE LAWRENCE

*"The Orion Nebula is a spectacular object, our nearest stellar nursery, and
this is an especially fine shot which shows detail both in the centre and out
along the long tendrils of gas that surround it."*

CHRIS LINTOTT

*"The swirls of colour in this image make me feel very happy that such an
object exists out there in the Universe."*

MAGGIE ADERIN-POCOCK

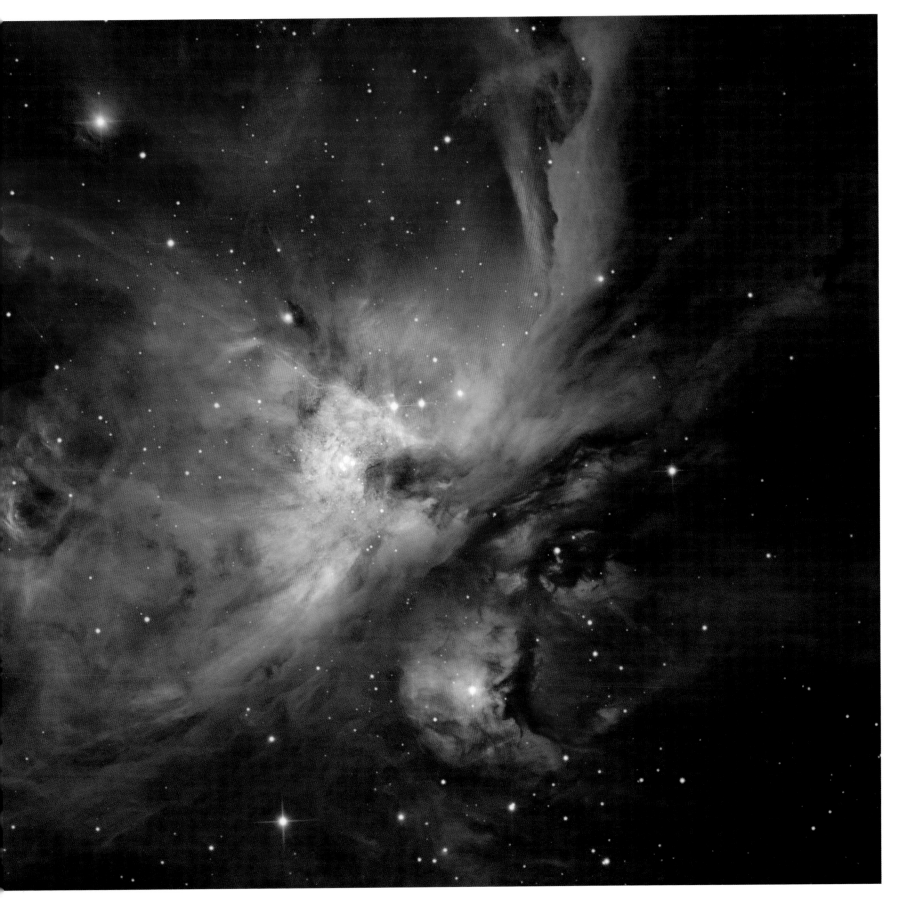

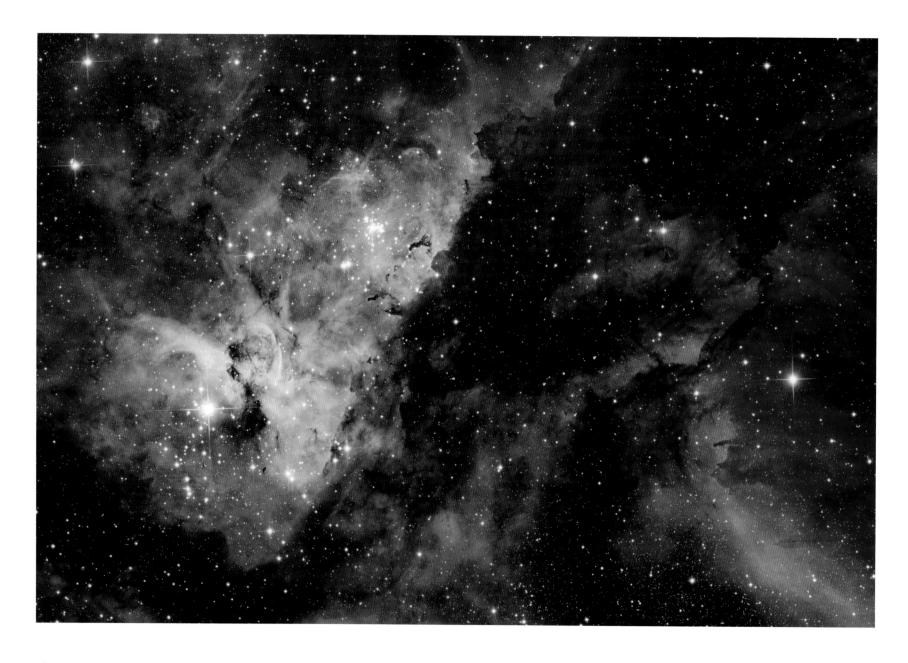

Λ

## LÁSZLÓ FRANCSICS *(Hungary)*

### The Carina Nebula
[*15 February 2013*]

**Original competition category: robotic scope**

**LÁSZLÓ FRANCSICS:** My plan was to capture the image of two stars with extraordinary features in the same field of view. Eta Carinae and WR22 are giant stars close to the end of their existence. Both of them are affecting their environment by blowing a cavity into the surrounding gas and dust clouds. These clouds form the Carina Nebula which is full of beautiful details. One of the significant elements of the composition of the photo is the dark western dust pillar, which separates two regions of strikingly different structure.

**BACKGROUND:** Two bright stars dominate this scene of turbulent gas and dust clouds in the Carina Nebula. Both stars are true giants: Eta Carinae (left) is over a hundred times the mass of – and a million times brighter than – our sun, while WR22 (right) is only slightly less impressive. Both these stars will race through their supplies of nuclear fuel in just a few million years, ending their lives in spectacular supernova explosions.

0.50m f/6.8 astrograph with f/4.5 focal reducer; Planewave Ascension 200HR mount; FLI-PL6303E CCD camera. Robotic telescope at Siding Spring Observatory, NSW, Australia accessed via iTelescope.net online

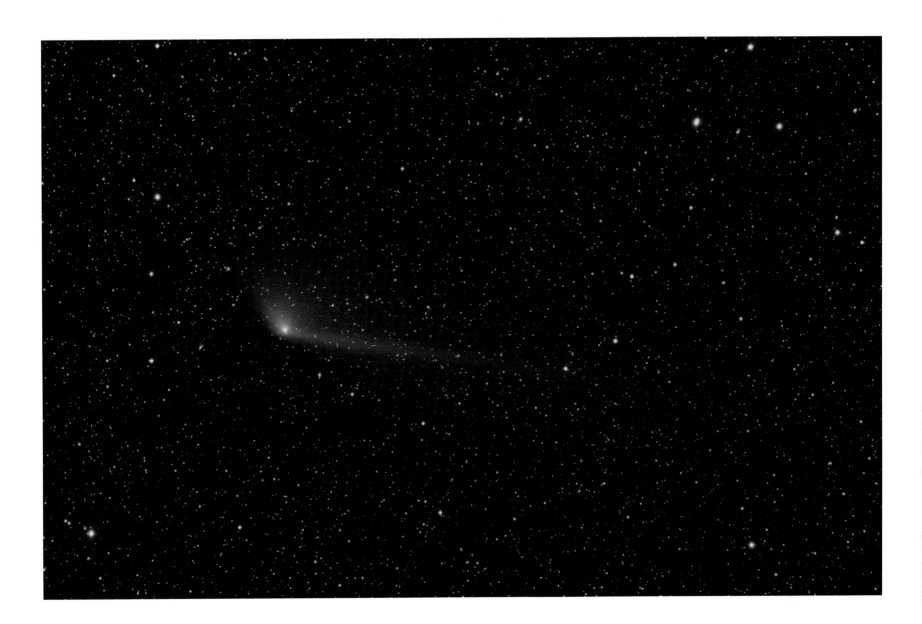

## DAMIAN PEACH *(UK)*

### Comet Panstarrs
*[11 June 2013]*

**Original competition category: robotic scope**

**DAMIAN PEACH:** This image shows Comet Panstarrs, one of this year's brightest comets. It has recently passed through Earth's orbital plane and sports a distinct anti-tail and hazy dust fan. It was taken during remote observing sessions at New Mexico, USA, in June 2013.

**BACKGROUND:** This deep exposure of Comet Panstarrs was taken after its closest approach to the Sun, when the comet was heading back out into the distant reaches of the Solar System. Two tails are visible: the long, straight 'ion tail' of charged particles which points directly away from the Sun, and a much broader fan-shaped tail of dust grains.

106mm f/5 refractor; Paramount ME mount; SBIG STL-11000M camera; 14-minutes total exposure. Robotic telescope in Mayhill, New Mexico accessed via iTelescope.net online

## KAYRON MERCIECA *(Gibraltar)*

### Rosette Nebula in Narrowband
*[27 December 2012]*

**Original competition category: best newcomer**

**KAYRON MERCIECA:** After setting up and showing off all my equipment to a work colleague and his friends, I waited for my target to move further away from the horizon. This image is the result of much experimenting in post-processing of narrowband data, to come up with my desired colour balance. If I were to image this target again, I would do

so in LRGB (Luminance, Red, Green and Blue) to have a complete set of data and indeed another look at this fine object.

**BACKGROUND:** Photographing deep sky objects like this requires a camera attached to a telescope to capture the faint light emitted by the nebula at different wavelengths. Computer software is then used to combine the different exposures and produce a full-colour image. At this stage, skill and judgement are required to bring out the detailed structure of the target object.

**Skywatcher Explorer 150PDS telescope; Skywatcher NEQ6 Pro mount; ATIK 383L+ Monochrome CCD camera; 5-hours total exposure**

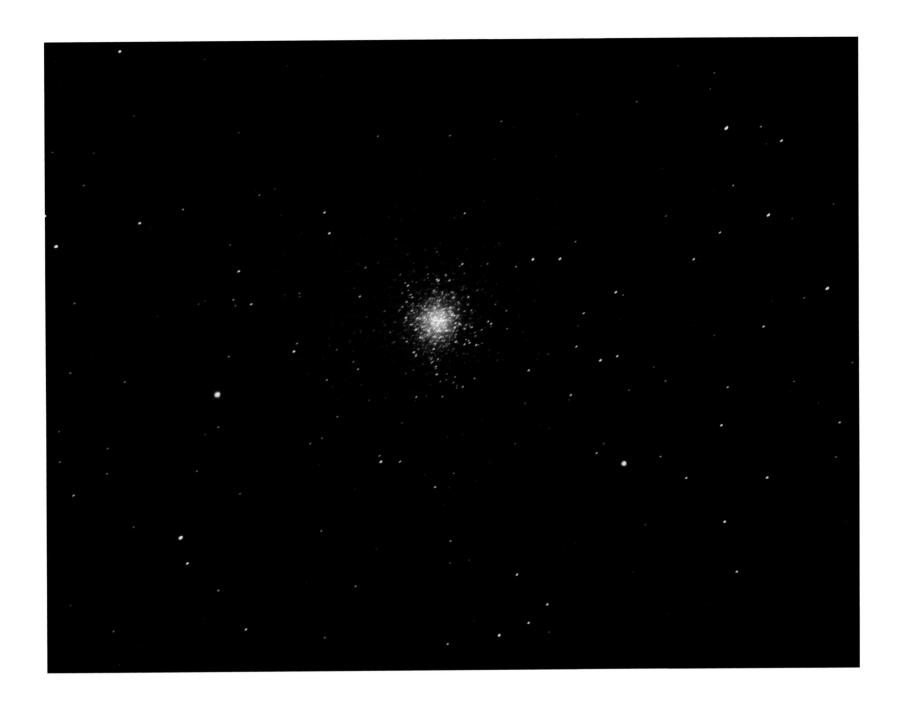

## SAMUEL COPLEY *(UK)*, AGED 15

### A Spider Web of Stars
*[20 April 2013]*

**Original competition category: young astronomer**

**SAMUEL COPLEY:** This is a photo of the Great Globular Cluster in Hercules. It was a nice target to try and image as it looked good in the telescope, so I slewed to Vega to focus the camera. After that I went back to M13 (the Cluster) and centred it with my finder scope. I used different exposures to see how it made a difference. So I went into the computer room to play with the image and this is what came out – by far the best photo I have taken to date.

**BACKGROUND:** A globular cluster is a challenging target for any astrophotographer. The hundreds of thousands of ancient stars which make up the cluster are closely packed together. Skill and judgement are required to ensure that the individual stars stand out clearly.

**Skywatcher 200mm mirror; EQ5 Pro equatorial mount; 200mm mirror lens; Lumix G10 camera; ISO 1600; 60-second exposure**

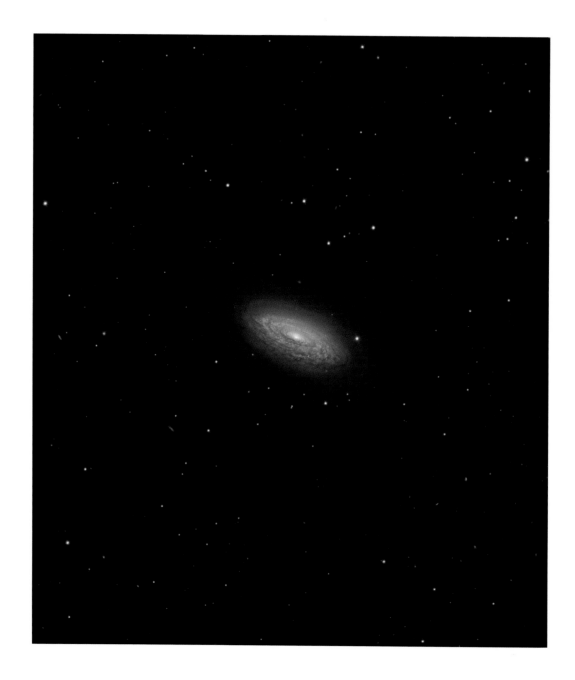

 Λ

## ADAM BLOCK *(USA)*

### Rapt with Spiral Arms
*[25 March 2014]*

**ADAM BLOCK:** I always enjoy highlighting objects that I feel do not receive enough attention. This is a spectacular galaxy which features a wealth of small details. I am especially fond of the dust lanes that circumscribe the galaxy within its extended halo. This data was collected on a few clear nights between winter storms. Since the time was limited, I carefully monitored the data acquisition so that each available second of time was used collecting light.

*Mount Lemmon SkyCenter, Tucson, Arizona, USA*

**BACKGROUND:** Despite the immense size of this galaxy, which is around 100,000 light years across and contains hundreds of billions of individual stars, the framing of the image emphasizes its isolation on the even vaster scales of intergalactic space. The typical distances between galaxies are so large that in the early twentieth century they were sometimes referred to as 'island universes'.

**0.8m reflector; equatorial mount; SBIG STX-16803 camera; f/7 lens; 9-hour exposure (L), 4-hour exposures (RGB)**

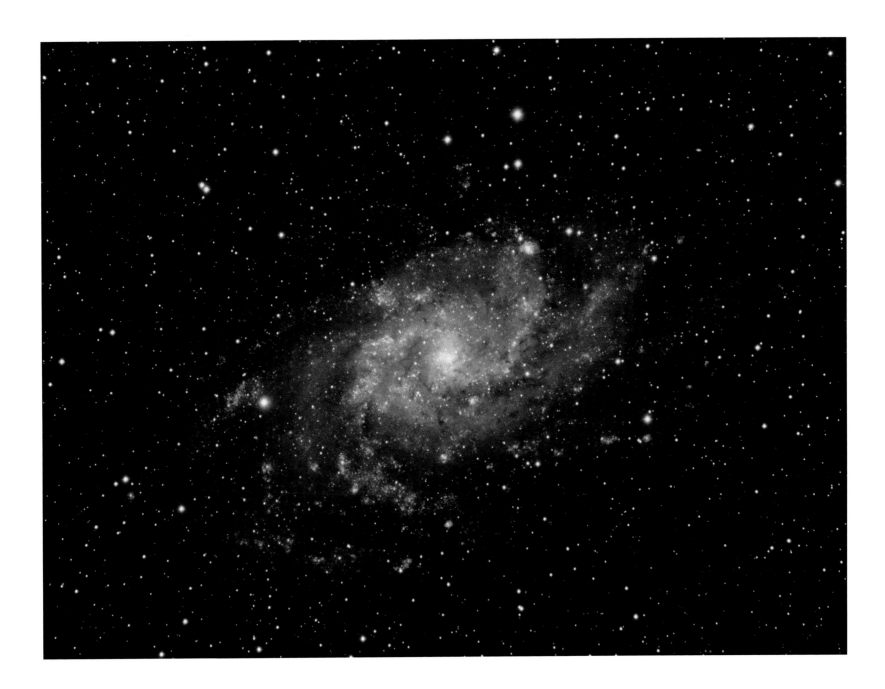

**MATTHEW FOYLE** *(UK)*

### The Triangulum Galaxy (M33)
[*7 September 2013*]

**MATTHEW FOYLE:** I could get no more than 13 hours of data for this image due to the bad UK winter weather. I have become fond of M33 in the short time I have been imaging because of its large hydrogen alpha regions and the size and scale of some of them. It also has some nice background galaxies. I feel it is often overlooked for the more famous Andromeda Galaxy. I have spent many hours trying to get some good data under reasonable skies.

*Bakewell, Derbyshire, England*

**BACKGROUND:** At a distance of just three million light years Messier 33, in the constellation of Triangulum, is one of our nearest and most photographed galactic neighbours. Along with the Andromeda Galaxy and our own Milky Way it is a member of the Local Group of galaxies and is one of the few galaxies that can be seen with the naked eye, although this requires excellent eyesight and extremely dark viewing conditions. Photography is able to reveal the full splendour of the galaxy's spiral structure, along with its prominent hydrogen alpha regions – clouds of hydrogen gas which glow with a characteristic red/pink light.

Takahashi FSQ-106ED telescope; NEQ6 Pro mount; QHY9M camera; 848mm f/8 lens; 10- and 20-minute exposures

## MICHAEL SIDONIO (Australia)

### The Jets of NGC 1097
[5 October 2013]

**MICHAEL SIDONIO:** Looking like antennae, very faint structures or jets associated with NGC 1097 in Fornax can be seen emanating above right and to the left of the galaxy in this image. These structures are thought to be streams of stars left after a smaller galaxy passed through the larger galaxy billions of years ago. The surface brightness of these jets is as faint as 27 magnitudes per square arcsecond.

*Wallaroo, Yorke Peninsula, South Australia*

**BACKGROUND:** To understand the Universe astronomers often have to take on the role of detectives, piecing together the history of an object from subtle clues. NGC 1097 is a good example of this. At first glance it looks like just an ordinary spiral galaxy drifting serenely through space, but a closer inspection reveals hints of a more turbulent past. Faint trails of stars may be the debris of a smaller galaxy, cannibalized by NGC 1097 long ago, while the galaxy's brilliant core contains a region of violent star-formation surrounding a supermassive black hole.

**Orion Optics AG12 f/3.8 Astrograph telescope; Astronomik filters; Starlight Xpress SXVR-H694 camera**

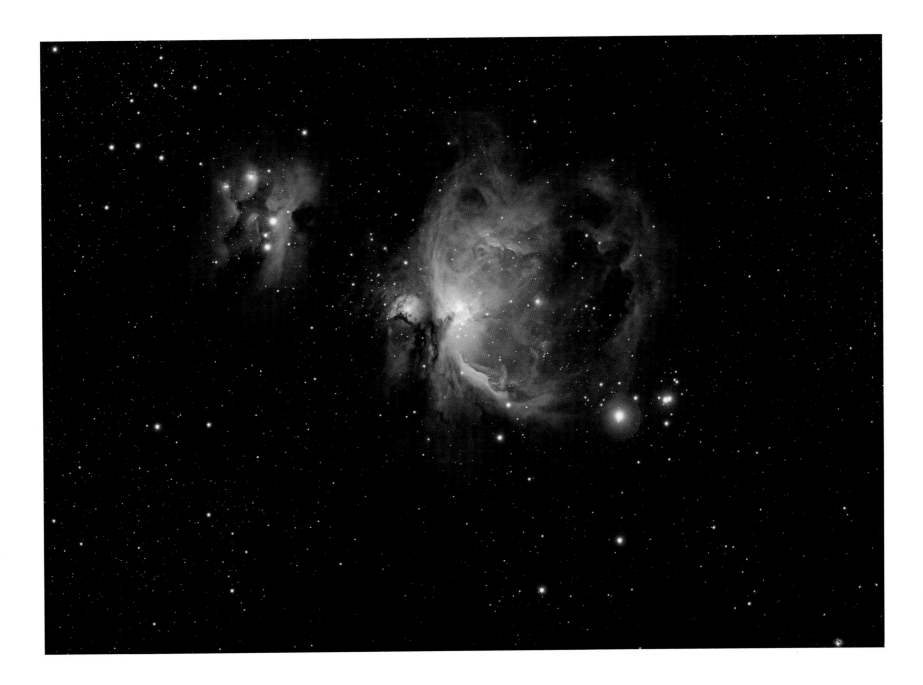

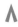

**TANJA SUND** *(South Africa)*

### Star Factory, the Orion Nebula
[*13 February 2014*]

**TANJA SUND:** M42 is a gloriously diffuse but bright nebula. It's a wonderful target for novices to experience as there's always more data and detail to find. It's easy to capture, but difficult to master.

*Johannesburg, Gauteng, South Africa*

**BACKGROUND:** A vast region of gas and dust in which new stars are constantly forming, the Orion Nebula is easily visible to the naked eye, appearing as a small, fuzzy patch of light in the middle of the Sword of Orion. Its proximity and brightness make it an extremely popular target for astrophotography but in choosing exposure times, colour filters, framing and image processing each photographer brings his or her own vision to the subject. Here, the nebula is shown floating peacefully among the surrounding stars.

**Officina Stellare telescope; Celestron Advance VX mount; OS Hiper APO 105mm lens; Canon 60Da camera; 650mm f/6.2 lens; ISO 400; 196-minute total exposure**

## DAVID FITZ-HENRY (Australia)

### The Helix Nebula (NGC 7293)
*[29 September 2013]*

**DAVID FITZ-HENRY:** The Helix Nebula is an example of a planetary nebula formed at the end of a star's evolution. Gases from the star in the surrounding space appear, from our vantage point, as if we are looking down a helix structure. The remnant central stellar core, known as a planetary nebula nucleus, is destined to become a white dwarf star. The observed glow of the central star is so energetic that it causes the previously expelled gases to brightly fluoresce.

*Bowen Mountain, New South Wales, Australia*

**BACKGROUND:** Looking like a giant eye peering across 700 light years of space, the Helix Nebula is one of the closest planetary nebulae to the Earth – and one of the best studied. This highly-accomplished image reveals delicate detail in the glowing gas that makes up the nebula, including the tadpole-like 'cometary knots' which seem to trail from the inner edge of the gaseous ring. These are actually nothing to do with comets but are clumps of gas being bombarded by fierce radiation from the dying star at the centre of the nebula. The 'head' of each knot is around the size of our solar system.

**Home-built Newtonian telescope; Paramount ME mount; 317.5mm mirror lens; STL-11000M camera; 1525mm f/4.8 lens**

*"The Helix Nebula always reminds me of the* Lord of the Rings *movies, for obvious reasons. The photographer has really brought out its resemblance to a staring eye."*
MAREK KUKULA

*"The level of detail in the inner part of the Helix is superb. It looks like a giant eye looking back at you!"*
PETE LAWRENCE

*"To me, the greatest example of the sublime aesthetic in this year's competition. The nebula is like an ominous eye looking over us; beauty can also be terrifying."*
MELANIE VANDENBROUCK

*"I gasped the first time I saw this picture. What an explosion of colour, almost like the eye of the Universe is staring right at you."*
MELANIE GRANT

*"Planetary nebulae like this one last for only a few tens of thousands of years; the beautiful rings of the Helix are the outer layers of the dying star visible right at the centre of the image."*
CHRIS LINTOTT

*"You get a real sense of peering into a 3D structure, looking at this image of this planetary nebula."*
CHRIS BRAMLEY

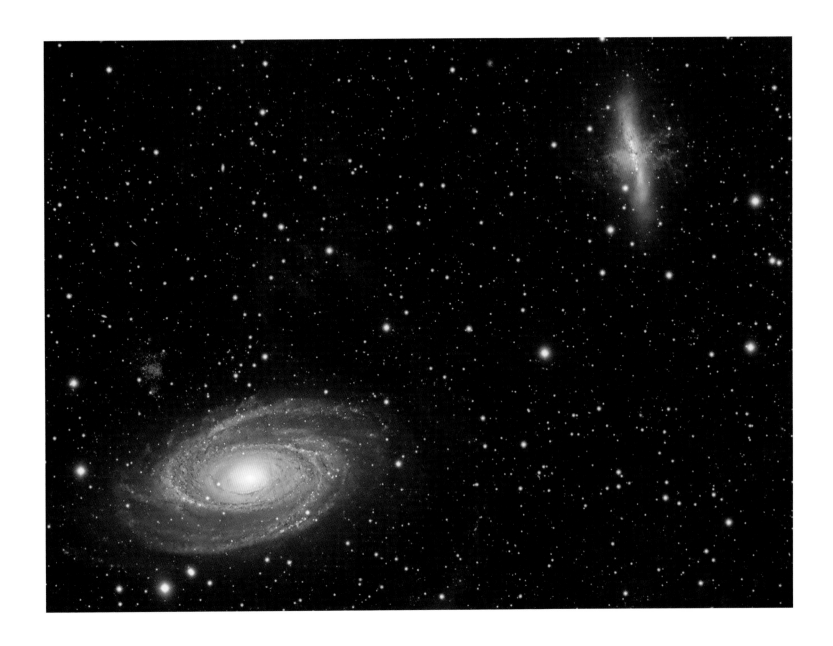

∧

## ANDRÉ VAN DER HOEVEN, MICHAEL VAN DOORN, NEIL FLEMING *(Netherlands)*

### M81/M82 with SN2014J – Extreme Deep Field
[*25 January 2014*]

**ANDRÉ VAN DER HOEVEN, MICHAEL VAN DOORN, NEIL FLEMING:**
This image shows the galaxy pair M81 and M82. This is a familiar object for many astronomers worldwide. In January 2014 a supernova was discovered in M82 and therefore the decision was made by André van der Hoeven to image this beautiful galaxy pair. The result was later combined with data from Neil Fleming and Michael van Doorn to bring out details in the much fainter Integrated Flux Nebula, showing dust reflecting light from our own galaxy, which is highly present in this region. For this image data from four different set-ups was combined with a total exposure time of 34.5 hours.

*Hendrik-Ido-Ambacht, Netherlands*

**BACKGROUND:** Found in the constellation Ursa Major, two distinctly different objects stand out: the larger, face-on spiral galaxy M81, and the smaller, edge-on starburst galaxy M82. The pair tidally interact, triggering the ferocious star formation in the smaller of the two by channelling gas into its core. Both are part of the M81 group, and are approximately twelve million light years from our solar system.

**TEC140 telescope; NEQ6 mount; QSI 583 WSG camera**
**Celestron C11 (Hyperstar) telescope; SXVR-H16 camera**
**TMB203 telescope; SBIG STL-6303E camera**

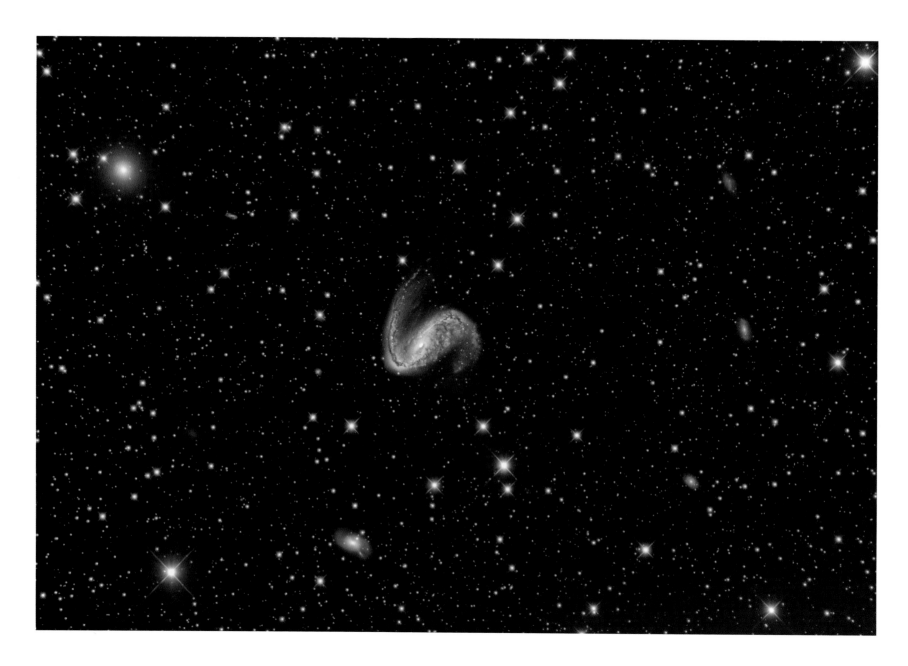

**PAUL HAESE** *(Australia)*

### The Meat Hook (NGC 2442)
[*4 March 2014*]

**PAUL HAESE:** The shape of this galaxy is what attracted me the most. It is hard to make out which arm is closest to us in space, so it is a unique-looking galaxy. It is a relatively dim object with a low surface brightness and that was all the more reason to image this interesting galaxy.

*Clayton Bay, South Australia*

**BACKGROUND:** A thick vein of dust and gas runs through the prominent hook-like arm of this unusual object. Its asymmetric shape is a hint that the galaxy has had an interesting life, perhaps surviving a close encounter with another galaxy. Detailed studies have revealed the presence of a nearby gas cloud which may have been torn away from the Meat Hook during the near miss.

GSO RC12 telescope; Paramount MX mount; SBIG STXL-11002 camera; 2440mm f/8 lens

**IVAN EDER** *(Hungary)*

### Centre of the Heart Nebula
[*5 October 2013*]

**IVAN EDER:** One of my favourite targets, this active star-forming region has a lot of interesting formations, arcs, triangles and geometric forms. This narrowband image was taken with H-alpha, OIII, SII filters, while the star colour data came from the DSLR camera taken with the same scope.

*Agasvar, Nógrád, Hungary*

**BACKGROUND:** Lying at a distance of 7500 light years in the 'W'-shaped constellation of Cassiopeia, the Heart Nebula is a vast region of glowing gas, energized by a cluster of young stars at its centre. Here we see a part of this central region, where dust clouds are being eroded and sculpted into mountainous shapes by the searing stellar radiation.

300/1130 self-built Newtonian telescope; Fornax 51 mount;
QSI 683 WSG and Canon 5D MkII cameras; 7-hour exposure

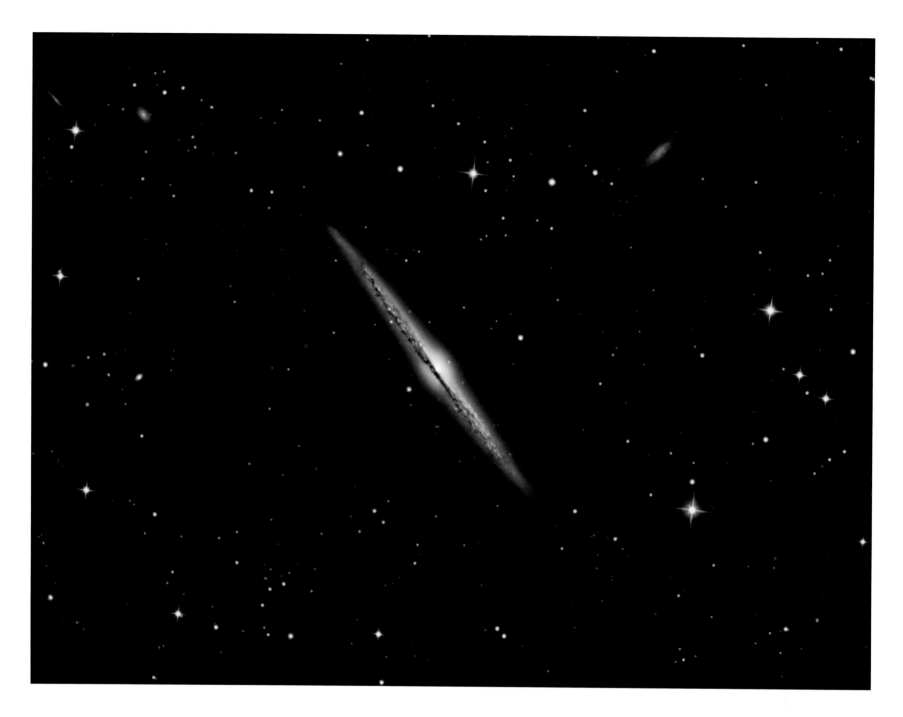

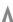

## ANTONIS FARMAKOPOULOS (*Greece*)

### NGC 4565 Galaxy
[*23 July 2013*]

**ANTONIS FARMAKOPOULOS:** The NGC 4565 Galaxy is also known as the Needle Galaxy because of its narrow profile, but in fact it is a spiral galaxy. The galaxy is located in the constellation Coma Berenices about 30 million light years away from us and has a diameter of 100,000 light years.

*Keratea, East Attica, Greece*

**BACKGROUND:** The edge-on view of this elegant spiral galaxy highlights how thin and delicate its disc of stars really is. The galaxy's dust lanes are thrown into sharp relief against the central 'bulge' of billions of ancient stars. Other, even more distant galaxies can be seen scattered across the background of the image.

**Toscano 10-inch Truss RC telescope; Celestron CGE Pro mount; QHY9M camera; 2250mm f/9 lens**

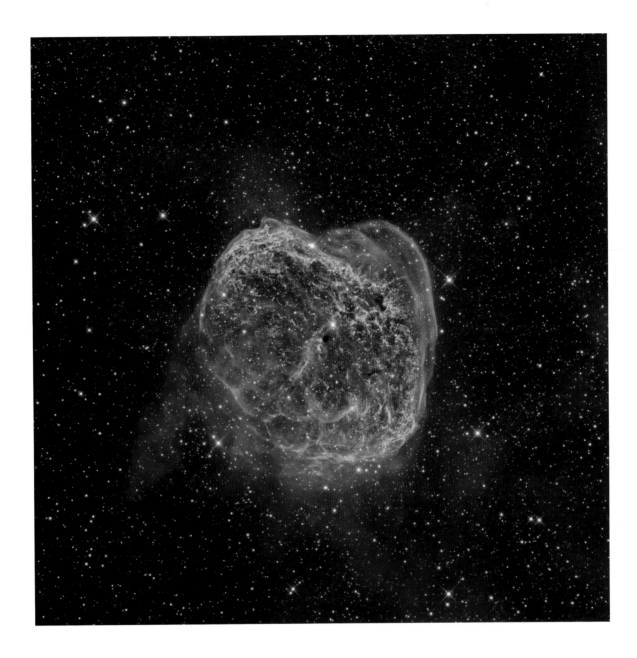

∧

**MARK HANSON** *(USA)*

### NGC 6888
[*29 September 2013*]

**Original competition category: robotic scope**

**MARK HANSON:** The Crescent Nebula is an often imaged object so I wanted to do something special with it by going as deep as possible with the OIII filter. I used one hour exposures and was quite surprised at how much OIII was in this image. It almost overwhelms the H-alpha data. This is such a striking image, it seems quite 3D and just pops out at you. I had imaged the Crescent Nebula quite a few times before with different telescopes and cameras over the years. I remember looking back at the data when the 'Soap Bubble' was discovered and sure enough it was in my images, so you just never know what you will capture even when it's been imaged so frequently.

*Rancho Hidalgo, New Mexico, USA*

**BACKGROUND:** This colourful starscape reveals the intricate structure of the Crescent Nebula, a colossal shell of material ejected from a powerful but short-lived Wolf-Rayet star (WR 136), seen close to the image centre. After just 4.5 million years, this volatile star ballooned into a red giant some 250,000 years ago, losing about half its mass to space. Ultraviolet radiation and stellar wind from WR 136 now heat the billowing cloud, causing it to glow. Deep exposures with narrowband filters (H-alpha and OIII) bring out the complex shapes carved by the star, as its fierce winds slam into the surrounding gas.

**RCOS 14.5-inch f/8 Ritchey-Chretién telescope; Paramount ME2 mount, off-axis guided; Apogee U16M CCD camera; 26-hours total exposure**

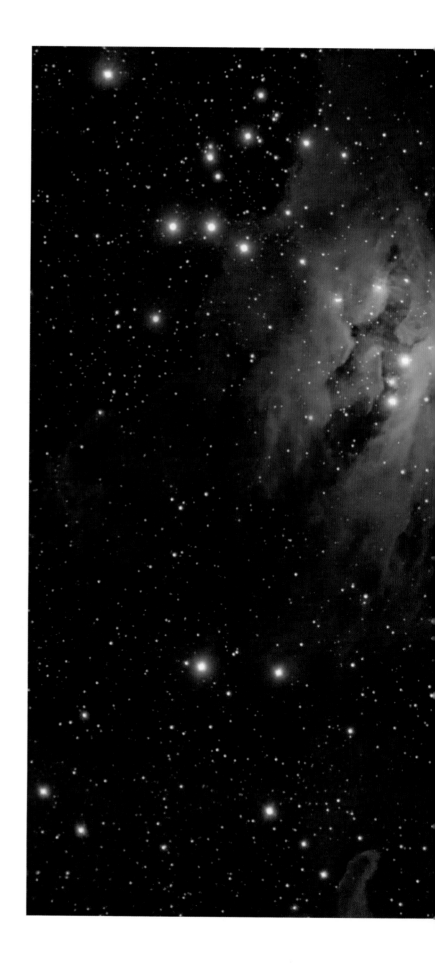

## ANNA MORRIS (USA)

### Orion Nebula
[10 December 2013]

**ANNA MORRIS:** I imaged Messier 42, the Orion Nebula, from my garden in Suffolk, England, before we moved back to the United States. It is a little bit more than eight hours of data, which was acquired over a few nights worth of imaging. Each night of imaging includes re-setting up my kit as I do not have a permanent observatory. The actual imaging was done with a stock Nikon D7000 and an Orion EON80ED scope. The processing to bring out the fainter dust lines from the data provided by my stock DSLR was a process that involved removing the stars for some super stretches and layering them back in with the original stack.

*Norton, Suffolk, UK*

**BACKGROUND:** In this view of M42 the photographer has chosen to emphasize the faint and delicate veils of dust that surround the more familiar glowing heart of the nebula. Her approach highlights the three-dimensional structure of the object, giving a sense of vast cavities filled with glowing pink hydrogen gas and the blue haze of reflected starlight.

Orion EON80ED telescope; Celestron CPC800XLT (on a wedge),
EON is piggybacked mount; Nikon D7000 camera; 500mm f/6.25 lens;
ISO 200; 8-hours total exposure

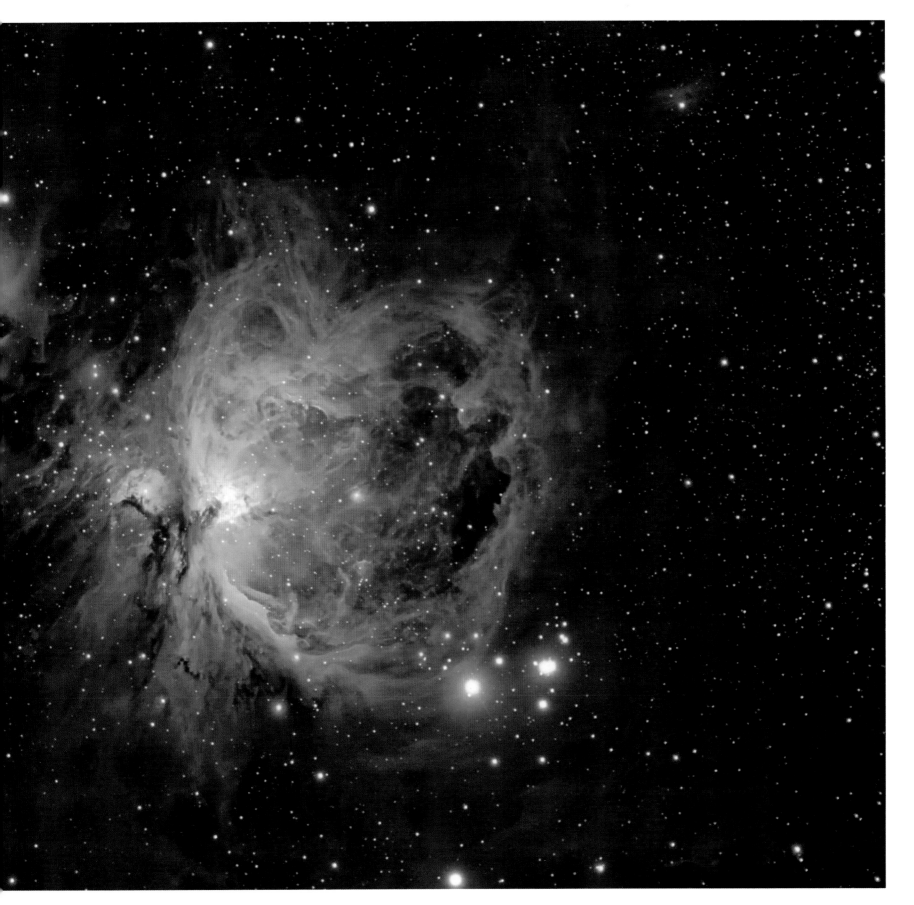

### J.P. METSÄVAINIO *(Finland)*

## Veil Nebula Detail (IC 1340)
*[29 October 2012]*

**J.P. METSÄVAINIO:** IC 1340 is part of the Veil Nebula, a supernova remnant in the constellation Cygnus at a distance of about 1470 light years. This is one of the more luminous areas in this SNR (supernova remnant). The shock fronts formed by the material ejected from giant explosions – the supernova – can be seen in this image.

*Oulu, Northern Ostrobothnia, Finland*

**BACKGROUND:** The angular shapes and garish colour palette help to convey the violent origins of this gaseous structure, part of the debris of an exploding star which detonated over 5000 years ago. The glowing relic is still expanding, and the entire nebula now covers an area of the sky about 36 times larger than the full Moon.

**Meade LX200 GPS 12-inch telescope; Meade fork mount; QHY9 camera; 2000mm f/6 lens**

*"There is a fabulous sense of movement, luminosity and weightlessness in the rendering of the gas emissions of this nebula."*

MELANIE VANDENBROUCK

*"Simply awe-inspiring."*

MELANIE GRANT

*"Rendering this reflection nebula with the Hubble palette brings to mind flickering flames – captivating!"*

CHRIS BRAMLEY

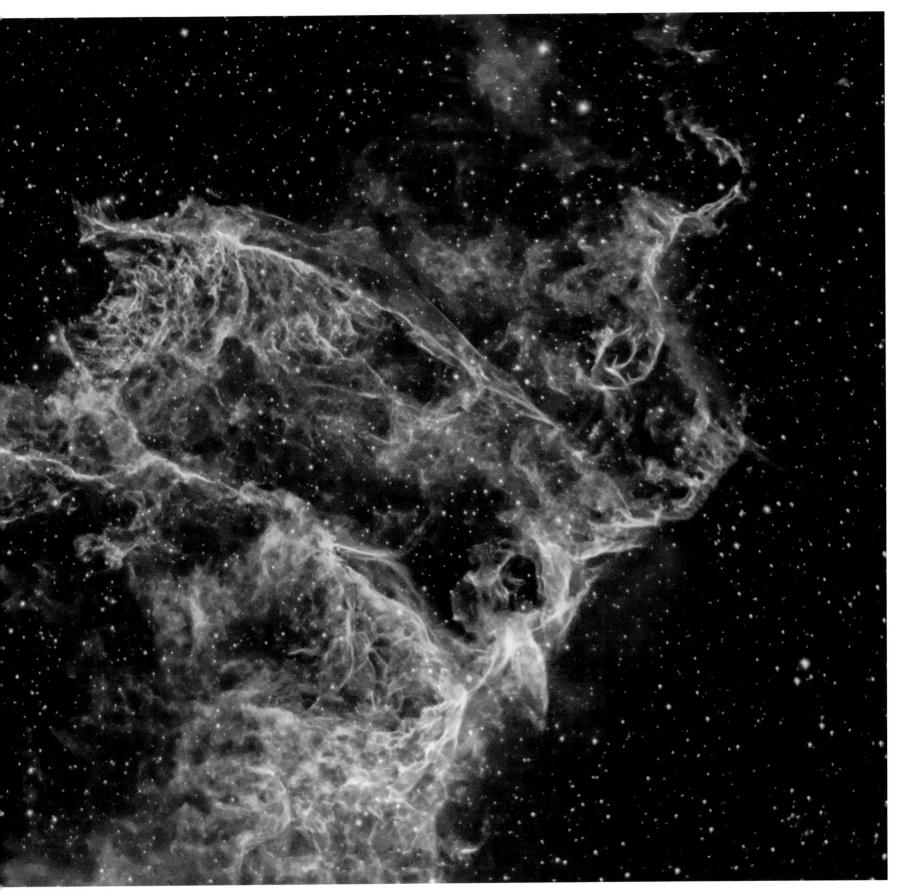

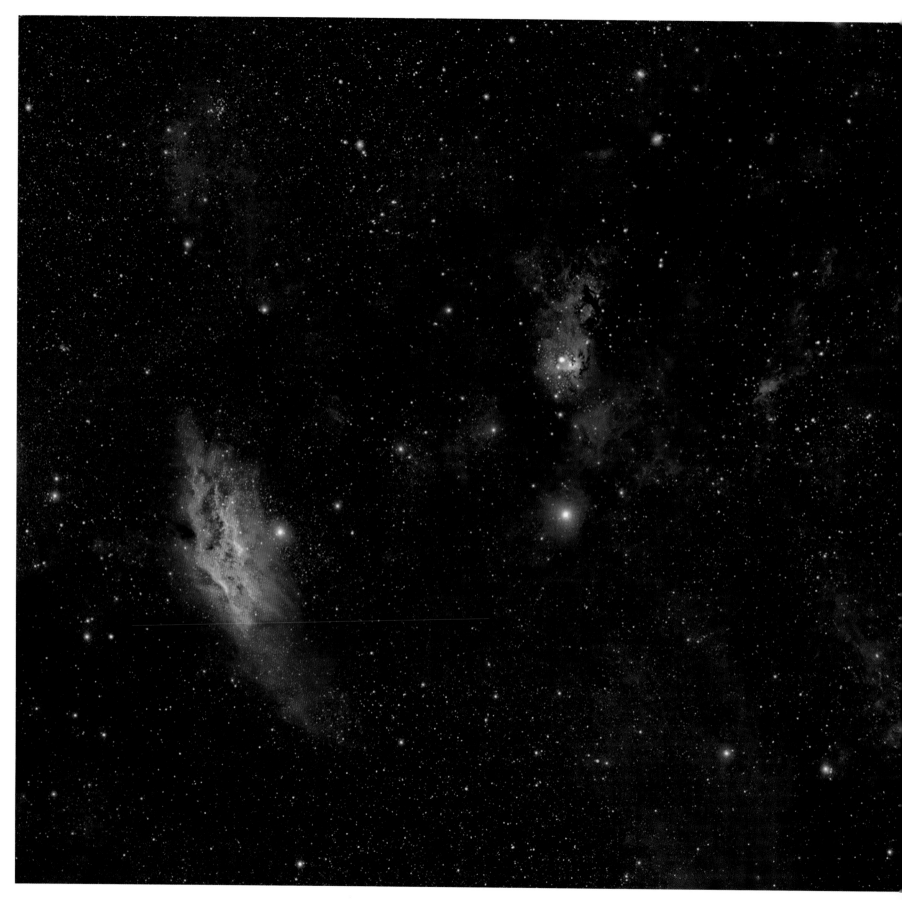

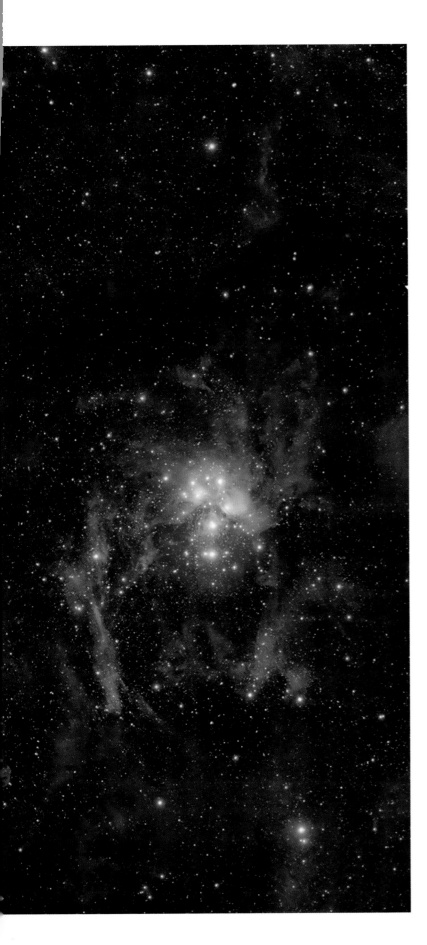

<

## ROGELIO BERNAL ANDREO *(USA)*    *HIGHLY COMMENDED*

### California vs Pleiades
[*20 November 2013*]

**ROGELIO BERNAL ANDREO:** A vast field featuring the California Nebula, the famous Pleiades and other lesser-known objects. My interest was not only the main characters but also anything else that might be there. In this case, numerous molecular clouds of dust remind us that the night sky is often filled with structures that escape the eye, and even the camera.

*DARC Observatory, Los Baños, California, USA*

**BACKGROUND:** Known since ancient times as the Seven Sisters, the Pleiades Cluster, to the right of this image, actually consists of around a thousand stars which formed together about 100 million years ago. The Pleiades are a perennial favourite of amateur astronomers and astrophotographers, but this unusual view shows the cluster in the broader context of its local environment, drifting through a chaotic region of dark dust. The California Nebula, named for its resemblance to the US state, is the cloud of glowing hydrogen gas to the left of the image.

**Takahashi FSQ-106 telescope; Takahashi EM-400 mount; SBIG STL-11000 camera; 385mm f/3.7 lens; 57-hour exposure**

*"It's great to see the Pleiades set in the wider context of dust clouds and glowing emission nebulae. I love how chaotic this familiar corner of the sky appears in this shot."*
MAREK KUKULA

*"Beautiful, complex; enigmatic too. The bright clusters draw your eye in."*
MELANIE VANDENBROUCK

*"This sort of extreme wide-field photography needs skill and patience to work – and here both have paid off wonderfully."*
CHRIS LINTOTT

*"Gazing up at the Pleiades on a clear night, you'd have no idea that this part of space is so full of delicate veils of dust."*
CHRIS BRAMLEY

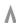

## SHISHIR & SHASHANK DHOLAKIA *(USA)*, AGED 15

### The Leo Triplet
[*30 December 2013*]

**Original competition category: young astronomer**

**SHISHIR & SHASHANK DHOLAKIA:** A striking triad of galaxies in the constellation Leo, these three gravitationally bound spiral galaxies are stunningly contrasted in their proximity to each other. These galaxies, M66, M65 and NGC 3628, are a perfect example of the multitude of shapes and sizes of galaxies in the cosmos. My twin brother and I decided to take this image on our second camping trip to Lake San Antonio in the wee hours of the morning, just as we noticed the

magnificent Leo rising. We used our father's equipment to take the photo, and we used PixInsight to post-process the images.

*Lake San Antonio, California, USA*

**BACKGROUND:** Although these galaxies are of the spiral variety, each one offers a different perspective. M66 is seen 'face-on', M65 is seen at an oblique angle and NGC 3628 is seen 'edge-on'. With multiple exposures using four filters, the astrophotographers obtained a crisp, clear image of the trio so that each is a visual treat when inspected up close. The light from these galaxies has had a journey of 35 million years.

**Astro-Tech 111mm f/7 triplet refractor; Orion Atlas EQ-G mount; SBIG ST-8300M camera; 8 x 900-second exposures (L) and 5 x 600-second exposures (RGB)**

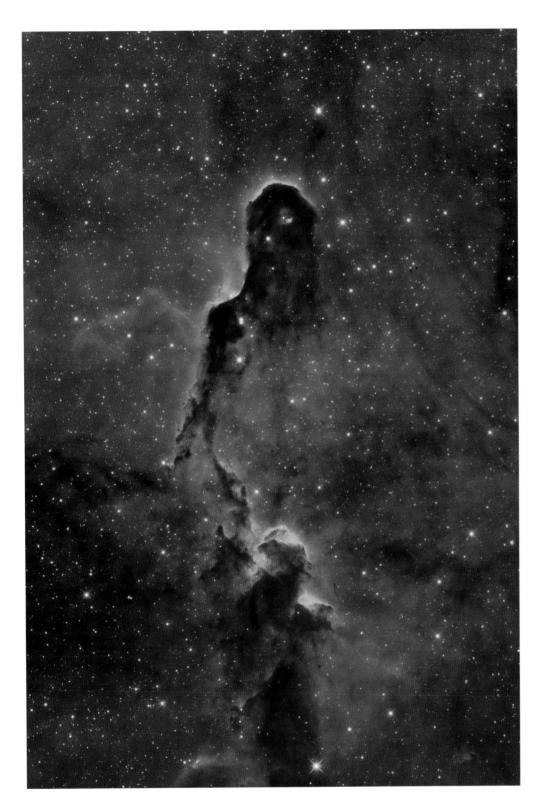

## IVAN EDER (Hungary)

### Elephant Trunk Nebula (IC 1396)
[5 October 2013]

**IVAN EDER:** This is not my first attempt at photographing this beautiful object. I have tried to image it several times during the last ten years with different telescopes and cameras; from old film techniques to modern digital SLR cameras. But I was never completely satisfied with my results. In October last year, the sky was remarkable over the mountains in Hungary – where I used to go out for imaging – so I chose this object again to make a tight and narrow composition. I used a CCD camera with narrowband filters and the false colour 'Hubble palette' technique. I believe both the tight composition and the new technique helped to bring life to this image, making the nebula shine brilliantly.

*Agasvar, Nógrád, Hungary*

**BACKGROUND:** The colour palette in this image is highly effective at revealing the complexity and subtle features present in the nebula. In particular, there is a beautiful contrast at the top of the central spire between the dark, dense gas and dust globule, and its edge where a massive, luminous star is ionizing the boundary of that structure.

**300/1130 self-built Newtonian telescope; Fornax 51 mount; QSI 683 WSG camera; 7.5-hour exposure**

## At the Feet of Orion (NGC 1999) — Full Field
[*16 December 2013*]

**MARCO LORENZI:** This shot is centred on NGC 1999, a fantastic area situated below Orion's Belt. The proximity of several popular targets in one of the richest constellations of the sky often means this tiny nebula and its surroundings are overlooked, and this is a real pity. In this 18-hour exposure, I particularly like the contrast between the yellow/brown dusts and red and blue gases — an explosion of colours in a rather small area. At the centre of the image, the small NGC 1999 looks like a tiny keyhole.

*Warrumbungle Observatory, Coonabarabran,*
*New South Wales, Australia*

**BACKGROUND:** Images like this one remind us that there is often more going on in our galaxy than meets the eye and that the space between the stars is rarely completely empty. An extremely long exposure brings out billowing dust and gas clouds that are normally overshadowed by their more glamorous neighbour at the top of the image, the dazzling heart of the Orion Nebula. The scatter of bright blue stars illuminates the dust, enabling us to see it.

**TEC140 refractor; Paramount ME mount; FLI Proline 16803 camera; f/7.2 lens; 12–360-minute exposures**

*"I'm impressed by the way the photographer has managed to convey the 3D texture of this nebula. The central regions almost pop out of the frame."*
MAREK KUKULA

*"What a lovely composition this is. Deep reds of swirling gas fill much of the frame, with the pink mist of the outer Orion Nebula visible in the upper right."*
PETE LAWRENCE

*"The level of detail here is incredible; there's a real sculptural quality stretching across the many light years of space captured in the image."*
CHRIS BRAMLEY

## MARK HANSON *(USA)*                      <span>WINNER</span>

## NGC 3718
*[3 March 2014]*

**Original competition category: robotic scope**

**MARK HANSON:** Taken from Rancho Hidalgo in Animas, New Mexico, this is a very deep image of NGC 3718. Rancho Hidalgo has quite a few remote observatories on its property. Our observatory is the Doc Greiner Research Observatory (DGRO). The luminance data was collected over two full nights of excellent seeing. Aladin Sky Atlas calculates over 5000 galaxies in this photo, down to 24th magnitude.

*Rancho Hidalgo, New Mexico, USA*

**BACKGROUND:** Found in the constellation Ursa Major, NGC 3718 is known as a *peculiar* barred spiral galaxy. Gravitational interactions with its near neighbour NGC 3729 (the spiral galaxy below and to the left) are the likely reason for the galaxy's significantly-warped spiral arms, while a dark dust lane wraps around the centre.

**RCOS 14.5-inch f/8 Ritchey-Chretién telescope; Paramount ME2 mount, off-axis guided; Apogee U16M CCD camera**

*"I love the variety of shapes and forms displayed by the galaxies in this image. A great choice of subject!"*

MAREK KUKULA

*"This beautiful image shows not one but hundreds, perhaps even thousands, of galaxies scattered across space. I particularly like the fine details in the streams of stars strewn around NGC 3718."*

WILL GATER

*"Incredible image of a complex but very beautiful set of galaxies. The unusual structures in the blue arms of NGC 3718 convey complex gravitational forces shaping this galaxy. The contrast between the warm colours of the core and the outer arms is very beautiful. Magnitude +24 is very deep indeed – a great image."*

PETE LAWRENCE

*"This galaxy's unusual shape portrays a complicated past; it's undergone a collision in the recent past, probably responsible for the bright blue young stars sprinkled throughout the halo."*

CHRIS LINTOTT

*"As well as the fantastically bizarre galaxy that is at the centre of this image, many more distant examples surround it."*

CHRIS BRAMLEY

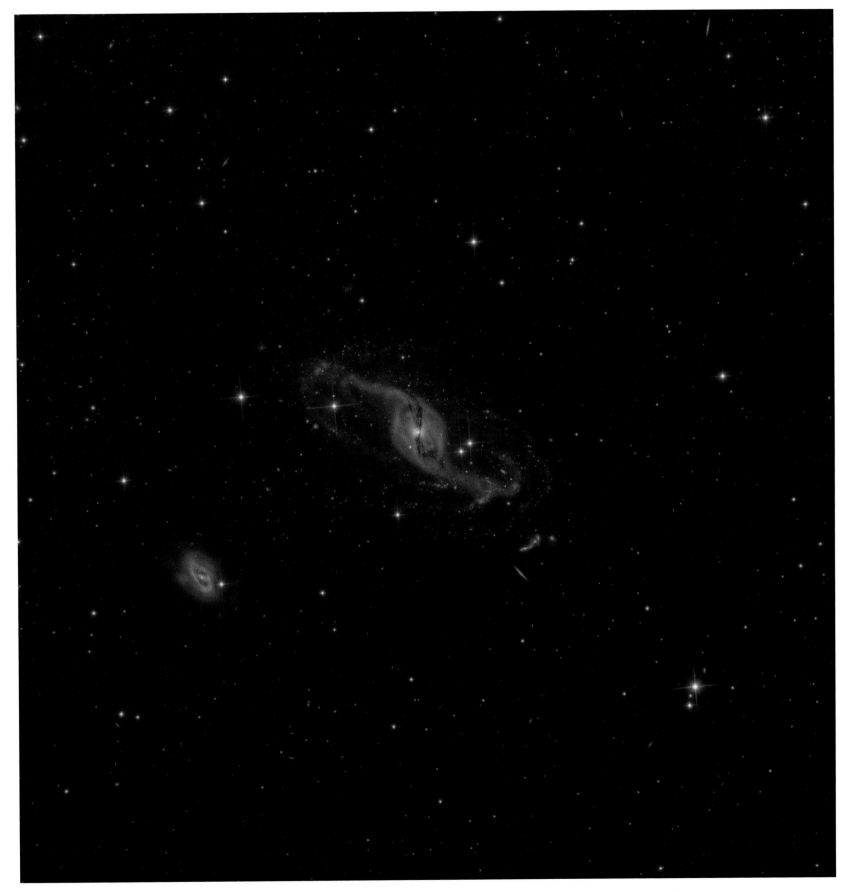

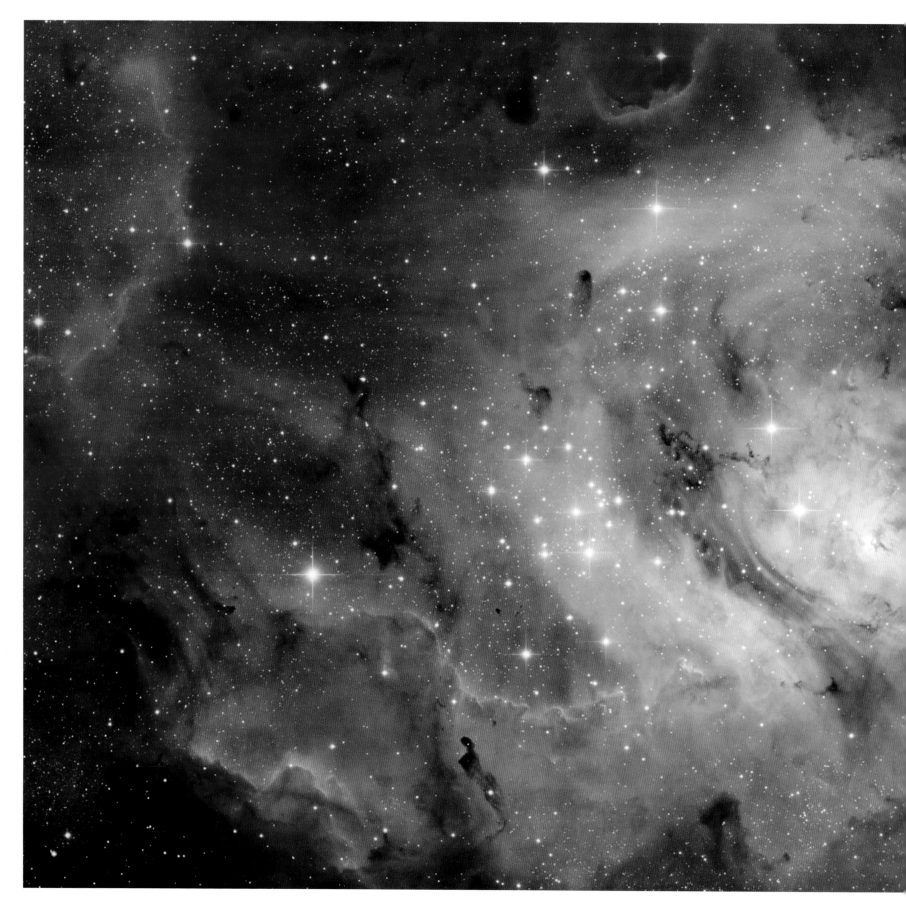

## LÁSZLÓ FRANCSICS *(Hungary)*

### The Morphology of the Lagoon Nebula
[*22 May 2014*]

**Original competition category: robotic scope**

**LÁSZLÓ FRANCSICS:** The Lagoon Nebula is well known for its oval form, crossed with a dark gas and dust stream, surrounded by young star clusters. However, when capturing it with a 0.5m aperture telescope, in good seeing conditions, smaller details are revealed. Thousands of gas filaments, dark globules containing protostars, and huge mountains of hydrogen clouds are visible. It is the thousands of undiscovered details that make the Lagoon Nebula even more interesting.

*Siding Spring Observatory, Coonabarabran, New South Wales, Australia*

**BACKGROUND:** The discovery of this giant stellar nursery dates back to the earliest days of modern astronomy and is often attributed to Giovanni Hodierna in the seventeenth century. Despite being thousands of light years away, its enormous size – over 100 light years wide – makes it highly conspicuous in binoculars and telescopes, seen roughly in the same apparent part of the sky as the centre of the Milky Way. The vivid pink colour, not visible to the eye but clear in this long exposure image, is characteristic of atomic hydrogen gas being ionized by the intense radiation of young stars.

**PlaneWave 20-inch Corrected Dall-Kirkham reflector; FLI-PL6303E CCD camera**

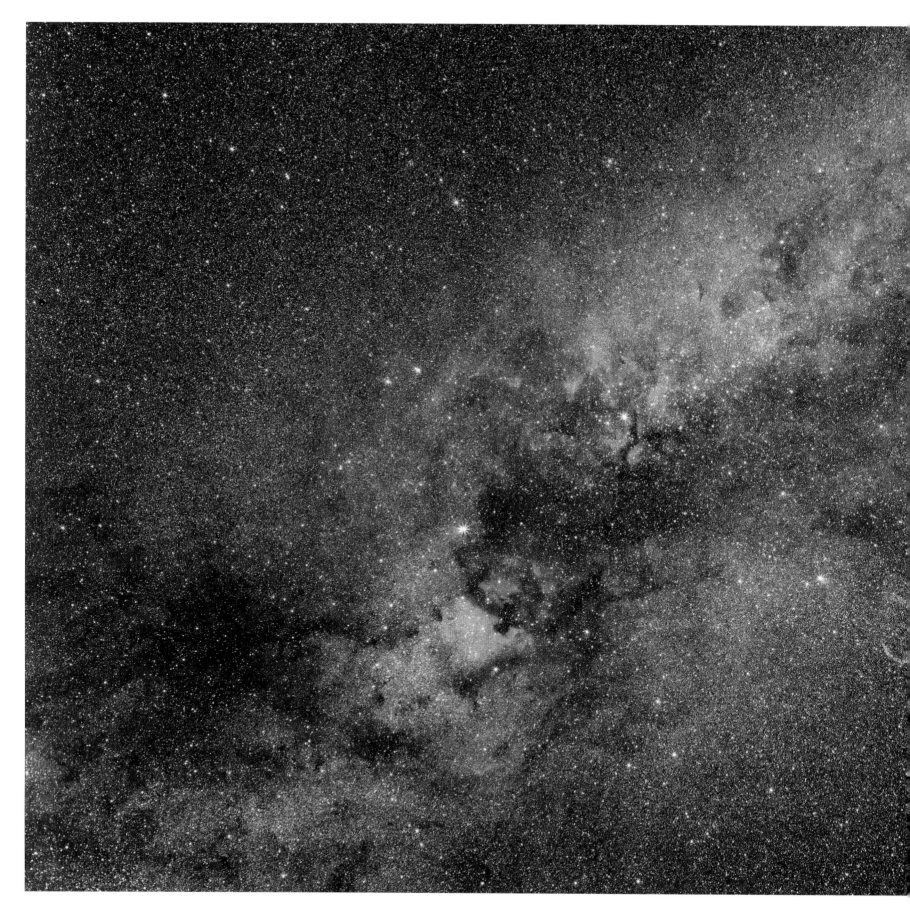

**LEONARDO ORAZI** *(Italy)*

### Zenith of the Northern Summer Sky
[*2 September 2013*]

**LEONARDO ORAZI:** Summer nights in European skies are dominated by the Cygnus constellation. Looking at the zenith from places dark enough – such as the Italian Alps – makes it easy to enjoy breathtaking views of this area of our Milky Way. The long exposure on this photo was unplanned – I was thinking of doing a few tens of seconds, but then I got lost in watching the stars. It's a beautiful reminder of the emotions that I will always carry in my heart.

*Pragelato, Turin, Italy*

**BACKGROUND:** Despite warmer temperatures, the short nights of summer can be problematic for astronomers as it rarely gets properly dark. Nevertheless, the summer skies of the Northern Hemisphere are graced by several prominent constellations, including Cygnus, the Swan, which stretches along the band of the Milky Way.

**Astro-Physics MACH1 GTO mount; Canon 50mm f/1.8 lens; Canon 5D MKII Baader camera; f/6 lens; ISO 1600; 1200-second exposure**

## DANIELE MALLEO *(USA)*

### The Crescent Nebula in H-alpha and OIII (NGC 6888)
*[8 November 2013]*

**Original competition category: best newcomer**

**DANIELE MALLEO:** The Crescent Nebula (also known as NGC 6888, Caldwell 27 and Sharpless 105) is an emission nebula in the constellation Cygnus, about 5000 light years away. It is formed by the fast stellar wind from the Wolf-Rayet Star WR 136 (HD 192163), colliding with and energizing the slower moving wind ejected by the star when it became a red giant around 250,000 to 400,000 years ago.

*El Cerrito, California, USA*

**BACKGROUND:** WR 136 is very close to the end of its life. Having 'puffed off' its outer layers into space, it now burns recklessly, poised to explode as a spectacular supernova, perhaps within the next 100,000 years. Fortunately it lies a great distance from our solar system, and presents no danger to Earth. Such an explosion will scatter 'metals' (in astronomy, elements heavier than helium) into the galaxy, perhaps seeding a new generation of solar systems.

**Celestron 8-inch Edge HD telescope; Astro-Physics Mach 1 mount, off-axis guided with Starlight Xpress SXV Lodestar and SXV-AO-LF Adaptive Optics unit; QSI 583 WSG camera; 2032mm f/10 lens; 18-hours total exposure**

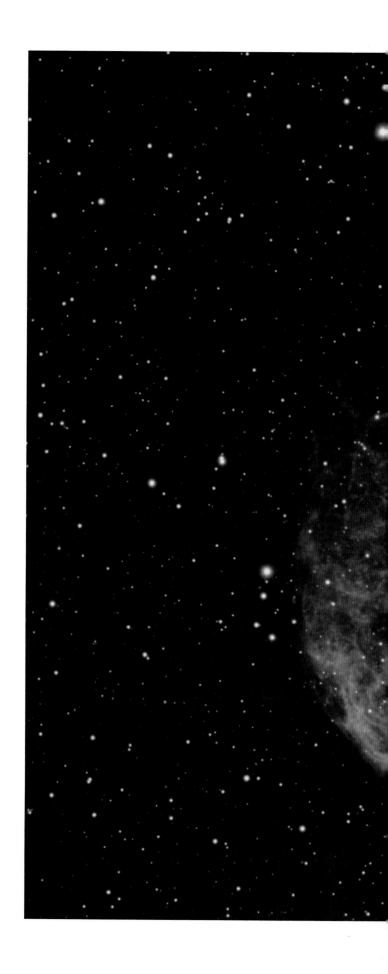

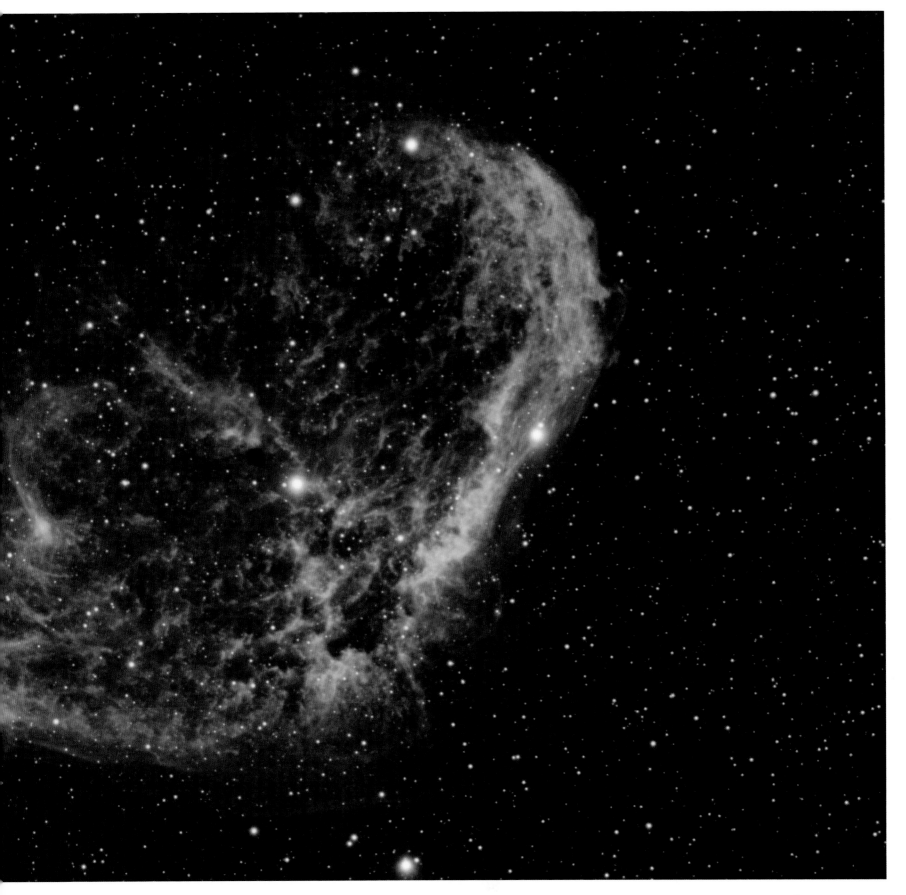

# ASTRONOMY ✦ PHOTOGRAPHER
## OF THE YEAR

# OVERALL WINNERS
## 2009–2014

The overall winners
from each year of
the competition

# CONTENTS: OVERALL WINNERS

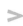

## MARTIN PUGH *(UK/Australia)*     *OVERALL WINNER 2009*

### Horsehead Nebula (IC 434)
[*16 March 2009*]

**MARTIN PUGH:** An extremely popular imaging target, it was an absolute 'must do' for me. My objective was to produce a high-quality, high-resolution image, blending in Hydrogen-alpha data to enhance the nebulosity. With this image, I really wanted to capture the delicate gas jets behind the Horsehead and kept only the very best data. If I could change anything about this photograph I would expand the frame to include the Flame Nebula and the Great Orion Nebula to create a superlative wide-field vista of this region.

My brother-in-law pulled a dusty old 3-inch refractor out of a closet in early 1999. This represented my first real look through a telescope and from then on I was completely hooked.

**BACKGROUND:** The Horsehead Nebula is a dark cloud of dust and gas, which from Earth appears to resemble the shape of a horse's head. The gas, dust and other materials condense to form dense knots, which will eventually become stars and planets. New stars have already formed inside part of the dust cloud, as can be seen on the bottom left. The nebula is silhouetted against a background of glowing hydrogen gas, with its characteristic reddish colour, and this exquisite image shows the delicate veils and ripples in the structure of the gas cloud. First identified in 1888, the nebula is located in the star constellation Orion and is about 1500 light years from Earth.

**SBIG STL11000 CCD camera guided with adaptive optics; 12.5-inch RC Optical Systems Ritchey-Chrétien telescope; Software Bisque Paramount ME mount; 19-hours of exposure**

*"The Horsehead Nebula is one of the most photographed objects in the sky, but this is one of the best images of it I've ever seen. Thirty years ago it would have taken hours of effort on a large professional telescope to make an image like this, so it really shows how far astronomy has come – a fitting way to celebrate the International Year of Astronomy in 2009."*

MAREK KUKULA

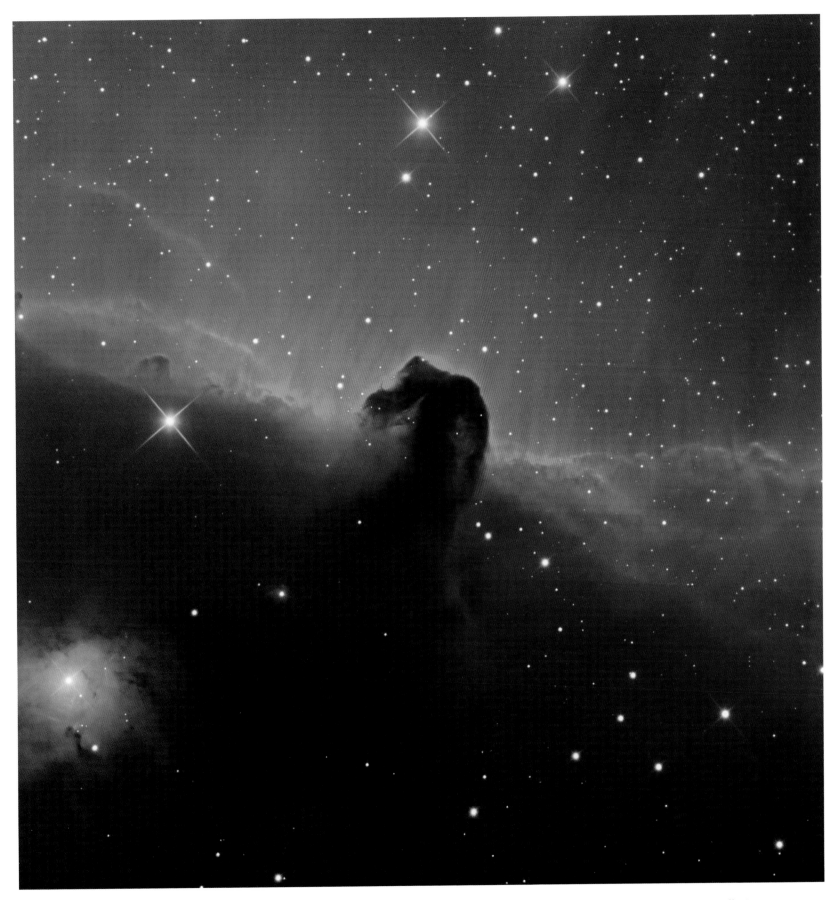

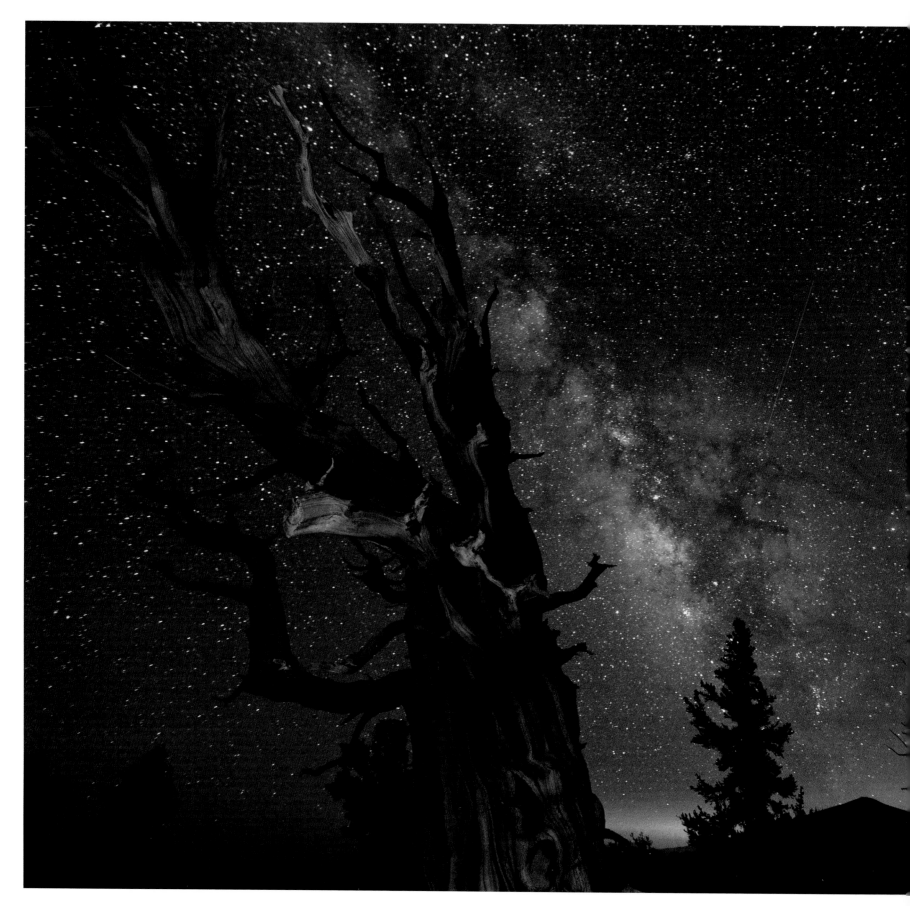

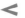

## TOM LOWE (USA)

### Blazing Bristlecone
*[14 August 2009]*

**TOM LOWE:** If I could change anything about this photo, it would be the artificial lighting! The light on that tree occurred accidentally because I had my headlamp and possibly a camping lantern on while I was taking a series of test shots! The artificial light is too frontal for me and not evenly distributed, but in the end the light did in fact show the amazing patterns in the tree's wood.

The reason these trees inspire me so much, aside from their obvious and striking beauty, is their age. Many of them were standing while Genghis Khan marauded across the plains of Asia. Being a timelapse photographer, it's natural for me to attempt to picture our world from the point of view of these ancient trees. Seasons and weather would barely register as events over a lifetime of several thousand years. The lives of humans and other animals would appear simply as momentary flashes.

**BACKGROUND:** The gnarled branches of an ancient tree align with a view of our Milky Way galaxy. The Milky Way is a flat, disc-like structure of stars, gas and dust measuring more than 100,000 light years across. Our sun lies within the disc, about two-thirds of the way out from the centre, so we see the Milky Way as a bright band encircling the sky.

This view is looking towards the centre of our galaxy, 26,000 light years away, where dark clouds of dust blot out the light of more distant stars. What appears to be an artificial satellite orbiting the Earth makes a faint streak of light across the centre of the image.

**Canon 5D Mark II camera; Canon EF 16–35mm lens at 16mm**

*"I like the way the tree follows the Milky Way and the definition is very good."*

SIR PATRICK MOORE

*"I think this beautiful picture perfectly captures the spirit of Astronomy Photographer of the Year, linking the awe-inspiring vista of the night sky with life here on Earth. The bristlecone pines in the foreground can live as long as 5000 years. But they are babies compared to the starlight shining behind them, some of which began its journey towards us almost 30,000 years ago."*

MAREK KUKULA

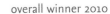

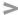

## DAMIAN PEACH (UK)

### Jupiter with Io and Ganymede, September 2010
[12 *September 2010*]

**DAMIAN PEACH:** This photograph was taken as part of a long series of images taken over a three-week period from the island of Barbados in the Caribbean – a location where the atmospheric clarity is frequently excellent, allowing very clear and detailed photographs of the planets to be obtained.

I've been interested in astronomy since the age of ten and have specialized in photographing the planets for the last 14 years. I'm very happy with the photo and wouldn't really change any aspect of it.

**BACKGROUND:** Jupiter is the largest planet in the Solar System. It is a giant ball of gas with no solid surface, streaked with colourful bands of clouds and dotted with huge oval storms.

In addition to the swirling clouds and storms in Jupiter's upper atmosphere, surface features of two of the planet's largest moons can be seen in this remarkably detailed montage. Io, to the lower left, is the closest to Jupiter. The most geologically active object in the Solar System, its red-orange hue comes from sulphurous lava flows. Ganymede, the largest moon in the Solar System, is composed of rock and water ice. The planet and its moons have been photographed separately, then brought together to form this composite image.

**Celestron 356mm Schmidt-Cassegrain telescope (C14); Point Grey Research Flea3 CCD camera**

*"This is a truly incredible image of the planet Jupiter. Damian has even managed to capture detail on two of Jupiter's moons! It's truly astonishing to think that this was taken from the ground by an amateur astronomer using his own equipment."*

PETE LAWRENCE

*"There were so many beautiful images this year but this one really stood out for me. It looks like a Hubble picture. The detail in Jupiter's clouds and storms is incredible, and the photographer has also managed to capture two of the planet's moons. An amazing image."*

MAREK KUKULA

**MARTIN PUGH** *(UK/Australia)*     OVERALL WINNER 2012

## M51 – The Whirlpool Galaxy
*[19 June 2012]*

**MARTIN PUGH:** I was always going to be excited about this image given the exceptional seeing conditions M51 was photographed under, and the addition of several hours of H-alpha data has really boosted the HII regions.

**BACKGROUND:** A typical spiral galaxy, the Whirlpool or M51, has been drawn and photographed many times, from the sketches of astronomer Lord Rosse in the 19th century to modern studies by the Hubble Space Telescope. This photograph is a worthy addition to that catalogue. It combines fine detail in the spiral arms with the faint tails of light that show how M51's small companion galaxy is being torn apart by the gravity of its giant neighbour.

**Planewave 17-inch CDK telescope; Software Bisque Paramount ME mount; Apogee U16M camera**

*"This is arguably one of the finest images of M51 ever taken by an amateur astronomer. It's not just the detail in the spiral arms of the Galaxy that's remarkable – look closely and you'll see many very distant galaxies in the background too."*

WILL GATER

*"The depth and clarity of this photograph makes me want to go into deep space myself! A breathtaking look at the Whirlpool Galaxy."*

MELANIE GRANT

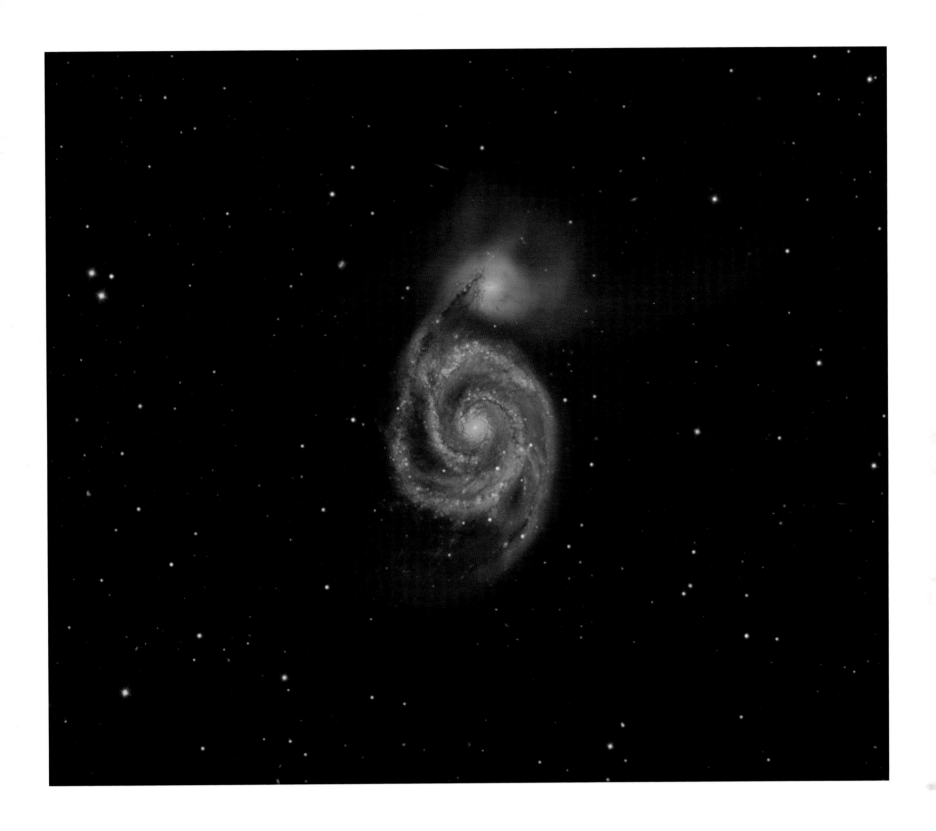

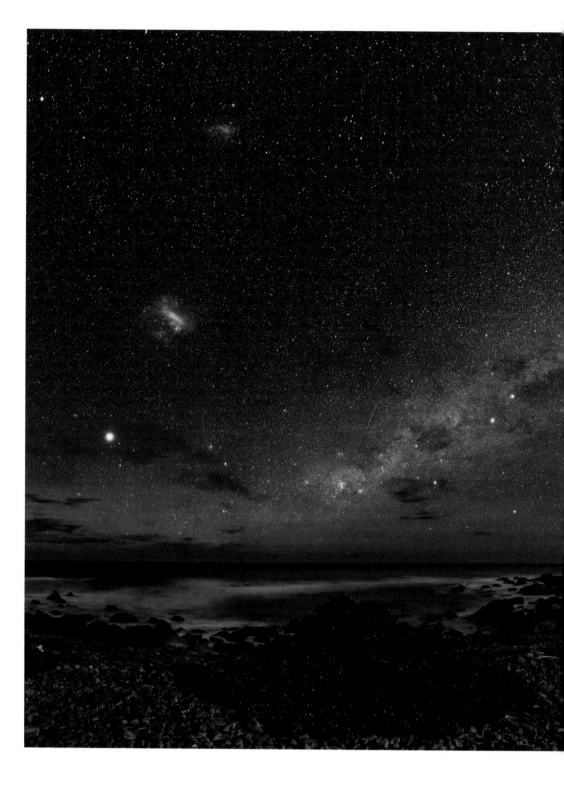

## MARK GEE (*Australia*)  OVERALL WINNER 2013

### Guiding Light to the Stars
[*8 June 2013*]

**MARK GEE:** I recently spent a night out at Cape Palliser on the North Island of New Zealand photographing the night sky. I woke after a few hours sleep at 5am to see the Milky Way low in the sky above the Cape. The only problem was my camera gear was at the top of the lighthouse, seen to the right of this image, so I had to climb the 250-plus steps to retrieve it before I could take this photo. By the time I got back the sky was beginning to get lighter, with sunrise only two hours away. I took a wide panorama made up of 20 individual images to get this shot. Stitching the images together was a challenge, but the result was worth it!

**BACKGROUND:** The skies of the Southern Hemisphere offer a rich variety of astronomical highlights. Here, the central regions of the Milky Way Galaxy, 26,000 light years away, appear as a tangle of dust and stars in the central part of the image. Two even more distant objects are visible as smudges of light in the upper left of the picture. These are the Magellanic Clouds, two small satellite galaxies in orbit around the Milky Way.

**Canon 5D Mark III camera; 24mm f/2.8 lens; ISO 3200; 30-second exposure**

*"One of the best landscapes I have seen in my five years as a judge. Much photographed as an area but overwhelming in scale and texture. Breathtaking!"*

MELANIE GRANT

*"This is a great composition. I love the way that the Milky Way appears to emanate from the lighthouse – really cementing the connection between the stars and the landscape. I also love the way the Milky Way drags your view out to sea, inviting you to go out and explore the unknown."*

PETE LAWRENCE

*"Some images have a real ability to evoke a real emotional response. This image gives me a feeling of pure peace. Cape Palliser in New Zealand is now on my list of places to visit."*

MAGGIE ADERIN-POCOCK

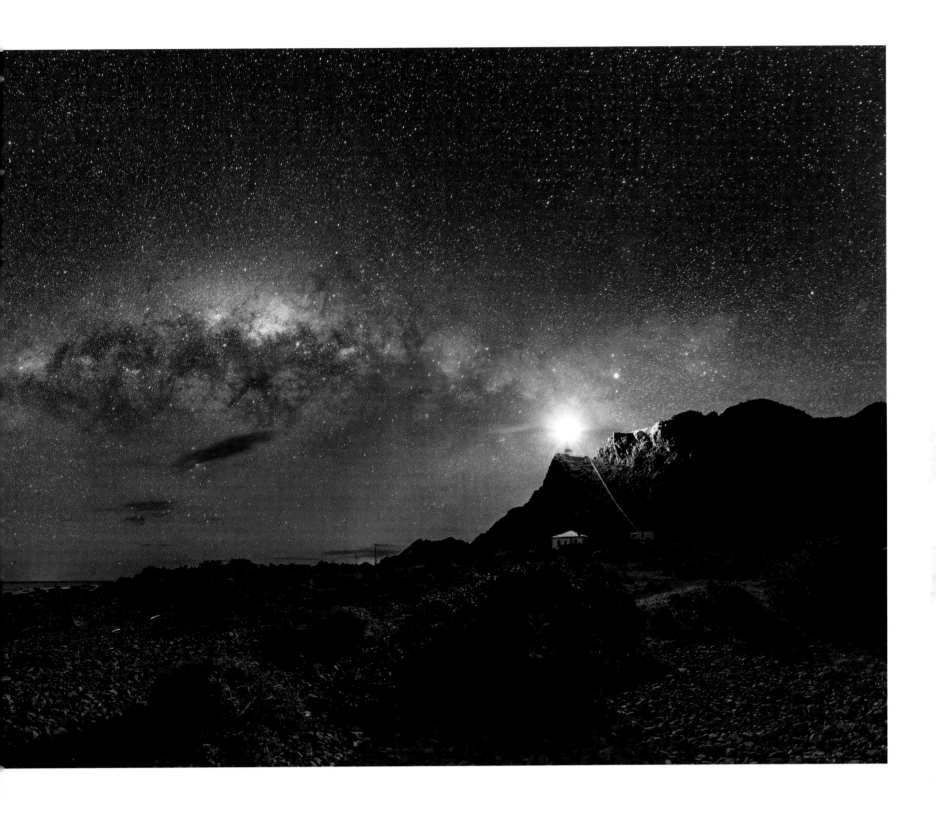

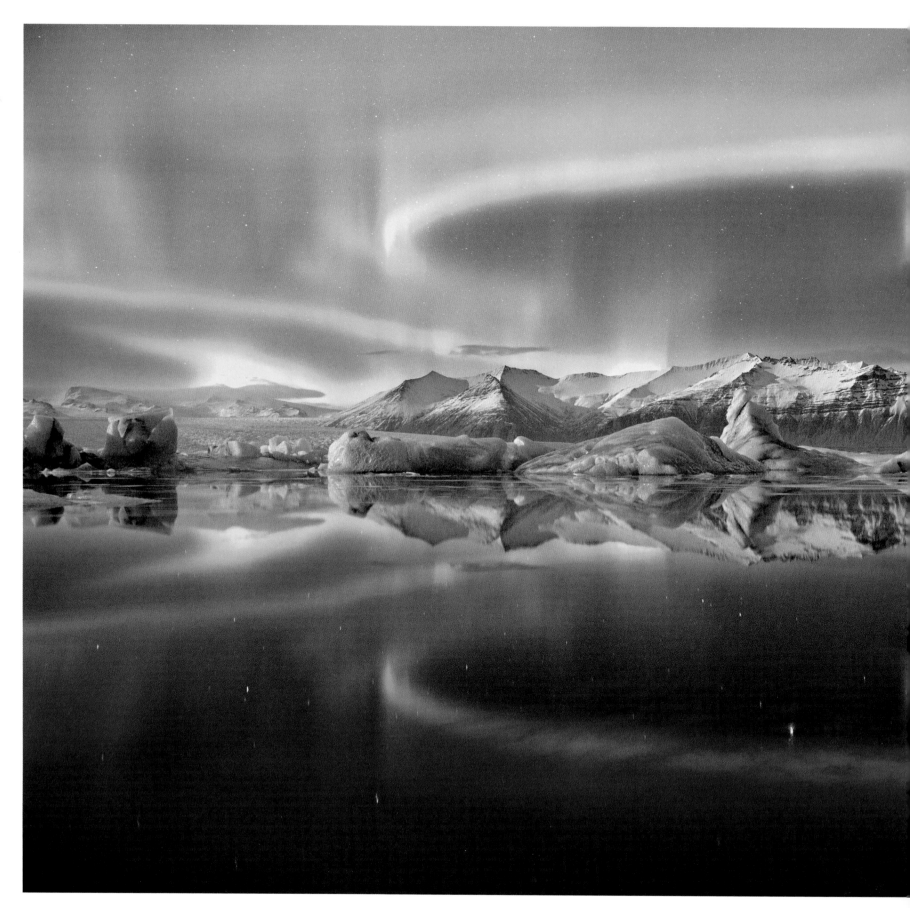

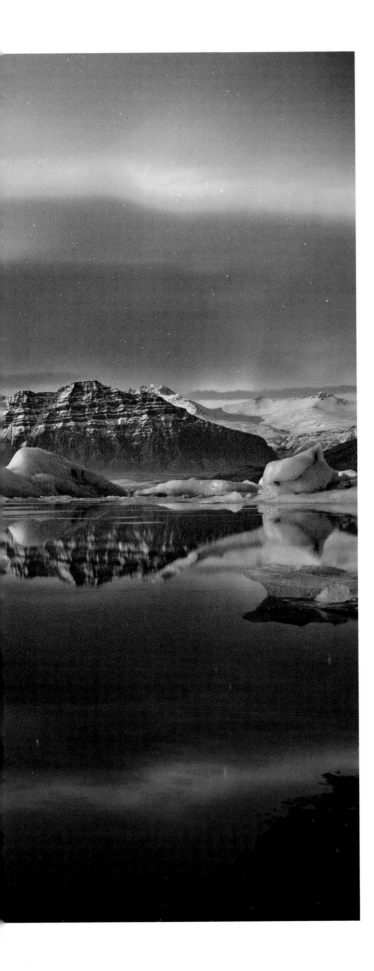

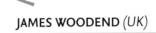

## JAMES WOODEND (UK)       OVERALL WINNER 2014

### Aurora over a Glacier Lagoon
[9 January 2014]

**JAMES WOODEND:** Jökulsárlón Glacier lagoon with an overhead aurora reflected in the water. Although it is not a strong aurora, sometimes these make the best reflection shots. The water was very still – you can see the icebergs floating in the lagoon and their reflections. In the background is the Vatnajökull Glacier.

*Jökulsárlón, Vatnajökull National Park, Iceland*

**BACKGROUND:** A total lack of wind and current combine in this sheltered lagoon to produce a striking mirror effect, giving the scene a feeling of utter stillness. Even here, however, there is motion on a surprising scale: the loops and arcs of the aurora are shaped by the slowly shifting forces of the Earth's enveloping magnetic field.

**Canon 5D Mk III camera; 33mm f/3.2 lens; ISO 1000; 10-second exposure**

*"Beautiful curves and symmetry! A wonderful, icy picture – I love the combination of whites and blue in the glacier with the chilly green of the aurora."*
MAREK KUKULA

*"I absolutely love the colours and auroral symmetry in this image as well as the contrast between the serene floating ice and the dramatic light display above. The blue ice is exquisite and the overall composition is mesmerizing. If you described this image on paper it would sound very alien indeed but the photographer has recorded the scene in a way that looks totally natural. The true beauty of planet Earth captured by camera: a worthy winner of the competition!"*
PETE LAWRENCE

*"Breathtaking shot! With its surreal colours and majestic aura it could be the landscape of a fairy-tale. I love the sense of depth, the sharpness of the turquoise ice, the structured symmetry, but, above all, its ethereal feel."*
MELANIE VANDENBROUCK

*"The lime greens and ice blues of this arctic landscape literally bounce off the page. A scenic dream of epic proportions."*
MELANIE GRANT

*"This beautiful image captures what it's really like to see a good aurora – the landscape, with the reflections which seem almost sharper than the shapes in the sky, is a terrific bonus, too! This is the first time an aurora image has won the overall prize; I think what captivated the judges was that it really looked like the aurora was right in front of the viewer – there's no need for exaggerated or stretched colour."*
CHRIS LINTOTT

*"This image is wonderful; it's a really natural portrayal of the aurora as diffuse and veil-like over the sparkling white landscape below."*
CHRIS BRAMLEY

## THE JUDGES

The judging panel is made up of individuals from the world of astronomy, photography, art and science:

**Maggie Aderin-Pocock** [2013–2014]
Space scientist and co-presenter of the BBC television programme *The Sky at Night*

**Chris Bramley** [2012–2014]
Editor of *BBC Sky at Night Magazine*, launched in 2005

**Will Gater** [2009–2014]
Astrophotographer and one of the UK's best-known astronomy writers

**Melanie Grant** [2009–2014]
Picture Editor of *Intelligent Life* magazine at *The Economist*

**Rebekah Higgitt** [2009–2012]
Former Curator of the History of Science and Technology at the Royal Observatory, Greenwich

**Dan Holdsworth** [2009–2012]
Photographic artist

**Olivia Johnson** [2009–2012]
Astronomy Programmes Manager at the Royal Observatory, Greenwich

**Marek Kukula** [2009–2014]
Public Astronomer at the Royal Observatory, Greenwich

**Pete Lawrence** [2009–2014]
World-class astrophotographer, presenter on *The Sky at Night* programme and writer for *BBC Sky at Night Magazine*

**Chris Lintott** [2009–2014]
Co-presenter of the BBC television programme *The Sky at Night* and an astronomy researcher at the University of Oxford

**Sir Patrick Moore** [2009–2012]
Author, presenter of *The Sky at Night* on BBC television for over 50 years and a noted lunar observer (1923–2012)

**Damian Peach** [2009]
Astrophotographer and planetary observer

**Graham Southorn** [2009–2011]
Former Editor of *BBC Sky at Night Magazine*

**Melanie Vandenbrouck** [2013–2014]
Curator of Art (post-1800) at the National Maritime Museum

## AUTHORS

**Background text for shortlisted entries was created by the following members of staff at Royal Museums Greenwich:**

**Edward Bloomer,** Planetarium Astronomer
**Olivia Johnson,** Astronomy Programmes Manager
**Tom Kerss,** Planetarium Astronomer
**Marek Kukula,** Public Astronomer
**Brendan Owens,** Astronomy Programmes Officer
**Elizabeth Roche,** Astronomy Education Manager
**Melanie Vandenbrouck,** Curator of Art (post-1800)

## FEELING INSPIRED?

You really do not need to have years of experience or expensive equipment to take a brilliant astrophoto, so why not have a go and enter your images into the Astronomy Photographer of the Year competition? There are great prizes to be won and you could see your photo on display at the Royal Observatory, Greenwich, part of Royal Museums Greenwich. Visit us online for more information about the competition and accompanying exhibition at rmg.co.uk/astrophoto

## JOIN THE ASTROPHOTO GROUP ON

Astronomy Photographer of the Year is powered by Flickr. Visit the Astronomy Photographer of the Year group to see hundreds of amazing astronomy photos, share astro-imaging tips with other enthusiasts and share your own photos of the night sky.
Visit flickr.com/groups/astrophoto

## Sky at Night MAGAZINE

*BBC Sky at Night Magazine* is the hands-on guide to astronomy for those who want to discover more about the wonders of the Universe from the world's leading astronomers ansd writers. Complementing *The Sky at Night* on BBC TV, the magazine features comment and analysis from its presenters Chris Lintott, Maggie Aderin-Pocock and Pete Lawrence, and covers the latest discoveries in astrophysics, monthly practical night-sky observing and astrophoto guides, plus in-depth equipment reviews. It is the definitive publication for astronomers of every level.

*BBC Sky at Night Magazine* is published by Immediate Media Co Ltd under licence from BBC Worldwide Ltd, the main commercial arm and a wholly owned subsidiary of the British Broadcasting Corporation (BBC). Visit skyatnightmagazine.com

## ASTRONOMICAL PHOTOGRAPHY
## AT THE ROYAL OBSERVATORY, GREENWICH

Each year the winning images from Astronomy Photographer of the Year are displayed in a free exhibition at the Royal Observatory's Astronomy Centre. This elegant building was constructed in the 1890s as the 'New Physical Observatory', providing facilities for the Greenwich astronomers to develop new tools and observing techniques, including astrophotography.

Photography had become an increasingly important part of astronomy from the 1870s, with the arrival of technologies that allowed faster exposures, improved resolution and smoother tracking. A department devoted to photography and spectroscopy was founded at the Royal Observatory in 1873.

At Greenwich photography was used to record sunspots, study solar eclipses and measure the distance and motion of stars. The Observatory was also a partner in an international project to produce a photographic map of the sky, the *Carte du Ciel*, and the New Physical Observatory housed telescopes, cameras and photographic laboratories. More than a century later the building is a fitting home for the Astronomy Photographer of the Year exhibition.

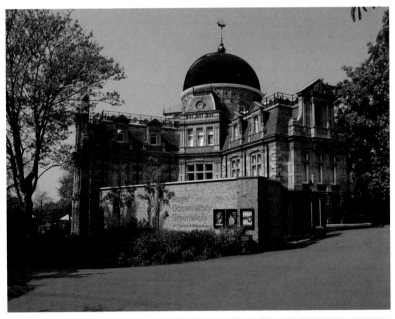

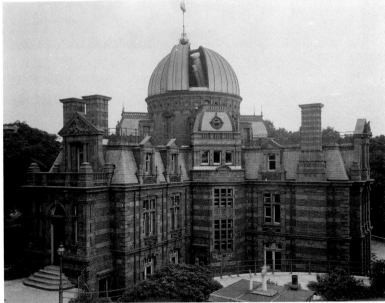

The New Physical Observatory, 1900–14

267

## PETER J. WARD *(Australia)*

### Worlds on Fire
[*10 May 2013*]

**PETER J. WARD:** This is a composite H-alpha (Hydrogen-alpha) image of the 10 May annular eclipse. I chose this image as it dramatically captures the Moon moving across the Sun, while showing high-resolution activity in the solar chromosphere.

**BACKGROUND:** This image is made up of two shots taken at different stages of a recent annular eclipse. The H-alpha filter isolates a specific colour of light which is emitted by hydrogen atoms. This allows details of the solar surface, including dark sunspots and arching solar prominences, to be seen more clearly.

Takahashi FSQ-85 telescope; Losmandy Starlapse mount; 85mm f/5 lens; PGR Grasshopper Express 6.0mp camera

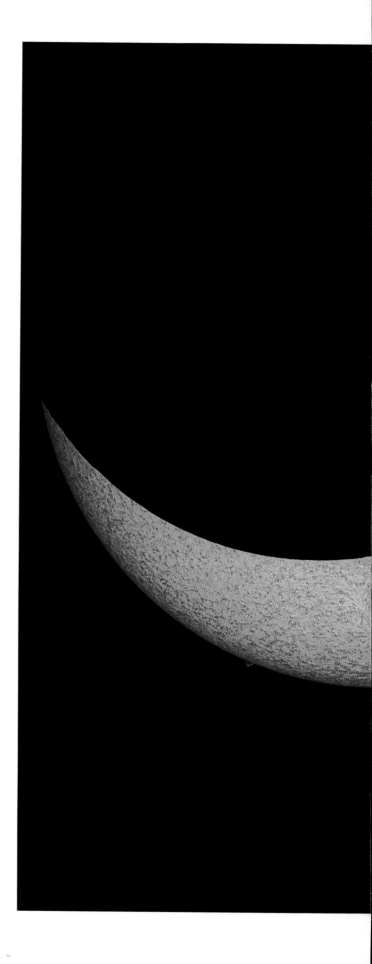

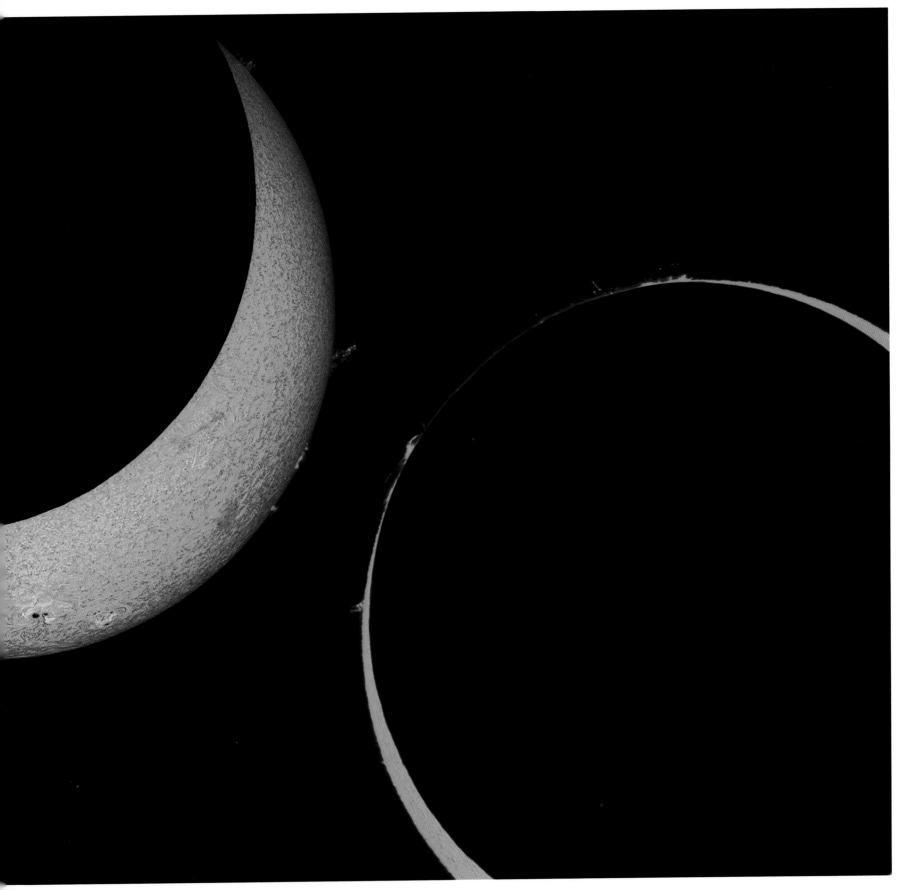

## > YOUR FIRST PHOTO OF THE STARS

Capture the night sky with nothing more than a compact camera and a tripod.

The night sky is just waiting to be captured, and you can take great pictures of it with simple equipment. Many of us have a compact camera, so why not turn it on the night sky? Today's compacts can take reasonable images in low-light conditions.

The ability to adjust a camera's settings for yourself will make for much improved images. With the Canon PowerShot ELPH 350 HS compact camera, you can keep the camera's shutter open to the starlight for up to 15 seconds, and make its imaging chip very sensitive to light, with ISO values up to 3200. The Nikon Coolpix L840 also allows for manual shooting at these high ISO values.

DSLR (Digital Single Lens Reflex) cameras offer a much wider range of functions, and most experienced astrophotographers will have one in their arsenal. They have the widest range of settings, providing full manual control. They also have interchangeable lenses so you can swap to a more powerful lens to get close in on a bright star cluster or a faint nebula, and wide ISO sensitivity ranges, allowing the faint light from many more stars to be recorded for great results.

With a DSLR you can set the opening of the camera's shutter – the exposure – in increments of seconds up to 30 seconds. After that, they'll have a manually controlled bulb or 'B' setting for even longer exposures – great for capturing star trails. In our equipment reviews at *BBC Sky at Night Magazine*, Canon and Nikon DSLRs have performed well. The Canon EOS Rebel T3, EOS Rebel T3i and EOS Rebel SL1 models are all good entry-level DSLRs for astrophotography, as is the Nikon D3300 and D5300.

To take nightscapes you also need a tripod to give you the stability for vibration-free long exposures. Exposures over one-thirtieth of a second will start to lose sharpness and show camera shake – it is very difficult to hand-hold a camera for long periods. Sturdy tripods are best, even if they are more expensive, since lightweight tripods can still shake slightly with just a breeze and this will spoil any nightscapes you take. Makes to consider include SLIK, Manfrotto and Velbon.

And there's one more thing to consider too: you can't simply press the shutter release button. You'll need a remote shutter release cable to do this. The act of pressing the shutter release to take the picture can move the camera enough to shake the image. A remote shutter-release cable can make a big difference between a shaky picture and a shot with pin-sharp stars.

*A tripod, DSLR or compact camera and shutter release cable are all you need to get started. With these you can take great pictures of the stars and constellations. (picture – Sky at Night Magazine/Will Gater, Nikon – Nikon Inc., Canon – Canon UK)*

## TARGET PRACTICE

With a DSLR and tripod there are many night-sky targets you can capture using your camera's basic settings

### Aurorae

Images of the Northern Lights will benefit from long exposures of between 3 and 30 seconds, making the green and red colours appear more vivid than if you were looking at them with your own eyes.

### Conjunctions

Conjunctions are when two or more bright planets appear close together in a twilight sky. These are a great target for testing out your camera's auto settings.

### Milky Way

During summer and early autumn, the swarm of stars in our home galaxy cuts high across the night sky. Take exposures between 15 and 40 seconds long from a really dark site.

## TAKING PHOTOS WITH A TELESCOPE
Image fainter and further into space with a scope and some key accessories

### ＞ Accessories
To fit a DSLR into your telescope's focuser you need two accessories: a 'T-mount' adapter ring (pictured) specific to your camera make, which sits in place of the lens on the DSLR's body; and an eyepiece barrel to slot into the focuser. If your scope accepts it, a 2-inch barrel is best. The barrel screws into the adapter ring.

### ＞ Mount
For sharp photos of faint night-sky objects, you'll need to open the camera shutter for quite a long time, sometimes for several minutes. As the stars appear to move through the night this can introduce blurring, unless you have a driven equatorial mount that tracks the stars' movement, like the Celestron Advanced VX computerized mount ($799) or the iOptron ZEQ25 Computerized Equatorial Mount ($948; pictured).

### ＞ Software
Even great astro images can be made better with some careful editing in photo-editing software, such as GIMP and DeepSkyStacker (free), Photoshop Elements ($99.99), or Photoshop ($9.99 per month). You can also use programs to help you plan when night-sky targets are best placed for imaging with software such as Stellarium (free; pictured) or Starry Night (from $79.99).

### ＞ Telescope
Connected to a DSLR, a telescope acts just like a telephoto lens. For good shots, choose a scope with a focal length between 400 and 2000 mm, that has good colour correction and doesn't distort the light passing through it. A solid, lockable and rotatable focuser is also desirable. Models include the William Optics Star 71mm ($1,068, pictured) and the Orion 8-inch f/3.9 Newtonian Astrograph ($535.99).

*all pictures – Sky at Night Magazine*

## ▼ ASTRO IMAGING WITH A DSLR
Master your camera to take the best night-sky shots

DSLRs are great for astro imaging because they are so flexible. The interchangeable camera lenses alone can give a wide range of magnifications, giving views similar to what you'd take in with your own eyes right up to what you'd see through a pair of binoculars. Their ability to take long exposures at light-sensitive, high ISO values means that from a dark site they can also capture vistas of the Milky Way that can't be seen by the naked eye. This is because when light reaches the eye, it sends signals immediately to the brain. But with a long exposure, light can build up on a camera's sensor before the shutter comes down.

A DSLR camera's auto settings aren't so good for the night sky. When it's dark, these auto routines find it hard to cope with the low light levels. Instead, use manual settings to control the ISO, exposure and lens aperture when taking shots of the heavens. The best way to do this is to bracket your exposures: take a range of different exposure lengths at various ISO values to see which produces the image with the best overall balance between sky darkness and star brightness. Try exposing for 5 seconds either side of an initial exposure of 15 to 20 seconds.

First, attach your camera to a tripod and plug in the remote shutter release cable. If you don't have one, use the camera's delayed timer setting. From a moderately dark site, you can get a good picture of a constellation such as Leo with a 50 mm focal-length lens by setting the ISO to 400, and using an exposure of 15 seconds (use the bulb setting if the long exposure range is limited). Set the lens aperture to a wide f-number of f/1.8 or f/2. Once you've taken the image, check it for elongated stars. If there is any of this 'star trailing', take another picture with the same settings but with an exposure of 10 seconds.

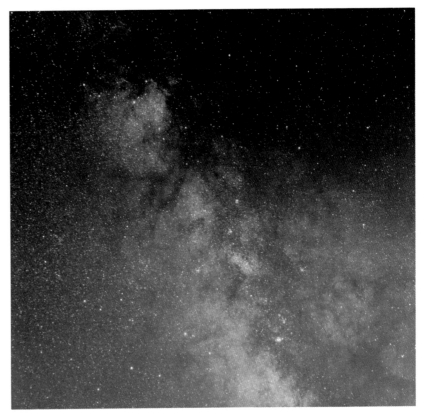

*Pictures of the Milky Way taken with a DSLR camera will reveal more than you can see with your eyes.*
*(picture – Will Gater)*

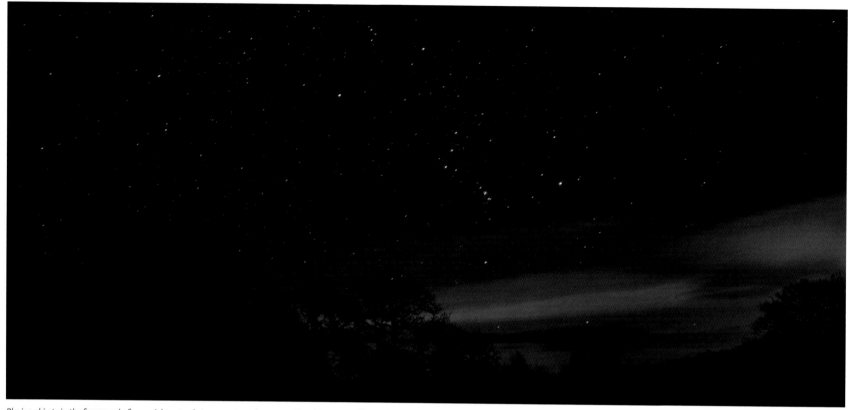

*Placing objects in the foreground of your nightscape shot can create a nice composition. (picture – Will Gater)*

## Λ CAPTURING CONSTELLATIONS
How to take stunning photos of the shapes in the stars

The night sky is full of patterns – constellations that have helped civilizations from the ancient Greeks and Romans to the Aboriginal Australians find their way round the night sky. Photographing the constellations is a great way to start taking astrophotos – you'll end up with some captivating images and learn your way around the night sky too.

It's not just constellations that make recognizable patters in the sky. Asterisms, such as the Plough in the constellation of Ursa Major, also make good, identifiable photo subjects. These familiar patterns typically consist of the brightest stars in a constellation, omitting the fainter stars that make up a constellation's main shape. Another nice asterism to train your camera on is the Sickle in Leo, which looks like a back-to-front question mark. The swarm of stars that is the Milky Way makes for a good target too, especially during the summer and early autumn, when the band of our galaxy cuts high across the night sky.

When they're high in the sky, constellations are ideal if you want to create an uncluttered photograph. But they can also look great when they're low on the horizon, either rising or setting. Adding a foreground object into the frame can really enhance the look of your nightscape photos too – experiment with houses, trees, people and your surrounding landscape.

Let's look at how we'd take a picture of the Sickle asterism in Leo with a DSLR camera. First, mount your camera on a tripod and attach the remote shutter release cable. Then set the aperture to its widest setting (the smallest f-number), choose an ISO setting of 400 and an exposure between 10 and 30 seconds long. Finally, press the shutter release to take the picture.

If you need to use the bulb setting, it's useful to have a watch that you can keep an eye on to check when to release the shutter. Once taken, have a look at the image on the camera's back screen and use the zoom function to see whether the stars in the image are sharp. If they look a bit blurred, try making the aperture smaller by one f-number and increasing the exposure time. To capture more stars you can increase the ISO to a higher value, but remember that if you're photographing from a light-polluted area, increasing the imaging chip's sensitivity will also increase the amount of orange streetlight glow that's picked up in the photo.

## COMPOSITION
Your shots will benefit from some artistic licence

To complement the star field or constellation in your picture, include an object in the foreground, such as trees, buildings with lit windows, dramatic landscapes, telescopes or people.

Use a red- or white-light torch or camera flash to illuminate the foreground; combining this with a longer exposure will still reveal the stars. You can even get one person to appear in several places in the photograph. Give them a torch, get them to stand still with the torch on, and then switch it off while they move to a new position, before turning the torch on again. In the finished photo, they will appear in several places at once.

A twilight sky can add drama by producing a lighter background sprinkled with stars, enabling you to silhouette a foreground object. Cities and towns taken from a high vantage point can also be used to great effect in wide-field shots. There are a few things that won't work though, like nearby streetlights or security lights. Light from these interferes with the image and can create distracting blobs of light called lens flares. In extreme cases it can wash out the colour and reduce contrast in your pictures.

## ˅ IMAGING THE MOON
Capture lunar seas and craters with a telescope and a point-and-shoot camera

One way to take an image of the Moon with a scope is by holding a point-and-shoot camera up to the eyepiece and clicking away. This method is known as 'afocal photography' or sometimes 'digiscoping', and with it you can take shots of the whole of the Moon's disc so that it fills the picture frame.

It can be a little fiddly positioning the camera over the eyepiece. But once you've overcome that, you can get some very pleasing results. The great thing about this method is that it's simple and, if you already have the camera and telescope, you don't need any extra specialist equipment. That being said, there are several things you can do to make your afocal lunar photography more effective. The first is to place your camera – be it a DSLR or a point-and-shoot – on a tripod. This way you won't wobble and spoil the shot when positioning the camera lens to look down the eyepiece. Similarly, using the camera's delayed timer setting or a remote shutter release cable will reduce the likelihood of you blurring the image when you press the shutter button.

You can also buy a specialist accessory called a digiscoping bracket that clamps to the eyepiece end of the telescope. It enables you to position your camera sturdily over the eyepiece. This is the best way to take an afocal photo of the Moon: it's a better solution than using a separate tripod for the camera since, once in place, it will move with the scope.

It's also important to choose the right eyepiece to use. An eyepiece with a tiny lens opening can be difficult to point your camera through. It's best to try out different eyepieces with your camera, seeing which gives the best results; a good place to start would be a standard 20–30 mm Plössl eyepiece.

*Using a compact camera and a telescope to take afocal images of the Moon can reveal a lot of detail.*

(picture – *Sky at Night Magazine*)

## CAPTURE STAR TRAILS
Four easy steps to a long-exposure photo that reveals the circular movement of stars through the night

### ➤ 1 Equipment
Wide-angle and standard lenses give the best results for star trails. Select your lens and fix your camera to a tripod. Adjust the tripod legs so that they provide a solid base. Attach the remote shutter release so you don't vibrate the camera when taking the shot.

*Canon USA*

### ➤ 2 Camera settings
Set your lens aperture wide to f/1.8 or f/2 and select ISO 400, then switch the camera to 'bulb' mode so there's no limit to the length of the exposure, and focus. Make sure your flash is disabled and switch on the long exposure noise reduction if your camera has it.

*Sky at Night Magazine*

### ➤ 3 Subject
As the Earth spins on its axis, the stars appear to rotate around Polaris, the star almost exactly on the north celestial pole. Star trails will come out shorter near Polaris and its constellation of Ursa Minor, and longer at constellations such as Orion which are nearer the celestial equator. Compose your shot depending on which trails you want in your photo.

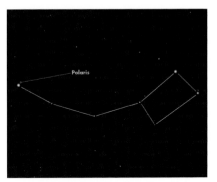

*Sky at Night Magazine*

### ➤ 4 Capture and review
Take exposures of 5, 10, 20 and 30 minutes and notice how the star trails get progressively longer. If the sky is too bright, reduce the ISO to 100 or 200 and narrow the aperture to f/4 or f/5.6. Exposures of 3 to 4 hours or more reveal the sky's circular rotation, but can also pick up an orange glow from light pollution.

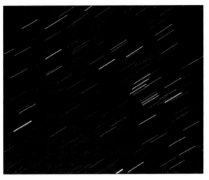

*Will Gater*

**18**
VINCENT MIU *(Australia)*
Venus, Jupiter and Moon Trails
over the Nepean River

**19**
KARL JOHNSTON *(Canada)*
Bow of Orion

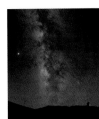

**20**
NIK SZYMANEK *(UK)*
Milky Way

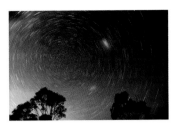

**22**
NIKHIL SHAHI *(USA)*
Death Valley Star Trails

**23**
TED DOBOSZ *(Australia)*
Star Trails, Blue Mountains

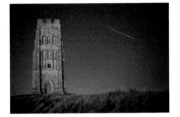

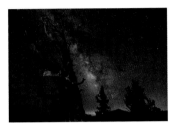

**24 and 254**
TOM LOWE *(USA)*
Blazing Bristlecone

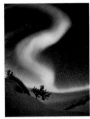

**26**
DAVE BROSHA *(Canada)*
Whisper of the Wind

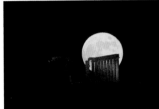

**27**
ANTHONY AYIOMAMITIS
*(Greece)*
Solstice Full Moon over Sounion

**28**
ANDREW STEELE *(UK)*
Red Moon rising over Oxford

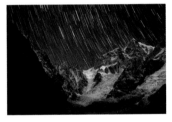

**29**
MIKE KEMPSEY *(UK)*
Meteor at Midnight,
Glastonbury Tor

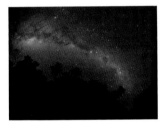

**30**
TUNÇ TEZEL *(Turkey)*
Galactic Paradise

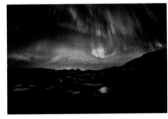

**32**
OLE C. SALOMONSEN *(Norway)*
Divine Presence

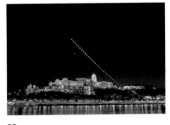

**33**
TAMAS LADANYI *(Hungary)*
Moon and Planets over Budapest

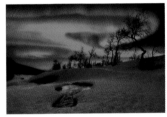

**34**
ARILD HEITMANN *(Norway)*
Green World

**36**
ATISH AMAN *(India)*
Star Trails over
Moonlit Himalayas

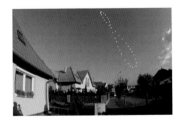

**37**
TAMAS LADANYI *(Hungary)*
Analemma over Hungary

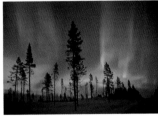

**38**
ANTONY SPENCER *(UK)*
Kiruna Aurora

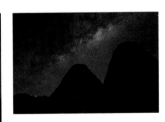

**39**
COLIN LEGG *(Australia)*
Galactic Domes

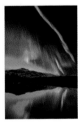

**40**
THOMAS O'BRIEN *(USA)*
Double Arch with a Perseid
Meteor and the Milky Way

**41**
TOMMY ELIASSEN *(Norway)*
Sky Show

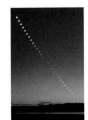

**42**
RICK WHITACRE *(USA)*
Strand of Pearls

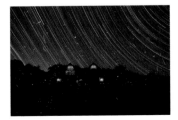

**43**
MICHAEL A. ROSINSKI *(USA)*
Summer Nights in Michigan

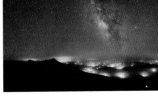

**44**
TUNÇ TEZEL *(Turkey)*
Sky away from the Lights

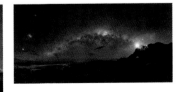

**46 and 260**
MARK GEE *(Australia)*
Guiding Light to the Stars

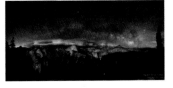

**48**
ROGELIO BERNAL ANDREO *(USA)*
A Flawless Point

**50**
DAVID KINGHAM *(USA)*
Snowy Range
Perseid Meteor Shower

**51**
STEFANO DE ROSA *(Italy)*
Hunter's Moon over the Alps

**52**
THOMAS HEATON *(UK)*
UK Meteor,
Clatteringshaws Loch

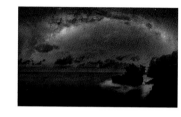

**54**
LUC PERROT *(Réunion Island)*
The Island Universe

**56**
ALAN TOUGH *(UK)*
Night-Shining Clouds

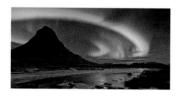

**57**
JAMES WOODEND *(UK)*
Aurora at Kirkjufell, West Iceland

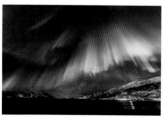

**58**
TOMMY RICHARDSEN *(Norway)*
Aurora Brutality

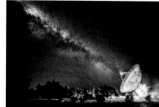

**60**
WAYNE ENGLAND *(Australia)*
Receiving the Galactic Beam

**61**
JUN YU *(China)*
Beyond the Milky Way

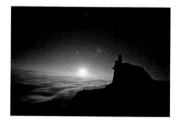

**62**
DINGYAN FU *(China)*
Pride Rock under Starry Sky

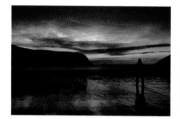

**63**
BRIAN WILSON *(Ireland)*
More Than Words

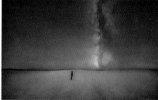

**64**
BEN CANALES *(USA)*
Hi.Hello.

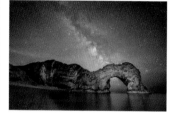

**66**
STEPHEN BANKS *(UK)*
Archway to Heaven

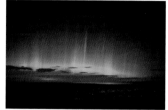

**67**
REED INGRAM WEIR *(UK)*
North-East Rays

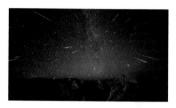

**68**
RICK WHITACRE *(USA)*
'Warp Factor 9, Mr Sulu' – 2013
Perseid Meteor Shower

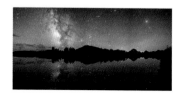

**70**
DAVID KINGHAM *(USA)*
Oxbow Bend Reflections

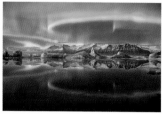

**72 and 262**
JAMES WOODEND *(UK)*
Aurora over a Glacier Lagoon

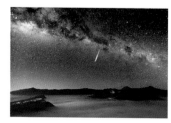

**74**
JUSTIN NG *(Singapore)*
Eta Aquarid Meteor Shower
over Mount Bromo

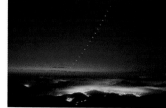

**76**
O CHUL KWON *(South Korea)*
Venus-Lunar Occultation

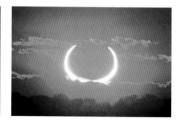

**78**
FABRIZIO MELANDRI *(Italy)*
Horns of Fire Sunrise

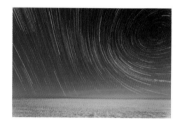

**79**
SEBASTIÁN GUILLERMAZ
*(Argentina)*
Star Trails on the Beach

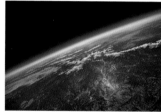

**80**
PATRICK CULLIS *(USA)*
Moon Balloon

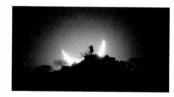

**82**
EUGEN KAMENEW *(Germany)*
Hybrid Solar Eclipse 2

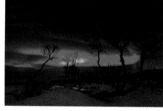

**84**
RUNE JOHAN ENGEBOE
*(Norway)*
Flow

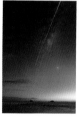

**85**
ANDREW CALDWELL
*(New Zealand)*
Falling to Earth

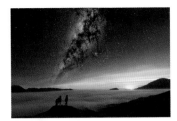

**86**
**JUSTIN NG** (*Singapore*)
Good Morning Horses!

**92**
**NICK HOWES** (*UK*)
Comet Holmes

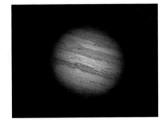

**93**
**NICK SMITH** (*UK*)
Jupiter

**94**
**RICHARD HIGBY** (*Australia*)
The Green Visitor – Comet Lulin

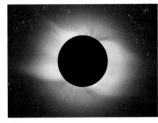

**95**
**ANTHONY AYIOMAMITIS**
(*Greece*)
Siberian Totality

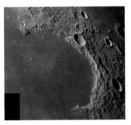

**96**
**NICK SMITH** (*UK*)
Sinus Iridum

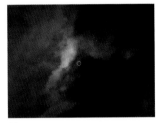

**98**
**DHRUV ARVIND PARANJPYE**
(*India*)
A Perfect Circle

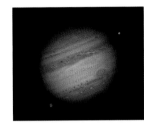

**100 and 256**
**DAMIAN PEACH** (*UK*)
Jupiter with Io and Ganymede,
September 2010

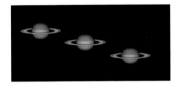

**102**
**PAUL HAESE** (*Australia*)
Dragon Storm

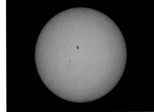

**103**
**DANI CAXETE** (*Spain*)
ISS and Endeavour
Crossing the Sun

**104**
**JATHIN PREMJITH** (*India*)
Lunar Eclipse and Occultation

**106**
**PETER PIHLMANN PEDERSEN**
(*UK*)
Lonely Moon

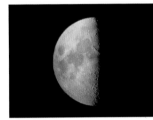

**107**
**TOM CHITSON** (*UK*)
First-Quarter Moon

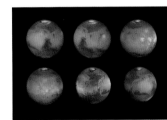

**108**
**DAMIAN PEACH** (*UK*)
Mars in 2012

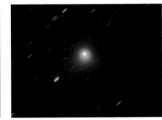

**110**
**GRAHAM RELF** (*UK*)
Comet C/2009 P1 (Garradd)

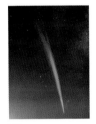

**111**
**PHIL HART** (*Australia*)
Lovejoy's Tail

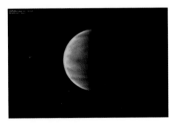

**112**
**GEORGE TARSOUDIS** (*Greece*)
Planet Venus 2012

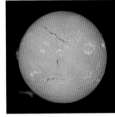

**113**
**PAUL HAESE** (*Australia*)
Active Sol

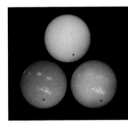

**114**
**PETER J. WARD** (*Australia*)
Tri-colour Transit

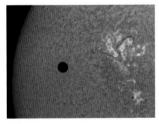

**115**
**TED DOBOSZ** (*Australia*)
Venus Transit of Sun in H-Alpha
Band

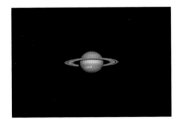

**116**
**TROY TRANTER** (*Australia*)
Saturn Super Storm

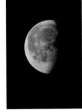

**117**
**PHIL MCGREW** (*USA*)
Space Station Flies
across the Moon!

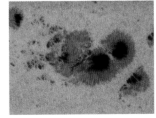

**118**
**ALAN FRIEDMAN** (*USA*)
Magnetic Maelstrom

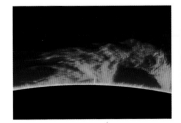

**120**
**PAUL ANDREW** (*UK*)
Incandescent Prominence

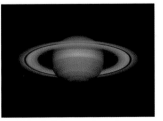

**122**
**DAMIAN PEACH** (*UK*)
Saturn at Opposition

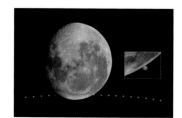

**123**
JACQUES DEACON (*South Africa*)
Lunar Occultation of Jupiter

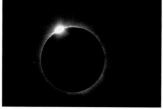

**124**
JACK NEWTON (*UK*)
The Diamond Ring

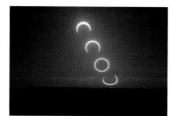

**126**
JIA HAO (*Singapore*)
Ring of Fire Sequence

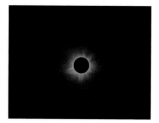

**128**
MAN-TO HUI (*China*)
Corona Composite of 2012:
Australian Totality

**130**
NICK SMITH (*UK*)
Ptolemaeus-Alphonsus-Arzachel

**132**
PAUL HAESE (*Australia*)
Solar Max

**134**
SAM CORNWELL (*UK*)
Venus Transit, Foxhunter's Grave,
Welsh Highlands

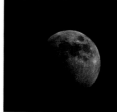

**136**
JACOB MARCHIO (*USA*)
The Waxing Gibbous Moon

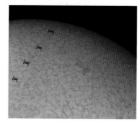

**137**
PAOLO PORCELLANA (*Italy*)
ISS Transit

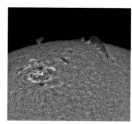

**138**
ALEXANDRA HART (*UK*)
Ripples in a Pond

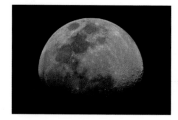

**140**
IGNACIO DIAZ BOBILLO
(*Argentina*)
Zenithal Colour Moon

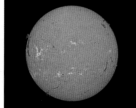

**142**
ALEXANDRA HART (*UK*)
Majesty

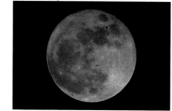

**143**
DANI CAXETE (*Spain*)
ISS Lunar Transit

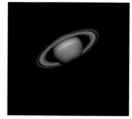

**144**
PETER RICHARDSON (*UK*)
Saturn from Somerset, April 2014

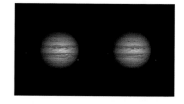

**145**
TOM HOWARD (*UK*)
Thirty Minutes

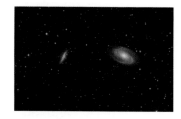

**150**
EDWARD HENRY (*USA*)
Galaxies M81 and M82

**151**
MICHAEL SIDONIO (*Australia*)
Centaurus A: Ultra-Deep Field

**152**
THOMAS DAVIS (*USA*)
Eta Carina Nebula

**153**
MARTIN PUGH (*UK/Australia*)
The Veil Nebula in Cygnus

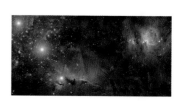

**154**
ROGELIO BERNAL ANDREO
(*USA*)
Orion Deep Wide Field

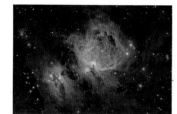

**6 and 155**
MARCUS DAVIES (*Australia*)
The Sword and the Rose
(Orion's Sword and M42)

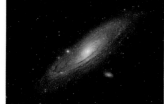

**156**
EDWARD HENRY (*USA*)
The Andromeda Galaxy (M31)

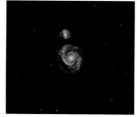

**158**
KEN MACKINTOSH (*UK*)
The Whirlpool Galaxy (M51)

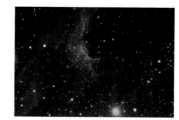

**160**
ELIAS JORDAN (*USA*)
The Pelican Nebula Up-Close

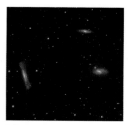

**161**
EDWARD HENRY (*USA*)
Leo Triplet

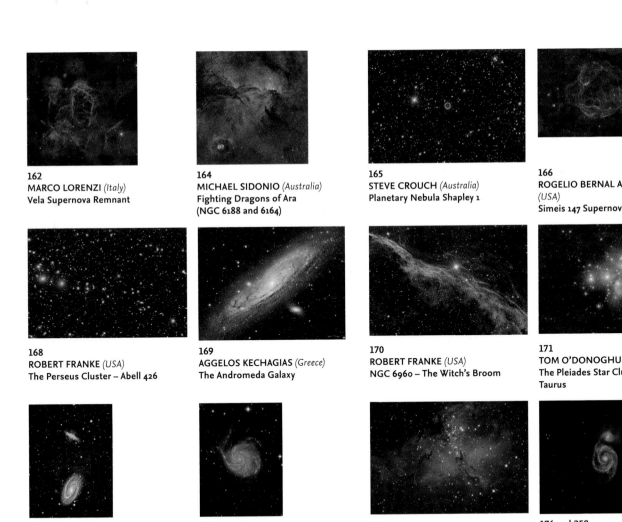

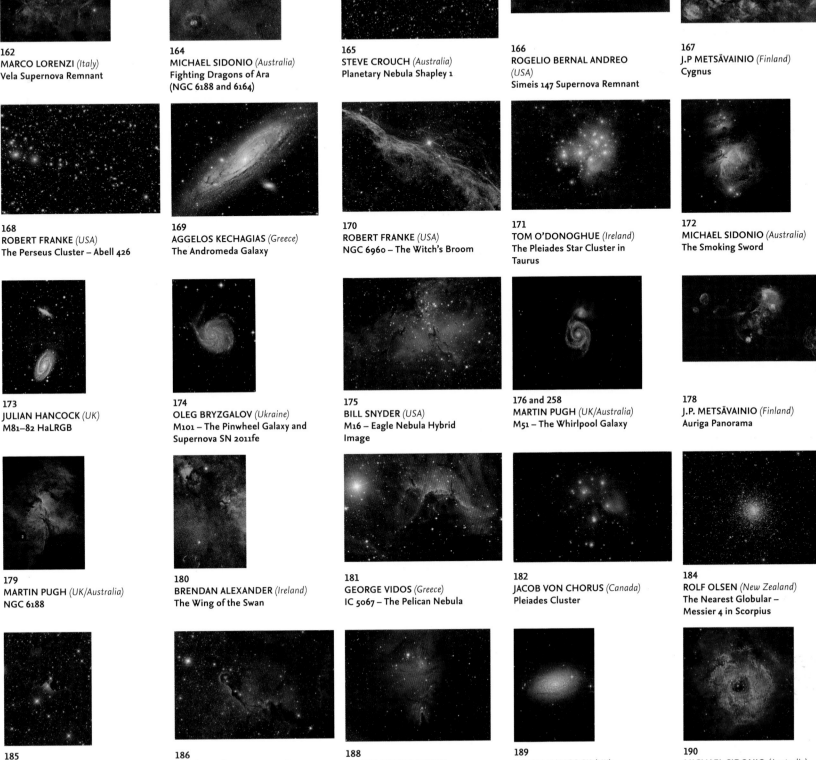

162
**MARCO LORENZI** (Italy)
Vela Supernova Remnant

164
**MICHAEL SIDONIO** (Australia)
Fighting Dragons of Ara
(NGC 6188 and 6164)

165
**STEVE CROUCH** (Australia)
Planetary Nebula Shapley 1

166
**ROGELIO BERNAL ANDREO**
(USA)
Simeis 147 Supernova Remnant

167
**J.P METSÄVAINIO** (Finland)
Cygnus

168
**ROBERT FRANKE** (USA)
The Perseus Cluster – Abell 426

169
**AGGELOS KECHAGIAS** (Greece)
The Andromeda Galaxy

170
**ROBERT FRANKE** (USA)
NGC 6960 – The Witch's Broom

171
**TOM O'DONOGHUE** (Ireland)
The Pleiades Star Cluster in
Taurus

172
**MICHAEL SIDONIO** (Australia)
The Smoking Sword

173
**JULIAN HANCOCK** (UK)
M81–82 HaLRGB

174
**OLEG BRYZGALOV** (Ukraine)
M101 – The Pinwheel Galaxy and
Supernova SN 2011fe

175
**BILL SNYDER** (USA)
M16 – Eagle Nebula Hybrid
Image

176 and 258
**MARTIN PUGH** (UK/Australia)
M51 – The Whirlpool Galaxy

178
**J.P. METSÄVAINIO** (Finland)
Auriga Panorama

179
**MARTIN PUGH** (UK/Australia)
NGC 6188

180
**BRENDAN ALEXANDER** (Ireland)
The Wing of the Swan

181
**GEORGE VIDOS** (Greece)
IC 5067 – The Pelican Nebula

182
**JACOB VON CHORUS** (Canada)
Pleiades Cluster

184
**ROLF OLSEN** (New Zealand)
The Nearest Globular –
Messier 4 in Scorpius

185
**OLEG BRYZGALOV** (Ukraine)
Sarpless-136: 'Ghost' in Cepheus

186
**LÓRÁND FÉNYES** (Hungary)
Elephant's Trunk with Ananas

188
**SHAUN REYNOLDS** (UK)
Cone Nebula

189
**JULIAN HANCOCK** (UK)
M63 LRGB

190
**MICHAEL SIDONIO** (Australia)
Tunnel of Fire

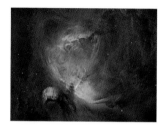

**191**
ROLF OLSEN (*New Zealand*)
Centaurus A Extreme Deep Field

**192**
ANDRÉ VAN DER HOEVEN (*Neth.*)
Herbig-Haro Objects in the
Pelican Nebula

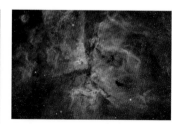

**193**
NICOLAS OUTTERS (*France*)
Dentelles du Cygne (Veil Nebula)

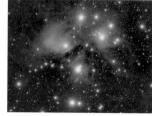

**194**
NIK SZYMANEK (*UK*)
Orion Nebula

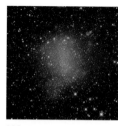

**195**
LEONARDO ORAZI (*Italy*)
NGC 6822 – Barnard's Galaxy

**196**
MARCO LORENZI (*Italy*)
Sharpless 308 –
Cosmic Bubble in Canis Major

**197**
MARCO LORENZI (*Italy*)
Fornax Galaxy Cluster

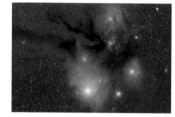

**198**
MICHAEL SIDONIO (*Australia*)
Floating Metropolis – NGC 253

**200**
MARCUS DAVIES (*Australia*)
The Wake of Argo

**202**
EVANGELOS SOUGLAKOS
(*Greece*)
Pleiades Cluster – M45

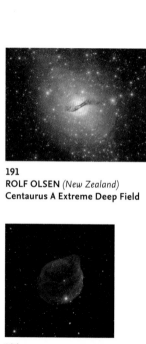

**204**
IGNACIO DIAZ BOBILLO
(*Argentina*)
Omega Centauri

**206**
DAVID FITZ-HENRY (*Australia*)
Horsehead Nebula, Reflection
Nebula and Flame Nebula

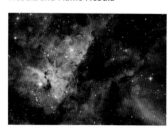

**208**
ADAM BLOCK (*USA*)
Celestial Impasto: Sh2 – 239

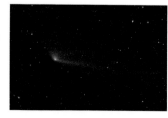

**210**
TOM O'DONOGHUE (*Ireland*)
Rho Ophiuchi and
Antares Nebulae

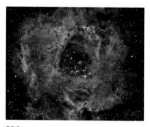

**212**
IVAN EDER (*Hungary*)
M81–82 and Integrated
Flux Nebula

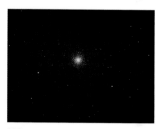

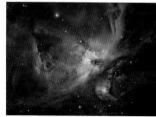

**214**
LÁSZLÓ FRANCSICS (*Hungary*)
The Trapezium Cluster and
Surrounding Nebulae

**216**
LÁSZLÓ FRANCSICS (*Hungary*)
The Carina Nebula

**217**
DAMIAN PEACH (*UK*)
Comet Panstarrs

**218**
KAYRON MERCIECA (*Gibraltar*)
Rosette Nebula in Narrowband

**219**
SAMUEL COPLEY (*UK*)
A Spider Web of Stars

**220**
ADAM BLOCK (*USA*)
Rapt with Spiral Arms

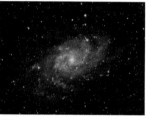

**221**
MATTHEW FOYLE (*UK*)
The Triangulum Galaxy (M33)

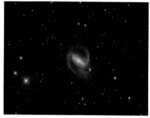

**222**
MICHAEL SIDONIO (*Australia*)
The Jets of NGC 1097

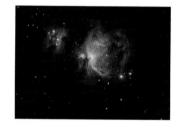

**223**
TANJA SUND (*South Africa*)
Star Factory, the Orion Nebula

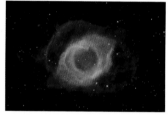

**224**
DAVID FITZ-HENRY (*Australia*)
The Helix Nebula (NGC 7293)

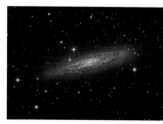

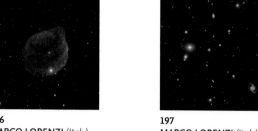

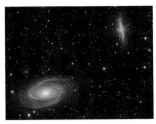

**225**
**ANDRÉ VAN DER HOEVEN, MICHAEL VAN DOORN, NEIL FLEMING**
*(Netherlands)* **M81/M82 with SN2014J**

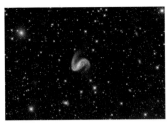

**226**
**PAUL HAESE** *(Australia)*
**The Meat Hook (NGC 2442)**

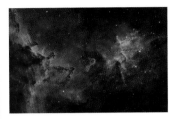

**227**
**IVAN EDER** *(Hungary)*
**Centre of the Heart Nebula**

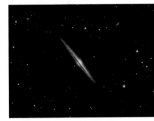

**228**
**ANTONIS FARMAKOPOULOS**
*(Greece)*
**NGC 4565 Galaxy**

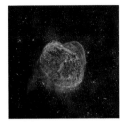

**229**
**MARK HANSON** *(USA)*
**NGC 6888**

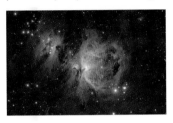

**230**
**ANNA MORRIS** *(USA)*
**Orion Nebula**

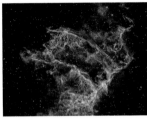

**232**
**J.P. METSÄVAINIO** *(Finland)*
**Veil Nebula Detail (IC 1340)**

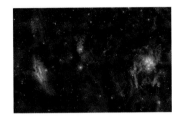

**234**
**ROGELIO BERNAL ANDREO**
*(USA)*
**California vs Pleiades**

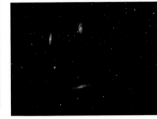

**236**
**SHISHIR & SHASHANK DHOLAKIA** *(USA)*
**The Leo Triplet**

**237**
**IVAN EDER** *(Hungary)*
**Elephant Trunk Nebula (IC 1396)**

**238**
**MARCO LORENZI** *(Italy)*
**At the Feet of Orion
(NGC 1999) – Full Field**

**240**
**MARK HANSON** *(USA)*
**NGC 3718**

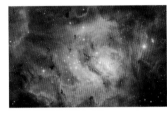

**242**
**LÁSZLÓ FRANCSICS** *(Hungary)*
**The Morphology of the
Lagoon Nebula**

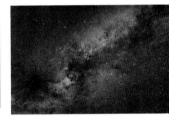

**244**
**LEONARDO ORAZI** *(Italy)*
**Zenith of the Northern
Summer Sky**

**246**
**DANIELE MALLEO** *(USA)*
**The Crescent Nebula in H-alpha
and OIII (NGC 6888)**

**252**
**MARTIN PUGH** *(UK/Australia)*
**Horsehead Nebula (IC 434)**

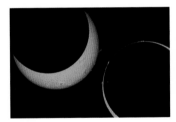

**268**
**PETER J. WARD** *(Australia)*
**Worlds on Fire**

**286**
**MARCO LORENZI** *(Italy)*
**Shell Galaxies (NGC 474 and
NGC 467)**

# PHOTOGRAPHERS INDEX

# SUBJECT INDEX

## MARCO LORENZI *(Italy)* WINNER

### Shell Galaxies (NGC 474 and NGC 467)
*[5 February 2011]*

**MARCO LORENZI:** These galaxies have been on my 'to-do' list for a very long time, since I saw a professional image of NGC 474 long ago showing its complex structure, like ripples in a pond.

**BACKGROUND:** In the upper left of this photograph, faint billowing shapes can be seen in the outer regions of an elliptical galaxy. Elliptical galaxies, which can contain up to a trillion stars, are typically smooth and shaped like a rugby ball. The delicate, wispy sheets seen in this galaxy may result from its gravitational interaction with the nearby spiral galaxy to the right.

**RCOS 14.5-inch f/9 telescope; APOGEE U16 CCD camera**

*"It's the vast variety of objects in this scene – nearby stars and distant galaxies of different shapes, colours and sizes – that makes this unusual image such a beautiful and intriguing window on the Universe for me."*

OLIVIA JOHNSON